GERMANY AT WAR

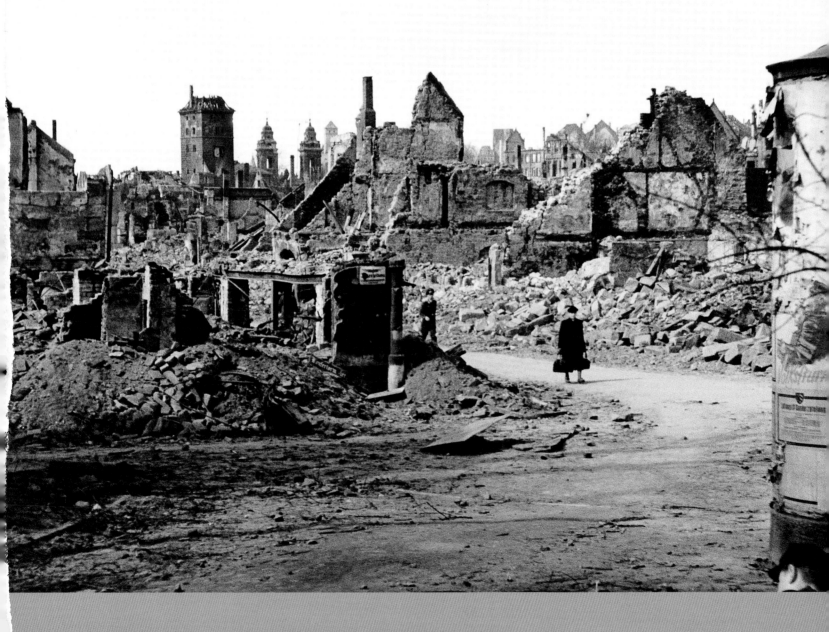

GERMANY

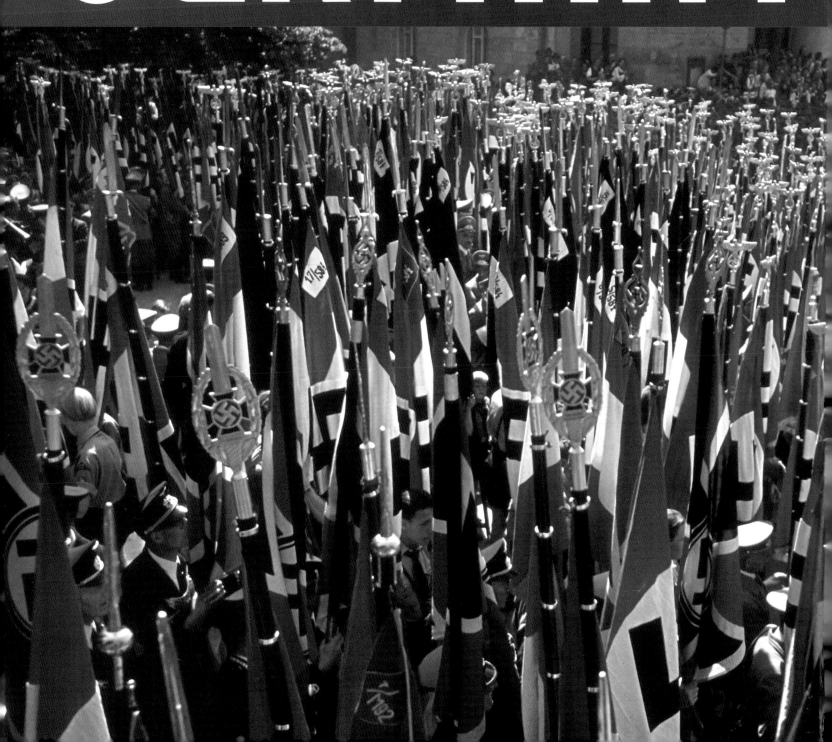

AT WAR

UNIQUE COLOR PHOTOGRAPHS OF THE SECOND WORLD WAR

Lt Col.George Forty

Picture research by Joanne King

CARLTON BOOKS

Project editor
Penny Simpson

Senior art editor
Diane Spender

Design
Addition

Picture research
Joanne King

Production
Lucy Woodhead

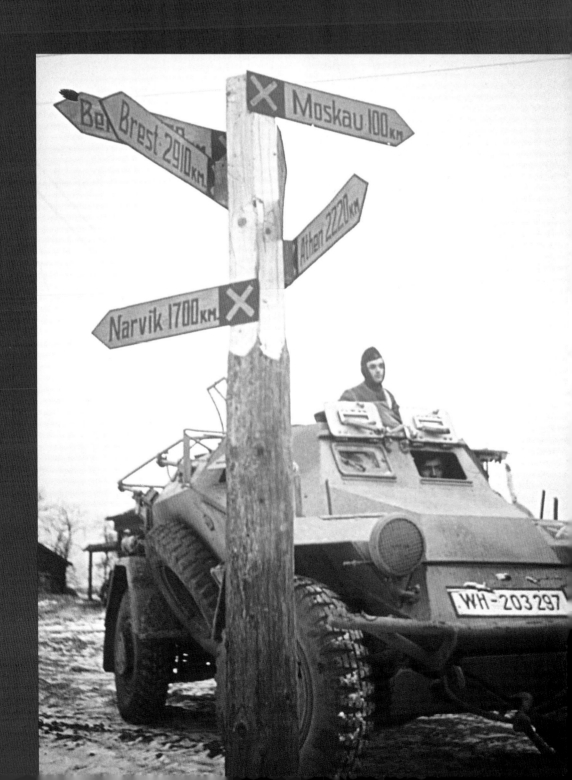

CONTENTS

PREFACE

A TURBULENT CENTURY

Any German who has lived through the past 70 years will have experienced an emotional roller-coaster that has taken them from the depths of despair to the highest peaks of euphoria and back again. The lessons that should have been learned from the disastrous outcome of the Great War were replaced in the minds of most Germans by a deep sense of injustice and resentment at what they saw as the swingeing restrictions and unfair reparations of the Versailles Treaty. Rightly or wrongly, it was this perception of injustice which, more than any other single factor, determined that just two decades later the world would be plunged into yet another horrific bloodbath even more widespread and awful than that of the "war to end all wars".

For the space of nearly two tumultuous decades Germans found themselves at the mercy of the whims and fancies of a political party that raised one man – Adolf Hitler, their Führer, their messianic leader – into a figure of godlike proportions. His one-time deputy, Rudolf Hess, said of him, "Adolf Hitler is Germany and Germany is Adolf Hitler." Undoubtedly Hess was echoing the view held, in the early days at least, by millions of Germans who desperately wanted a strong leader – one who could shrug off the image of Germany the defeated nation, whose government could beat the economic depression of the period – a leader who could make Germany great again. And the Führer confidently assured them that he was the man for the job.

Baldur von Schirach, former leader of the Hitler Youth and a member of Hitler's inner circle, explained in 1967 why Hitler was able to exert this power over the German people. He now wrote about his long-dead Führer in very different language to that he had used to extol him in the 1930s: "The German catastrophe was not only caused by what Hitler made of us but what we made of Hitler. Hitler did not come from outside; he was not, as many see him today, a demonical beast who seized power by himself. He was the man the German people wanted and the man we made master of our own destiny by our own unrestrained glorification of him. For a Hitler only appears in a people which has the desire and the will to have a Hitler. It is a collective failing in us Germans that we give honour to men of extraordinary talents – and nobody can deny that Hitler had those talents – and arouse in them the feeling that they are infallible supermen."

This book tells the story of the turbulent years of the Nazis in colour photographs, a medium which enhances and dramatizes even the most ordinary events. I am indeed grateful to the owners of all those picture collections who have allowed us to use their remarkable photographs, and my thanks go especially to Joanne King, who has spent many hours of photographic research with such excellent results. I must also thank my eldest son, Simon, for his continued assistance, my editor, Penny Simpson, and everyone at Carlton Publishing Group for their splendid support.

George Forty

CHRONOLOGY

1933

January 30	Birth of Third Reich; Hitler appointed chancellor.
February 27	Reichstag destroyed by fire.
February 28	Personal liberties clauses of constitution suspended and provision made for custody of dissenters in concentration camps. First three – Dachau, Buchenwald and Sachsenhausen – set up.
March 23	Reichstag passes Enabling Act allowing Hitler to rule as dictator.
April 1	Official boycott of Jewish shops.
Aug 31–Sept 3	"Congress of Victory" rally at Nuremberg.

1934

June 30	"Night of the Long Knives", in which Hitler purges Sturmabteilung (SA) and murders over two hundred, including leader Ernst Röhm.
August 2	Death of President Paul von Hindenburg and post of president abolished. Hitler becomes Führer of Third Reich and Chancellor.
Sept 3–10	Nuremberg Rally, at which Leni Riefenstahl films Triumph of the Will.

1935

January 13	Plebiscite returns Saar to Germany.
March 16	Hitler denounces Versailles Treaty. Universal conscription ordered.
June 26–Oct	All German citizens required to serve in Deutsche Arbeitsfront (DAF), German Labour Front.
September	Nazi swastika banner becomes national flag.
September 15	Nuremberg Rally, at which Hitler presents Nuremberg Laws, effectively legalizing persecution of German Jews.

1936

March 7	German troops re-enter Rhineland.
July 18	Spanish Civil War begins.
October 25	Rome – Berlin Pact.

November	Anti-Comintern Pact between Germany and Japan. Condor Legion (German volunteer force) goes to Spain to fight for Franco.

1937

April 27	Condor Legion attacks Guernica.
November 5	Hossbach Conference outlines Hitler's military plans to provide Lebensraum (living space) for Germans.
November 6	Italy joins Anti-Comintern Pact.

1938

March 11	Anschluss – German troops enter Austria.
March 13	Austria declared part of Third Reich. In Czechoslovakia, Henlein increases agitation in Sudetenland (parts of Bohemia and Moravia occupied by German speakers after the First World War).
May	Condor Legion leaves Spain.
Sept 5–12	Final Nuremberg Rally, attended by one million.
Sept 15 and 27	British Prime Minister Neville Chamberlain flies to meet Hitler about Sudetenland.
September 29	Munich conference transfers Sudetenland to Germany and guarantees remaining Czech frontiers.
October 1–10	German troops occupy Sudetenland.
November 9	Kristallnacht – terror attacks on Jewish shops and synagogues.

1939

March 15	Hitler breaks Munich agreement by invading Czechoslovakia and occupying Prague.
March 28	Spanish Civil War ends.
March 31	Britain and France make secret pledge to help Poland in event of German aggression.
May 22	Hitler and Mussolini agree to 10-year alliance – "The Pact of Steel".
August 23	Germany and Soviet Union sign non-aggression pact.

September 1	Germany invades Poland.
September 3	Britain and France declare war on Germany.
September 17	Soviet Union invades Poland.
September 28	Germans reach Warsaw.
November 30	Soviet Union invades Finland.

1940

April 9	Germany invades Norway and Denmark.
May 7	Churchill becomes Britain's Prime Minister after Chamberlain resigns.
May 10	Germany invades Holland, Luxemburg and Belgium.
May 14	Germany breaks through French defences.
May 28	Belgium capitulates.
June 10	Italy declares war on Britain and France.
June 14	Germans enter Paris.
June 22	France signs armistice and soon afterwards is divided into occupied and unoccupied (Vichy) zones.
Aug–Sept	RAF defeats Germans in Battle of Britain.
September 27	Japan joins Axis powers (Germany and Italy).
October 18	Anti-semitic laws introduced in France.
October 28	Italy invades Greece.
November 26	Work begins on creation of Jewish ghetto in Warsaw.
December 9	British begin Operation Compass against Italians in North Africa.

1941

February 5–7	Defeat of Tenth Italian Army at Beda Fomm, in Western Desert, by British and Commonwealth troops of General O'Connor's XIII Corps.
Feb–March	(Deutsches) Afrika Korps lands in North Africa to support Italians; opens successful counter-offensive.
April 6	Germany invades Yugoslavia and Greece.
June 22	Germany invades Soviet Union.
September 3	German troops reach outskirts of Leningrad.
October 25	German offensive against Moscow repulsed.
December 7	Pearl Harbor bombed by Japan, which also attacks Malaya.
December 8	USA and Britain declare war on Japan.
December 11	Germany and Italy declare war on United States, which reciprocates.

1942

January 20	Wannsee Conference adopts "Final Solution" – the extermination of the Jews – which SS General Reinhard Heydrich is appointed to administer.
February 1	Vidkun Quisling becomes Premier of Norway.
January 31	Singapore falls to Japanese.
May 29	Heydrich attacked in Prague; dies June 4. In reprisal Nazis destroy Lidice.

May 30–31	Cologne is first German city to be attacked in a thousand-bomber raid.
September 13	Germans launch main attack on Stalingrad.
October 23	Battle of El Alamein, followed by Axis withdrawal across North Africa and into Tunisia.
November 8	Operation Torch – Allied landings in North Africa.
November 19	Soviet winter offensive surrounds German troops in Stalingrad.

1943

January 31	Von Paulus surrenders German forces at Stalingrad. Three days of national mourning begin in Germany on February 4.
February–May	Heavy bombing raids on German cities, particularly Berlin, Essen, Duisburg and the Ruhr; Dambusters Raid on May 16–17.
April 19	SS troops massacre Polish Jews in Warsaw after Ghetto rises.
May 12	German and Italian armies in North Africa surrender.
July 10	Operation Husky – Allies land on Sicily.
July 25	Mussolini falls from power and is arrested.
July 5–12	Germans attack at Kursk in largest tank battle of war.
September 3–9	Operations Baytown, Slapstick and Avalanche – Allies land in Italy.
October 13	New Italian government changes sides.

1944

June 4	Allies enter Rome.
June 6	Operation Overlord – D-Day landings on Normandy coast.
July 20	Von Stauffenberg bomb plot to assassinate Hitler fails; savage retaliation follows.
August 1	Warsaw rising against Germans is put down while Russians wait and watch.
August 15	Operation Dragoon – Allies land in southern France.
August 22–6	Paris liberated.
September 29	Red Army invades Yugoslavia.
October	Red Army invades Hungary.
December 16	Germans launch Battle of the Bulge.

1945

February 13–15	Allied bombing of Dresden kills 70,000.
February 15	Allied troops reach Rhine.
April 20	Red Army enters Berlin.
April 28	Mussolini captured and killed by Italian partisans.
April 30	Hitler and Eva Braun commit suicide in Berlin bunker.
May 2	Berlin surrenders.
May 7	German surrenders unconditionally.
June 5	Allies divide Germany into US, British, French and Soviet zones of occupation.
November 20	Nuremberg Trials begin.

CHAPTER 1

The Nazis Gain Power

Germany was a young country in 1914. Its constituent parts – some 38 states – may have had their own long histories and identities, but the nation itself had existed only since 1871, when Bismarck created it. Its people needed to see tangible national success to give the new country the gravitas and position in world politics they felt it deserved. When war came, they embraced it in a way that was different to the attitude of the Western allies. Belief in the Fatherland, the fraternity of men fighting for their country, the initial success of their forces: all these things gave the German troops such an unshakeable self-belief and pride in their country and countrymen that they could not comprehend the possibility of defeat.

The sense of betrayal felt by the junior officers and rank and file of the defeated German army of 1918 was palpable and would dominate the post-war political scene. After the success of the German Spring Offensive of that year, which so nearly achieved victory before US forces could swing into action, the speed of the Allies' progress and the fact that the armistice took place with Germany's borders intact left the soldiers disoriented. The government that ruled Germany after the war felt the brunt of their acrimony: many people believed the Weimar Republic had betrayed them by accepting the terms of the Treaty of Versailles, in particular the "War Guilt" clause that identified Germany and her allies as being guilty of the aggression that started the conflict.

However, by the late 1920s the Weimar Republic seemed to have weathered the storm despite these feelings and the problems caused by having to pay heavy war reparations, continued fighting between left- and right-wing militants and the currency collapse of 1923 that had led to the occupation of the Ruhr by French and Belgian troops (who would leave in 1925). Germany's industry was at last strengthening; currency problems and rampant inflation had been curbed; the Dawes Plan of 1924 had eased the burden of reparations. In 1929 there was a further revision to the payment of reparations: the Young Plan, which was accepted by the Reichstag and by popular referendum.

The Young Plan and the success of the German economy depended upon continuing growth, but the Wall Street Crash of October 1929 put paid to all that. The losses on the US Stock Market affected the whole of Europe, but Germany – its economy already weakened by the currency problems of the 1920s and the losses sustained by its middle class – suffered most. There was a massive downturn in production – it halved between 1929 and 1932 – and with it came massive unemployment: in 1930 there were three million unemployed; by 1932 the figure had doubled.

In such chaos the Nazi Party thrived. In the 1928 Reichstag elections the Nazis had won only 12 seats. In 1930 they polled a sixth of the votes and gained 107 seats. In 1932 Hitler lost out to Paul von Hindenburg for the presidency, but he polled nearly 13.5 million votes. "We [the Nazis] are the result of the distress for which others are responsible," he would later claim. In 1923, during the currency crisis, the fledgling Nazi Party had attempted a putsch in Munich: the government had been strong enough to overcome it easily and its leader was sentenced to five years in Landsberg prison (where he dictated to fellow prisoner Rudolph Hess the first chapter of *Mein Kampf*). Ten years later that prisoner was Chancellor of Germany and the inmates had taken over the asylum.

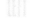

An SA Camp at Nuremberg, during the Reich Party Congress of 1938. The Sturmabteilung, Storm Troopers, of the Nazi Party, also called the Brownshirts, began as squads of roughnecks under Ernst Röhm, formed to protect Nazi mass meetings from rivals. In the 'Night of the Long Knives', in June 1934, the SA were purged by the SS and Röhm murdered.

THE THIRD REICH IS BORN

The world crisis engendered by the Wall Street crash destroyed the improvements the German economy had enjoyed in the late 1920s. To a country that had lost so much during the currency crisis a few years earlier, this was the last straw. Public order problems added to the difficulties. In January 1933 a coalition government brought together the right-wing Nazi Party and the "middle of the road" moderate conservatives of Franz von Papen's Catholic Centre Party. Von Papen, who was convinced that he could control the messianic Hitler, agreed to his heading the coalition so that he could make use of Hitler's undoubted powers of oratory to manipulate the masses. The 85-year-old President, Paul von Hindenburg, was persuaded to appoint Hitler the new chancellor – despite his active dislike of the "Austrian Corporal", as he called him. Thus the Third Reich came into being – the first had been the Holy Roman Empire which began in AD 962; the second the empire founded by Bismarck that ended in 1918.

Once he became Chancellor, Hitler's "coalition" immediately passed legislation banning rival political meetings and publications, dissolving parliament and terrorizing the Communists. One month later, on February 27, 1933, fire razed the parliament building to the ground. Blamed on the Communists but probably engineered by the Nazis, the Reichstag fire gave Hitler the opportunity he needed to suspend civil liberties under an Enabling Act, the Gesetz zur Erhebung der Not von Volk und Reich (roughly, "Law to remove the distress of the people and the state"). This took away from the Reichstag powers of legislation, of control of the budget, of constitutional amendments and of approval of treaties with foreign countries. From then on Hitler had dictatorial powers and Germany was to all intents and purposes a police state.

Anyone who stood against the Nazis – and even many of those who stood with them, such as the purged members of the Sturmabteilung (SA), or Storm Detachment, and other people Hitler felt were his enemies in the party after the "Night of the Long Knives" on June 30, 1934 – were rounded up and put into concentration camps. The first three of these – Dachau, near Munich, Buchenwald, near Weimar, and Sachsenhausen, near Berlin – were set up at the start of the Nazi regime. By its end the Nazis had built many more concentration camps to house the myriad opponents of their regime: here they interned Communists and Jews at first, then a wider selection of intellectuals, religious leaders, trade unionists, socialists, democrats, pacifists and gypsies. At the start of the war the camps held 50,000 inmates and a further 200,000 had spent time in them. As well as the concentration camps, after the start of the war eight special extermination camps were created to eliminate a variety of "enemies", in particular the Jews in a holocaust of genocide that still has harsh echoes today.

CONSOLIDATING POWER

The overt requirement for the Nazis when they came to power was to sort out Germany's economy and unemployment. In his speech on May Day 1933 Hitler promised that he would bring peace on the labour front. He did so by banning all trade unions, his Brownshirts of the Sturmabteilung taking over all their offices and assets. From then on there was only one trade union – the Deutsche Arbeitsfront (DAF), German Labour Front, all its officials being Nazi Party members. On top of this the Reichsarbeitsdienst (RAD), State Labour Service, was created on June 26, 1935. This obliged all able-bodied Germans between the ages of 19 and 25 to work for the state. Thus, at a stroke, the entire German labour force of over 20 million was put under Nazi control – and often that meant individual Nazi leaders. In 1937 the state set up the Hermann Goering Works to make steel from local low-grade ore, and this became the largest industrial operation in Europe.

The creation of the DAF and RAD allowed the Nazis to reduce unemployment (Hitler boasted in 1936 that the Nazis had reduced it from six to one million) by either putting the unemployed into the armed forces or using them in the RAD. Public work schemes helped, a prime example being the building of motorways – so much a part of the landscape today, but new in the 1930s. The Nazis didn't invent these Autobahnen (the first had been built in the 1920s), but under Fritz Todt the thirty thousand workers (rising to seventy thousand by the late 1930s) of the Organisation Todt had completed about a quarter of the 11,750 kilometres (7,300 miles) Hitler wanted. And the motorways served a double purpose: as well as their peacetime use they would contribute to the quick movement of troops between the Western and Eastern Fronts that Hitler anticipated in a future war.

The covert requirements for the Nazis were to take hold of the country ideologically, prepare the populace for war and build the infrastructure and armaments that the armed forces would need. Important factors in producing an ideologically correct Nazi population were propaganda, organization and education. The propaganda was arranged by the Minister for Enlightenment, Dr Joseph Goebbels; the Gestapo (Geheime Staatspolizei, secret state police) provided the organization to maintain the regime. Education was to be completely overhauled, for, as Hitler said, "whoever has the youth has the future". Under Bernhard Rust, Minister for Science, Education and Culture, the teachers were purged of Jews, organized into the NS-Lehrer-Bund (NSLB), National Socialist Teachers' Alliance, and provided with a Nazi curriculum. Thus an education system that had been a model of organization for the world was perverted into a school for Nazis.

Additionally, in 1933 two youth organizations were set up: the Hitler Jugend (HJ), Hitler Youth, and the Bund Deutscher Mädel (BDM), League of German Girls. All existing youth clubs were taken into these bodies and every youth was expected to join. In 1930 the HJ had about one hundred thousand members; by 1938 that figure was over seven million. After membership of the youth organizations came compulsory work in the RAD and then the armed forces.

On August 2, 1934 President Hindenburg died and Hitler was already powerful enough to refuse to succeed him in this role. He chose instead to rule as Führer (leader) and Chancellor, but he made sure he took on Hindenburg's powers, including supreme command of the armed forces. Some 38 million Germans – 90 per cent of the voting strength – agreed with Hitler's actions in a plebiscite. From the day of Hindenburg's death Hitler demanded that all soldiers swore a loyalty oath to him personally, and four years later he would also become Minister of War and Commander-in-Chief of the Wehrmacht, when the former Minister (Blomberg) was dismissed and the C-in-C (Fritsch) was forced to resign on a trumped-up charge.

THE GERMAN SOLDIER'S OATH

"I swear by God this sacred oath, that I will give unlimited obedience to the Leader of the German Reich and People, Adolf Hitler, and as a brave soldier will be ready to stake my life for this oath at any time."

EXPANSION

With the Nazi position in power consolidated, Hitler began his mission – as outlined in *Mein Kampf* – to resurrect German power. At first secretly, and later openly, he disobeyed the strictures of the Versailles Treaty and began rearming. In March 1935 he announced to the world that he would build a peacetime army of half a million men, bringing out in the open the fact that Germany had long been secretly rearming. Now he boasted of the recreation of the Luftwaffe (air force), the resurgence of the Reichsmarine (navy), which would become the Kriegsmarine in wartime and, above all, the massive expansion of the Heer (army). By the time war began, the army would number over 2.7 million soldiers.

The fulfilment of Hitler's promise to form a "Greater Germany" began in 1935, the first territory to rejoin the Third Reich being the Saar – 2,600 square kilometres (1,000 square miles) of land to the east of the Rhine, rich in coal and iron

deposits – that had been put under League of Nations control in 1919, with France able to exploit its resources. A plebiscite held in January 1935 unanimously opted for the Saar's return to Germany. This was followed in March 1936 by the occupation of the Rhineland, which comprised all formerly German territory to the west of the river plus a 48-kilometre (30-mile) strip to the east, including the city of Cologne. Once again this fait accompli was achieved by a small force of German soldiers: France, Great Britain and their Allies did nothing except protest weakly. The following year, in a speech in the Reichstag, Hitler formally abrogated the provisions of the Versailles Treaty and Germany withdrew from the League of Nations, without any serious opposition being raised.

Emboldened, Hitler next proceeded to agitate for Anschluss (the union of Austria and Germany), which had been forbidden by the Versailles Treaty. Around the same time he demanded self-determination for all Germans living in the Sudetenland, the most westerly province of Czechoslovakia, encouraging the sizeable German minority there to voice its support. However, the Czechs were not cowed by his rhetoric, having a fairly strong army of their own, so Hitler backed down when President Benes ordered general mobilization. Instead he went back to Austria, where, on March 13, 1938, German troops marched across the frontier, to be followed the next day by Hitler driving through Vienna to a tumultuous welcome from the people. But Hitler had not given up on the Sudetenland and continued to make his demands. Afraid of war, the British Prime Minister, Neville Chamberlain, flew to Munich to talk with the German leader, who persuaded him that this was to be his very last demand for Lebensraum (living space). Chamberlain believed him and persuaded France to accept the "Peace in our Time" agreement in exchange for the occupation of the Czech territory.

"LET SLIP THE DOGS OF WAR"

It was not to be. Hitler's last territorial claim in Europe was followed in March 1939 by the crossing of the Czech frontier and the occupation of Bohemia and Moravia as German protectorates. Next, Memel was annexed, Danzig and the "Polish corridor" demanded and the most unlikely of all treaties – a non-aggression pact between the Soviet Union and Germany – was signed on August 23 of that year. No one apart from the signatories knew of the secret clauses it contained: that Poland would be divided between them once hostilities had been declared.

The world moved inexorably toward war, the unsuspecting German people straining at the leash, eager to fulfil their chosen destiny, little realizing the hideous depths of the abyss into which they were so willingly being led by their charismatic leader.

BERLIN BEFORE THE WAR

The capital and chief city of Germany from 1871, Berlin had a population of some four million people by the mid-1920s, with a cosmopolitan mix of French, Jewish, Dutch, Polish, Russian, Austrian and Turkish immigrants, as well as German nationals. Voluntary and enforced emigration reduced the Jewish population of Berlin from 4.3 per cent to 1.8 per cent between 1925 and 1939. As befits a thriving capital, this cosmopolitan city had a vibrant cultural life, particularly during the Weimar Republic of 1918–33. In addition to containing many fine buildings, it benefited from being surrounded by lakes and woods.

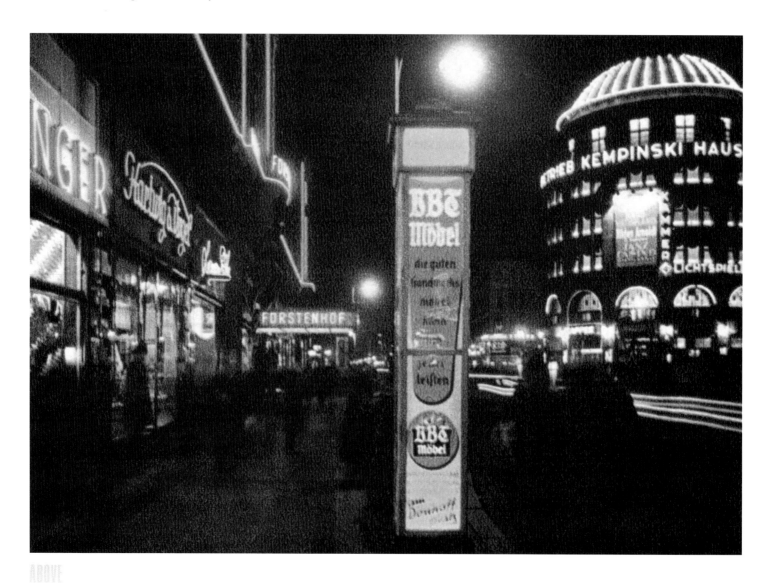

ABOVE

Berlin by night. Theatres, clubs, cabarets and other entertainments made the city's nightlife exciting and notorious during the interwar years. However, much of the cultural fare, and especially satirical reviews, ran counter to the Nazi ethos.

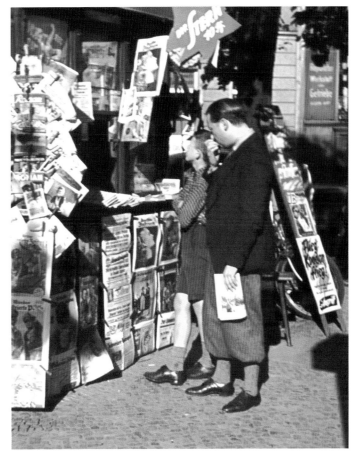

This city newsstand sells a wide variety of newspapers and magazines. However, from early 1933 there was an ever-increasing Nazi-run monopoly on German newspapers. The one remaining Jewish-owned paper, the *Berliner Tageblatt*, survived only until 1937.

A walk in the park. The lovely Indian summers so often enjoyed in Berlin in the autumn had nearly everyone flocking to the city's parks and open spaces.

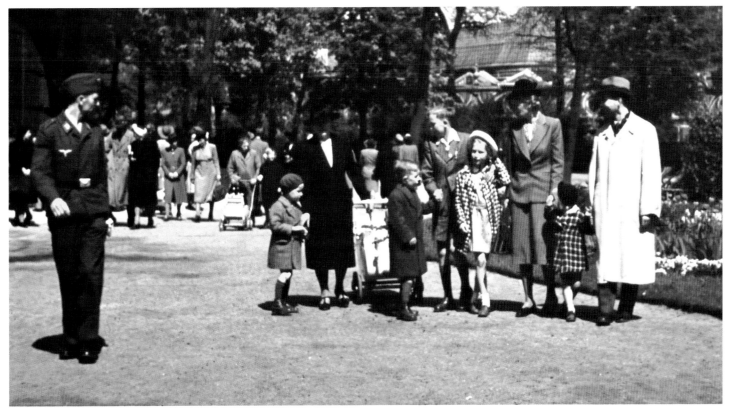

BELOW

Hitler Youth in Graz, Austria, 1938. The Hitler Jugend, or HJ,
was the male branch of the Nazis' youth movement.
Established in 1933, the HJ numbered over seven million five
years later, under the command of Reichsjugendführer (Reich
Youth Leader) Baldur von Schirach.

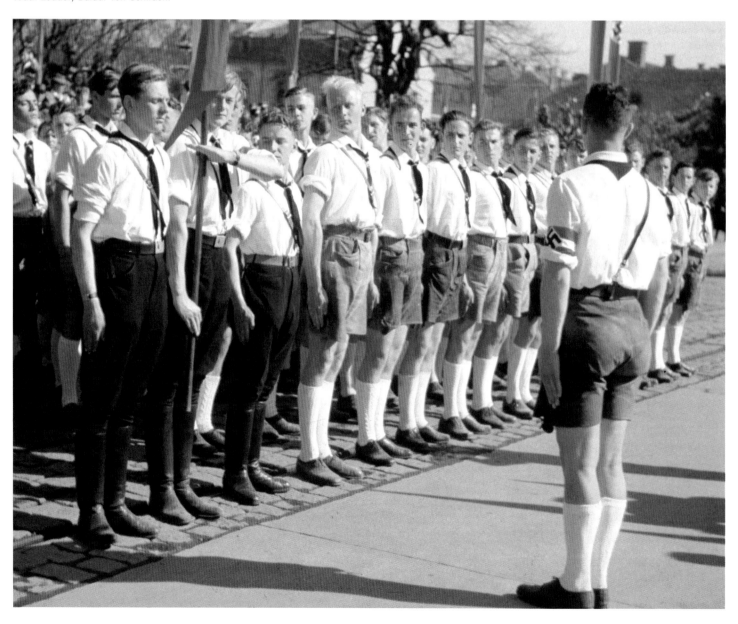

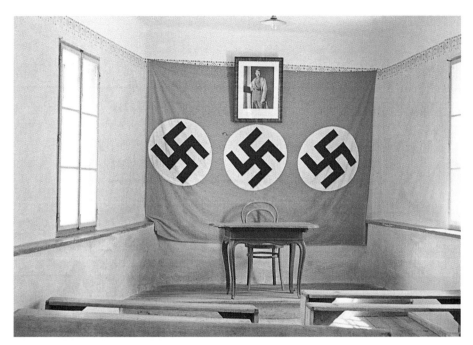

LEFT

LEFT

Hitler in the classroom. "Whoever has the youth has the future" were the Führer's words, and his philosophy on education was based largely on his personal antagonism towards educational authority. His two prime educational aims were to instil a sense of race and to make German youth ready for war.

BELOW

A contingent of Hitler Jugend marching in Berlin, led by drummers of the Deutsches Jungvolk (German Young People). By March 15 of their tenth year, every German youngster had to register with Reich Youth HQ to join the Deutsches Jungvolk. They remained in this organisation until the age of fourteen before graduating to the HJ if a boy and to the Bund Deutscher Mädel if a girl, and staying there until they were eighteen.

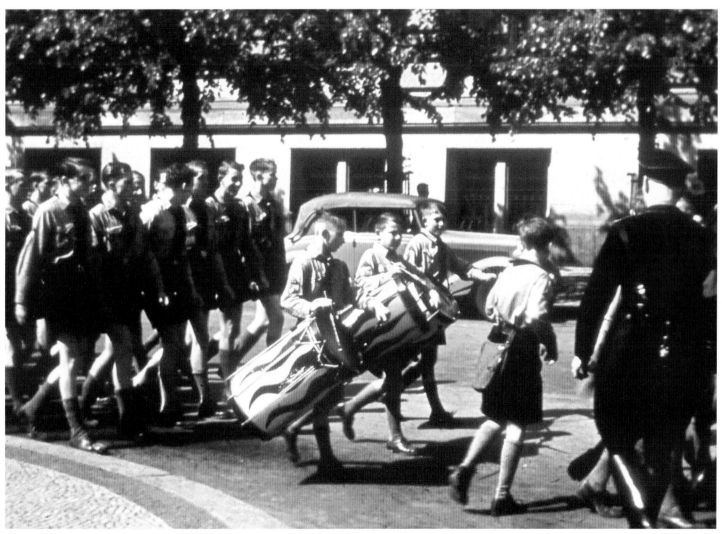

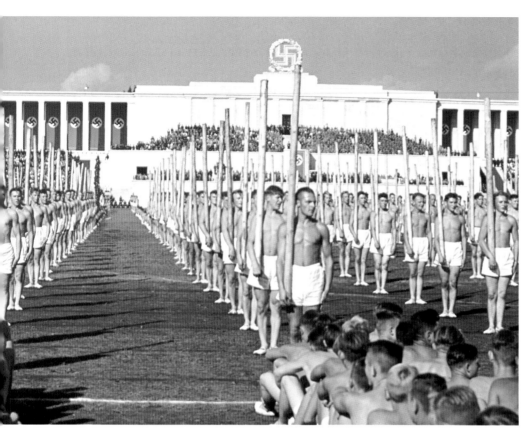

LEFT

Youth Reich Party Congress in Nuremberg, September 1938. The Germans had long been interested in sport, which Hitler regarded as essential for a healthy nation (even though he took practically no form of exercise himself). Physical education teachers became the most important members of a school's staff.

RIGHT

The Honour Cross of the German Mother honoured fertile women. Recipients were proposed by the Reich's Chief Medical Director, Dr Gerhardt Wagner, and approved by Hitler. The award was divided into three classes: a bronze medal for having four children, silver for six and gold for eight.

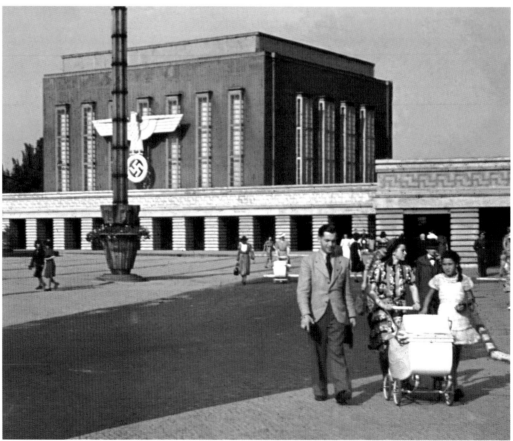

RIGHT

While the large Nazi emblem provides an impressive backdrop, the subject of this photograph is the model German family – father and mother, plus two children, all well dressed, although not ostentatiously so.

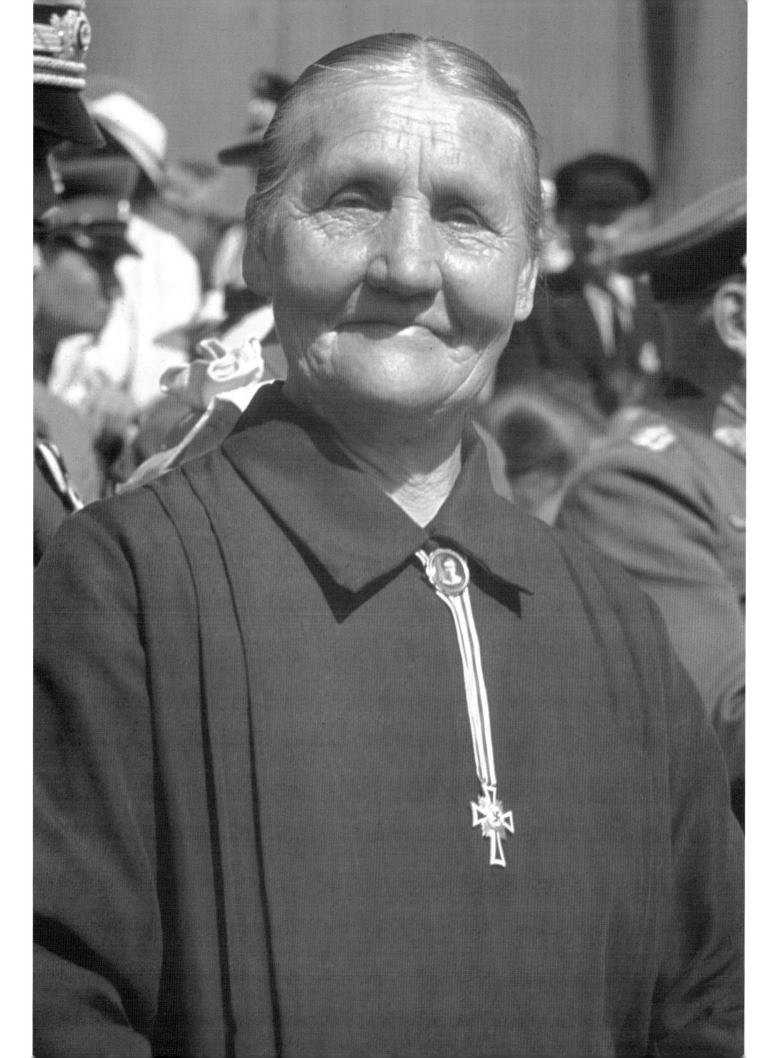

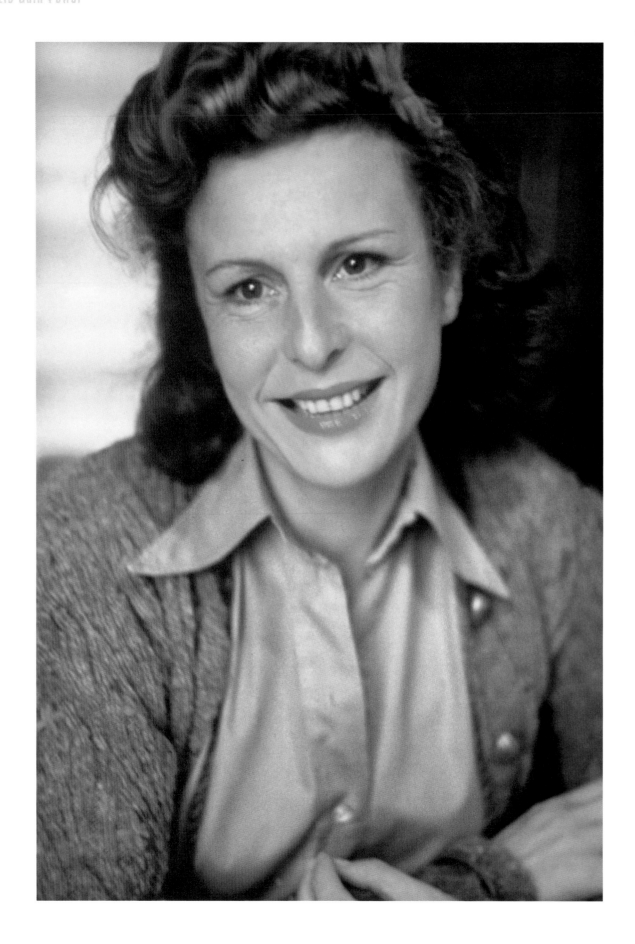

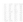

Leni Riefenstahl, the German film actress, producer and director whom Hitler placed in charge of making propaganda films for the Nazi Party. Her masterpiece, a documentary film on the 1936 Berlin Olympic Games, was "a unique and incomparable glorification of the strength and beauty of our Party", according to the Führer.

BELOW

Goebbels addresses German artists in Berlin's Charlottenburg Theatre in 1939. On becoming Chancellor, Hitler set up the Reich Chamber of Culture (Reichskulturkammer), with sections for fine arts, music, theatre, literature, press, radio and film.

PROPAGANDA, ART AND ARCHITECTURE

Hitler's Minister of Propaganda and Public Enlightenment, Joseph Goebbels, masterminded the furthering of Nazi ideology by every means possible. Books that did not conform were burned, people who did likewise were liquidated; massive rallies were staged to whip up enthusiasm for the cause, while newspapers, magazines, posters, films, even art and architecture, were made to play their part in the promotion of the "Thousand Year Reich". The small, wiry, highly intelligent Goebbels, despite his club foot and raging inferiority complex, rose to the very pinnacle of power, bringing the orchestration of propaganda in the mass media to a fine art. Robert Ley's Kraft durch Freude (Strength through Joy) movement promoted a whole range of artistic activities approved by the Party, while those considered unacceptable were jeered at, condemned and then "purged". Writers and artists, architects, painters and sculptors either conformed or suffered such a fate.

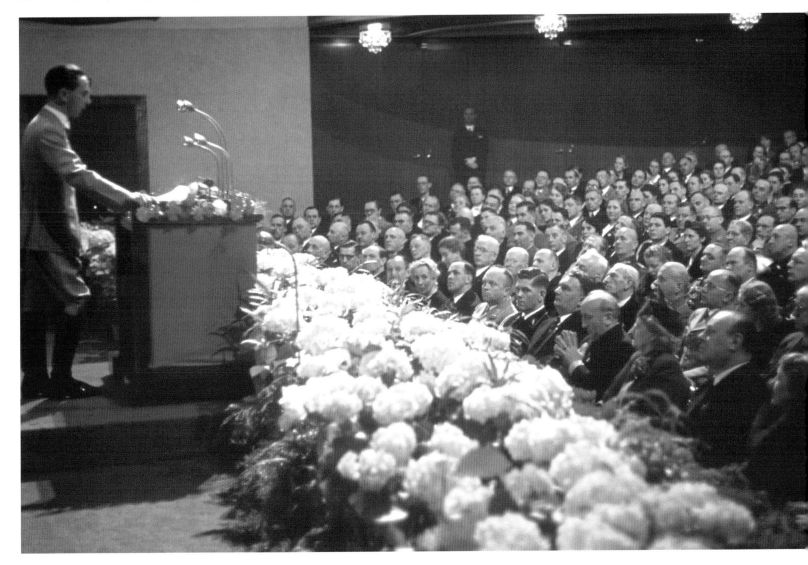

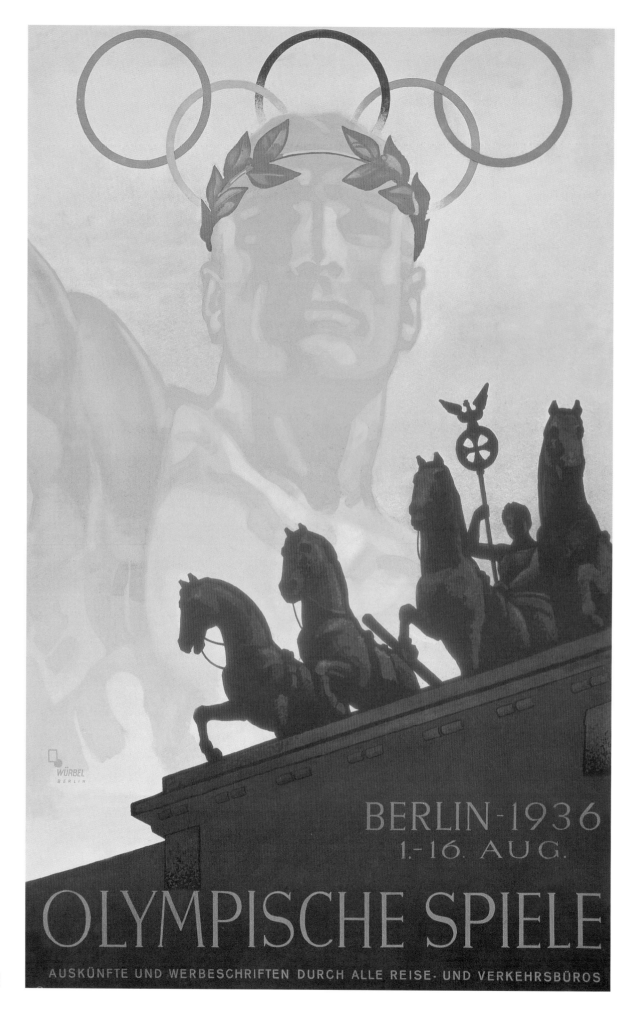

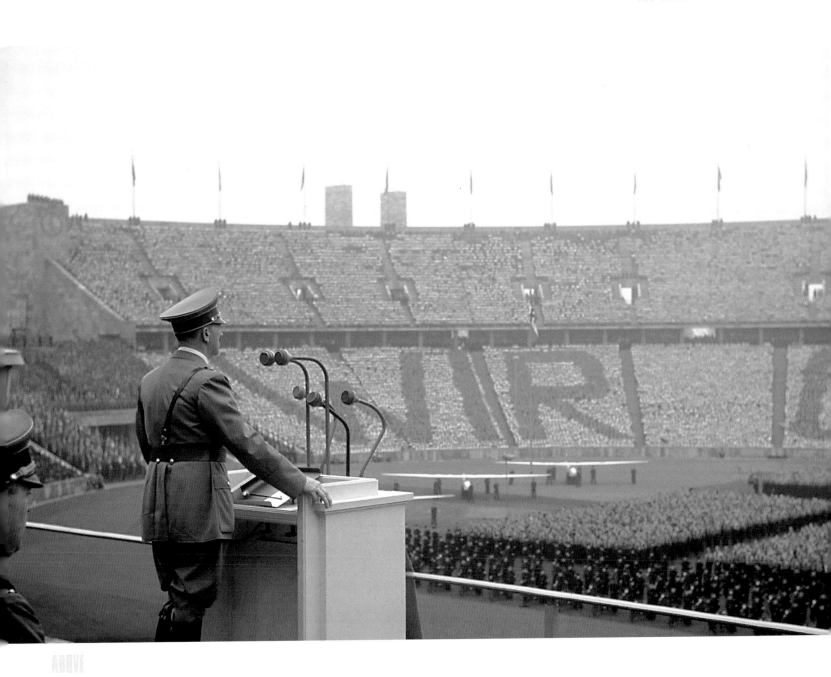

ABOVE

Hitler speaks in Berlin's Olympic Stadium on May Day 1939.
The Nazis appropriated National Labour Day, May 1, as one of
their holidays. Workers marched, waved banners, built bonfires
and danced around maypoles when they were not being
addressed by Hitler and other leading Nazis.

LEFT

For the Eleventh Olympiad, held in Berlin in 1936, the Nazis
spent millions of marks on building nine arenas, including a
magnificent athletics stadium. That year's Olympics are best
remembered for the spectacular performances of the black
American athlete Jesse Owens, who won three gold medals.

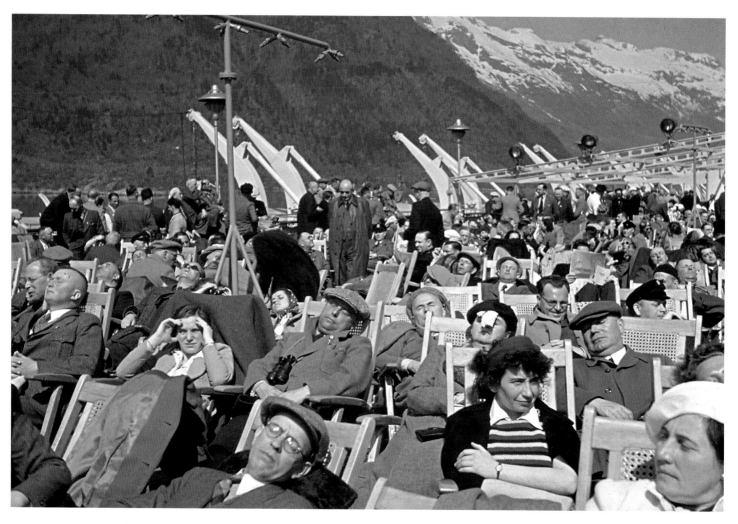

The *Robert Ley* was one of the KDF (Kraft Durch Freude, or Strength through Joy) ships, which took workers on cruises; this one was on a trip to Norway in May 1939. They had a theatre, swimming pool and sports deck and could hold 1,500 passengers. Cruises cost only five to seven marks a day.

LEFT

Dedication of the German Hunting Museum, in Munich, on October 16, 1938. Hunting was close to the hearts of many leading figures in the Third Reich, most notably Hermann Goering, who often sported hunting gear even when not out in the field.

An entertainment at Nymphenburg Castle Park in 1939. Reminiscent of a scene from a Busby Berkeley movie, this elegant tower of beautiful "nymphs" was part of the spectacle staged at the castle. Situated just outside Munich, Nymphenburg was the former summer residence of the Wittelsbach family, which at one time ruled Bavaria.

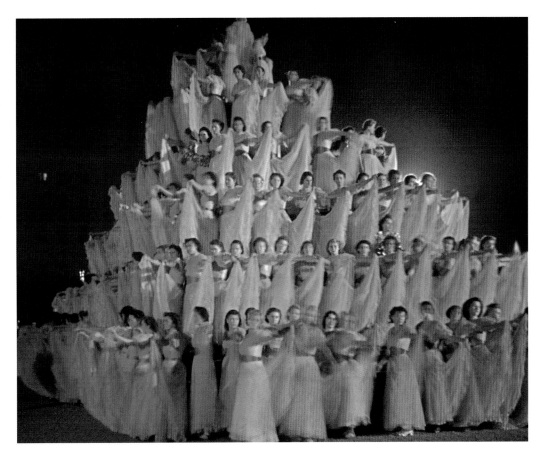

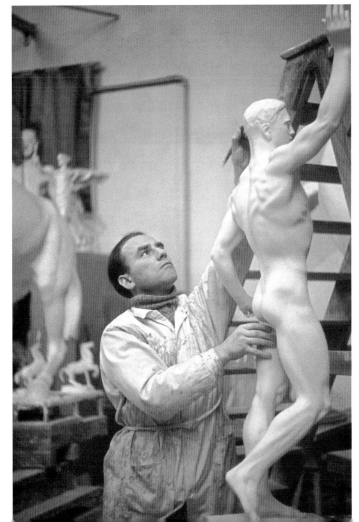

LEFT

The sculptor Arno Breker at work in his studio in Berlin in 1939. Internationally renowned, Breker had demonstrated a fine, subtle sensitivity in the culturally freer days of the Weimar Republic. But during the Third Reich he became the Nazis' "court sculptor" and his work deteriorated.

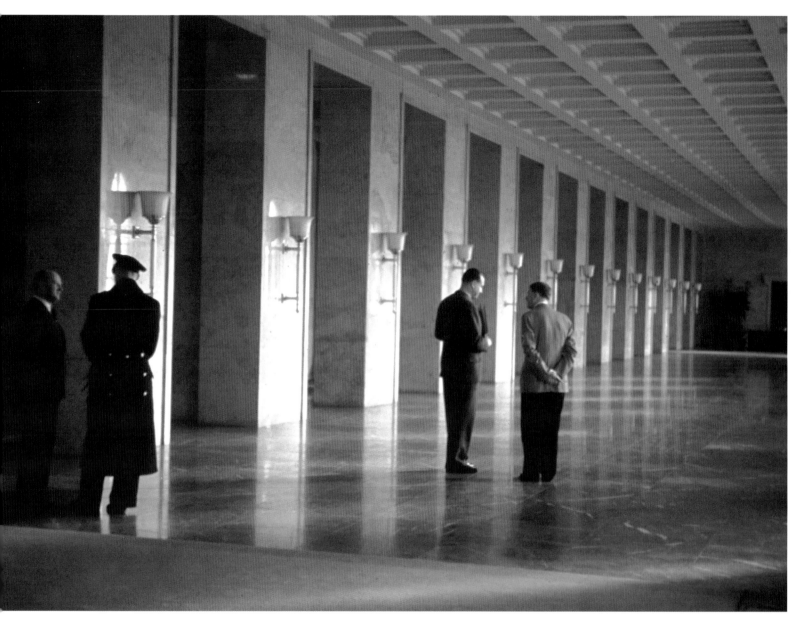

Die Führerbau, Hitler's official residence in Munich, seen here
soon after its completion in 1938. It was a monumental stone
structure with a spacious hall 20 metres (65 feet) high and 33
metres (100 feet) wide, from which two impressive stone
staircases curved up to a huge conference room.

The Chancellery, Berlin, in 1939. Designed by Albert Speer and built in just under a year, the long, squat building on Voss Strasse, one of the city's main streets, brought Nazi architecture into the heart of the nation's capital. Inside was a spectacular 148-metre (485 feet) long corridor leading to Hitler's office.

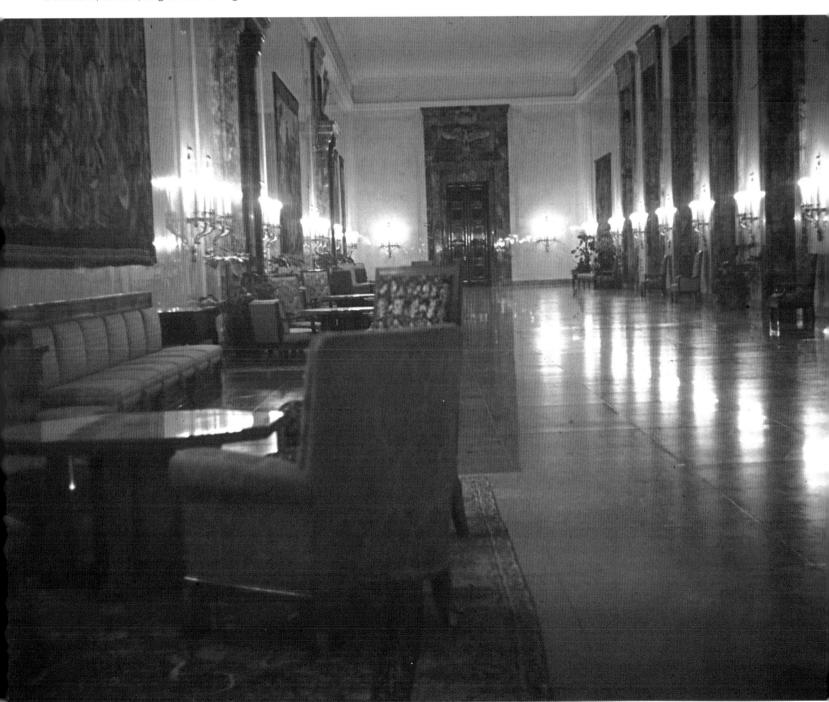

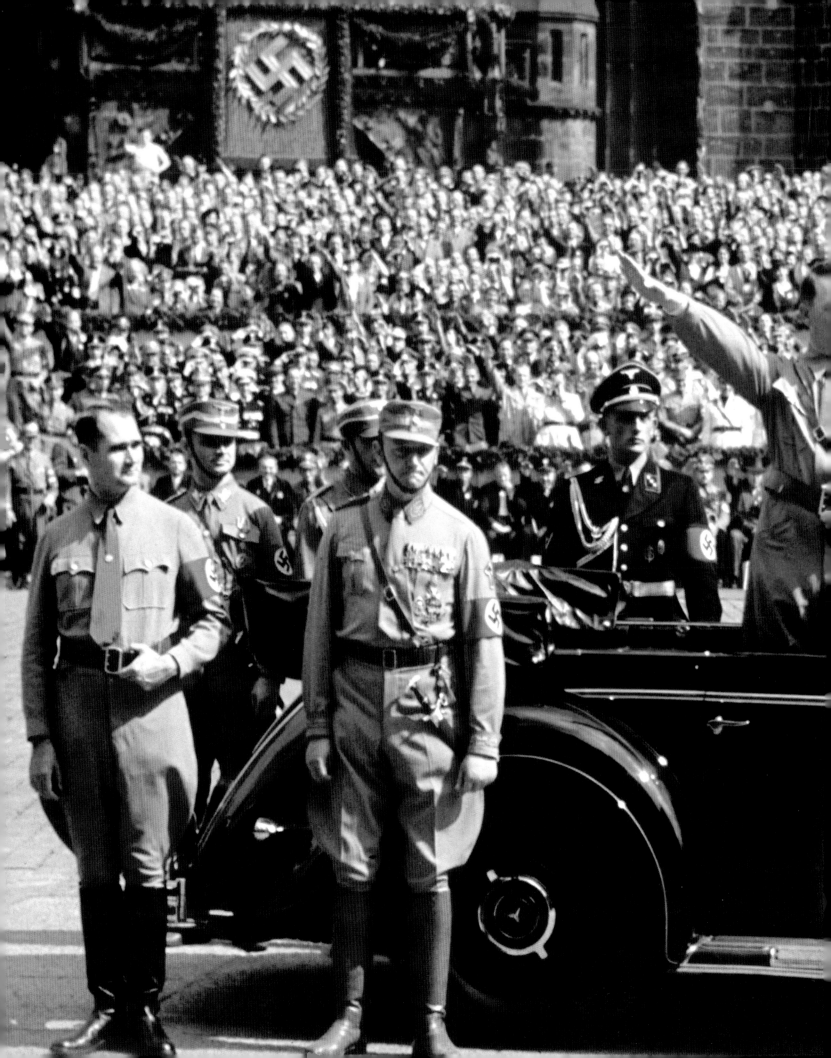

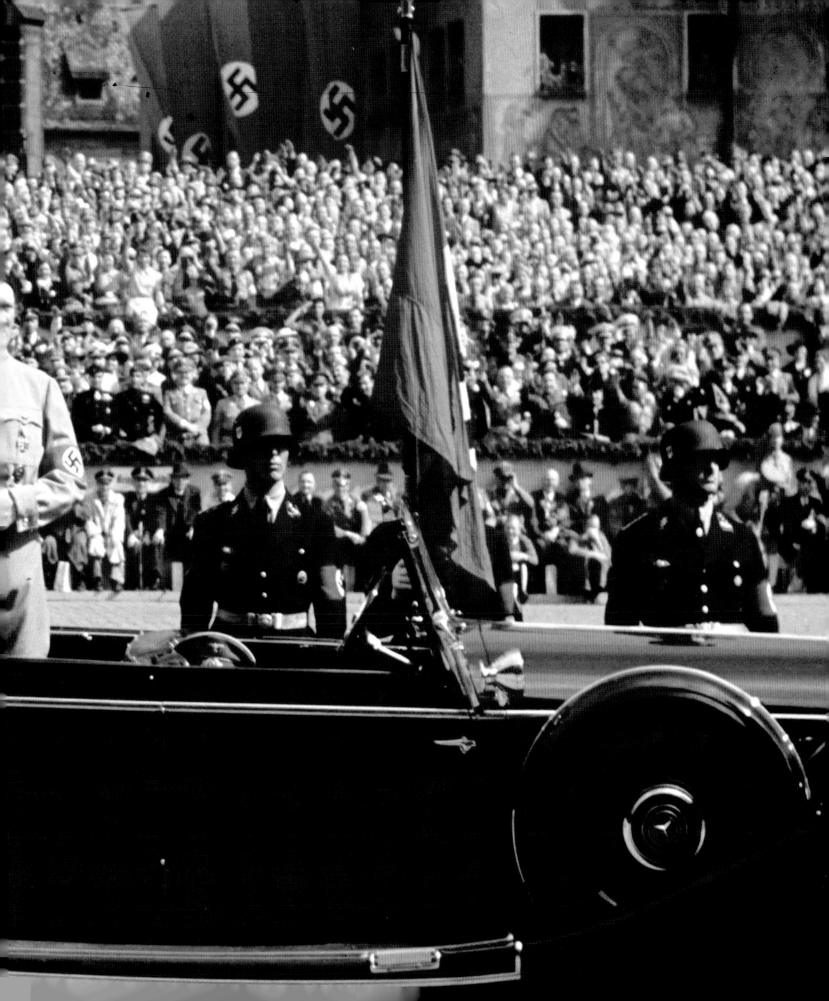

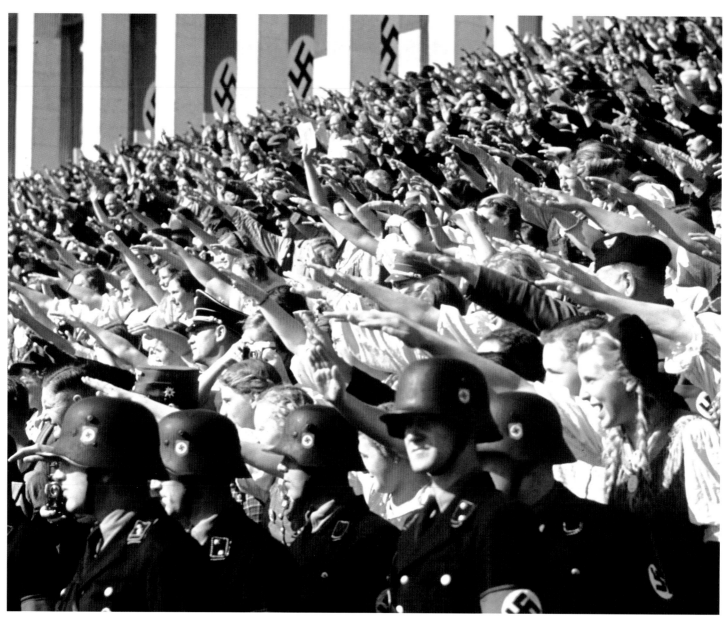

An adoring crowd greets their beloved Führer at the opening of
the Reich Party Congress in Nuremberg on September 6, 1938.
After inspecting his personal bodyguard Hitler drove through the
beflagged city to the sound of church bells and cheering crowds.

"Sieg Heil!" ("Hail to Victory!") Hitler returns the Nazi salute to
the crowds in Nuremberg's Adolf Hitler Platz during the 1938
Reich Party Congress. Near his limousine are his one-time
Deputy, Rudolf Hess, and SA Chief of Staff Viktor Lutze. Behind
him is his valet and personal bodyguard, Karl Wilhelm Krause.

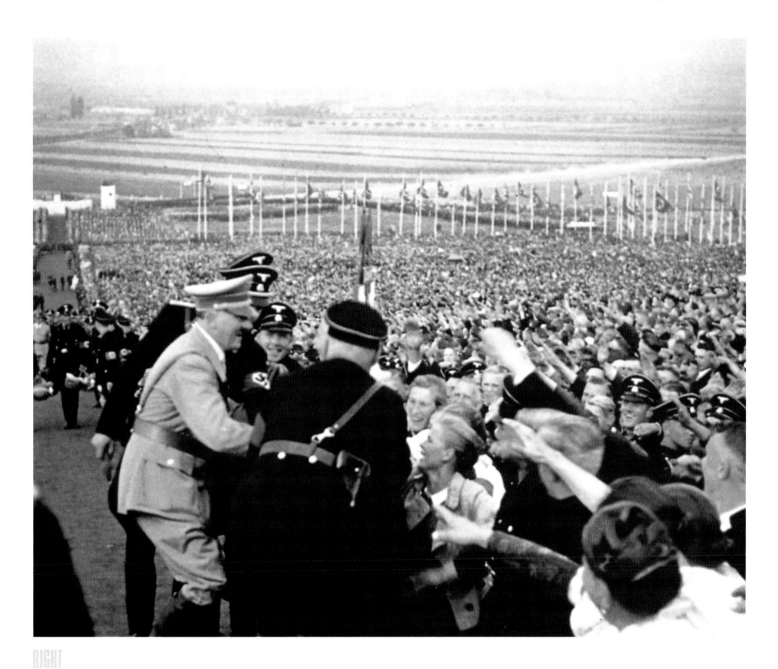

RIGHT

The adulation that ordinary Germans initially felt for their Führer
can be seen on the faces of this crowd at one of the many Nazi
Party rallies. Before the war he could do no wrong and seemed
to be leading Germany to prosperity and world acclaim.

On the same night, orders were given to destroy all synagogues in Germany and Austria. Over 100 were set on fire and over 75 torn down in what was clearly a Nazi-orchestrated assault on the Jewish faith.

Kristallnacht, or Night of the Broken Glass. On the night of November 9, 1938 terror attacks were made on Jewish property. Bands of Nazis looted and destroyed seven and a half thousand Jewish shops, claiming the attacks were the public's reaction to the murder of Ernst vom Rath, Third Secretary of the German Embassy in Paris, by a Polish Jew.

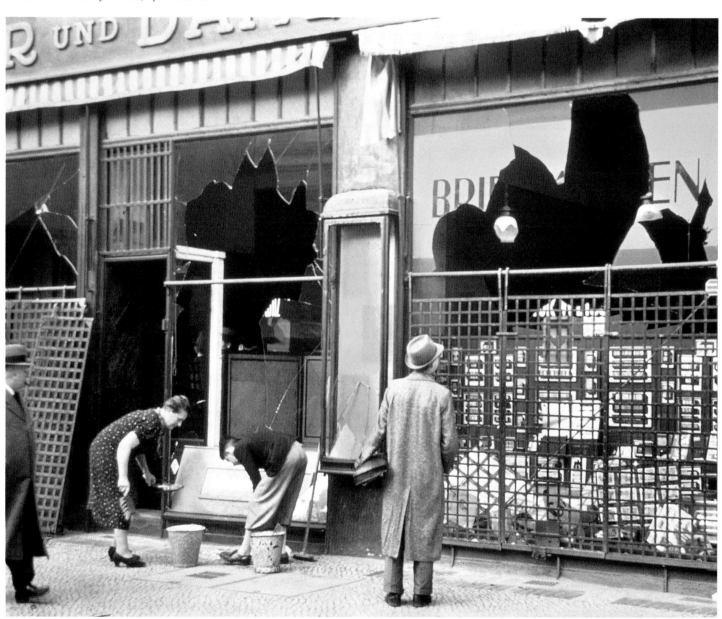

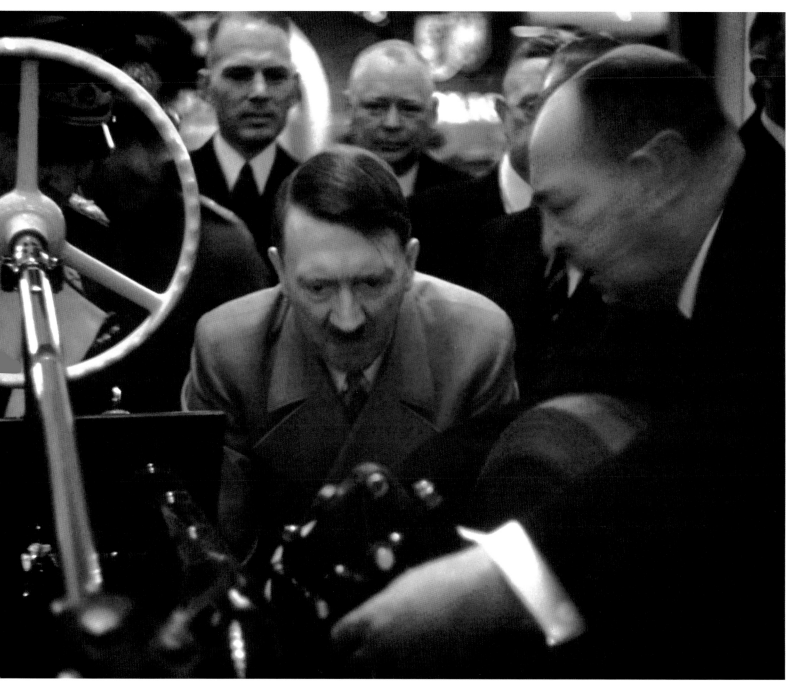

Hitler at the Auto Exhibition in Berlin on February 17, 1939. He took an interest in cars and made sure that the Volkswagen "Beetle" was dangled like a carrot in front of the people and that they were encouraged to save up for "the People's Car". Money was soon diverted to the war effort, however, along with the car factories' capacities.

BELOW

Hitler at the Reich Chancellery on June 1, 1939, during a
ceremony to award banners to outstanding industrial plants. He
had long wooed leading industrialists, and arms giants such as
Krupp, realizing where their future lay, were not slow in putting
their finances and support firmly behind the Nazis.

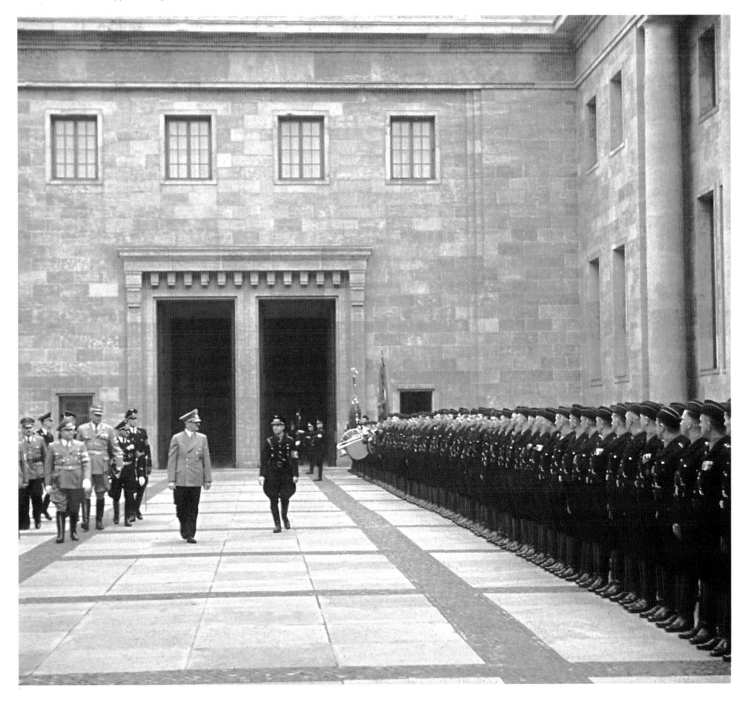

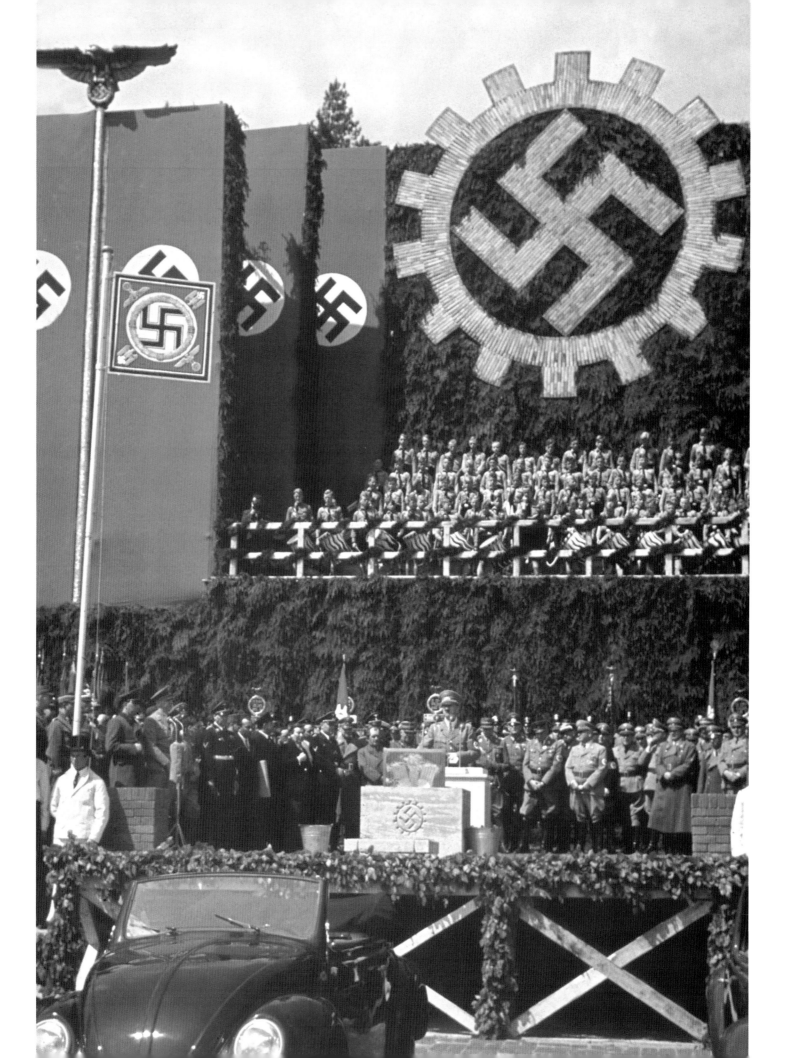

Hitler laying a cornerstone at the new
Volkswagen Works at Fallersleben,
near Braunschweig, on June 25, 1938.
The VW "Beetle" was designed by
Dr Ferdinand Porsche and 30 prototypes
were built. However, in 1939 the factory
went over to war production of the open-
topped military version, the Kübelwagen.
There was also an amphibious version,
the Schwimmwagen.

An autobahn filling station. The
Reichsautobahn (National Superhighway)
was described by Hitler as "an overture
to peace" but was actually intended to
facilitate the rapid movement of troops
and war supplies. Hitler ordered Dr Fritz
Todt to build more new highways as
quickly as possible, and 2,940
kilometres (1,825 miles) of four-lane
roads had been constructed by 1938.

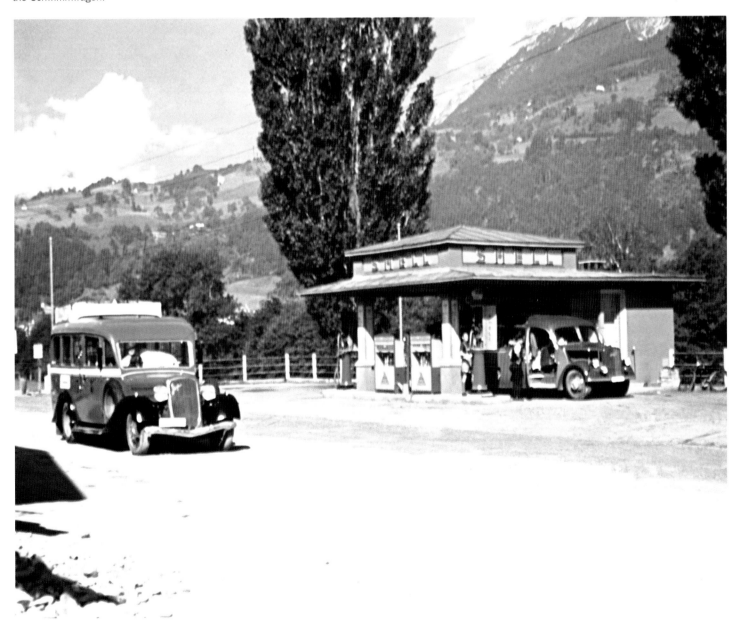

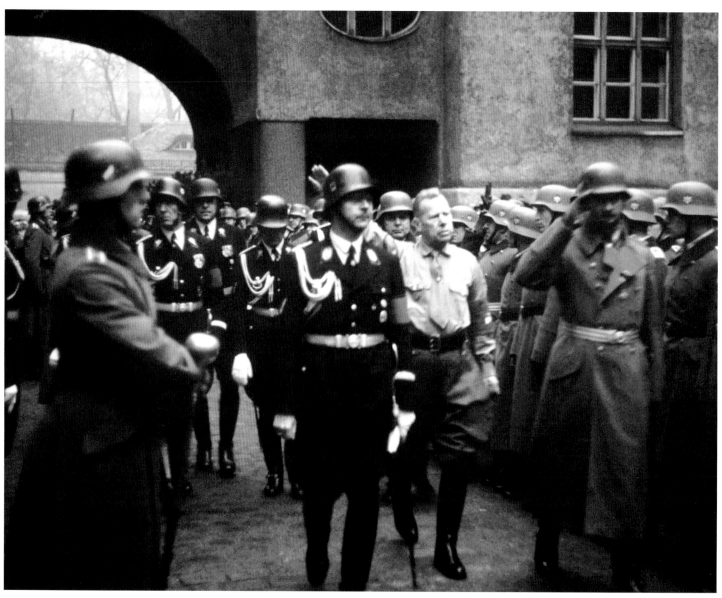

PREPARATIONS FOR WAR

Hitler's stated intention was to rebuild the Wehrmacht and he had the full support of the nation, which still smarted under the harsh restrictions of the hated Versailles Treaty. Initially this had to be done in secret. Aircraft were built ostensibly for civilian use, while military pilots were trained on gliders. Tank training used dummy wooden tank bodies covering motor cars, and later real tanks at the Kazan training ground in the Soviet Union. Other European countries colluded in such subterfuges, allowing Krupp to open armaments factories on their soil. Later Hitler threw off all pretence, renounced the Versailles Treaty rearmament clauses, rearmed openly and introduced universal conscription.

ABOVE AND ABOVE RIGHT

A march took place in Munich on November 9, 1938, in remembrance of the "Beer Hall Putsch" of November 8–9, 1923. The annual midnight swearing in of new SS men in Munich's Feldherrnhalle took place on the same day. Ceremonies such as these were part of the remilitarisation of German society under Hitler.

BELOW RIGHT

Members of the German Condor Legion carry plaques bearing the names of comrades killed in the Spanish Civil War. Men of the Wehrmacht gained valuable combat experience fighting as "volunteers" for Franco's Nationalists in Spain.

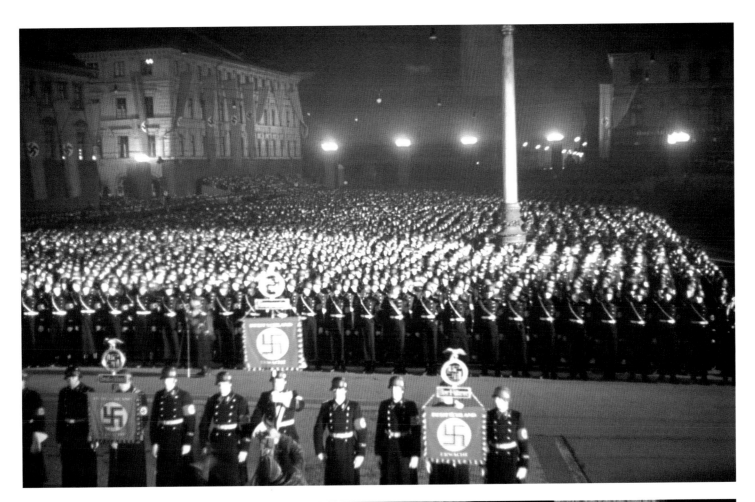

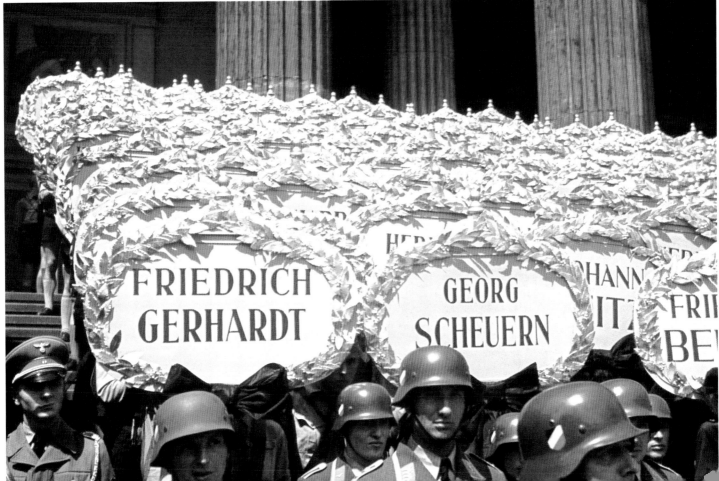

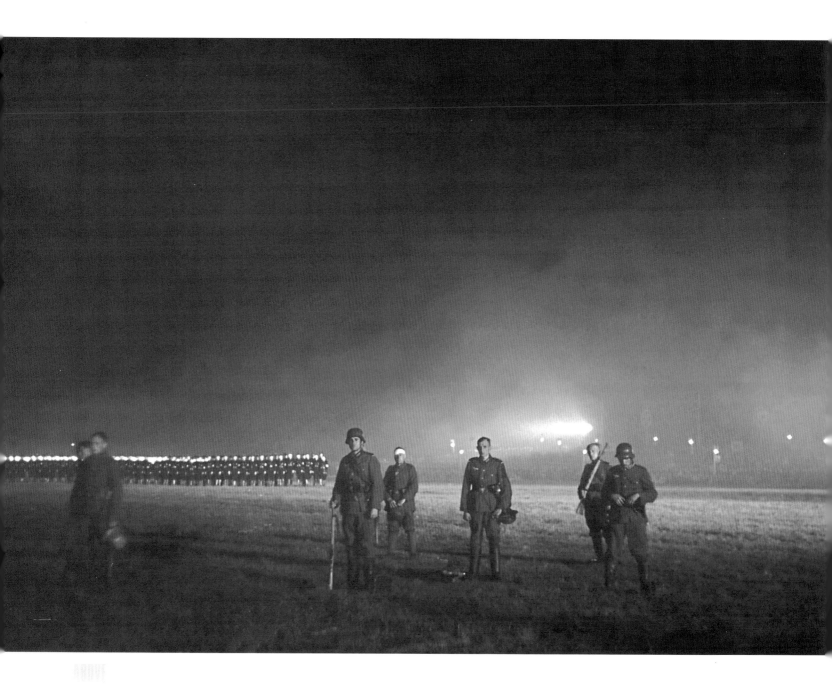

Reich Veterans Day, June 4, 1939. These night-time "war games" were for entertainment rather than serious training. Nevertheless, the massed ranks of soldiers, partially illuminated by searchlights, are an impressive spectacle.

From March 16, 1935, service in the German armed forces was compulsory. Mobilization took place in waves within Military Districts (Wehrkreise), which handled all recruitment, drafting, induction and basic training. Here draftees march to their local Rhineland district headquarters for medical examination.

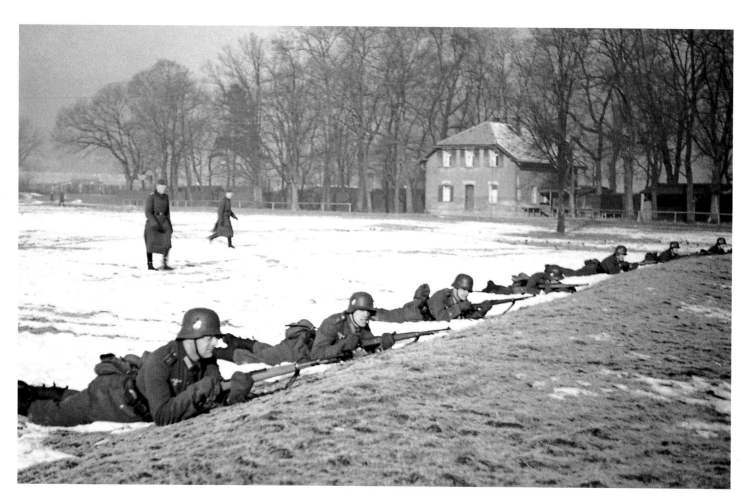

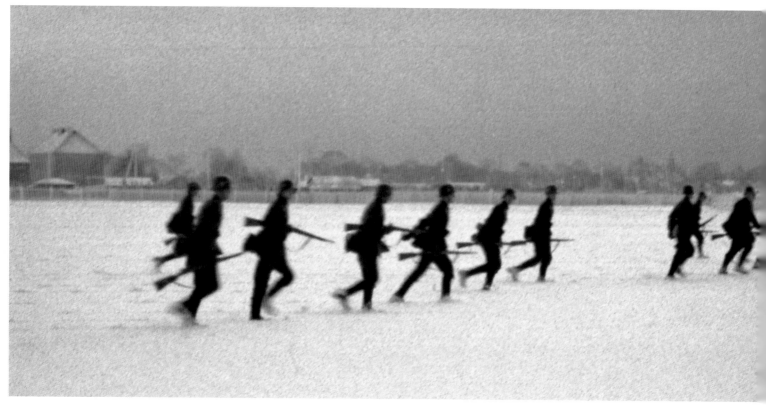

LEFT

Basic training near Munich. Every infantry soldier was armed with a rifle (usually the 7.92mm Karabiner 98k) and had to become proficient at using it, so plenty of time was spent on the firing range.

BELOW

Infantry training in snowy Munich. Marching, shooting, fieldcraft and other skills were taught, but the first aim of basic training was to get recruits fit and teach them to obey orders. Most had already served in the State Labour Service (Reichsarbeitsdienst).

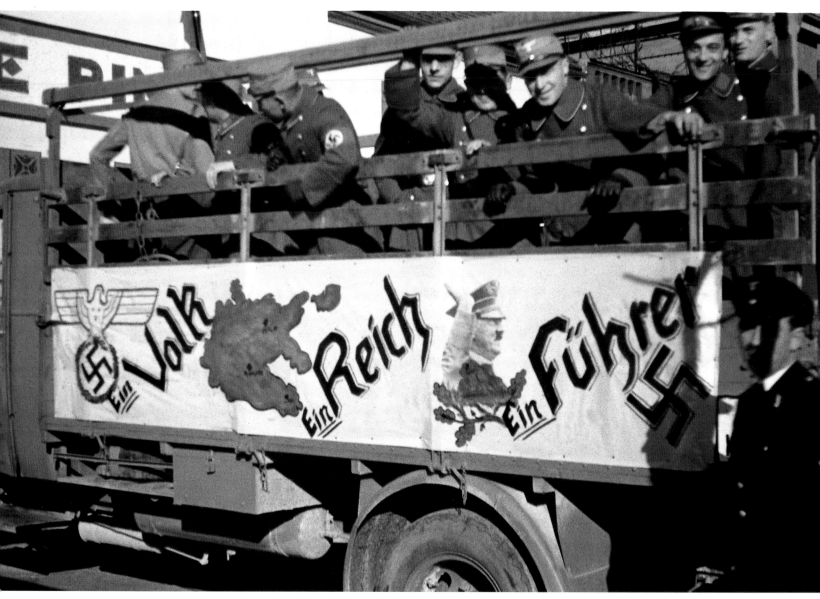

"One People! One Government! One Leader!" This well-known
Nazi rallying cry, popularized by Goebbels's propaganda
machine, is emblazoned on an army truck engaged in a
recruiting drive in Straubing, Bavaria.

This 6x6 Einheits–Lkw 2.5-tonne truck has been made into a
distribution point at Oberplan, in the Sudetenland, for the NSV,
the National Socialist People's Welfare Organization.

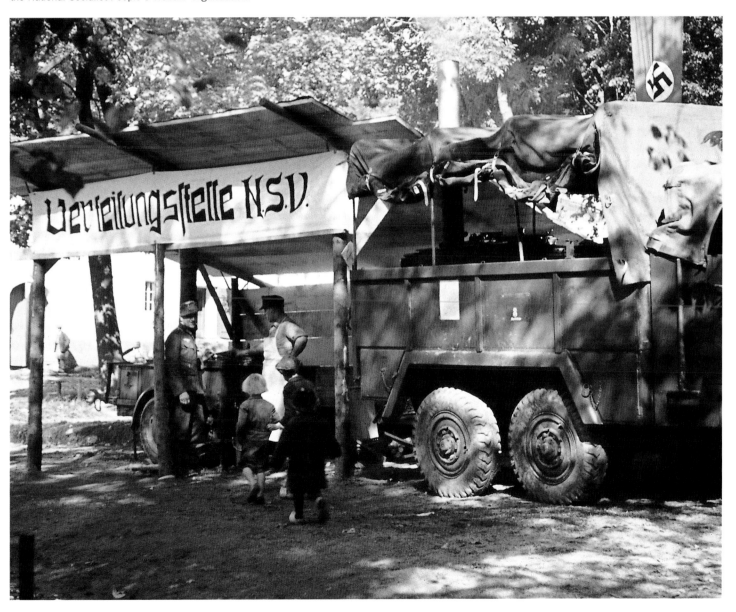

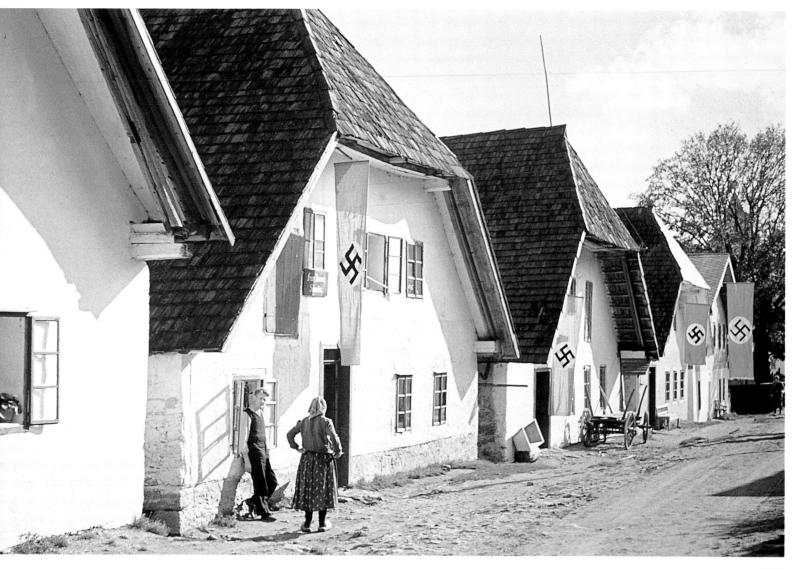

Flags are out in the small Sudetenland town of Kuschwarda to show support for the recent takeover by Germany. Most of what had been Czechoslovakia became a Military District, with its headquarters in Prague, and locals like these were then subject to conscription.

The German army still had cavalry regiments at the start of the war. Some infantry officers also rode on horses during the early campaigns in the West, while thousands of horses still pulled guns and supply wagons.

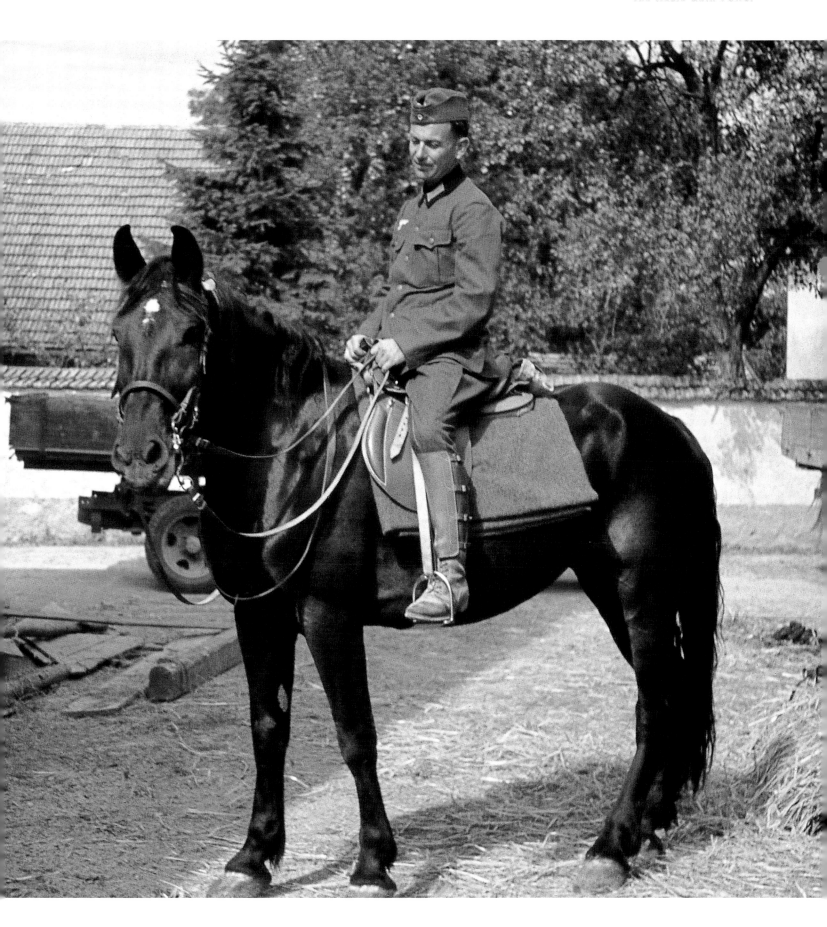

RIGHT

The pocket battleship *Graf Spee* displaced only 12,090 tonnes (11,900 tons) but was armed with six 28-cm (11-inch) guns. Launched on June 30, 1934, she had a short but successful career, sinking nine British merchant ships in two months. After the Battle of the Plate, in 1939, she was scuttled by her crew.

BELOW

The newly launched 43,600-tonne (42,900 tons) *Tirpitz* at Wilhelmshaven on April 1, 1939. Two hundred and forty-four metres (800 feet) long and armed with eight 38-cm (15-inch) guns, she was sunk on November 12, 1944 by the RAF.

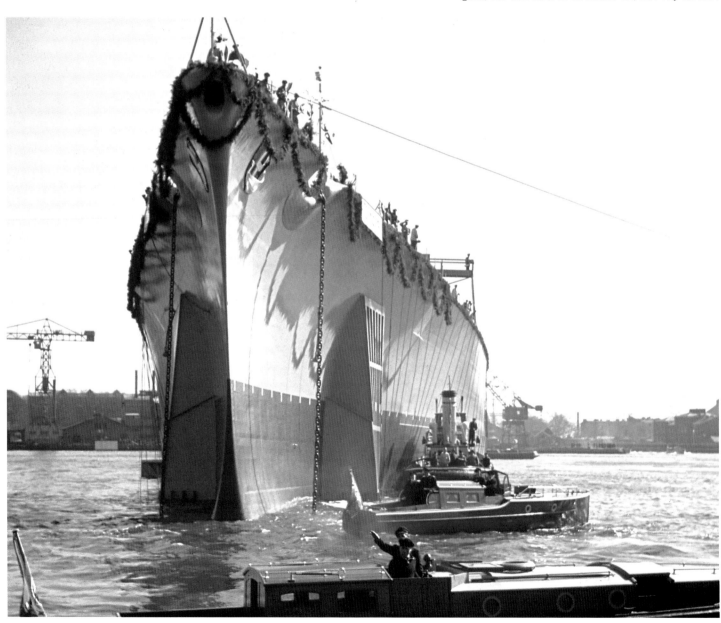

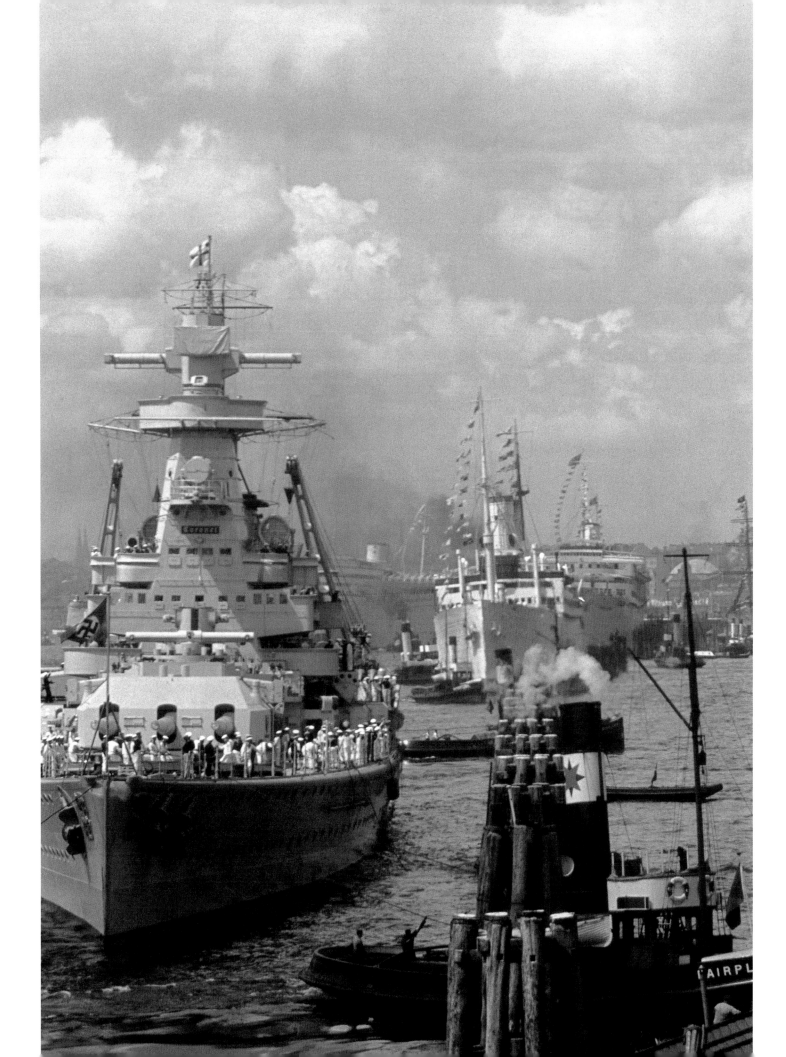

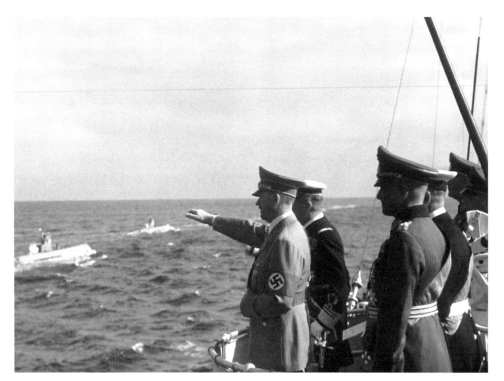

RIGHT

Hitler's fiftieth birthday, on April 20, 1939, was yet another occasion for a military parade in Berlin. Here the Führer takes the salute as heavy artillery passes in review.

LEFT

Hitler and Admiral Miklos Horthy, Regent of Hungary, watch submarine manoeuvres at Kiel in August 1938. U-boats were built as soon as the Treaty of Versailles was repudiated in 1936.

BELOW

With Heinrich Himmler, Hitler inspects, in August 1938, maps of the Westwall, which ran 480 kilometres (300 miles) from the Swiss-German border to Luxemburg.

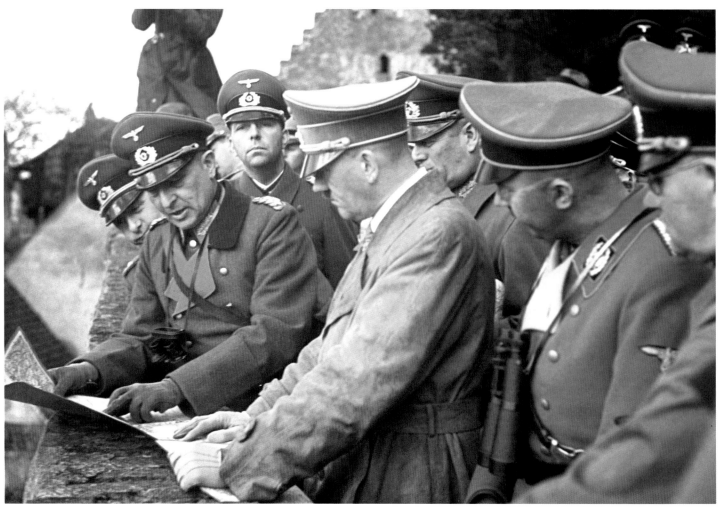

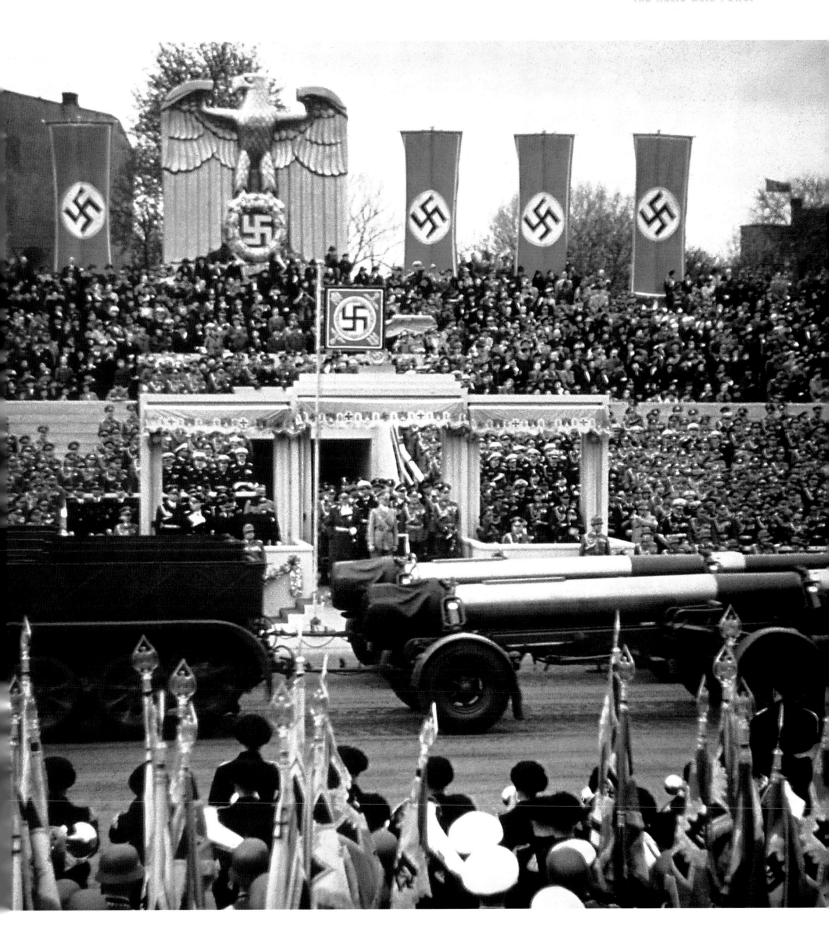

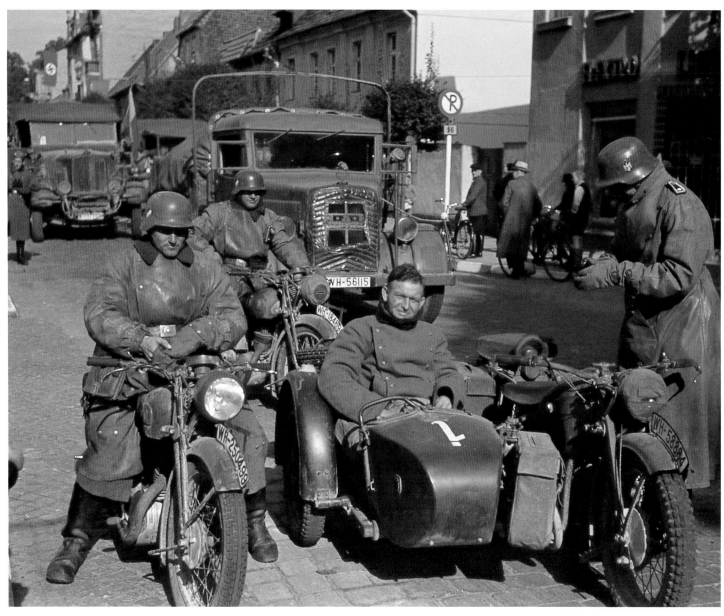

ABOVE

German Kradschützen, motorcycle troops, enter Austria on
March 12, 1938 to cement the Anschluss (Union) of Germany
and Austria, which had been expressly forbidden by the
Versailles Treaty. Dr Artur Seyss-Inquart, leader of the Austrian
Nazis, had asked Germany to invade to "restore order".

ABOVE RIGHT

Hitler's motorcade enters Vienna on May 13,
1938. The Führer had a great love for his native
Austria, choosing to build his remote mountain
retreat on the Obersalzberg, overlooking the
Austrian and Bavarian alps.

BELOW RIGHT

Adolf entertains the ladies. There was undoubtedly
a mutual fascination between women and Hitler,
despite the fact that Nazi propaganda portrayed
him as an asexual bachelor. It is said that women
would faint from ecstasy in his presence.

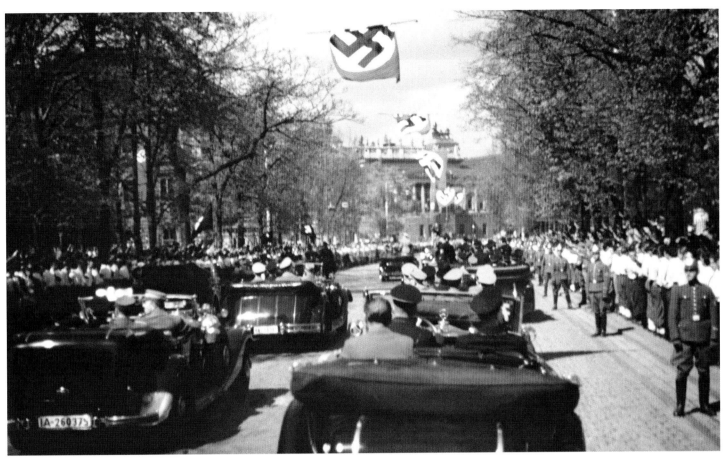

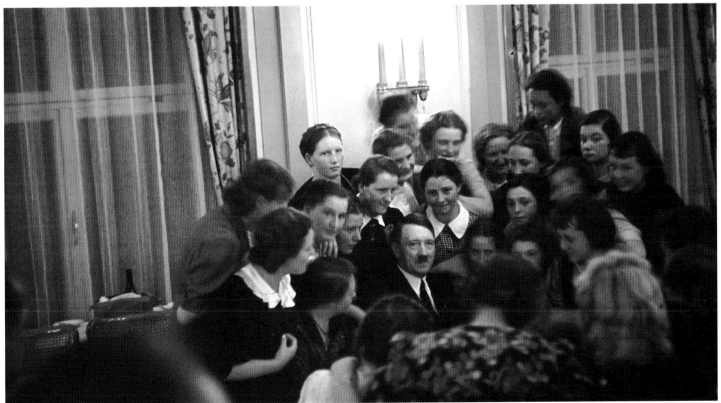

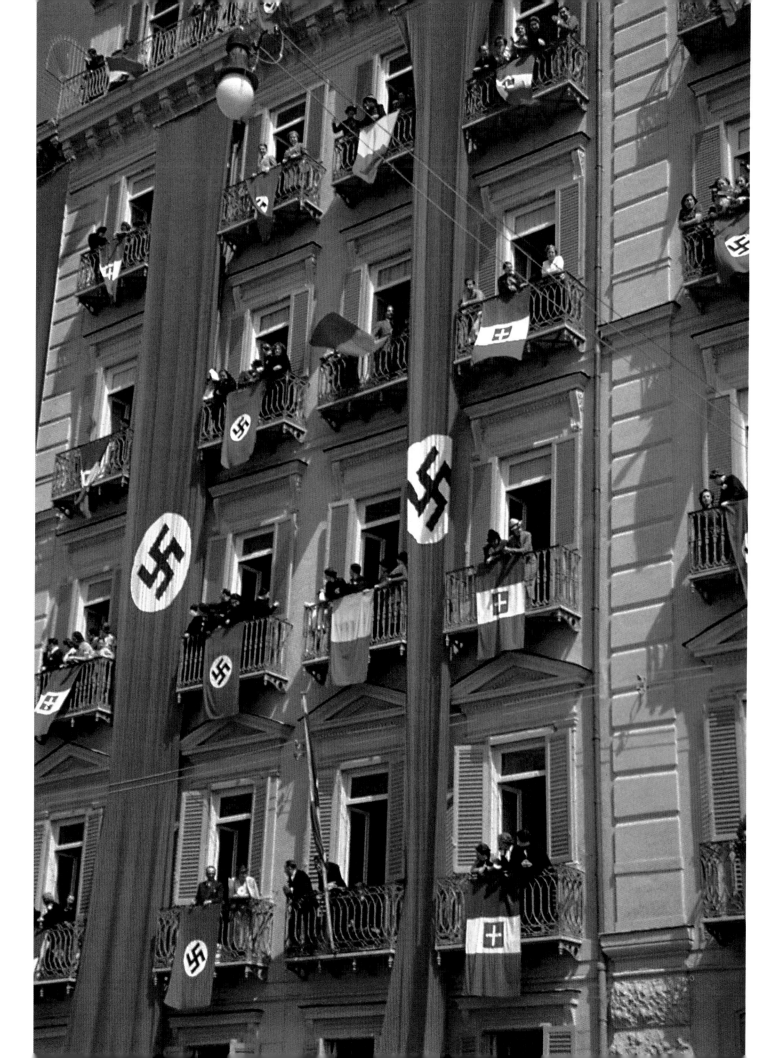

German staff cars drive through the Sudetenland in September 1938. This area in Bohemia had been ceded to Czechoslovakia in 1919, but the Nazi Sudeten Deutsche Partei had long waged a campaign for union with Germany.

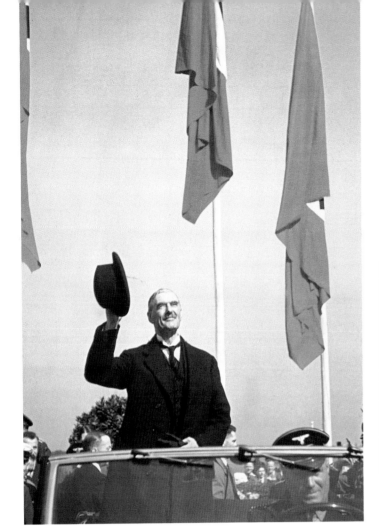

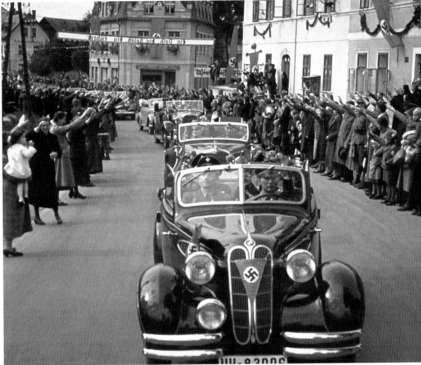

ABOVE

The British Prime Minister, Neville Chamberlain, arrives at Munich in September 1938. At first hoping to settle the Czechoslovakian issue in talks with Hitler, he abandoned his policy of appeasement when Germany occupied Prague in March 1939.

RIGHT

A group of smiling German generals pose by a Czech bunker during the German occupation of the Sudetenland. The Munich Agreement of September 1938 gave the territory, with its three million German speakers, back to Germany.

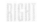

LEFT

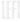

On a state visit to Italy in 1938, Hitler is welcomed by both Italian and German flags adorning the apartment buildings. He went to Rome on May 2 to get Mussolini's approval before seizing Czechoslovakia the following year.

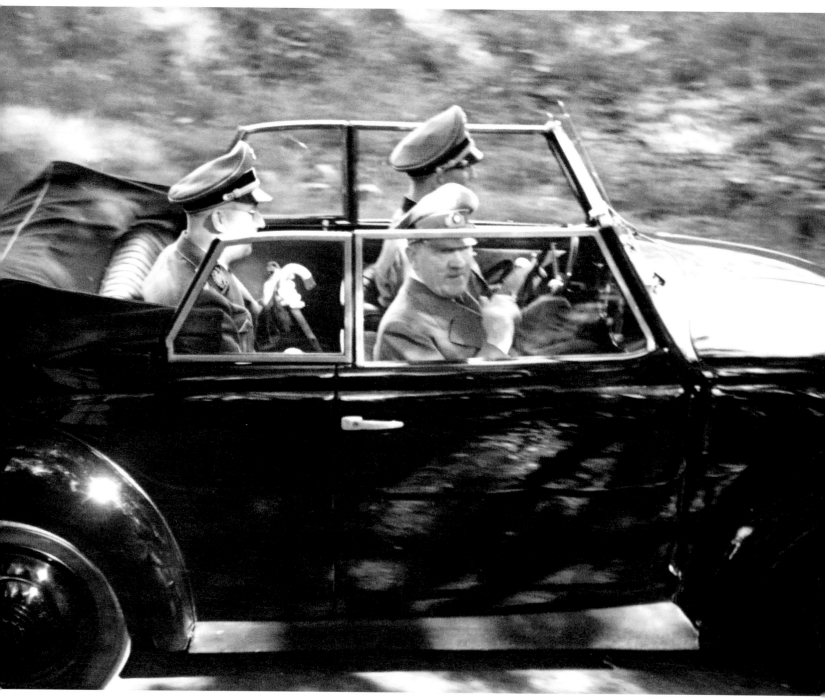

THE CULT OF HITLER

"Führer Worship" was actively encouraged throughout the Third Reich by constant propaganda, at times inducing almost mass hysteria. Goebbels declared: "We are witnessing the greatest miracle in history. A genius is building the world!" The required German greeting became "Heil Hitler!" and children were told to denounce their parents if they did not return the salute properly. Once war began, the propaganda machine portrayed the Führer as the greatest general the world had ever known, and "Hitler ist der Sieg!" ("Hitler is Victory!") became the battle cry. When news of his suicide, in Berlin on April 30, 1945, leaked out, it sparked a wave of copycat suicides and thousands of panic-stricken people wept openly.

Hitler in a Volkswagen. After declaring himself "the Führer", the supreme head of the Third Reich, in 1933, he was now a dictator in the same mould as "Il Duce" (Mussolini) and "El Caudillo" (Franco). Despite this, he was portrayed as a benign, modern-thinking leader, interested in popular matters such as the "People's Car".

BELOW

At his fiftieth birthday party, on April 20, 1939. Hitler shakes
hands with his photographer Heinrich Hoffmann. A member of
the trusted inner circle, Hoffmann introduced both Eva Braun
and Dr Theodor Morell (in right-hand foreground) to him. Morell
was Hitler's personal physician from the mid-1930s until 1944.

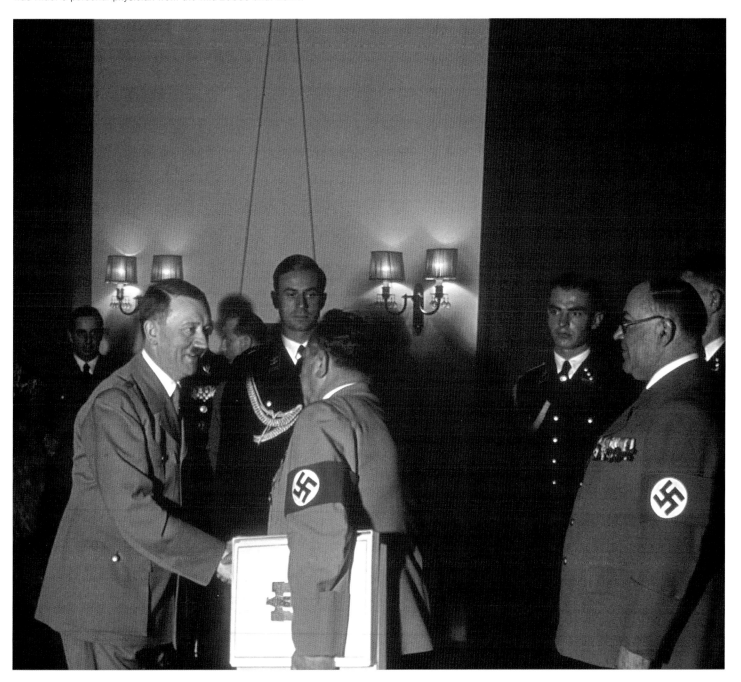

RIGHT

Hitler chats with an elegantly dressed woman at a social event in 1939. Women of all classes regarded him as a German Adonis, and sent him thousands of adoring letters, many of them begging him to father their children.

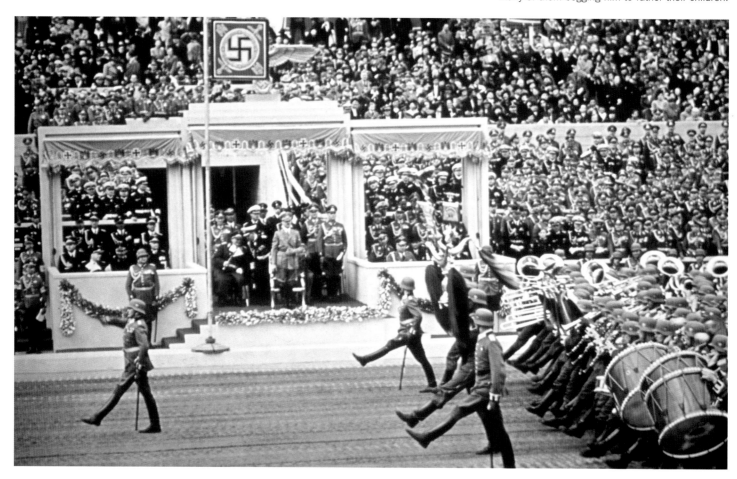

ABOVE

Goose-stepping past their Führer during his fiftieth-birthday celebration parade in Berlin is an immaculately dressed military band. Both battalion and regimental bands of the Wehrmacht contained brass, woodwind and percussion instruments.

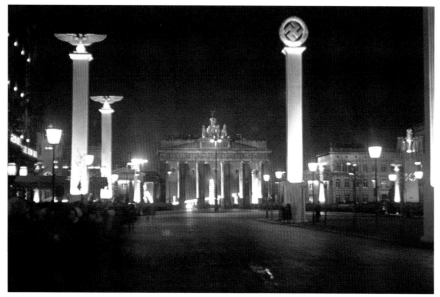

LEFT

The Brandenberg Gate and colonnade, spectacularly lit at midnight on Hitler's fiftieth birthday. Built in 1788–91 by Karl Langhans as Berlin's "Arch of Triumph", the monument is surmounted by a four-horse chariot, the famous Quadriga of Victory.

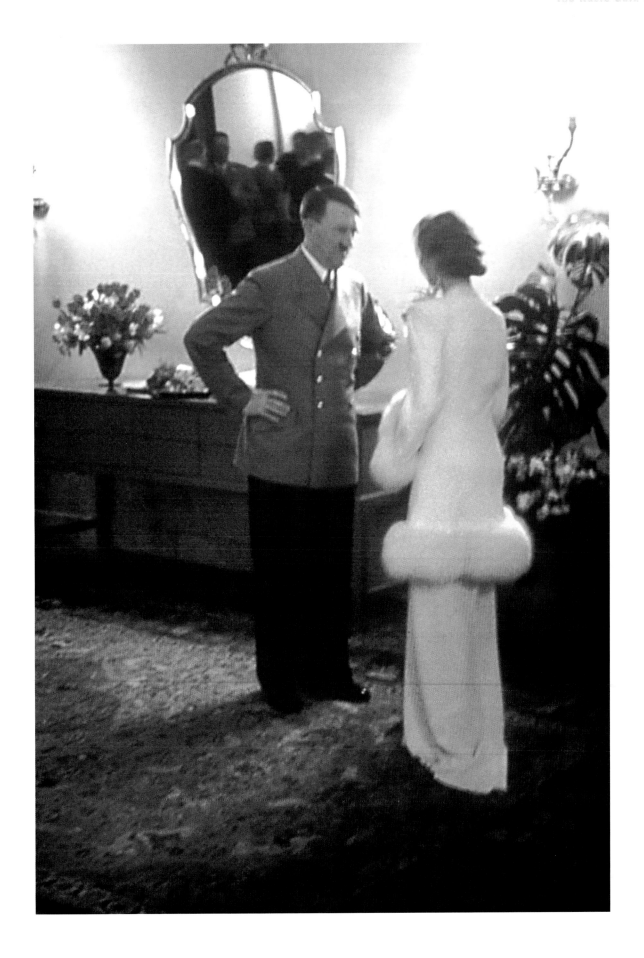

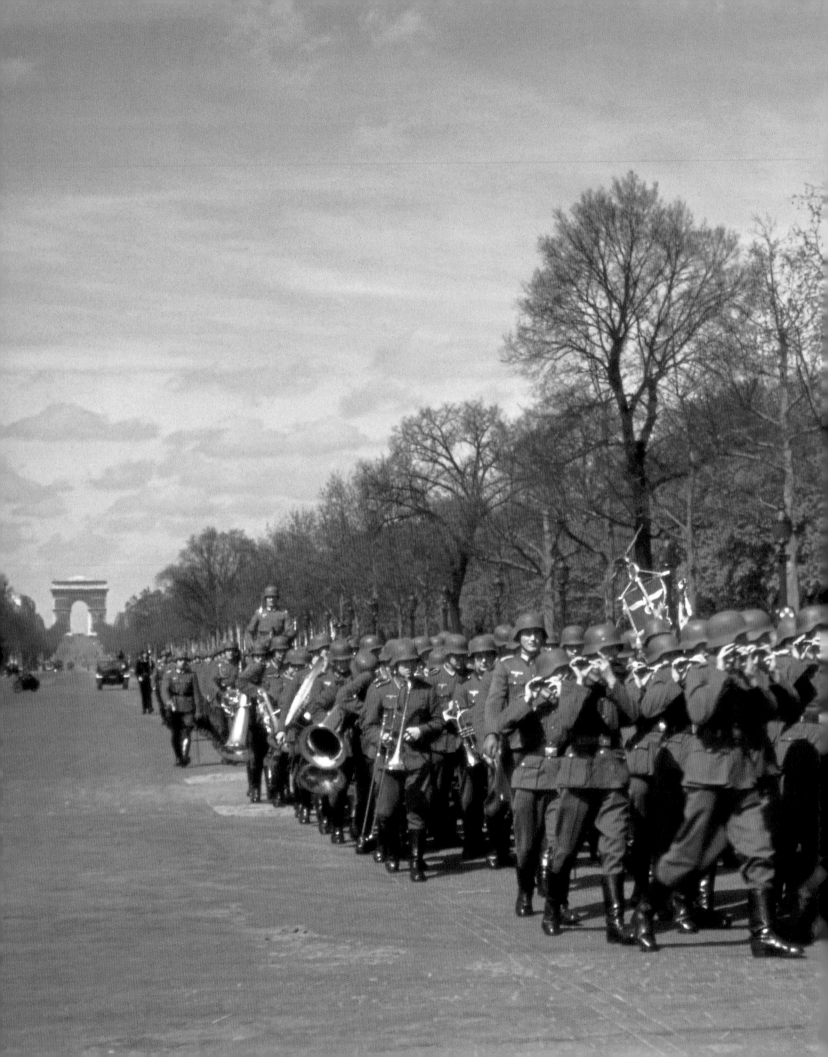

Blitzkrieg! The Victory Years

On August 31, 1939 Adolf Hitler issued a "Most Secret" document to his senior commanders. It was delivered by hand and contained the first of the Führer's many wartime instructions. Headed "Directive No. 1 for the Conduct of the War", it outlined how Fall Weiss (Operation White) – the attack on Poland – would be carried out, the date and time being inserted in red pencil. It also laid down the opening wartime strategy for all the armed forces.

At dawn on September 1, 1939 two German army groups swept across the Polish frontier – Fedor von Bock's in the north and Karl von Rundstedt's in the south. Both were spearheaded by a Panzer corps, their primary aim being to encircle and annihilate the Polish army in a gigantic pincer movement. The Germans appreciated that the Poles would fight stubbornly, buoyed up by promises of support

from Britain and France. However, unknown to any of them, Hitler held a trump card – the top-secret clauses of the recently signed Nazi–Soviet Pact, in which he and Stalin had agreed to divide Poland between them. The bitter, hard-fought campaign lasted for only 35 days, Warsaw holding out until September 27 and some isolated places for even longer, but all organized resistance had ended by October 5. The Poles fought with great courage, but they were no match for their well-trained opponents, who were using a new form of warfare: blitzkrieg.

The concept of blitzkrieg, or "lightning war", had been discussed by military theorists, in the years following the First World War, as a method of bypassing static trench warfare. Blitzkrieg involved surprising the enemy with the speed of your attack; dropping paratroops behind enemy lines to secure vital points (for example, major river bridges); using close air support and armour to punch holes in the enemy's defences; bypassing enemy strongpoints and mopping them up later; and, above all, using speed and concentration of forces to keep the enemy off balance. The Nazis put the theories into practice brilliantly in Poland and later on both Western and Eastern Fronts.

Britain and France declared war on Germany on September 3, but neither was able to give the Poles any practical assistance. When the Russians invaded on the 17th, they met little opposition and quickly occupied the eastern part of the country, thus dividing Poland roughly in half. The swift outcome of the campaign spread alarm and despondency in the West, leading to panic and rumour-mongering. It also gave an aura of invincibility to the German armoured troops, the Panzertruppen, whose prowess was eulogized

The Supreme Commander of the Armed Forces

OKW/WFA Nr 170/39g. K. Chefs. Li Berlin
MOST SECRET 31st August 1939

Senior Commanders only 8 copies
By hand of Officer only COPY No...

Directive No.1 for the Conduct of the War

1. Now that the political possibilities of disposing by peaceful means of a situation on the Eastern Frontier which is intolerable for Germany have been exhausted, I have determined on a solution by force.
2. The attack on Poland is to be carried out in accordance with the preparation made for "Fall Weiss", with the alterations which result, where the Army is concerned, from the fact that it has in the meantime almost completed its dispositions. Allotment of tasks and the operational targets remain unchanged. The date of attack – 1 September, 1939. Time of attack – 4.45 *(inserted in red pencil)*. This timing also applies to operations at Gydnia, the bay of Danzig and the Dirschau bridge.
3. In the West it is important that the responsibility for the opening of hostilities should rest unequivocally with England and France. Minor frontier violations will be dealt with locally for the time being. The neutrality of Holland, Belgium, Luxemburg and Switzerland, which we have assured, is to be strictly observed. The Western frontier will not be crossed by land without my explicit orders. This also applies to all acts of war at sea. Defensive measures by the Luftwaffe are to be restricted to repulsing firmly any enemy air attacks on the frontiers of the Reich. Care must be taken to respect the frontiers of neutral countries as far as possible, when countering single aircraft or small units. Only when large numbers of French or British bombers are employed against German territory across neutral territory, will the Air Force be allowed to fly counter-attacks over the same neutral soil. It is especially important to keep the OKW informed of every infringement of neutral territory by our Western enemies.
4. Should England and France open hostilities against Germany then it will be the duty of the Armed Forces operating in the

West, while conserving their strength as much as possible, to maintain conditions for the successful conclusion of operations against Poland. The order to commence offensive operations is reserved absolutely to me.
The Army will hold the West Wall and should take steps to secure it from being outflanked in the north, by any violation of Belgian or Dutch borders by the Western powers. Should the French invade Luxemburg, permission is given to blow the frontier bridges.
The Navy will operate against merchant shipping, with England as the focal point. Certain zones may be declared danger areas in order to increase the effectiveness of such measures. The OKM will report on these areas and will submit the text of a public declaration in this matter, which is to be drawn up in collaboration with the Foreign Office and submitted to me for approval via the OKW. The Baltic Sea is to be secured against enemy incursions. OKM will decide if it is necessary to mine the entrances to the Baltic for this purpose.
The Air Force is primarily to prevent French or English air forces attacking German land forces or German territory. In operations against England it is the task of the Luftwaffe to harass England's import trade at sea, her armaments industry and the transport of troops to France. Any favourable opportunity to attack enemy naval concentrations, especially battleships and aircraft carriers, must be taken. Any decision to attack London rests with me. Attacks against the English homeland should be prepared, bearing in mind that partial success with insufficient forces is to be avoided at all costs.
signed: **ADOLF HITLER**

(translated from the original in Part II of the Nuremberg Documents)

LEFT

A final indignity for France. Led by a military band, a long column of German soldiers marches along the Avenue des Champs-Élysées in Paris, with the Arc de Triomphe in the background.

in the German propaganda magazine *Signal*: "Tank units mobile, fast and hard-hitting, directed by wireless from headquarters, attack the enemy. This armoured machine paves the way to victory, flattening and crushing all obstacles and spitting out destruction."

THE ATTACK ON THE WEST

After the fall of Poland, the first months of the war passed with little activity on the land. Instead of an instant attack on the West, the German victory in Poland was followed by eight months of what the British called the "Phoney War" and the Germans called Sitzkrieg ("sitting war"). Action did take place elsewhere. Russia invaded Finland at the end of November and in the West there were air battles during which the RAF bombed German military locations, including warships in the Heligoland Bight, and dropped leaflets on Germany itself. But it was at sea that the most activity took place: German submarines – U-boats – sank 41 ships in September 1939, including the passenger liner SS *Athenia* (mistaken for a cruiser) and the British carrier HMS *Courageous*. In October their surface raiders – among them the pocket battleship *Graf Spee* – scored their first successes. On October 14, in a massive propaganda coup, U-47, commanded by Günther Prien, sank HMS *Royal Oak* in the British fleet's base of Scapa Flow. This success was countered on December 13, when *Graf Spee* was lost following the Battle of the River Plate.

On land the Germans prepared for Fall Gelb (Operation Yellow), the attack on the West, assimilating the Czech tanks and other weapons they had acquired and bringing their forces to a peak of efficiency, their Polish success having lifted the morale of their armed forces and citizens to an extremely high level. On the other side the British Expeditionary Force (BEF) was transported safely across the Channel, but the lessons of Poland were not learned and the disposition of Allied forces – particularly the considerable French armoured forces – was inadequate to meet the attack that was coming. Hampered by the fact that the Belgians and Dutch were desperate to remain neutral and would not allow Allied forces to occupy their main defensive positions in the Low Countries (the Dyle Line) or to prepare them for battle, the West put its faith in the Maginot Line, which extended along the Franco-German border for some 140 kilometres (87 miles) from the Swiss border to Luxemburg and was considered impregnable.

On April 9 the war began in the West. First, Germany invaded Denmark and Norway, the former surrendering immediately, while the latter, with the help of British and French troops, put up a spirited resistance – fighting would continue until June 7, when the collapse of France caused the Allied forces to be finally withdrawn. Then, at 5.35 on the morning of May 10, the Germans launched Fall Gelb, their armies invading Holland, Belgium and Luxemburg.

These were led by special forces – highly trained commandos (the "Brandenburgers") and paratroops – who captured vital bridges, key fortresses (such as the Belgian fortress Eben Emael) and the Hague, the latter in an attempt to eliminate the Dutch government and capture the royal family. Apart from failing to capture either the Dutch monarchy or the government, both of whom fled to England, all these operations were highly successful and led to the Allies pushing forward to man the Dyle Line. However, this was exactly what the Germans wanted, because Fall Gelb was based upon a feint attack through Belgium, while the main assault came through the Ardennes (considered impassable by French tactical experts). Massed tank divisions crossed the Meuse near Sedan and, despite stout resistance, there was soon a mass of German armour queuing up to cross the river.

This was a blitzkrieg campaign such as had not been seen before. The armour provided the battering ram, allowing German forces to drive on toward the Channel coast, spreading chaos in their path. First across the river was Generalmajor Erwin Rommel's 7th Panzer Division, nicknamed the "Ghost Division". The Rommel legend began at the Meuse, when his men saw their commander, waist deep in water, helping his engineers to construct a tank ferry and staying around under fire until the job was finished.

The German armour pressed on, achieving advances of over 80 kilometres (50 miles) in a day in some areas, swiftly cutting France in two and isolating the northern Allied armies from their supply bases in the south. The outcome was inevitable and the BEF was soon forced to evacuate from the Channel ports. Time for the evacuation was gained, thanks in no small way to an armoured counter-attack at Arras by the British 4th and 7th Royal Tank Regiments. The possibilities of this situation have long provided food for thought for historians – as Liddell-Hart, the British exponent of blitzkrieg, put it: "if two well-equipped armoured divisions had been available, the Battle of France might have been saved."

But it was not to be. The Arras counter-attack simply provided a breathing space and allowed the BEF to withdraw its manpower – but not its vehicles or weapons – from the beaches of Dunkirk. France was left to continue the battle alone, knowing full well that there was no way its demoralized and disintegrating army could stop the now triumphant Wehrmacht. Paris surrendered on June 14 and a week later Hitler met the French delegation at Compiègne, some 80 kilometres (50 miles) to the north-east. He was "afire with scorn, anger, hate, revenge and triumph", ready to receive the French surrender in the same railway carriage in which the Kaiser's representatives had surrendered at the end of the First World War – the carriage being specially brought out of its French museum for the ceremony. To the German people it must have seemed as if a burden had been lifted from them: the betrayals of 1918 could be

forgotten after a campaign that had lasted just six weeks.

Now Germany had but one enemy left in Europe – Britain – and, as Churchill did not sue for peace as he had expected, Hitler set about preparations for a seaborne invasion, codenamed Seelöwe (Sealion). This was preceded by the almost bloodless occupation of the Channel Islands on July 1–3, 1940. Despite this successful start to his "March against England", Hitler soon realized that British air and sea power were too strong to allow an immediate invasion: the Luftwaffe must even the odds. And so the Battle of Britain took place in the sky rather than on the beaches, and the heroic and successful defence of the British Isles by RAF Fighter Command in September of that year earned its special place in history. Thoughts of a seaborne invasion faded and instead Hitler decided to starve Britain into submission through Dönitz's U-boats and the battle of the Atlantic. The convoys from the United States were the lifeline that kept Britain afloat in 1941 and 1942, but they only just succeeded in doing so. Even after the Americans entered the war in December 1941, victory in the Atlantic was a close-run thing, with huge casualties on both sides – the eventual cost of the battle was around 17.2 million tonnes (16.9 million tons) of Allied shipping (3,843 ships) and 687 U-boats.

NORTH AFRICA AND THE MEDITERRANEAN

While Hitler's thoughts turned from the West to his goal of achieving Lebensraum in the East, problems occurred in North Africa, where the other side of the Axis – Mussolini's Italy – had just received a tremendous thrashing. Britain's General Richard O'Connor's tiny XIII Corps destroyed the entire Tenth Italian Army, taking over 130,000 prisoners, 400 tanks and 1,300 artillery guns for the loss of just 500 men. The Italians asked for help and Hitler agreed, launching Operation Sonnenblume (Sunflower). Under the inspired leadership of Generalleutnant Erwin Rommel, the "Desert Fox", the Afrika Korps bolstered the Italian forces and took them to the brink of victory. These battles against the British and Commonwealth forces – later to be known as the Eighth Army – were fought in the inhospitable Western Desert of North Africa, from Egypt to Tunisia, with first one side then the other gaining the initiative. By June 1942, however, Rommel and his "Afrikaners" had the upper hand; the Afrika Korps had taken Tobruk, almost reached Cairo and the Suez Canal and had driven the British back to Alam Halfa. For this victory Rommel received his field marshal's baton, at 50 the youngest in the German army to do so.

In addition to providing help to the Italians in North Africa, the Germans also had to go to their assistance in the Balkans. On April 6, 1941 they launched simultaneous attacks on Greece and Yugoslavia. The brave but badly equipped Greek army, with its token British and Commonwealth support, was swiftly crushed by the Germans who entered Athens on April 27. Greece surrendered but many of the British and Commonwealth troops escaped to Crete, which became the Germans' next target. Attacking with paratroopers supported by crack mountain troops, they took the island after a short, hard-fought campaign. However, Hitler was so shocked by the scale of casualties among his paratroopers that he never again allowed a similar operation to be mounted, preferring, for example, to try to neutralize the key island of Malta by bombing and starvation rather than the aerial invasion that had been planned.

OPERATION BARBAROSSA

The successes of blitzkrieg in the West so far paled into insignificance on June 22, 1941, when Hitler launched Barbarossa on a 3,200-kilometre (2,000-mile) front stretching from the Baltic to the Black Sea. Three massive army groups took part. In the north, Army Group C (26 divisions under von Leeb, spearheaded by the 3rd and 4th Panzer Groups) had Leningrad as its main objective. In the centre, Army Group B (51 divisions under von Bock, led by the 2nd Panzer Group) was to drive along the axis Minsk-Smolensk, north of the Pripet Marshes, with Moscow as its ultimate target. In the south, Army Group A (59 divisions under von Rundstedt, with the 1st Panzer Group leading) was to overrun the Ukraine. Opposing them were some 148 Soviet divisions under Voroshilov, Timoshenko and Budenny.

The surprise attack against an erstwhile ally saw the Red Army pushed back in disorder. The greatest disaster for the Russians came in the Kiev area, where 600,000 troops of Budenny's command were trapped by a gigantic armoured pincer movement. By the autumn the Germans had advanced by over 880 kilometres (550 miles), occupied 1.3 million square kilometres (500,000 square miles) of the Soviet Union, inflicted 2.5 million casualties on the Red Army and taken over 1 million prisoners. More than 3,000 Russian tanks had been destroyed or captured. However, despite this crushing defeat, Leningrad had still not fallen. The Soviets operated a scorched-earth policy, allowing the bitter winter weather that followed to take its toll.

In the spring of 1942 the Germans resumed their attacks, reaching the very gates of Moscow, while in the south all available forces concentrated on capturing the Caucasian oilfields. This necessitated the taking of Stalingrad and during the summer of 1942 a major drive – Fall Blau (Operation Blue) – was launched. The city might well have fallen by mid-July, but Hitler kept interfering, altering the scope of operations, so that the main assault did not reach the outskirts until late August. Stalingrad would now assume a special importance – the Soviet leader was determined that the city bearing his name would never be taken. Its fate was destined to become a major turning point in the war.

BELOW

Among the loot taken by the Germans as they overran Poland in
early September 1939 were these unfinished bombers, seized at
Okezie military airport near Warsaw. Despite heavy losses, the
Polish Air Force continued to make determined attacks on the
invading enemy forces until September 16.

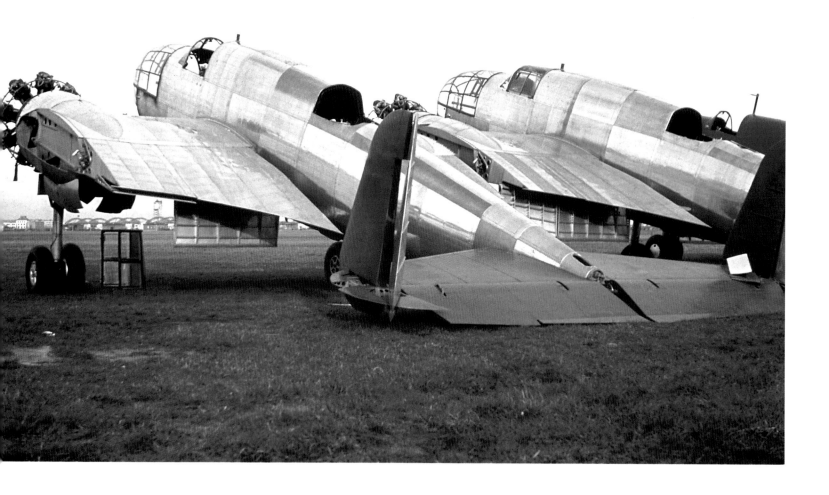

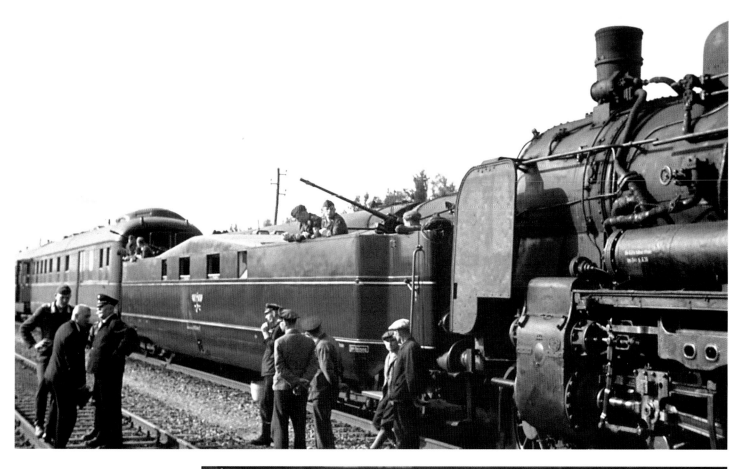

ABOVE

Hitler's first wartime headquarters was the Führersonderzug (the Leader's Special Train). He travelled from Berlin to the Polish border on the evening of September 3, arriving at Bad Polzin station at 0156 hours the next morning. This is one of the train's two Flakwagen, manned by the Führer Begleit (Escort) Battalion under General Erwin Rommel.

RIGHT

The Führersonderzug's radio car, which allowed Hitler and his staff to remain in touch, while travelling, with both the invading army and Berlin via radio and teleprinter.

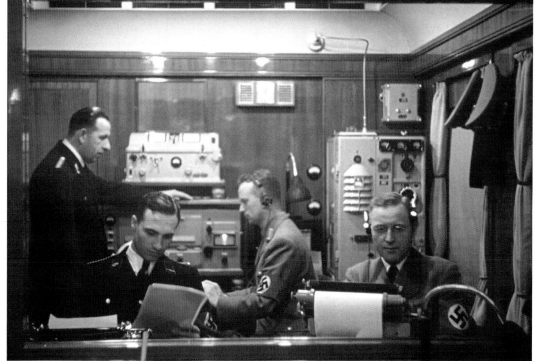

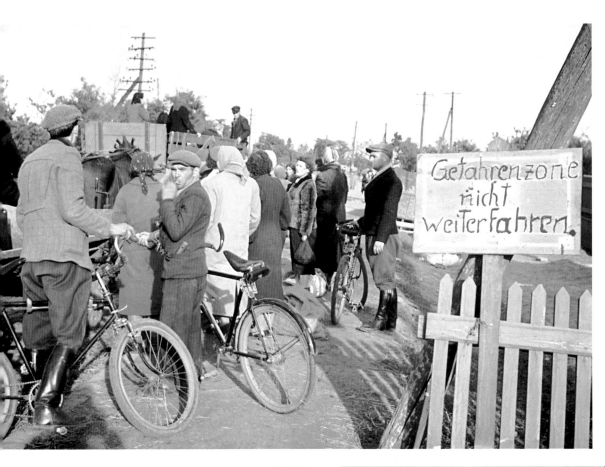

LEFT

"Danger Zone – Do Not Proceed."
Bewildered refugees clog the roads
near Warsaw despite the warning
signs put up by the Germans.

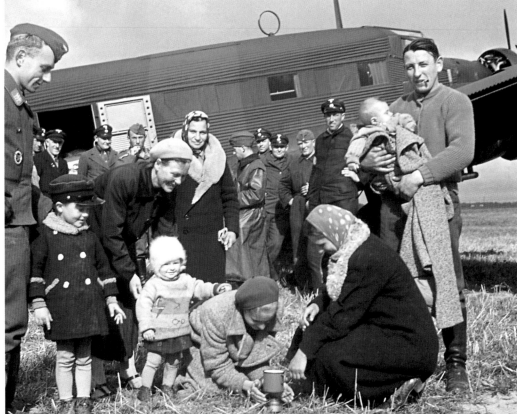

RIGHT

Happy German nationals prepare to
be repatriated during the invasion of
Poland. As they wait to get on board
a Junkers Ju 52, they brew up a hot
drink on a camping stove and pose
for the cameras.

German armour, although generally superior to Polish tanks and armoured cars, was not invulnerable. Seen here in Warsaw is a burnt-out Panzerkampfwagen II, one of the main combat tanks used in the attack on Poland.

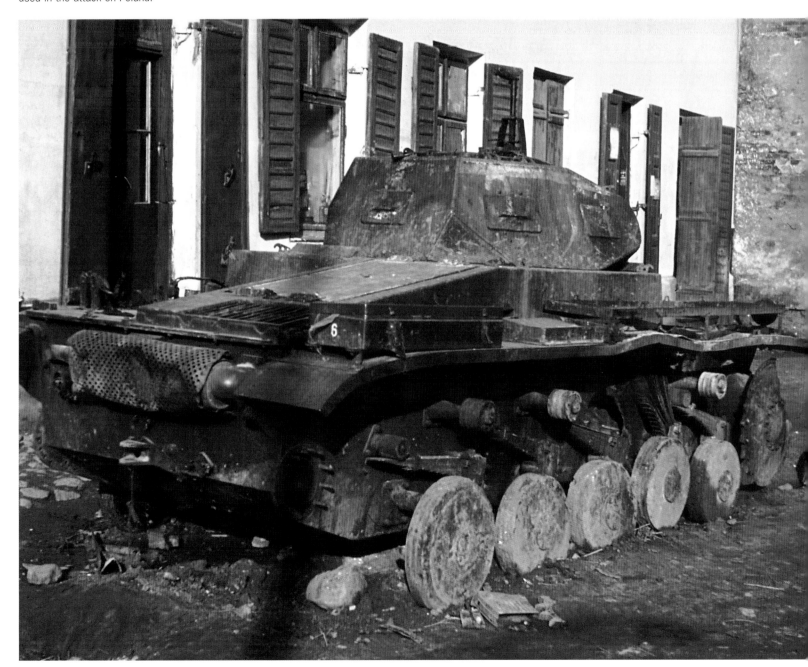

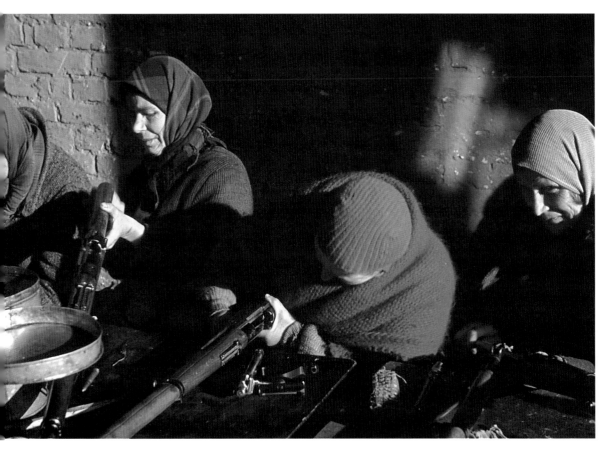

LEFT

October 1939 and Poland has fallen. Polish women clean captured guns for their conquerors inside the walls of Modlin Castle, north-west of Warsaw. Built in the early nineteenth century and devastated during the war, the castle is now an eerie, atmospheric ruin.

RIGHT

Hitler reviews the German Victory Parade of October 5 1939. Held in Warsaw's Pilsudski Square, the procession was composed of mounted officers, marching troops and horse-drawn artillery.

BELOW

Four Polish soldiers and a Red Cross nurse, taken prisoner
during the invasion of Poland. The men wear the khaki uniform
adopted by the Polish Army in 1936, the most recognizable item
of which is the chapska, a peaked cap with a square crown.

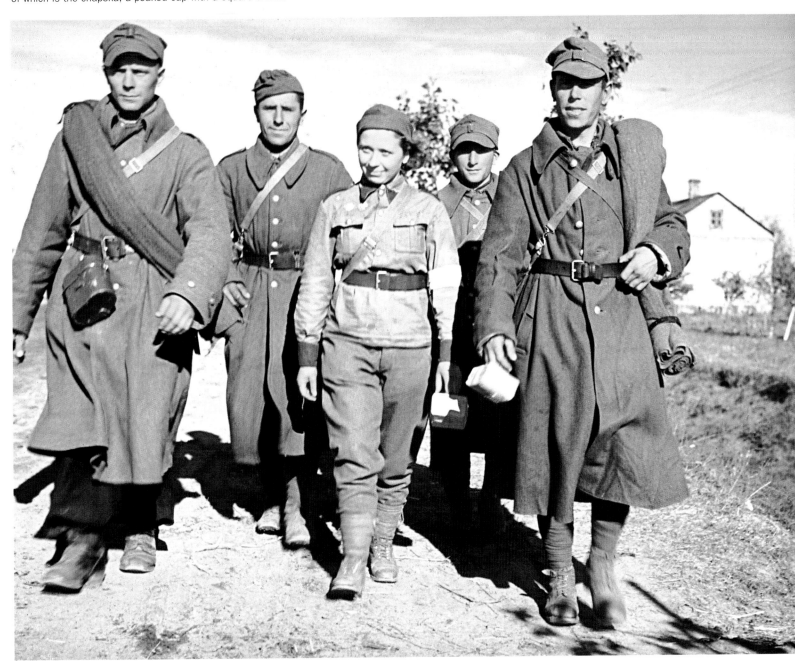

BELOW

Women in the ghetto in the town of Kutno, north of Lodz, where all the Jews from the surrounding area were corralled by the Germans. Seen here soon after the occupation, one woman smiles hesitantly for the camera, as if not yet fully aware that the barbed wire means loss of freedom for them all.

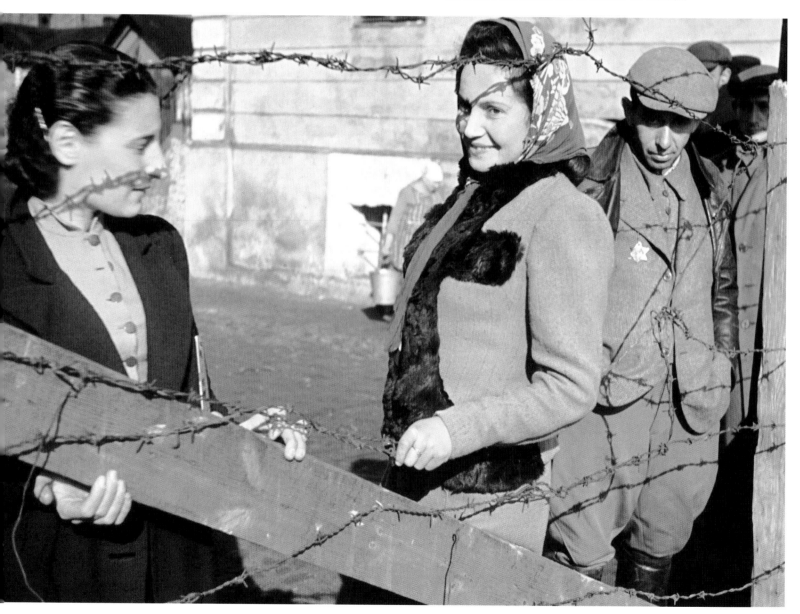

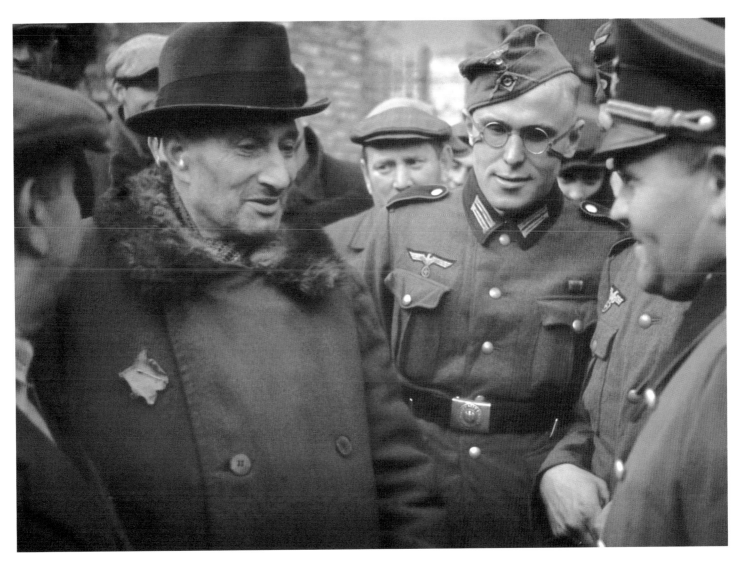

An elderly Jewish man, wearing a tattered Star of
David on his coat, talks to German soldiers in
Kutno during the round-up of all the Jews. Despite
the smiles, there is a hint of menace in the scene
and resignation on the old man's face.

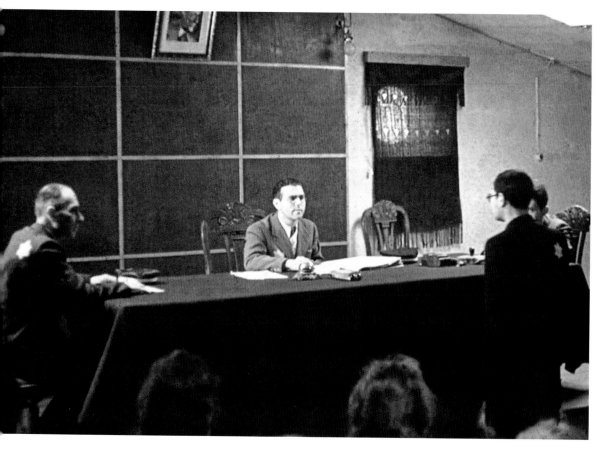

A court in session in the ghetto in Lodz. The accused was charged with stealing four potatoes. This sort of farce was played out by the German authorities to make the ghetto's occupants feel they had some say in their affairs. However, poverty, hunger and despair were all that awaited them. And those who did not die in the ghetto would be sent to the extermination camps.

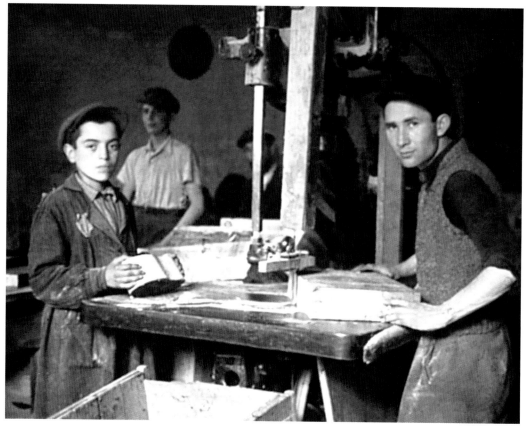

RIGHT

A workshop in the Lodz ghetto. At least these young men had work to do, making furniture, to keep their minds off what lay ahead. By the summer of 1943 all the ghettos in Poland, apart from Lodz, had been broken up. Only a few companies of Jewish prisoners in labour camps remained. Sooner or later they too would be sent to the execution pits or the gas chambers.

An elderly Jew is detained by two members of the Lodz Ghetto
Police, wearing special armbands and military-style caps as well
as the Star of David on their jackets. The Jewish Councils tried
to use Jews to help the authorities to maintain law and order
fairly, but they knew that these policemen would be beaten up
or suffer an even worse fate if they did not do their job properly.

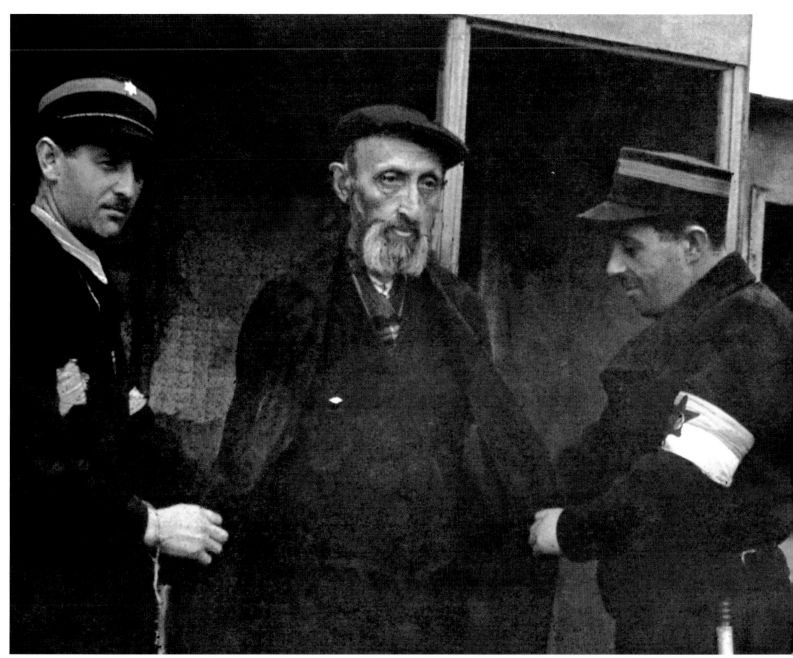

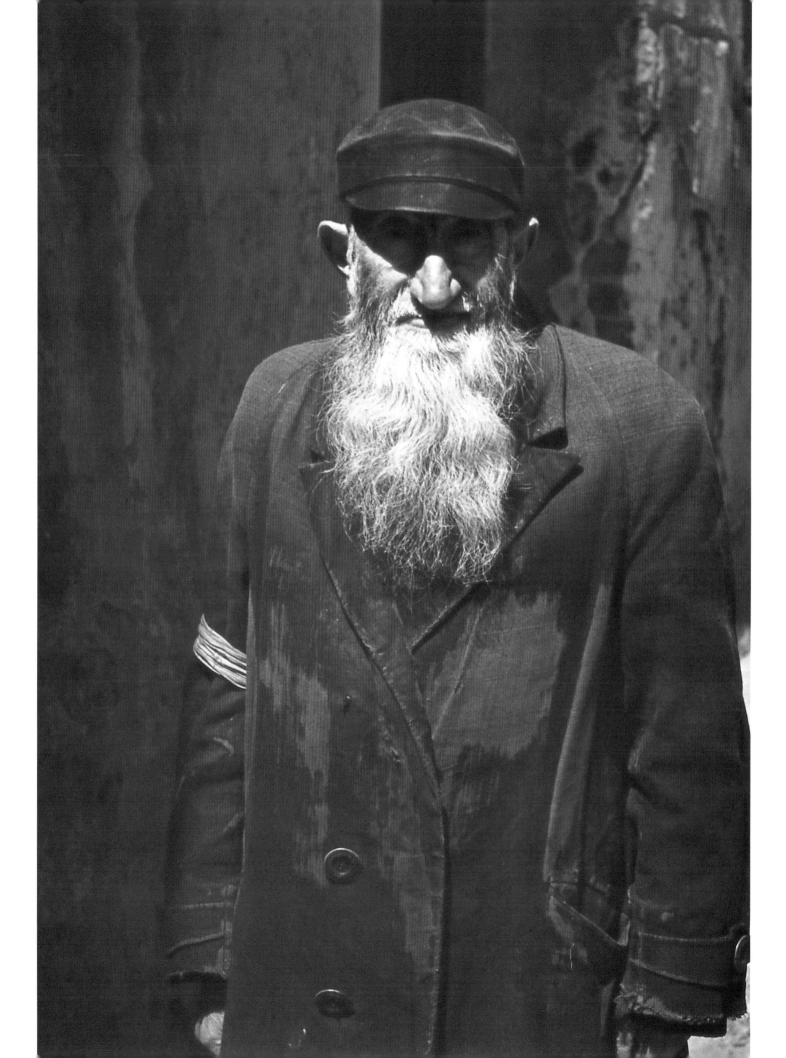

Lublin, June 1941. The Nazis
eventually murdered all of the 40,000
Jews in this city, the largest in
eastern Poland. In March 1942 old
people like this man, and the sick,
were herded into the square in the
ghetto and shot, while the others
were transported by rail to the death
camp at Belzec.

In Izbica, in south-west Poland, Jews are
put to work shovelling coal in May 1941.

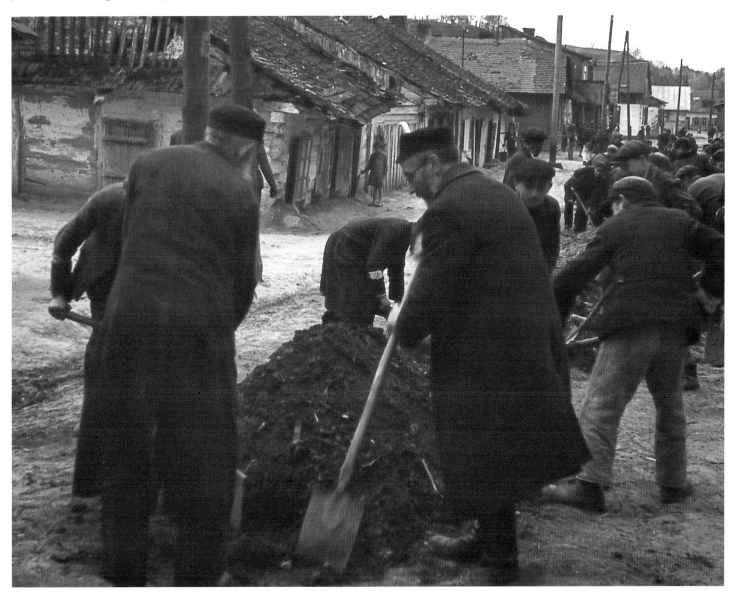

BELOW

Two smiling young gypsy women, photographed in Lublin
in June 1940, are blissfully unaware of what lies in store
for the city. Gypsies were also persecuted by the Nazis
as "racial inferiors": 2,800 of them were deported from
Germany to Lublin in May 1940. Less than two years after
the deportation of Jews to Belzec, the 18,000 Jews who
remained in the ghetto were taken to the Majdanek death
camp and shot. Their extermination, on November 3 1943,
was codenamed Erntefest (Harvest Festival).

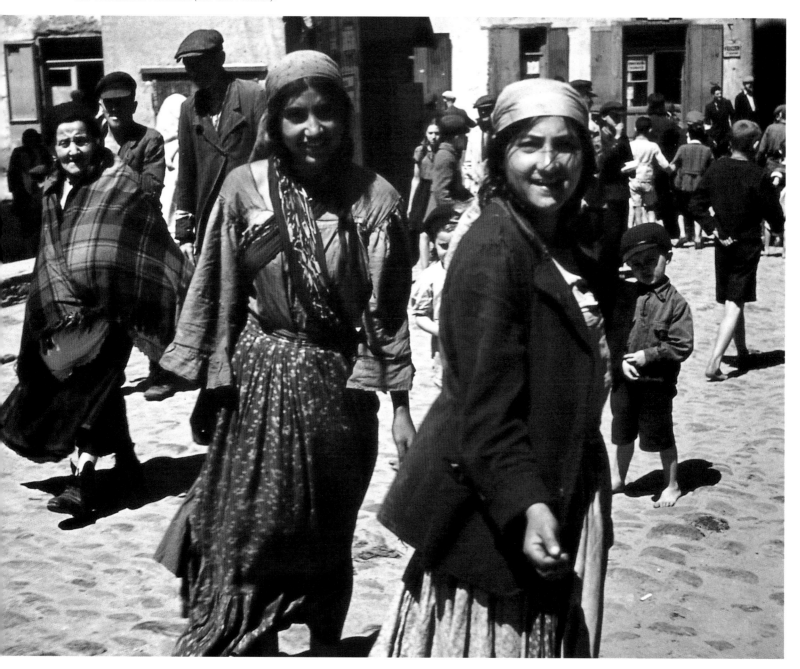

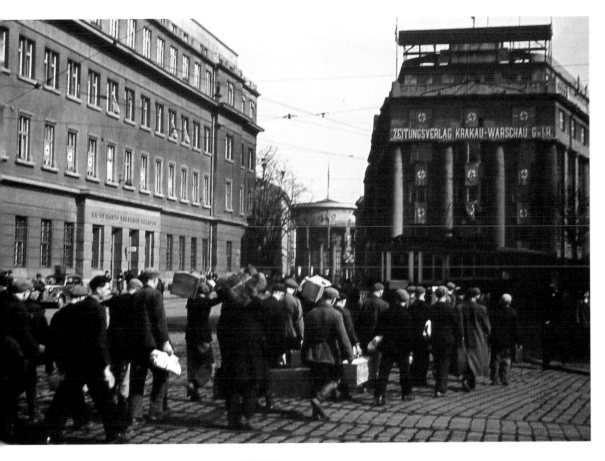

Able-bodied Polish men being deported from Krakow in May 1940, probably to work for the Germans as slave labourers. Later the city's Jews would be taken to a new labour camp at nearby Plazszow, run by the notoriously cruel Amon Goeth.

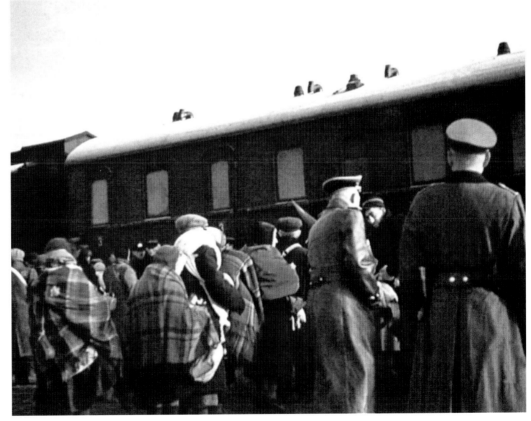

RIGHT

This orderly scene may date from the early part of the war as it does not portray the way in which Jews were later transported by the Nazis. Once the first rumour of the gas chambers penetrated the ghettos, brute force had to be used to drive the terrified people into the cattle trucks that would deliver them to the death camps.

German paratroopers landing on the snowy hills around Narvik, to reinforce General Eduard Dietl's mountain troops, who had earlier captured the port.

Vidkun Quisling gave his name to a new type of traitor. This arrogant and dogmatic Norwegian proclaimed himself head of the country's government. However, when King Haakon VII refused to sanction his claim, Quisling could not gain enough popular support. He was executed by a firing squad on October 24 1945.

German Gebirgsjäger mountain troops on operations. The 3rd Gebirgs Division spearheaded the invasion of Norway. Tough and well trained in mountain warfare, they were ideally suited to fighting in the mountainous north of the country.

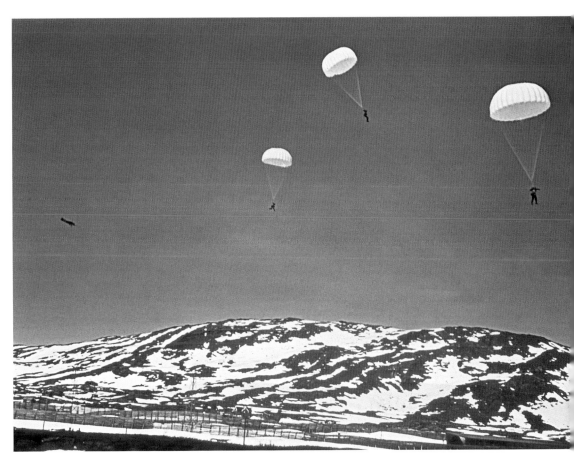

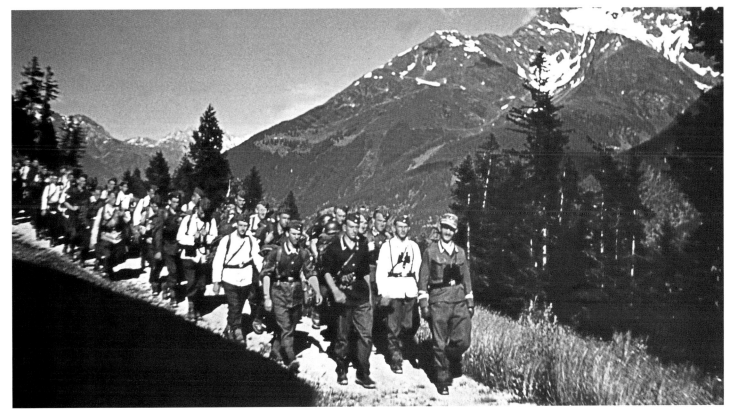

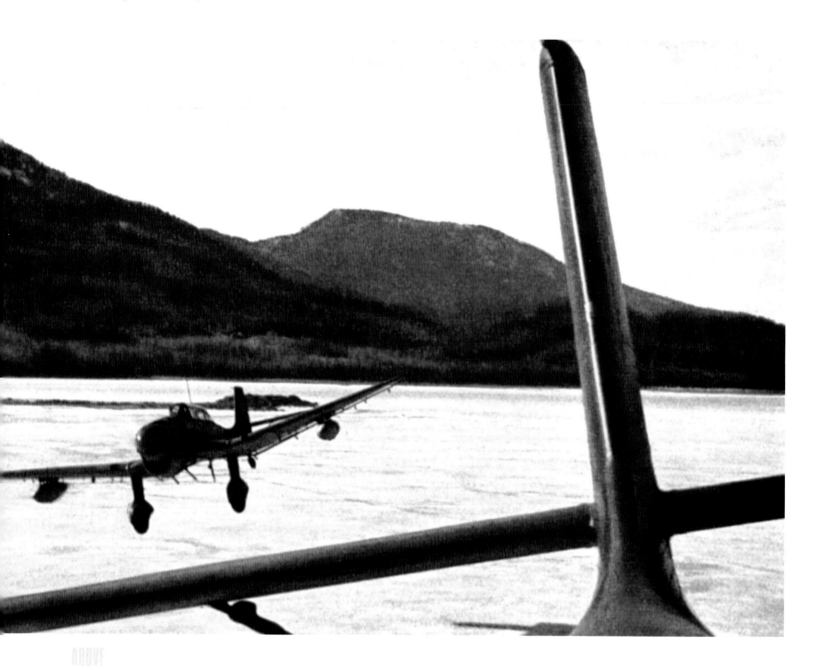

The Junkers Ju 87 was a vital part of the German assault, its nickname, "Stuka", a shortened form of Sturzkampfflugzeug, or dive bomber. Its thick, angled wings and fixed undercarriage made it instantly recognizable, while its "screamer" produced a terrifying noise as the aircraft dived. Here Stukas are seen attacking targets in the Norwegian fjords.

Narvik Harbour was captured by German Gebirgsjäger but then,
after bitter fighting, was taken by British, French and Polish
troops. However, eleven days later, on June 8 1940, King Haakon
VII and his government left Norway and the Allies withdrew.

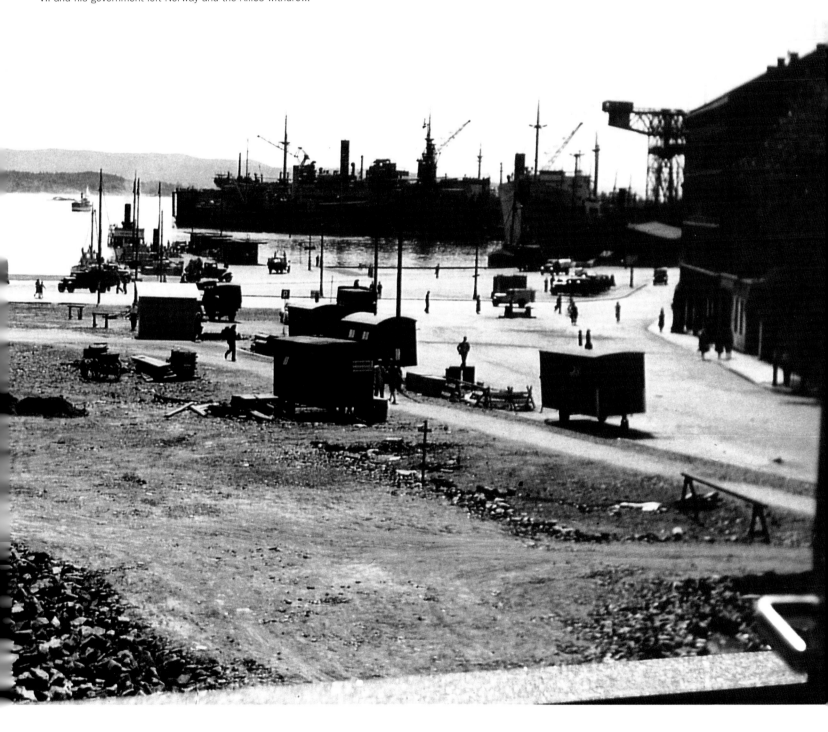

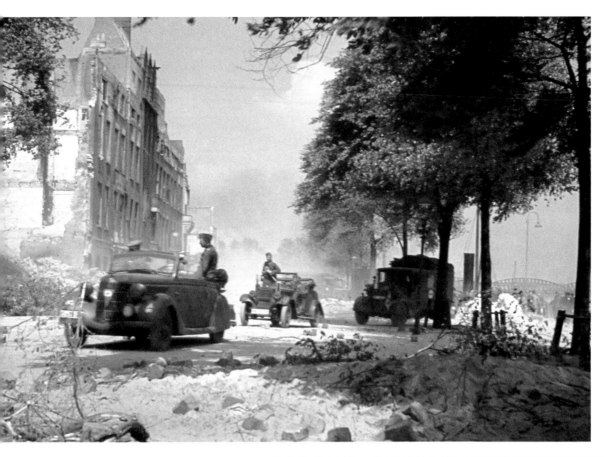

A German motorized column moves through a ruined street in Rotterdam on May 15 1940. The day before cease-fire negotiations began, sixty Heinkel He 111 bombers attacked the centre of Rotterdam to ensure compliance. The raid caused many casualties and 78,000 people were made homeless.

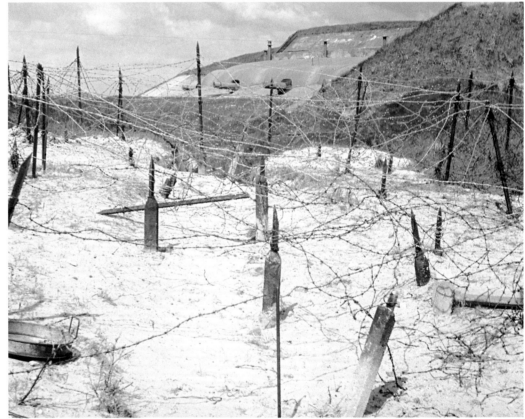

These defences at a fort at Muiden, just east of Amsterdam, were part of what the Dutch called "Vesting Holland" (Fortress Holland). They look impressive, but, like other fortresses, they were easily avoided, German paratroops simply landing behind them.

Panzers advance. A Dutch boy looks on as a German tank
commander and his crew talk to a group of infantrymen in
Rijsoord. It was in this town that the Dutch capitulation was
signed on May 15 1940.

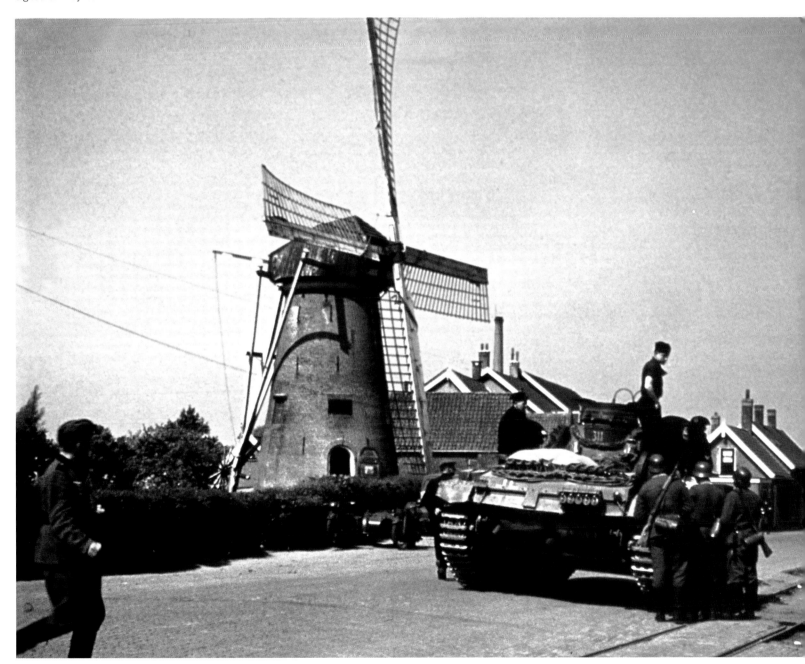

RIGHT

Living off the land. A German infantryman milks a Dutch cow during the advance through Holland. Many young German soldiers were of farming stock, so tasks like this were no problem for them.

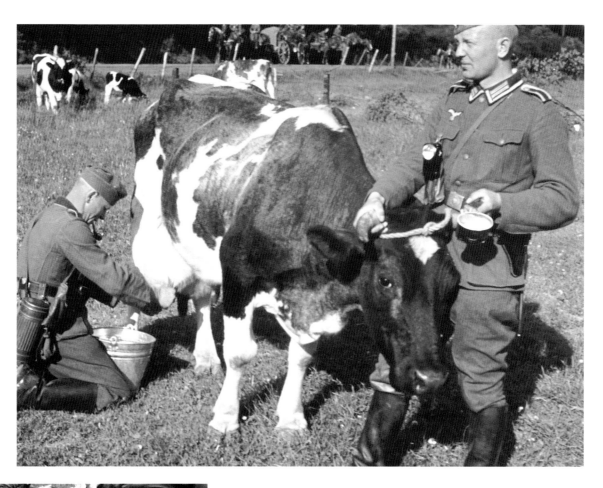

LEFT

Exhausted German infantrymen rest during their progress through Holland and Belgium. Despite the fact that the Germans portrayed their army as being highly mechanized, most of their soldiers still marched, while thousands of horses were used to pull supply wagons and artillery guns.

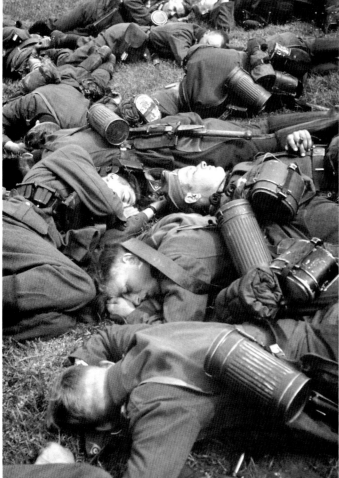

RIGHT

Firemen in Amsterdam deal with a blaze started by German bombardment. Field Marshal von Keuchler's 18th Army, part of Army Group B, had advanced northwards on Amsterdam once resistance in Rotterdam had been broken.

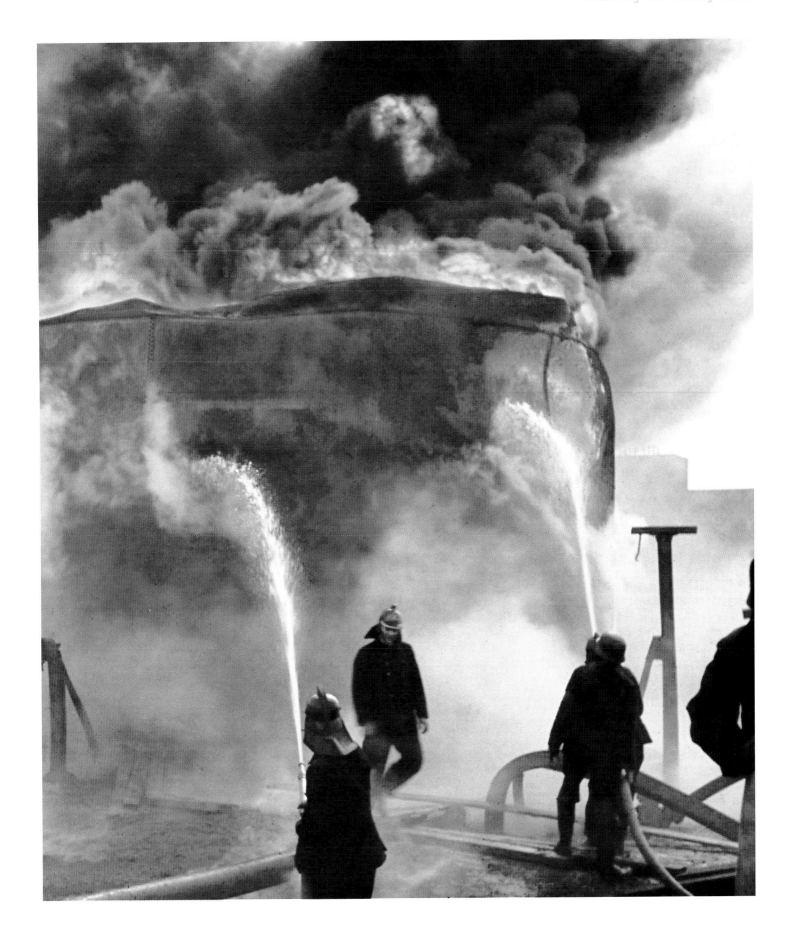

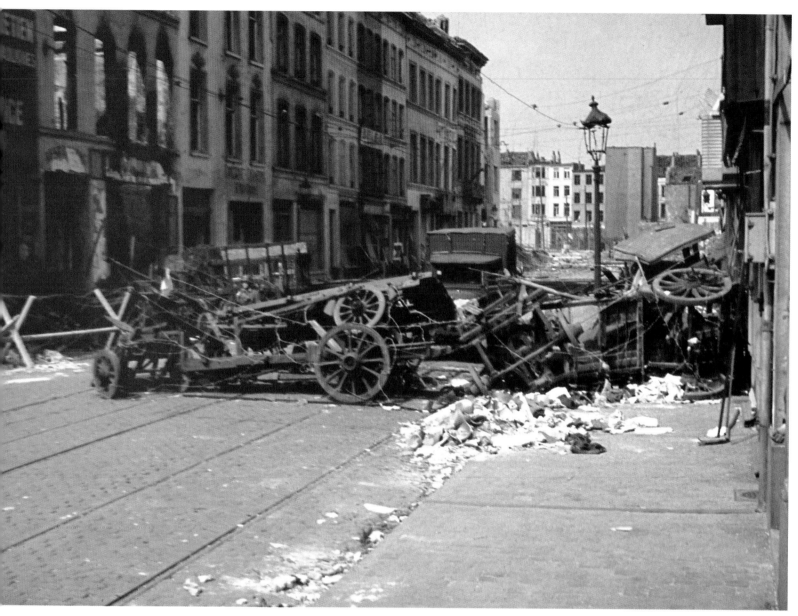

A makeshift barricade in a deserted street in Brussels. Allied
troops pulled out of the Belgian capital on May 17 1940,
leaving it defenceless. That evening men of the German
14th Infantry Division arrived and the German flag was
hoisted over the town hall.

Surrendered Belgian troops – note the white flags on their
lorries – pass a German horsed column. The Belgian Army
laid down its arms in response to a demand for unconditional
surrender made by the Germans on May 27 1940. The
cease-fire came into effect at 0400 hours the following day.

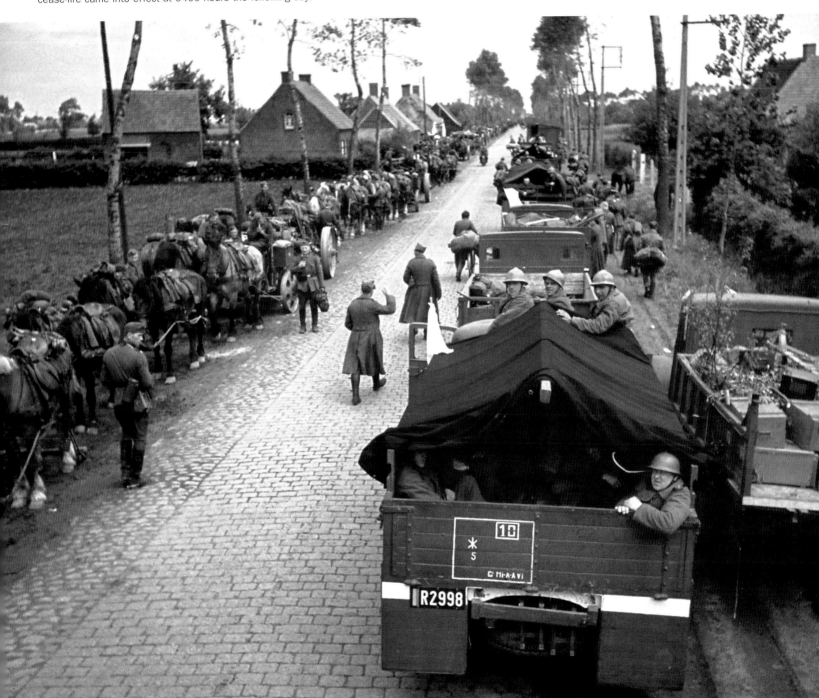

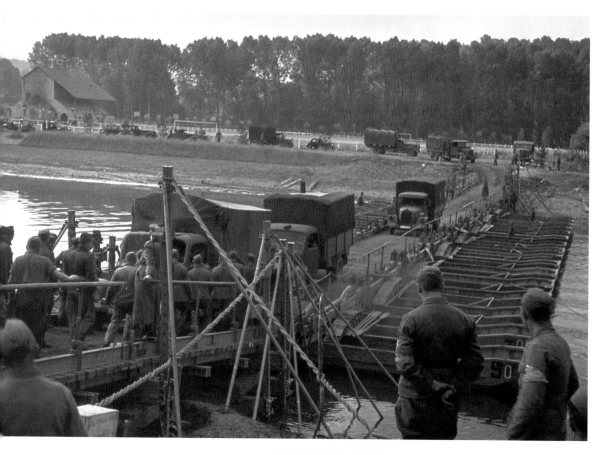

LEFT
German engineers built this pontoon bridge, over which a column of vehicles is moving. The engineer battalions in both infantry and tank divisions contained a bridging column that carried both medium- and heavy-capacity bridges.

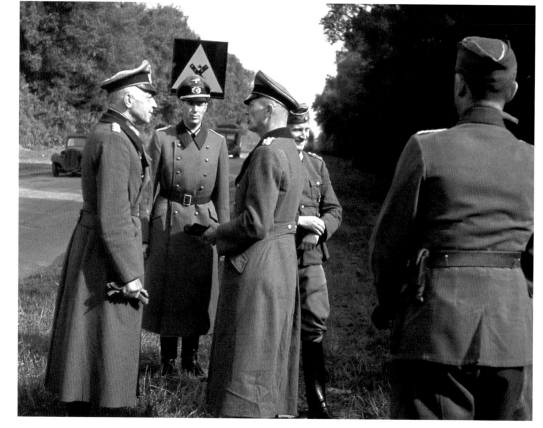

RIGHT
Just 20 kilometres (12 miles) from Paris, Field Marshal Fedor von Bock, who commanded Army Group B, talks with some of his staff officers. The Germans had advanced on the French capital from three directions and the garrison was ordered to withdraw southwards. The Prime Minister, Paul Reynaud, and the Allied Commander-in-Chief, General Maxime Weygand, declared Paris an open city.

A German soldier using a flame-thrower (Flammenwerfer). This device projected a stream of burning oil or creosote a distance of about 25 metres (80 feet). Fuel was carried in a tank on the operator's back.

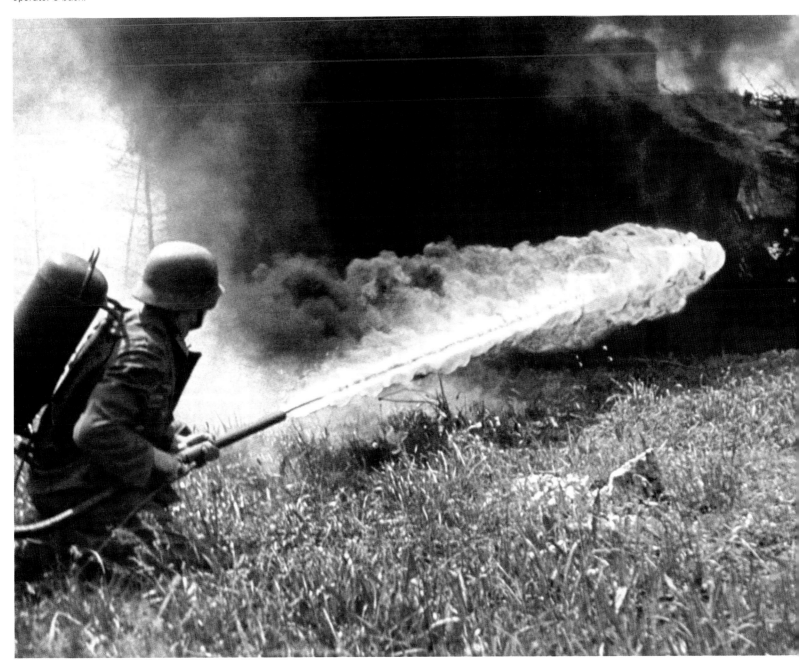

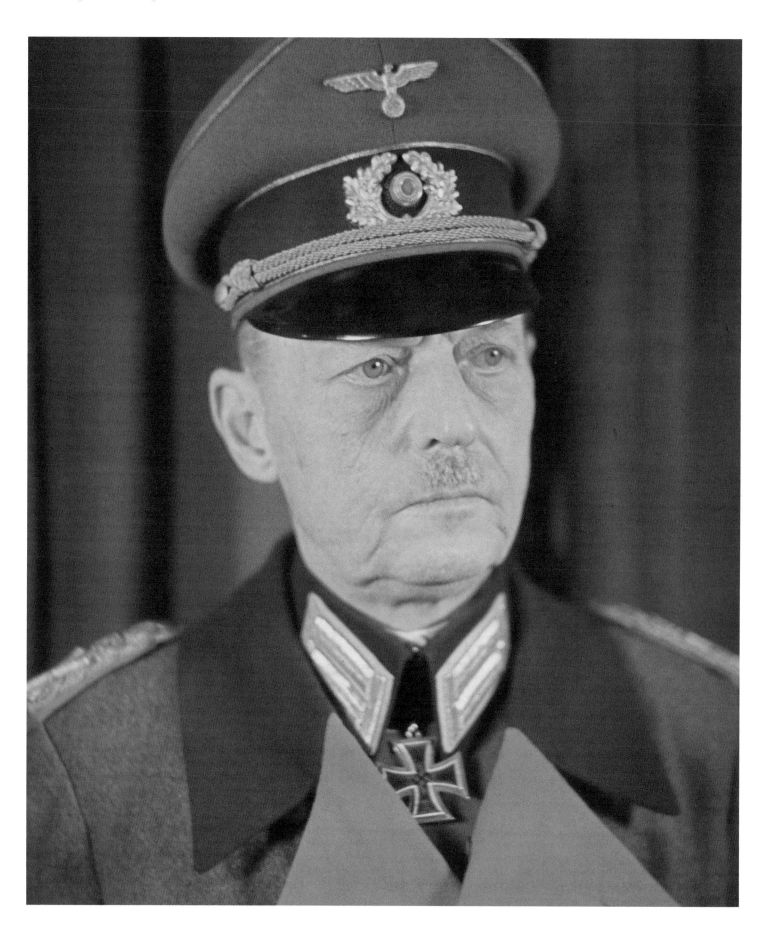

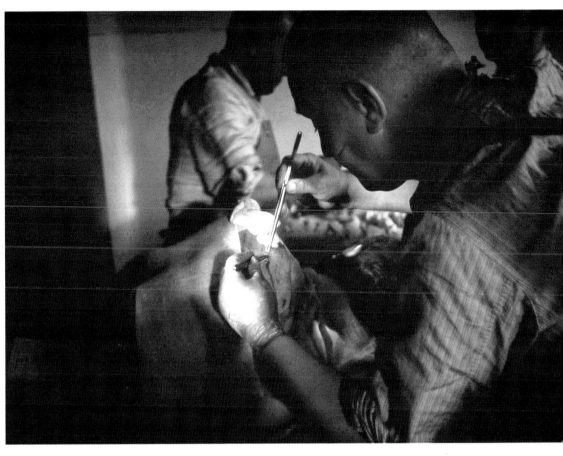

An operation in progress in a field hospital. Each infantry division had such a facility, run by some seven officers and 85 men of other ranks and equipped with 30 motor vehicles and five motorcycles.

Field Marshal Gerd von Rundstedt commanded Army Group A in Poland and France, then Army Group South in the assault on Russia. In 1942 he was put in charge of the occupation of Vichy France, and then made C-in-C West. Sacked in July 1944 and reinstated two months later, he remained in command until March 1945.

Stretcher bearers carry a wounded man into a field hospital in France. Every field army had a number of medical companies, as well as detachments able to form field hospitals and several ambulance sections.

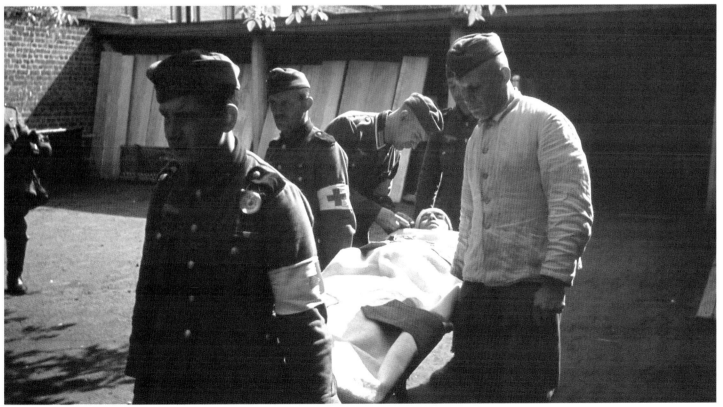

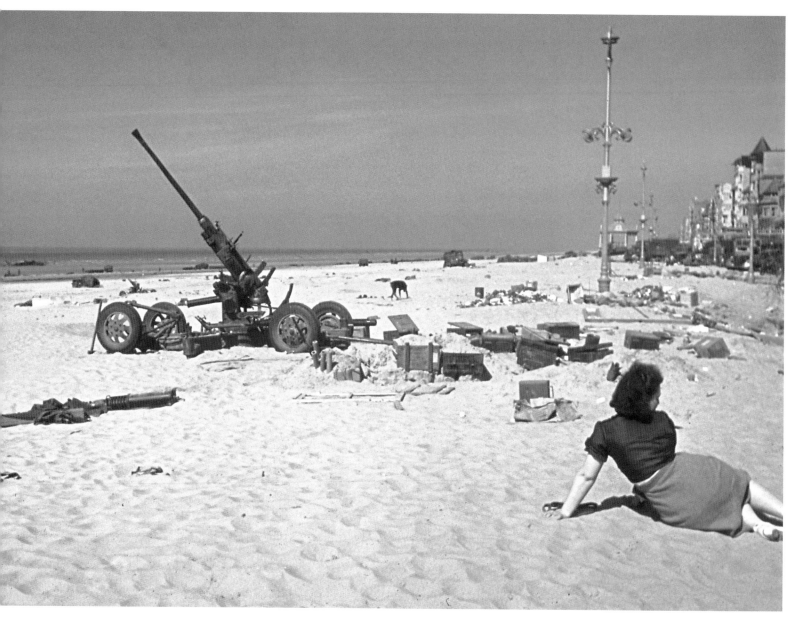

The beach at La Panne (De Panne) just across the French-Belgian border from Dunkirk (Dunkerque). This photograph was taken after Operation Dynamo, which saved the British Expeditionary Force. A lone woman and her dog (behind the AA gun) look strangely out of place amid the military debris.

British soldiers captured at Dunkirk in May 1940 wait to be
moved to a POW camp. Like all prisoners, they look dirty,
dishevelled and bewildered, and none of them wears a hat,
every man having discarded his steel helmet.

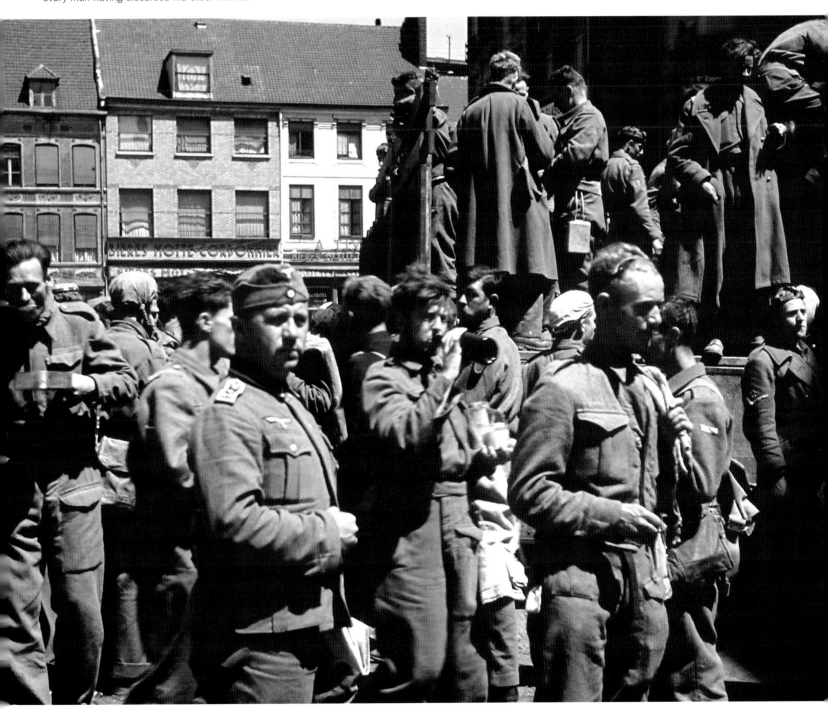

These French soldiers are prisoners of the Germans. As their
faces and headgear show, they are a mixture of native French
and colonial troops. The latter included Senegalese, Moroccans,
Tunisians and Algerians.

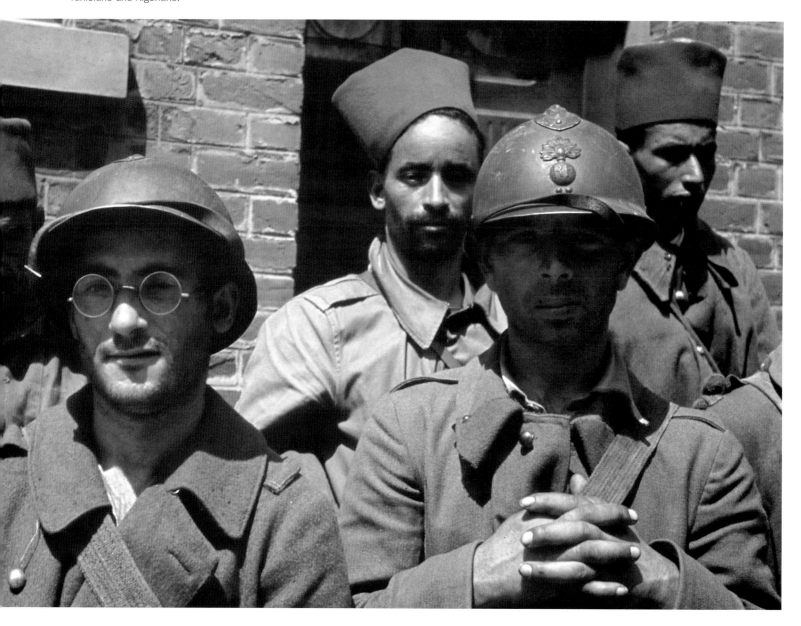

A German soldier has climbed to a vantage point among the debris of war to survey the wreckage. Fortunately, not all French villages were as devastated as this one.

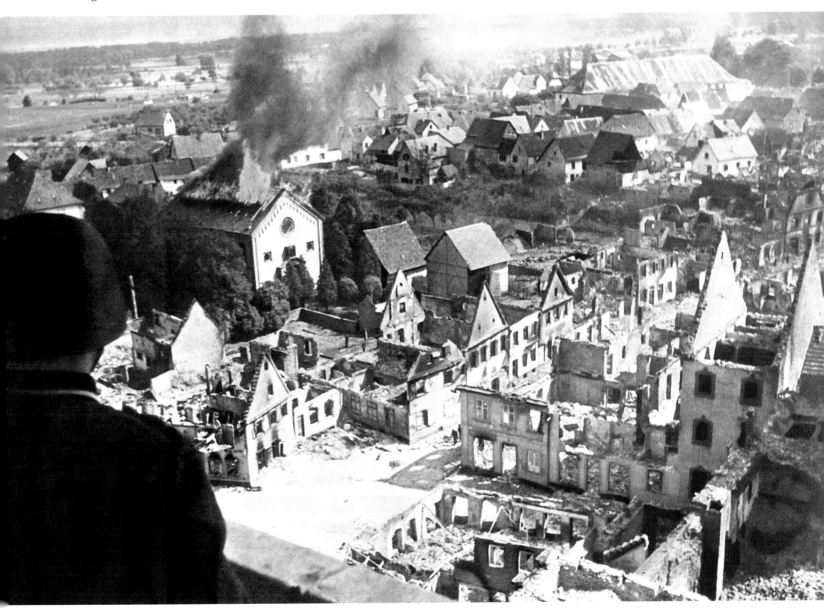

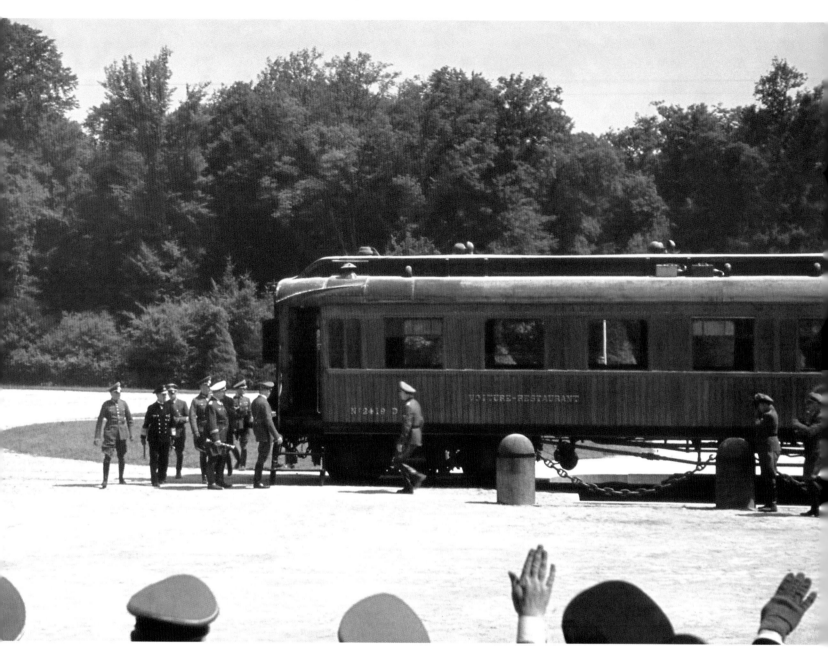

A triumphant Hitler and his entourage are about to
enter the railway dining car in which the German
surrender was signed at the end of the First World
War. It was specially brought out of its museum for
the signing of the French surrender on June 21 1940.

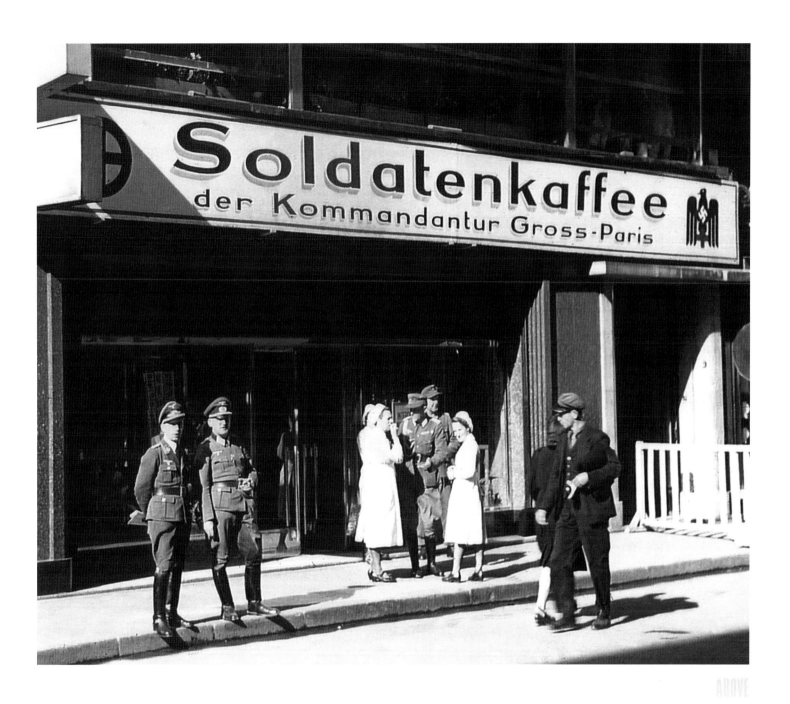

For a while this sign must have been a strange sight to see in the heart of Paris. This coffee house for German soldiers, which had a counterpart in the American Stagedoor Canteen in London, was opened so that troops visiting Paris could relax and socialize with nurses and other women.

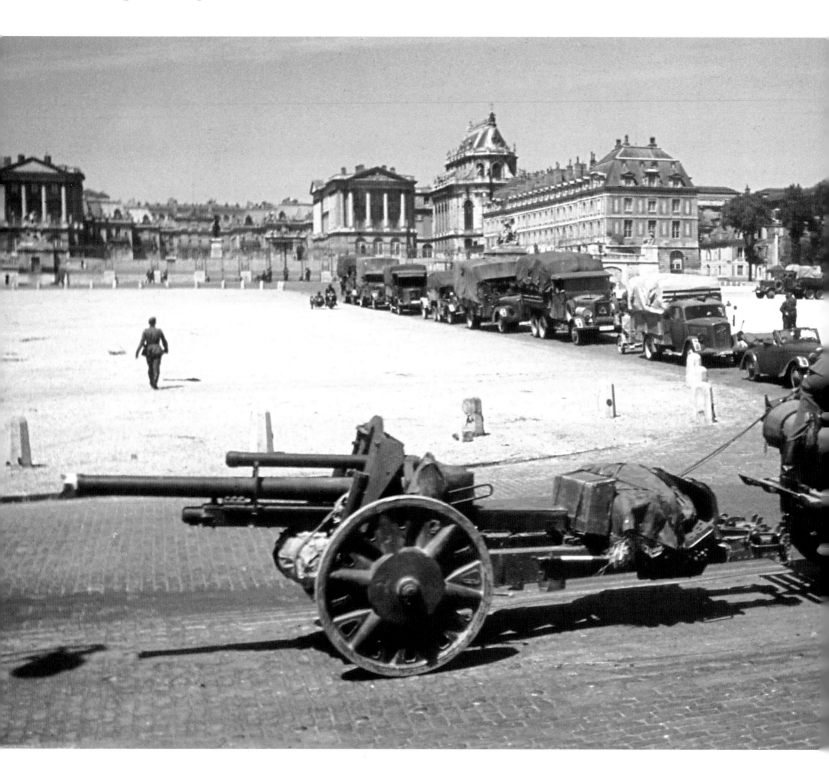

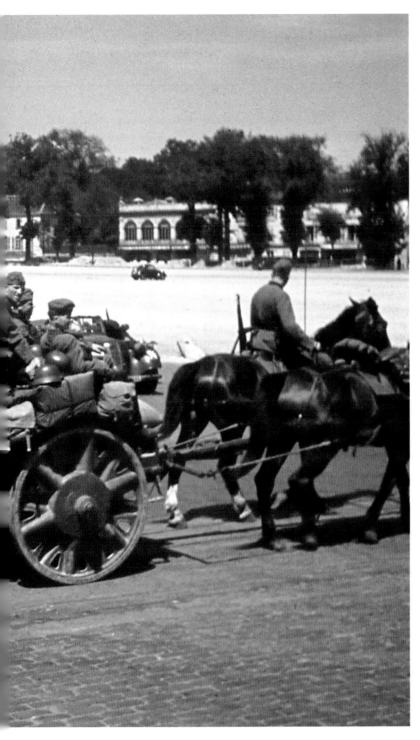

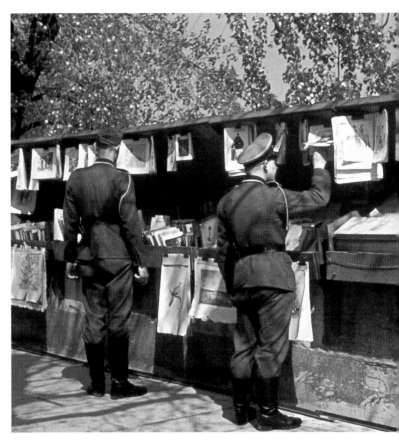

ABOVE

"Looking for pin-ups, sir?" German soldiers in Paris inspecting "art" on the Left Bank of the River Seine.

ABOVE

A German motorized column moving away from the Palace of Versailles appears to have stopped to allow a horse-drawn 10.5-cm (4-inch) Leichte Feldhaubitze 18 to pass. This light field howitzer was the backbone of the German field artillery at the start of the war.

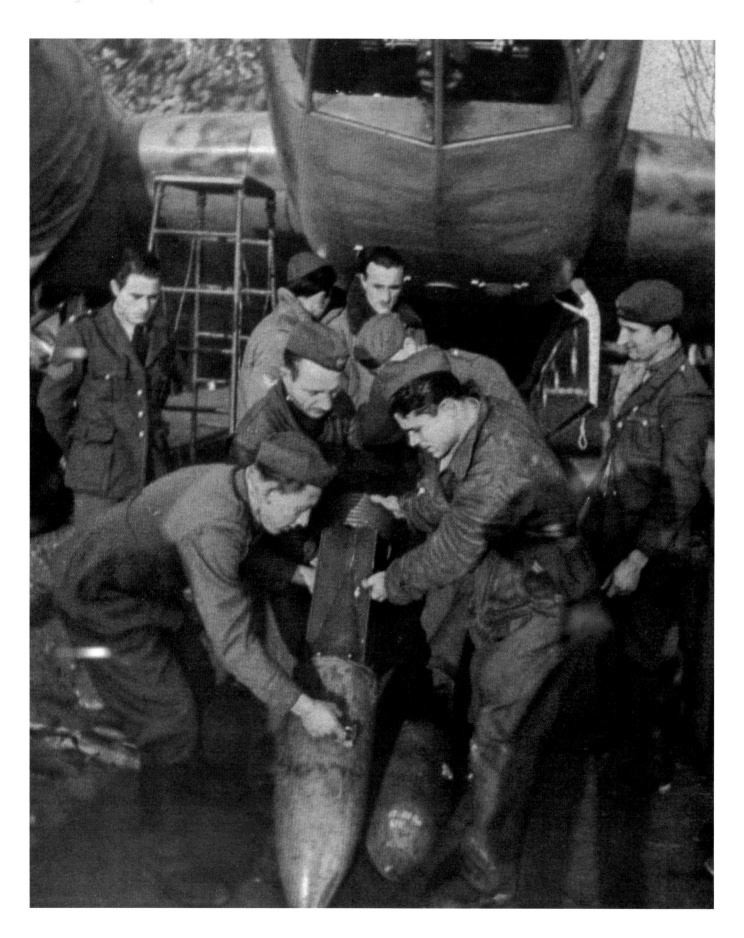

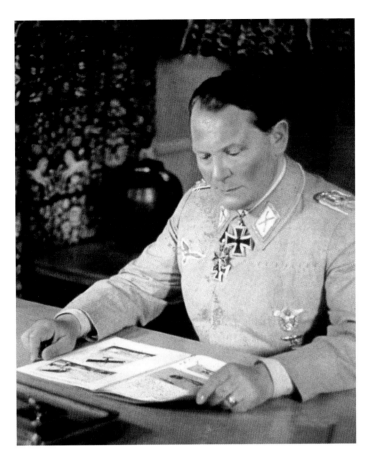

LEFT

The flamboyant Reichsmarschall Hermann Goering, a brave and successful fighter pilot in the First World War, rose in the Nazi Party to become second only to Hitler. Under Goering's leadership the Luftwaffe grew rapidly from 1935 onwards. Although impressive in Poland, France and Russia in 1940–41, German air power was insufficient to win the Battle of Britain, and by the end of 1942 the Luftwaffe was under severe pressure on all battlefronts.

BELOW

All ready to scramble. Fighter pilots wait for the signal to take off and accompany German bombers over England to fight the Battle of Britain.

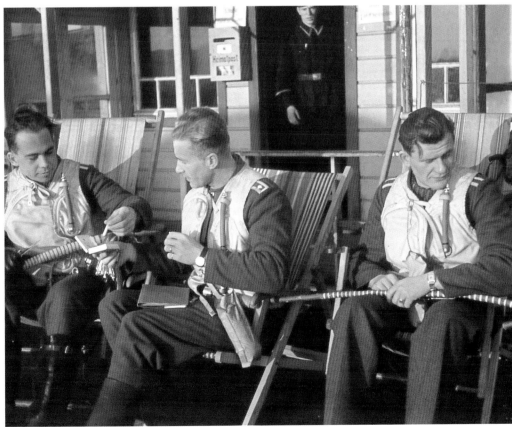

LEFT

Italian ground crew load a bomber. While the Regia Aeronautica, the air force, operated mainly in the North African and Mediterranean theatres, it also attempted, unsuccessfully, to support Luftwaffe bombing raids on England from bases in Belgium in October 1940.

These two Guernsey boys wear British-type steel helmets and carry wooden guns. War is a game to them, but even they will have eventually felt the pressure of being on the only British soil to be occupied by the Nazis.

A street scene in Guernsey soon after the German invasion on June 30 1940. At first the occupation was peaceful and the invaders worked strenuously to get on with civilians. But later pressures, especially the near starvation of the "Great Hunger Winter" of 1944–45, made everyone long for release.

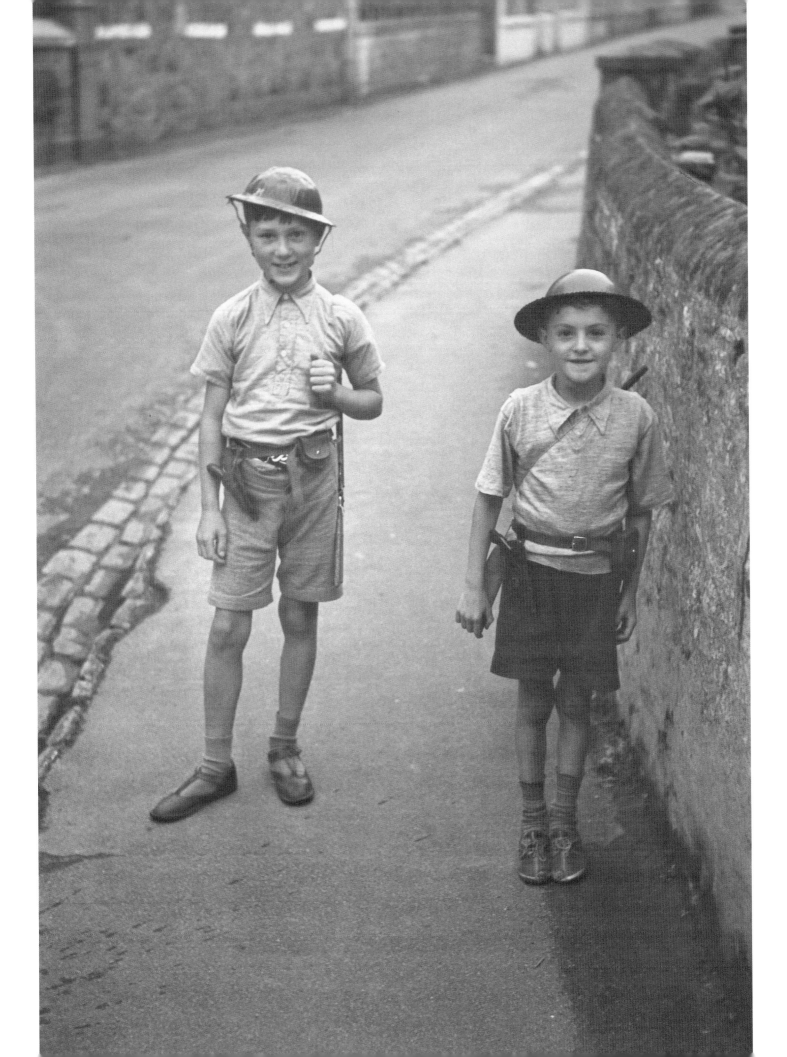

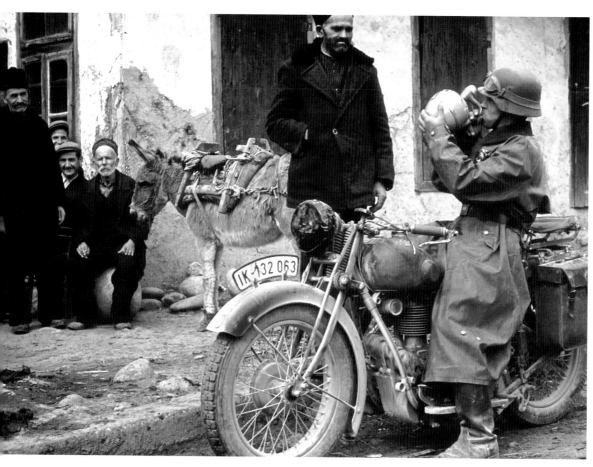

LEFT

In March 1941 the Germans
invaded Bulgaria, occupying the
Black Sea ports. Here a dispatch
rider pauses for refreshment in a
village in the south of the country.

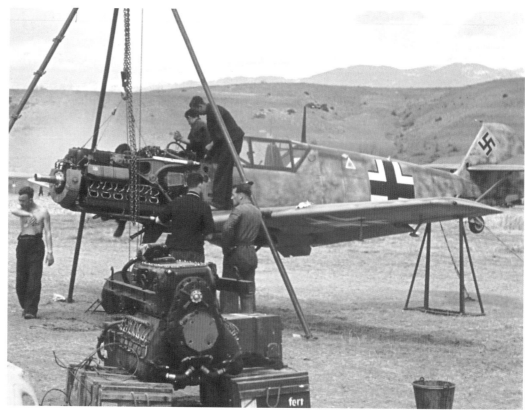

RIGHT

Ground crew work on the engine of a
Messerschmitt 109 at the Svretv-
Vrax airstrip at the Kresna Pass, in
Bulgaria, in 1941. The Me 109 was
one of the most successful German
single-seat fighters of the war.

BELOW

German cavalrymen attend to personal hygiene amid the
mountains of southern Bulgaria. The tent is made from Zeltbahn,
or bivouac sheets. Each soldier was issued with one of these
triangular waterproof sheets, which also served as a cape.

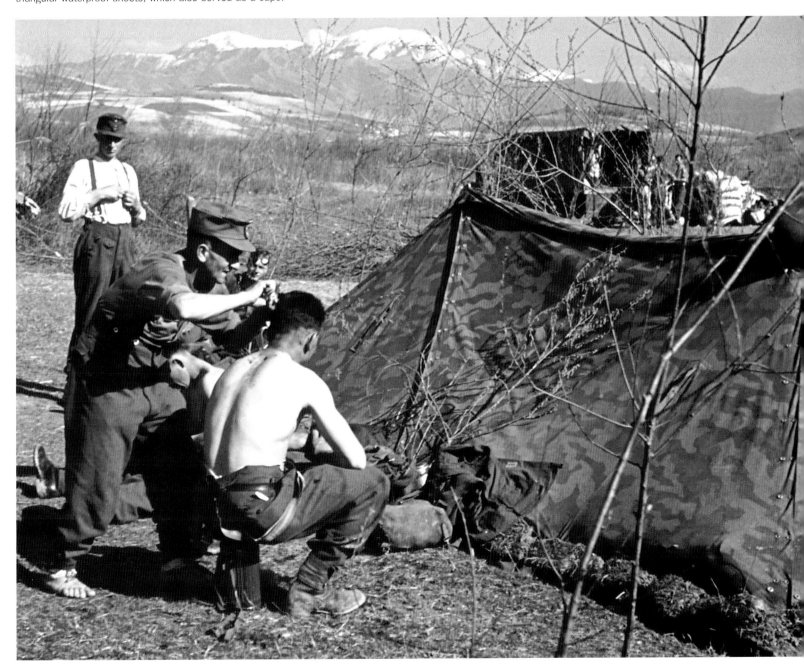

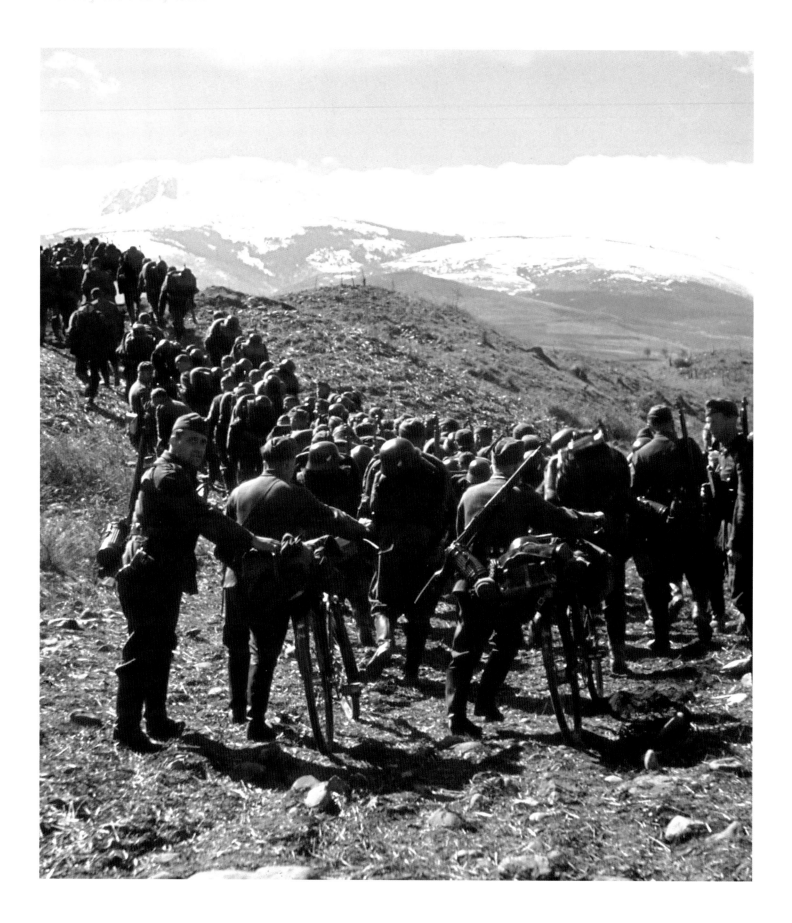

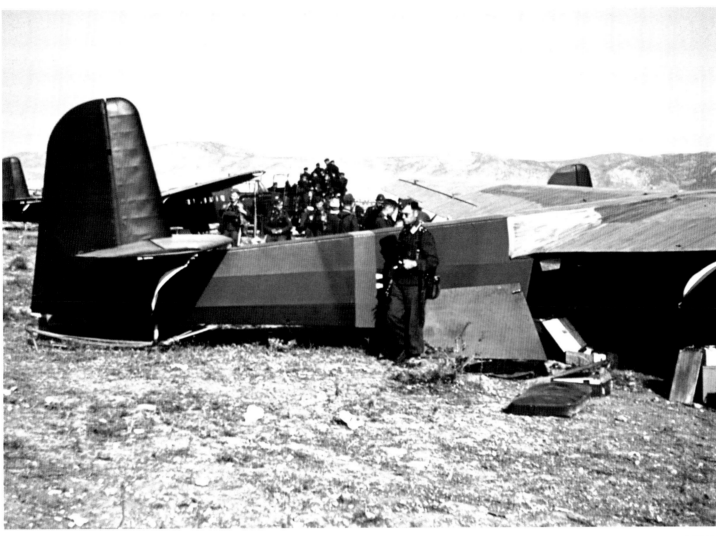

The Germans launched an airborne assault
on Crete on May 20 1941 using gliders
carrying mountain infantry and Ju 52s
carrying some 10,000 paratroopers. Heavy
fighting ensued, the battle lasting until
June 1, when what was left of the British
and Commonwealth garrison surrendered.

LEFT

German infantrymen march through
the mountains during Operation Marita.
Germany's invasion of Greece was
launched to support its inept Italian
partners. Field Marshal List's Twelfth
Army attacked the Greeks' Metaxas
and Aliakmon Lines on April 6 1941.
By the 23rd, Greece had surrendered
and the British and Commonwealth
forces supporting its efforts had
evacuated or been captured.

Hitler with the Prince Regent of Yugoslavia (Prince
Paul Karageorgevic) at a parade in June 1939.
Although Paul's sympathies lay with the Allies, he
was forced to align his country with the Axis.

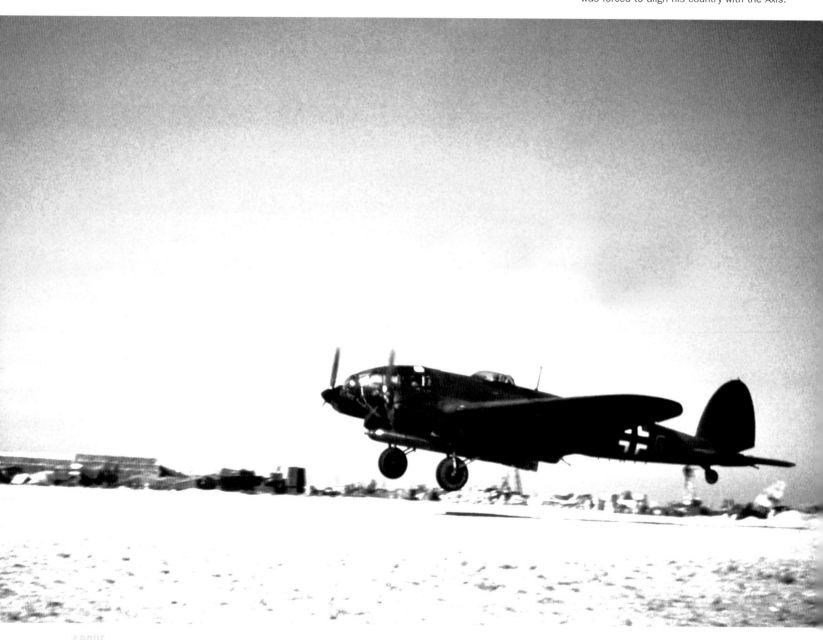

ABOVE

A Heinkel He 111 medium bomber landing at Heraklion airfield,
Crete, in 1942, after the Germans had occupied the island. The
He 111 was the mainstay of the Luftwaffe. The two torpedoes
under this aircraft's fuselage identify it as the anti-ship variant.

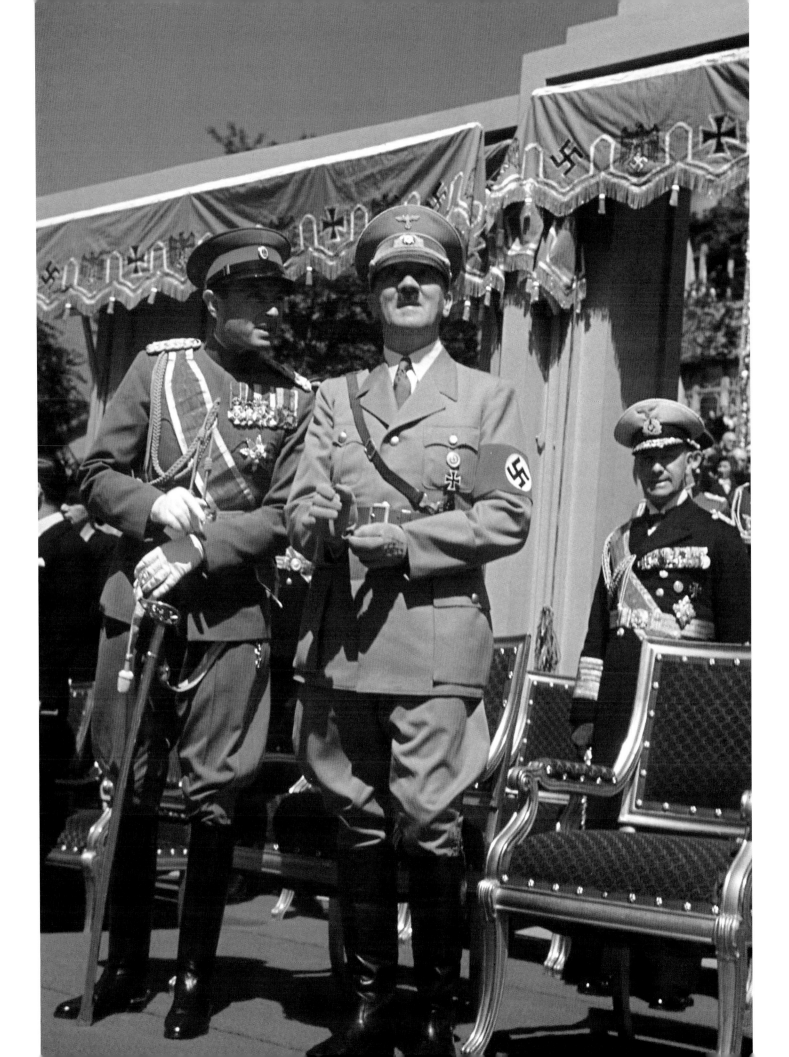

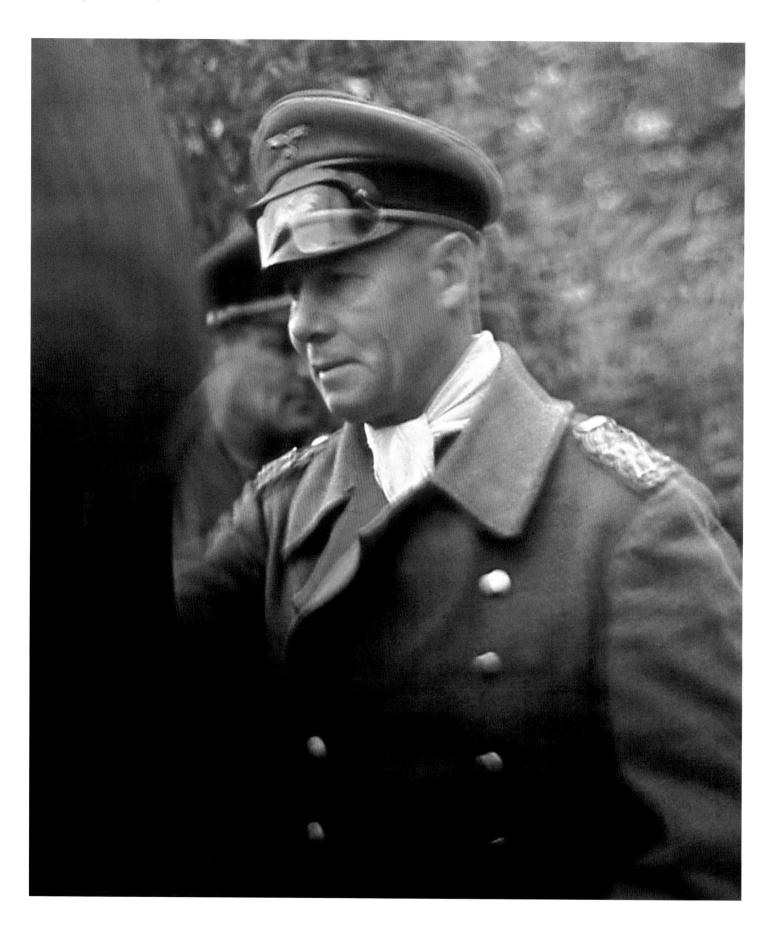

LEFT

General (later Field Marshal) Erwin Rommel, the brilliant charismatic commander in North Africa, earned the nickname the "Desert Fox" and went on to command Army Group B in north-west Europe. Implicated in the bomb plot against Hitler of July 20 1944, he was forced to commit suicide on October 14 that year.

RIGHT

A Junkers Ju 52 prepares for take-off to North Africa. This versatile aircraft had a maximum speed of 275kph (170mph) and could climb to 5,900 metres (19,360 feet).

BELOW

At the Berghof on April 29 1942, Hilter and some of his senior generals, including, just behind him, Field Marshal Keitel, Chief of the German High Command, are joined by Mussolini to plan the war in the Mediterranean theatre.

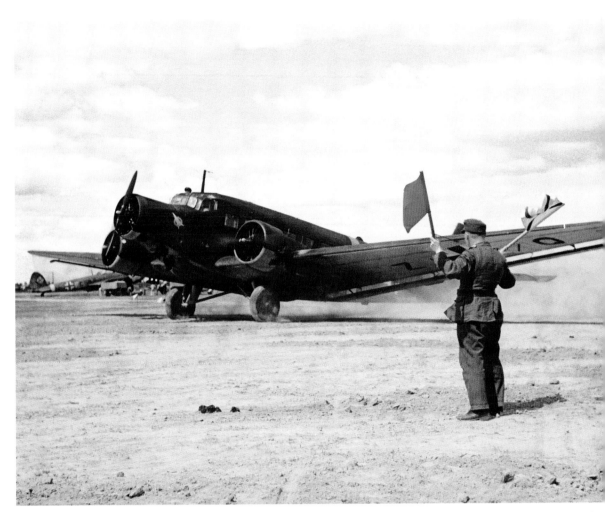

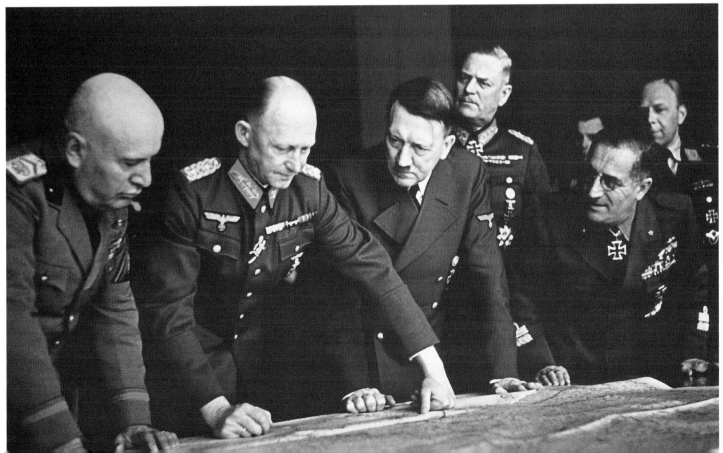

BELOW

Sand played havoc with aircraft engines, so desert
warfare demanded constant, careful attention of the
kind being given to these Ju 87 Stuka dive bombers.

RIGHT

An Afrika Korps artillery observer using a
pair of "scissors-type" binoculars in a
forward observation position in the desert.

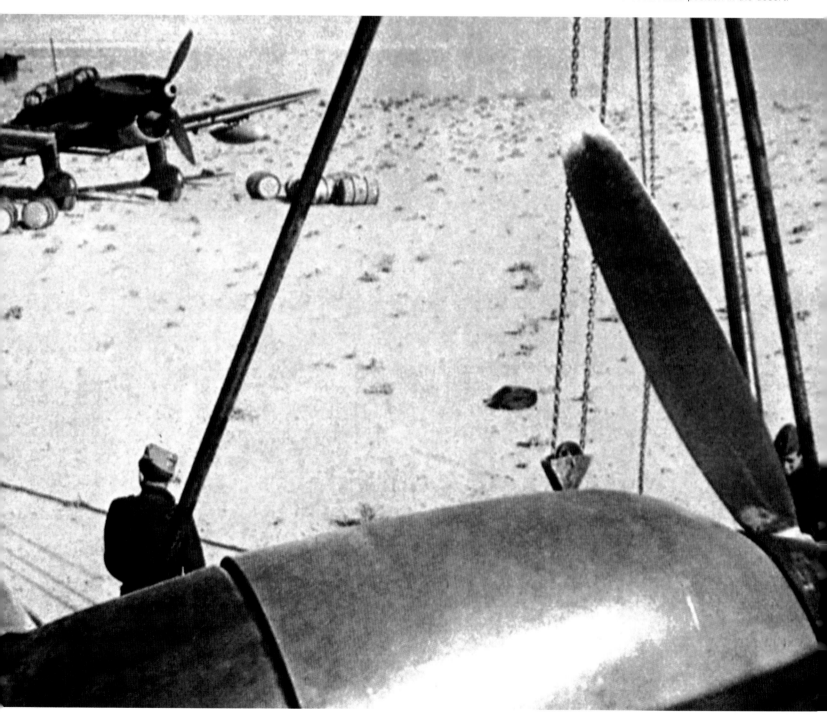

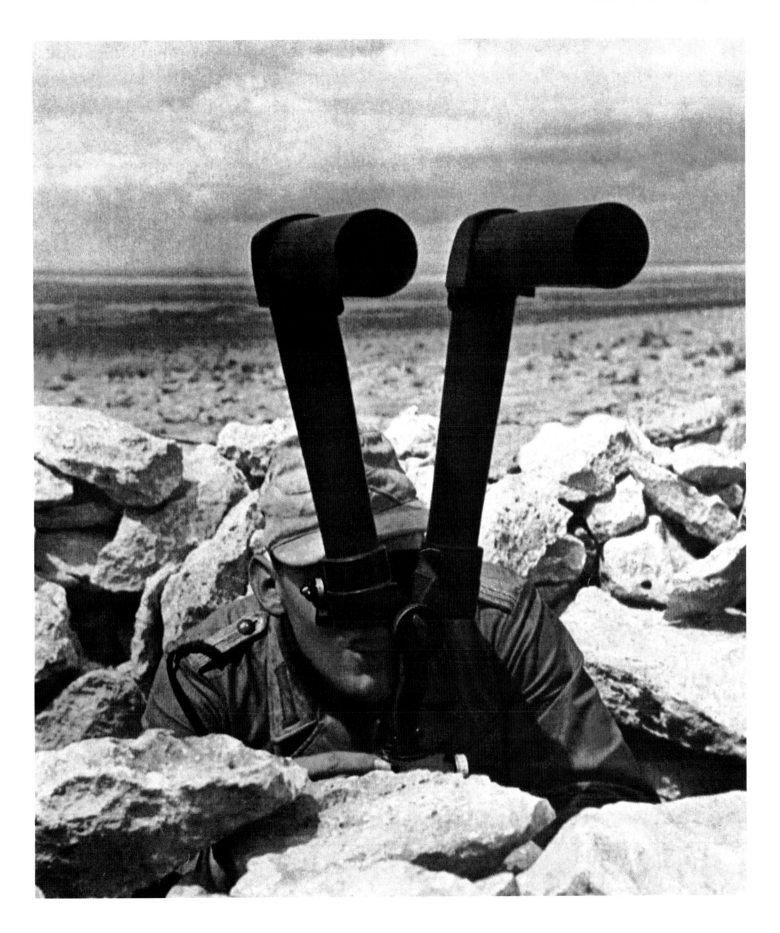

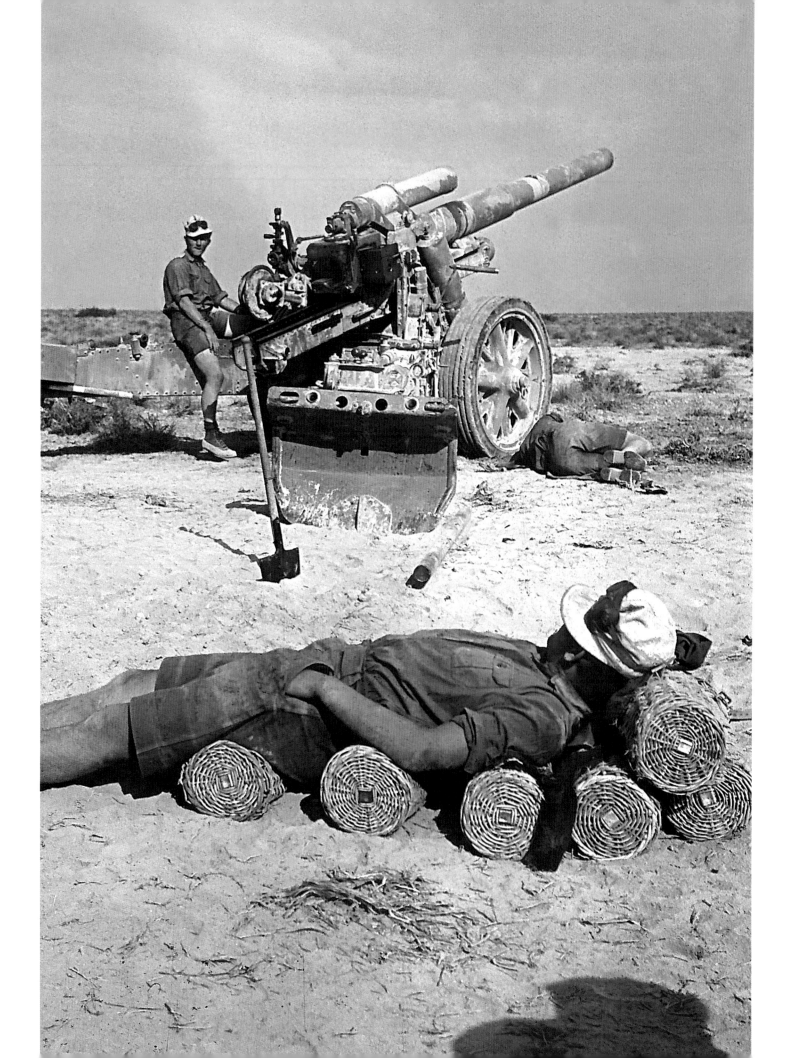

LEFT

While two members of a German
gun crew take a rest, the third
stays relatively alert, perched on
the trail of their 150mm howitzer.

RIGHT

A PzKpfw IV of the Afrika Korps climbs
a sand dune, followed by a Bedouin
and donkey. Until the arrival of the
American Grant and Sherman tanks
under the Lend-Lease scheme, the
tanks used by the British in North
Africa were greatly inferior to the
Germans' PzKpfw IIIs and IVs.

BELOW

Rommel reviews some of his newly
arrived Afrika Korps troops, on parade
in Tripoli, the capital and chief port of
Libya, on February 27 1941. The
"Desert Fox" is accompanied by
the Italian Commander-in-Chief in
North Africa, General Italo Gariboldi.

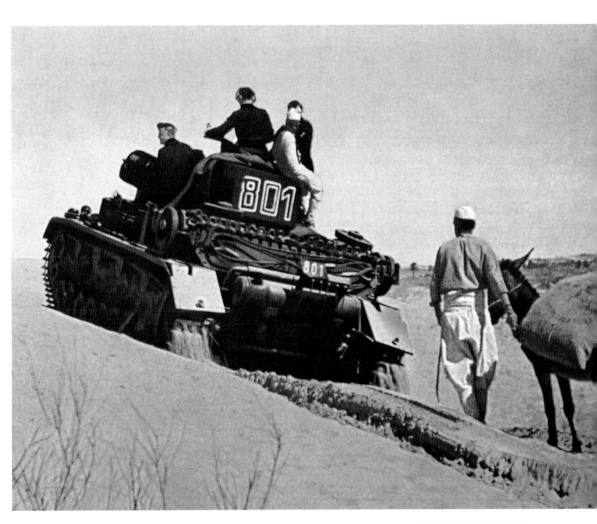

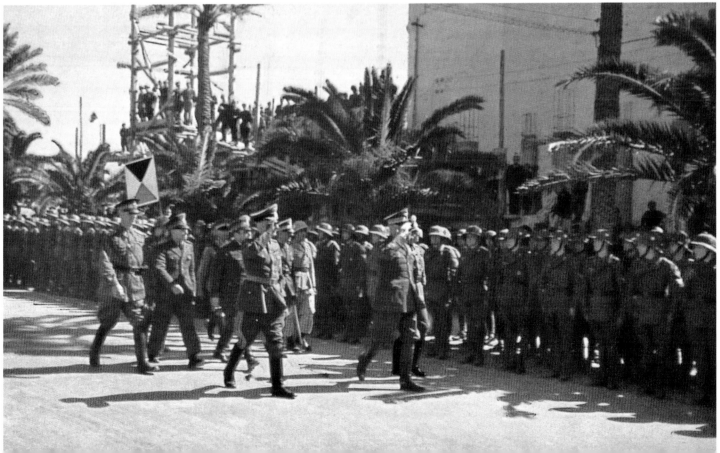

OPERATION BARBAROSSA

At 0315 hours on June 22 1941 the Germans launched a massive surprise attack on the Soviet Union. Three Army Groups took part in Operation Barbarossa: a total of 136 divisions, spearheaded by fast-moving armour, on a front that extended from the Baltic to the Black Sea. Initially all went well and by the autumn the Germans had advanced more than 900 kilometres (550 miles), occupied a huge area of land and inflicted 2.5 million casualties on the Red Army. However, like Napoleon before him, Hitler had underrated both the resources of the vast country he was seeking to conquer and the fighting qualities and determination of its soldiers. But, most importantly, the bitter winter weather worked against him, and its effects were made even worse by the scorched-earth policy adopted by the Russians.

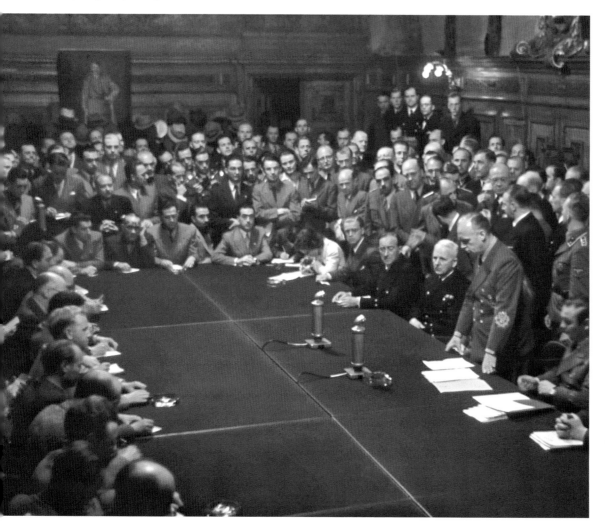

German infantrymen march into Russia, while supplies go forward in horse-drawn carts. As in the attacks on Poland, France and the Low Countries, most German troops marched into battle and thousands of horses were needed.

A German nurse tends wounded soldiers at an airport near Leningrad. The 900-day siege of the city, which cost the lives of a million soldiers and civilians, began in September 1941 and lasted until January 1944.

On June 22 1941 Joachim von Ribbentrop announces the outbreak of war against the Soviet Union. The Foreign Minister had been closely involved in contriving the Nazi-Soviet non-aggression pact in August 1939, but after this Hitler consistently pushed him into the background.

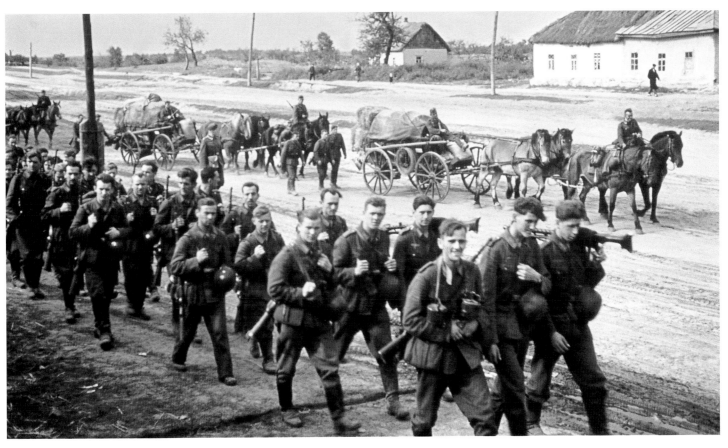

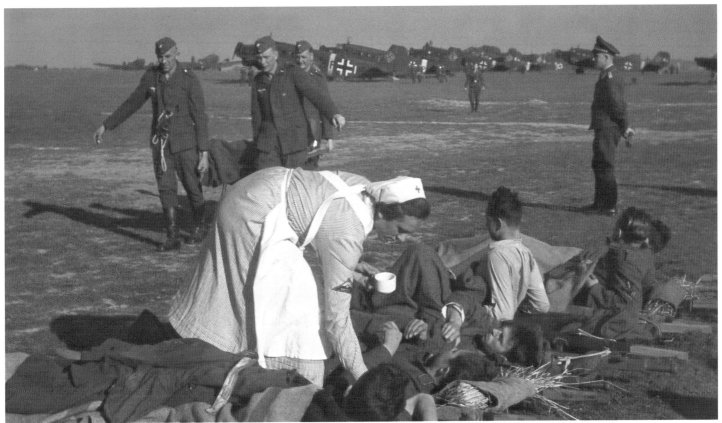

ABOVE

German field artillery guns – 10.5-cm (4-inch) Schwere Kanone 18/40 – in action near a church on the Steppes, the broad band of grassland that stretches across the Ukraine and southern Russia and into central Asia.

RIGHT

Russian prisoners are moved under armed guard. The Germans showed no concern for those races that they regarded as subhuman, with the result that millions of Russians and others died in captivity or while toiling as slave labour.

ABOVE

Heinrich Himmler, the head of the SS, and two members of his terror organization interrogate women near Minsk. This important industrial city in Byelorussia was almost totally destroyed in the war, while the countryside around it was subjected to a ferocious assault.

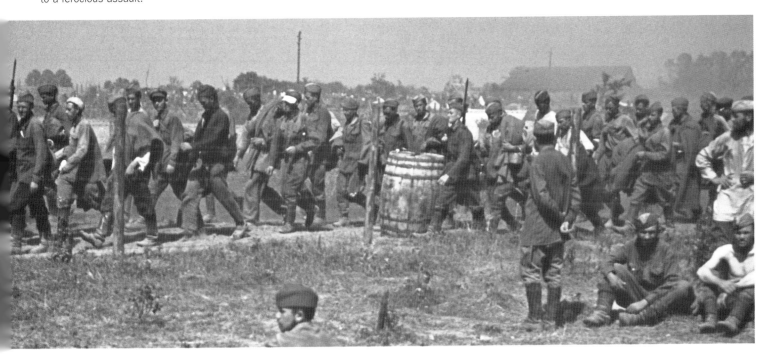

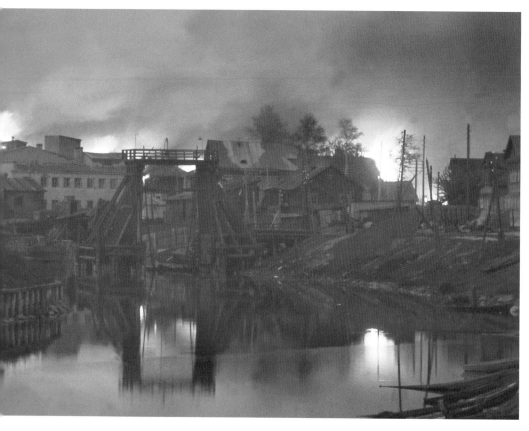

LEFT

A town near Leningrad burns after being bombarded by the Germans.

Two girls give the photographer a frightened glance as they carry their bundles of belongings through the ruins of Minsk.

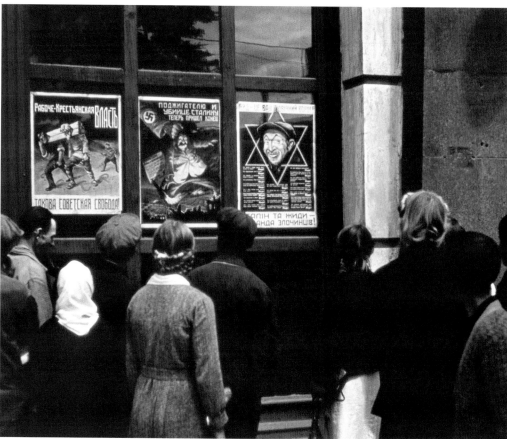

German anti-Jewish propaganda posters in Kharkov. The Ukrainian city was captured by the Germans in October 1941, but not before the Russians had managed to evacuate much of the industry from this major centre.

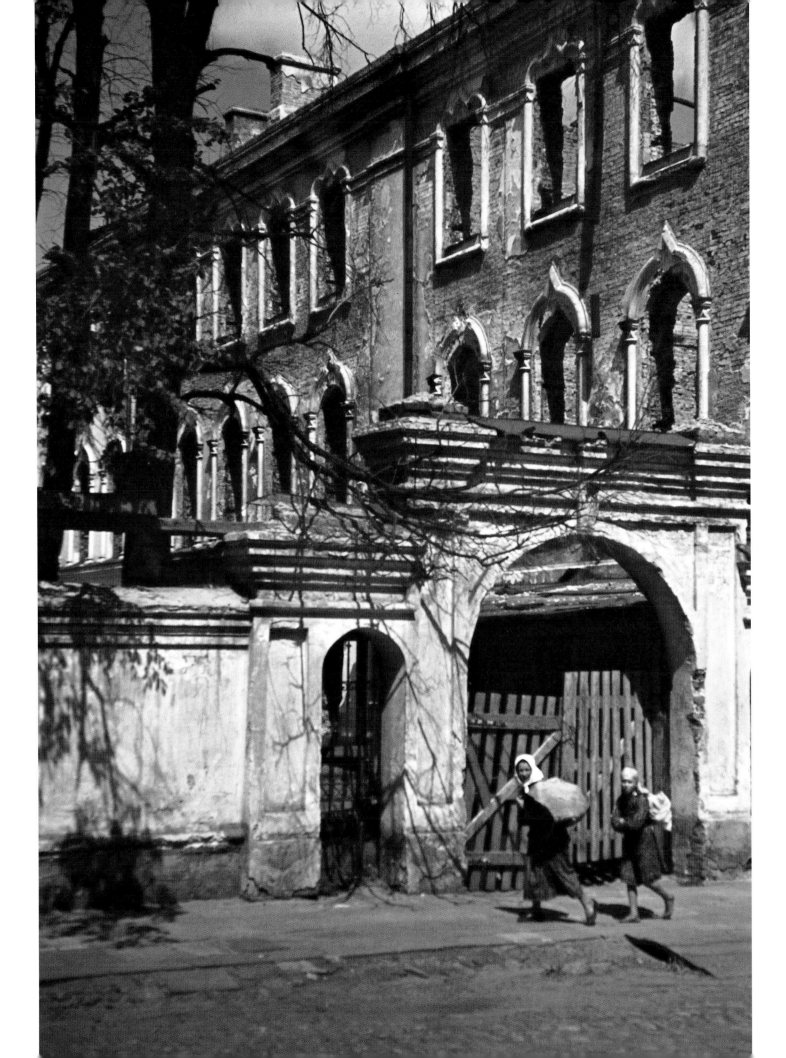

RIGHT

Auxiliary tanks gave the Ju 52 a very
useful range of 1,300 kilometres (800
miles), but refuelling in the middle of
winter was always a cold job.

BELOW

This German PzKpfw III was within 100 kilometres (60 miles) of
Moscow when it became bogged down. Some troops managed
to reach the suburbs but could not break through, and between
the middle of November and early December 1941 tens of
thousands of them died in the attempt.

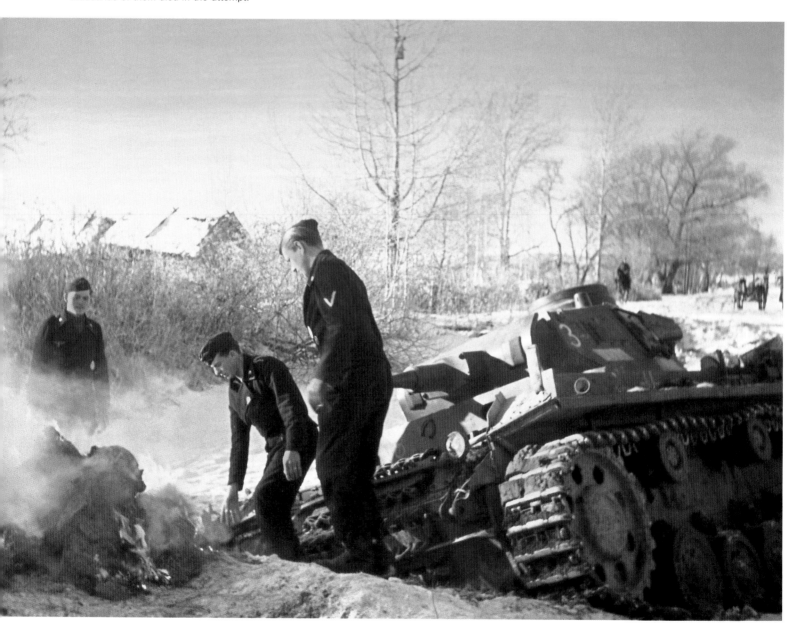

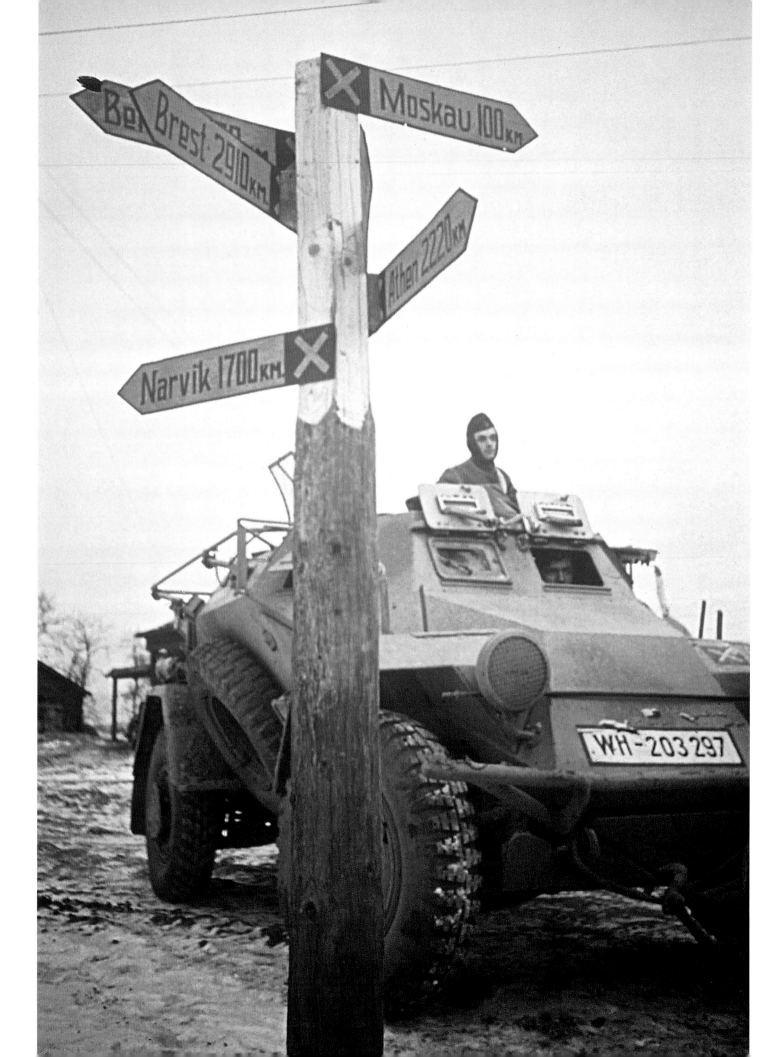

LEFT

The driver of this light armoured
radio car, a Kleiner Panzerfunkwagen
– Sd Kfz 260/261, was perhaps
wishing he was heading for any of
the other locations on the signpost,
rather than joining the fearsome
battle for the Russian capital, but
orders are orders.

BELOW

A column of PzKpfw IIIs, crammed with infantrymen,
move across the desolate and seemingly unending
Steppes during the winter of 1941–42.

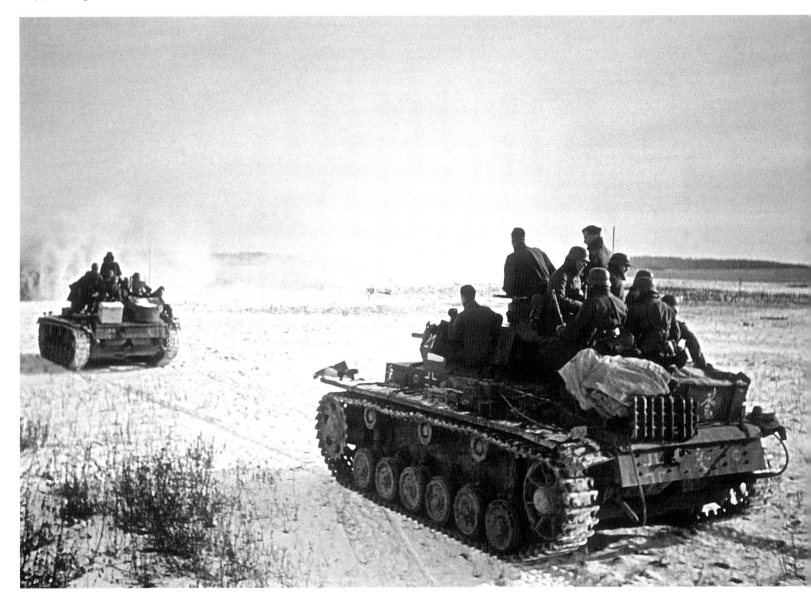

BELOW

The Hitler salute is much in evidence in a photograph taken in Munich in 1939, during a visit by General Hiroshi Oshima, Japan's Military Attaché in Berlin. The following year he signed the Tripartite Pact on behalf of Japan and was Ambassador in Berlin for the rest of the war.

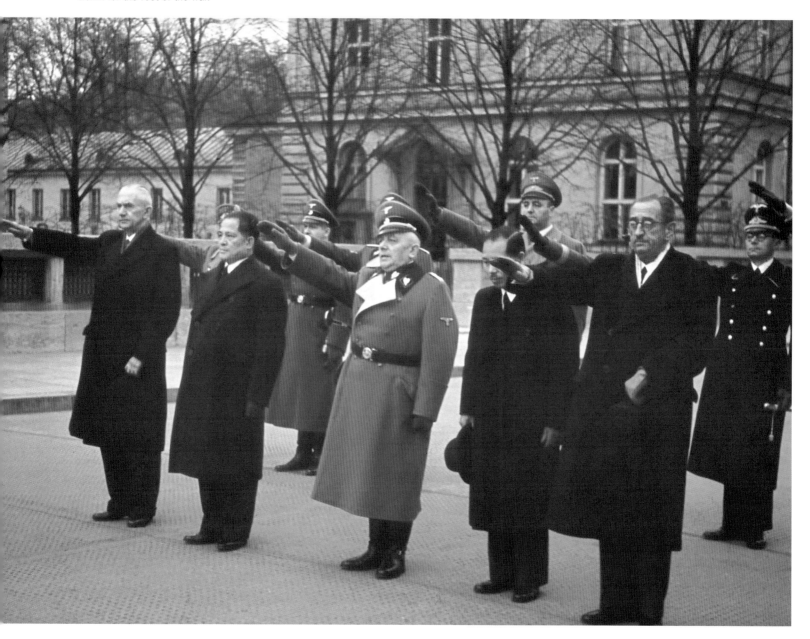

BELOW

The "Rising Sun" in Berlin. On September 27 1940 Germany, Italy and Japan signed the Tripartite Pact to promote mutual military and economic assistance, the three nations becoming known as "The Axis". Four days after Japan's unprovoked attack on the USA's Pearl Harbor naval base on December 7 1941, Germany and Italy also declared war on America.

ATLANTIC WAR

When it became clear to Hitler that Germany could not dominate Britain's skies in preparation for a seaborne invasion, Operation Seelöwe, or Sealion, was shelved. After losing the Battle of Britain in the summer of 1940, he decided instead to starve the enemy into submission. The German Navy, in particular the U-boat fleet then under the command of Grand Admiral Karl Dönitz, endeavoured, with the support of the Luftwaffe, to cut the vital maritime supply lines from the USA which were sustaining Britain. The "Atlantic War" reached a climax in 1943, but, as a result of the development of the escort carrier and growing Allied air strength, as well as invaluable intelligence gained through decrypting the Germans' Enigma messages, losses to vital Atlantic shipping were sharply reduced.

RIGHT

View from the foredeck of the *Bismarck*. Built in 1939, she displaced 42,400 tonnes (41,700 tons) and was armed with eight 38-cm (15-inch) guns. This Atlantic raider was sunk on May 27 1941 by torpedoes from British destroyers and then from the cruiser HMS *Dorsetshire*.

BELOW

A cheerful German worker at the Blohm und Voss Works in Hamburg. This shipyard began construction of U-boats relatively late in the war, but soon was the most efficient in Germany.

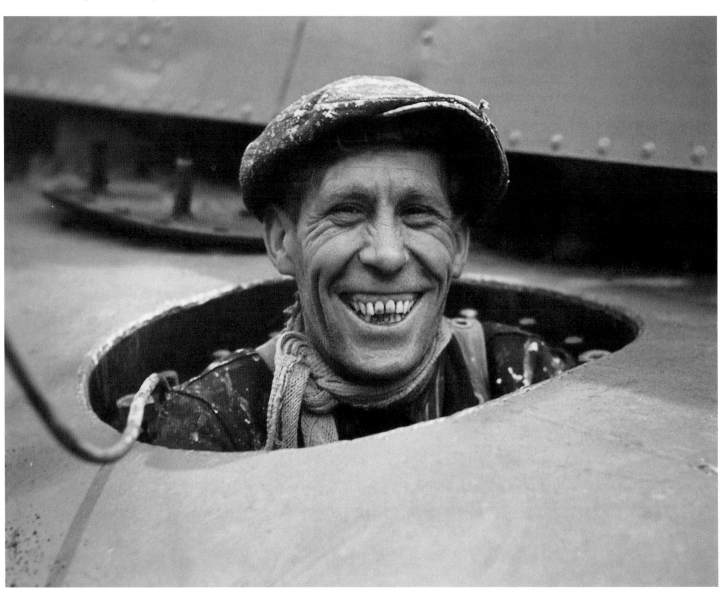

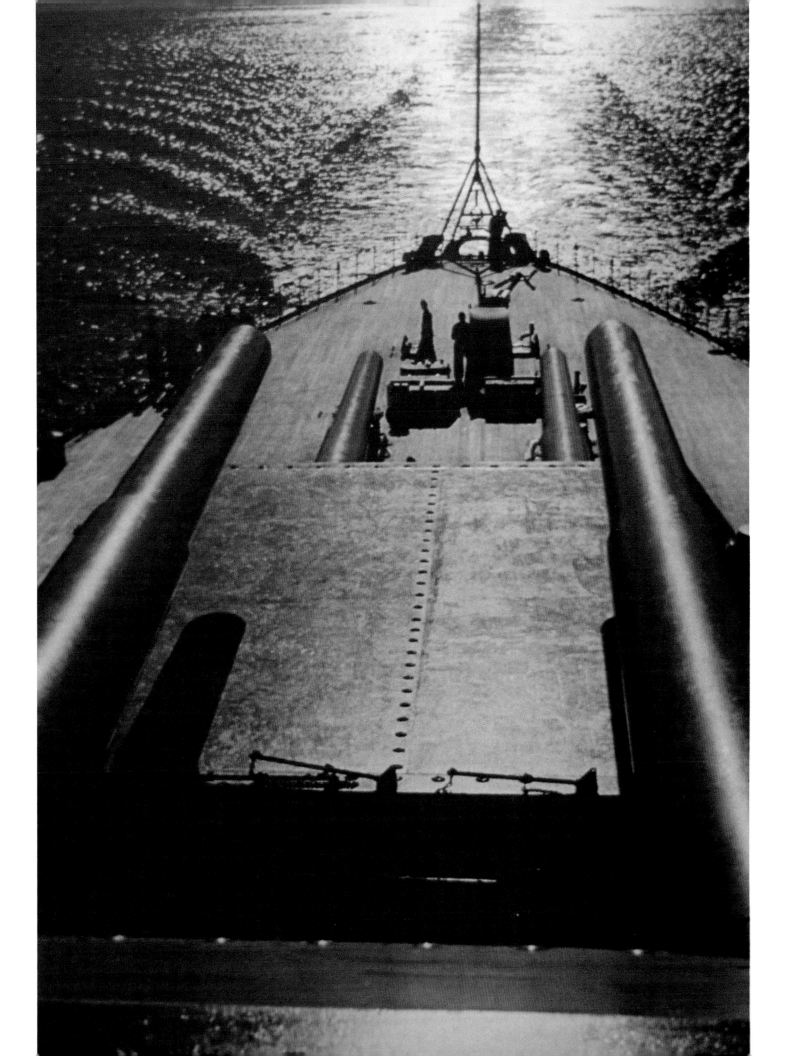

BELOW

The reason for Blohm und Voss's success in manufacturing
U-boats was the introduction of a production line for building the
revolutionary all-electric Type XXI submarine. One hundred and
nineteen of these were made, although few saw much action.

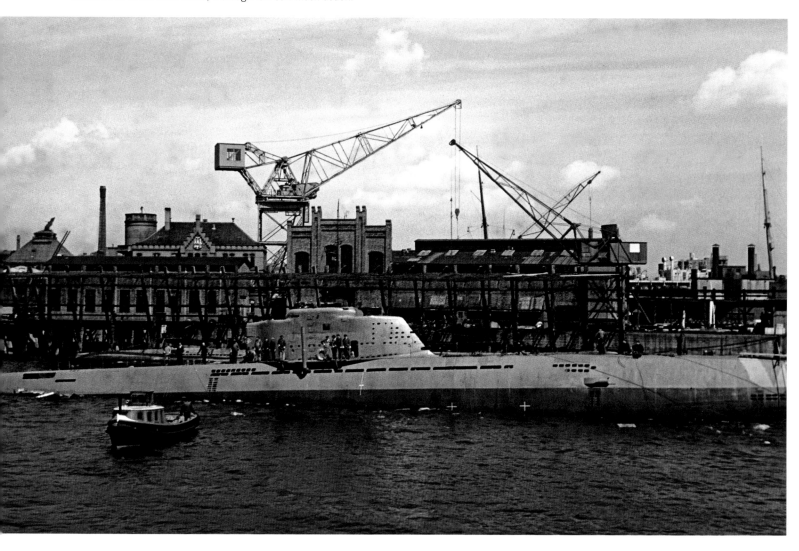

BELOW

The scourge of the Atlantic convoys. A U-boat on its way out of
its base on the west coast of France – possibly St Nazaire, La
Pallice or Bordeaux – to join a "wolf pack" in the North Atlantic.

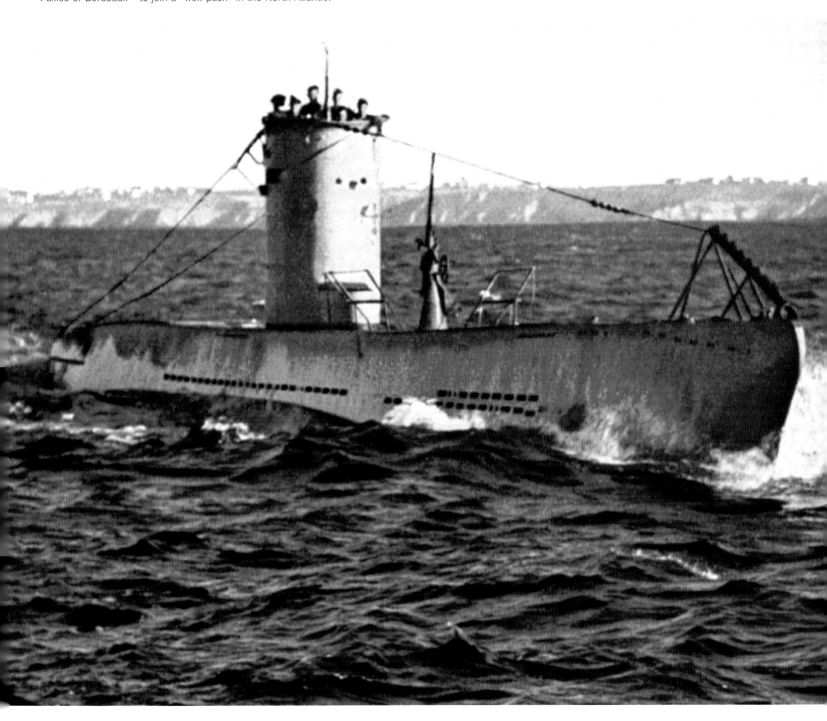

LEFT

In rough weather in mid-Atlantic, oilskins and strong nerves were both essential when in the conning tower on the surface. This photograph was probably taken in 1941–42, as by 1943 the Allied air threat had made surface patrolling too hazardous.

BELOW

Inside a U-boat, there was very little room and conditions were barely tolerable, especially as the crew had to be at immediate readiness to attack or be attacked.

BLITZKREIG

General Heinz Guderian, appointed head of the Panzerwaffe (tank army) in 1938, was the chief proponent of the new tactical system of blitzkrieg, or lightning war, which would prove so successful in piercing the enemy's front, then encircling and destroying him. It required the fullest co-operation of all arms, particularly armour, and the constant assistance of Stuka dive bombers. Teamwork, good command and control, rapid low-level decision making, careful timing, continuous radio communications, speed and, where possible, surprise, were the essentials of blitzkrieg. Guderian added his own philosophy: always reinforce success and abandon failure. By contrast with the centralized command and control of the Great War, low-level commanders were able to think and act for themselves within the framework of a master plan.

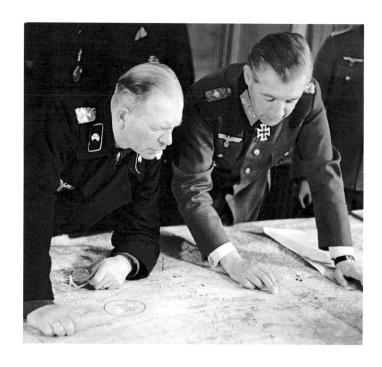

General Guderian lived up to his nickname "Schnelle Heinz" (Hurrying Heinz) as a tough, demanding commander. Here Guderian (on left) studies a map with fellow tank general Walther Wenck.

A vital component of blitzkrieg was a "cab rank" of dive bombers. To support a major attack an entire Gruppe of 30 aircraft would be used to maintain constant pressure. This system was guaranteed to strike terror into those who encountered it, and was particularly successful in the early stages of the war.

Mechanized infantry, who would have to leave their half-tracks and fight on foot, played an important role in "mopping up" opposition and ensuring that the gap made by the armour remained open. This task was known as Aufrollen, or "rolling up".

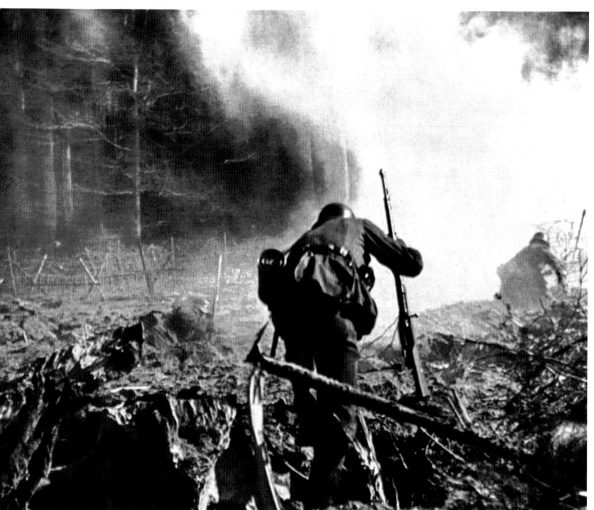

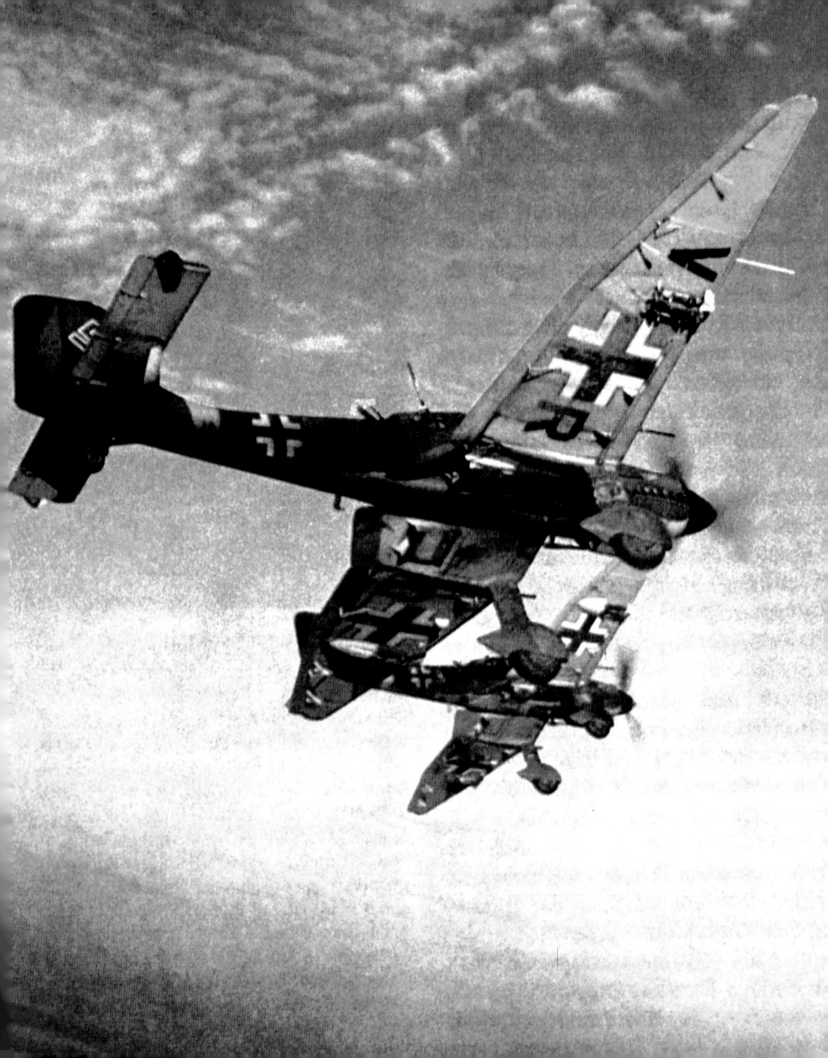

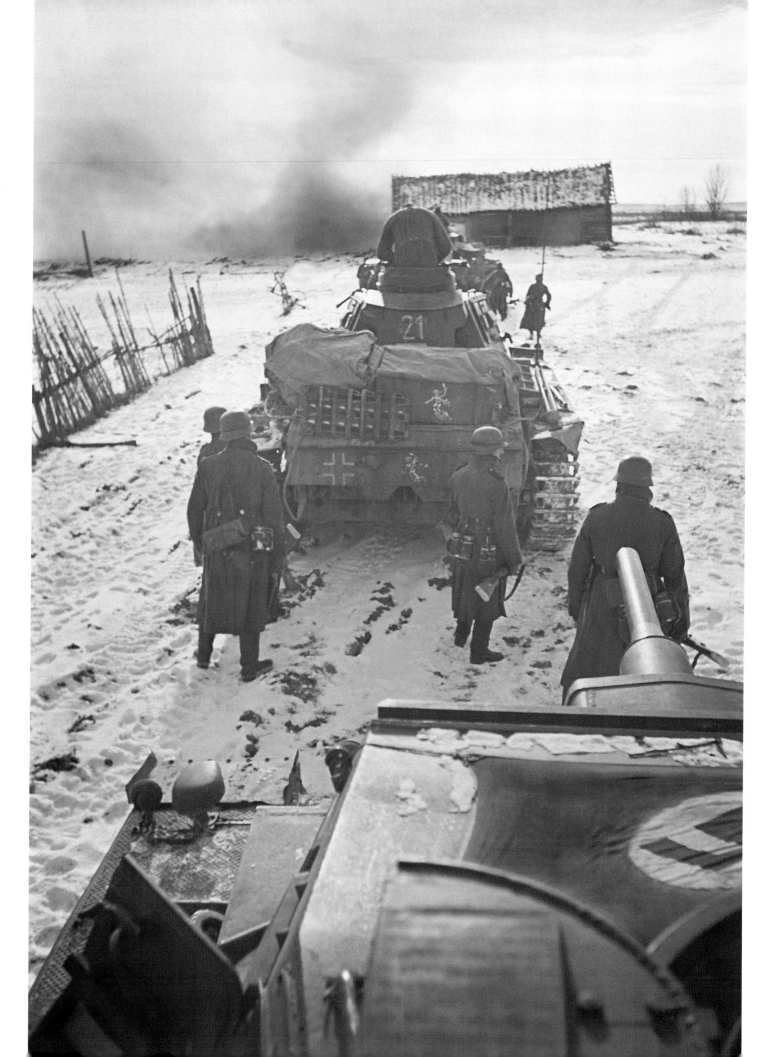

Anything that would give the German attack an edge was used, including this flame-throwing tank, the PzKpfw III (Fl). The 14-mm (0.5-inch) flame projector, fitted in the turret in place of the main gun, had a range of 55–60 metres (180–200 feet).

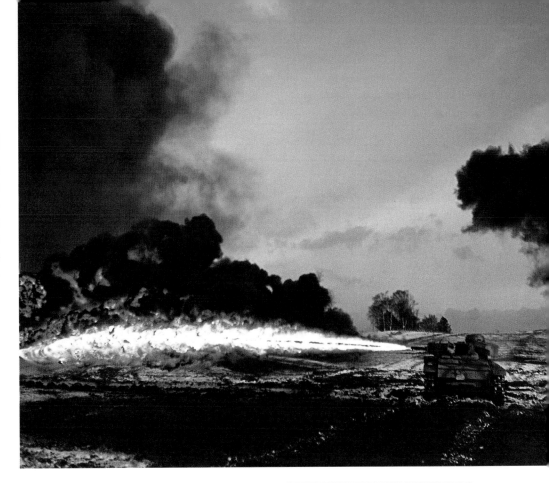

LEFT

Tanks were the most important element of blitzkrieg, forming the Schwerpunkt, or centre of gravity, of an assault. The aim was to achieve a concentration of overwhelming forces so as to, as Guderian put it, "Klotzen nicht Kleckern!" ("Thump them hard, don't pat them!")

ABOVE

To the tanks used in blitzkrieg, the mobile artillery coming up behind them was just as important as having dive bombers overhead. However, the artillery's role was to provide fire on call during an attack, not a prolonged opening barrage.

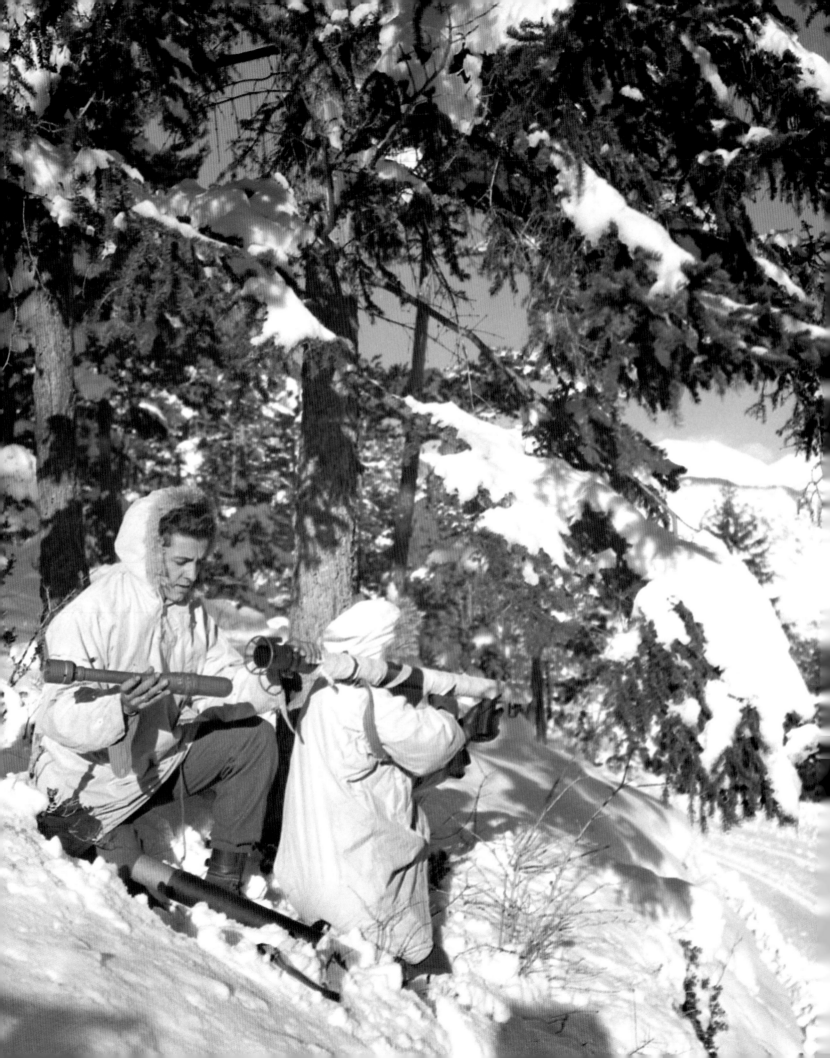

The Tide Starts to Turn

The summer and early autumn of 1942 saw the high-water mark of German military achievement. At sea, the U-boats were at the peak of their effectiveness between January 1942 and March 1943 and Allied losses were reaching a critical point. In 1942 the Allies lost 1,664 ships – 7.9 million tonnes (7.75 million tons) – and 1,160 of those ships were lost to U-boats. Almost the entire subcontinent of Europe was now under their control, as were vast areas of the Soviet Union. In the west, the Germans' coastal defences had been tested by an Allied raid on Dieppe and the Atlantic Wall had been found secure. Hitler had great personal faith in these defences, recounting how during one of his visits, an Organisation Todt worker had told him, "Mein Führer, I hope we're never going away from here. After all this tremendous work that would be a pity." Hitler commented that there was a "wealth of wisdom in the remarks", adding that "nothing on earth would persuade us to abandon such safe positions".

In North Africa, Rommel and his Panzerarmee Afrika were now at the very gates of Cairo, while close by in the middle of the Mediterranean the vital island stronghold of Malta was under heavy attack and would soon, it was confidently assumed, be starved and bombed into submission. The campaign in the Soviet Union was going well, with Leningrad and now Stalingrad under continuous assault. Sevastopol, which had withstood a 247-day siege, had fallen in early July and Fall Blau had thrust deep into the Caucasus, with its rich prizes of oil and wheat. Hitler's armies seemed all-conquering.

To crown it all, the Einsatzgruppen – the special task forces of the Schutzstaffel (SS), the Third Reich's political police – had begun to clear the Lebensraum that Germany needed in Poland and the Soviet Union, sending thousands to the extermination centres. At its height a camp such as Auschwitz could house over 100,000 people and gas more than 12,000 a day: Hitler's genocide of the Jews and other Untermenschen (subhumans) was proceeding apace.

THE TIDE TURNS

This rosy Nazi situation report hides numerous problems. First, and most obvious, was that Hitler had declared war on the United States four days after the Americans declared war against the Japanese on December 7, 1941 in response to the Japanese attack on Pearl Harbor. While US forces were some way off being able to assist the British, they would do so by the end of 1942 in such numbers and with so much modern equipment that the balance of power would change completely. Three years of aggression had taken its toll on the German forces. In the Soviet Union the German army had lost half a million of its best men by September 1941, one-third of these losses being leaders – NCOs or junior officers. By the end of 1942 such losses could not be sustained and training periods for replacements were eroded simply to fill dead men's shoes. With millions of fresh US troops entering the war, the writing was on the wall.

LEFT

US mountain troops load a hollow-charge anti-tank rocket into their 6-cm (2.36 inches) M1 Bazooka. With millions of fresh American soldiers now entering the war, the Axis was under ever greater pressure as its losses could not easily be made up.

Another problem was that Hitler was now playing a personal role in the German offensive in the East, having moved to his "Werewolf" headquarters at Vinnitsa in the Ukraine to supervise the German advance over the River Volga. Army Group B reached the Volga by the end of August, and the Sixth German Army under von Paulus made a major assault on Stalingrad, capturing much of the city and reducing the Red Army perimeter to some 48 kilometres (30 miles) in length. Hand-to-hand street fighting took place, while the winter months brought bitter weather, making living conditions terrible for both sides. The Russians just managed to hold on to the remaining riverside areas of the city, then launched counter-attacks from both flanks in November, surrounding their attackers. Now the boot was on the other foot and despite reinforcements, the situation deteriorated and von Paulus was soon in desperate straits.

The Luftwaffe tried to supply the Sixth Army by air, but failed; nor could von Manstein's relief column break through. The Soviets offered surrender terms, which Hitler dismissed, ordering von Paulus to fight on and promoting him to field marshal to stiffen his resolve. By February 1943, however, German casualties had risen to some 120,000 and von Paulus was forced to surrender his remaining troops, including 24 generals. "That's the last field marshal I shall appoint in this war," stormed the Führer. "He could have got out of his vale of tears and into eternity [by suicide], and been immortalized by the nation, but he'd rather go to Moscow. What kind of a choice is that?"

Undoubtedly this surrender was a major defeat for the Third Reich and one that was soon followed up by further Red Army attacks. Von Manstein managed to halt the Soviets and subsequent successful counter-attacks left a large enemy salient protruding into the middle of Army Group Centre's front, around Kursk, which he was determined to destroy. Operation Citadel called for Model's Ninth Army to attack from the north and Hoth's Fourth Panzer Army from the south – in all this represented some 3,500 tanks and self-propelled guns, including many of the already proven heavy Tiger tanks and the as yet untested Panther. In the "bulge" were eight concentric defensive zones, crammed with anti-tank, anti-aircraft and anti-infantry weapons, plus mobile reserves. The Russians had just as many tanks as the Germans and were helped by an excellent spy network and good intelligence.

Initially the German attack went well, but then the Russians dug in their tanks and fought from hull-down positions, taking on the Panzers as they continued to advance. The greatest tank battle of the war ensued, with the Germans being decisively beaten and losing over 300 tanks, including 70 Tigers. Kursk marked the beginning of the end for the German army in the East and heralded the start of a Soviet counter-offensive that would eventually take them all the way to Berlin. The siege of Leningrad would also be lifted in January 1944 and Sevastopol recaptured that May.

In North Africa the British Eighth Army, under its new charismatic commander Montgomery, won the battle of Alam Halfa in July 1942, stopping the Axis forces in their tracks. Rommel, his supply lines overstretched and much of his reinforcements hampered by British forces in the Mediterranean, was forced back on to the defensive. Both sides now prepared for what would be the most crucial battle of the desert campaign, El Alamein. Rommel, with fewer than 600 Panzers, many of those being obsolete Italian vehicles, was facing a British force with double that number, many of them straight off the ship from the United States.

Showing far more strength of will than his predecessors, "Monty" refused to be rushed into battle by Churchill, instead taking the time carefully and methodically to prepare his troops. On October 23 he launched a massive attack on the German-Italian positions. Rommel had established strong defences based on extensive minefields – known as his "Devil's Gardens" – but he was no longer fighting blitzkrieg but a static defensive battle, which did not allow him to make best use of the skill and tactical flair of his armoured forces. Instead the battle turned into what Monty called a "slogging match". In addition, when the British assault came, Rommel was in Germany on sick leave. He hurried back, took over his army once more and fought a dogged positional defence. But the defensive lines were eventually breached and, as Churchill put it in his famous "End of the Beginning" speech in November, "The bright gleam has caught the helmets of our soldiers and warmed and cheered all our hearts."

For Rommel there was nothing left but to begin a long, difficult and stubborn fighting withdrawal back across North Africa, his plight soon made even worse by the news of Allied landings in French North Africa (by Operation Torch on November 8, 1942). Kesselring quickly flew extra troops into Tunisia, but from then on the Axis forces had to fight on two fronts. In the east, Derna, Benghazi, then Tripoli, were all taken as Monty pushed the "Desert Fox" almost out of Libya, and into the last defensive positions on the Mareth Line. At the same time fresh American and British troops were clearing French Morocco and Algeria of scattered Vichy opposition and driving the Germans and Italians back into Tunisia. At this time still "green", the Americans were blooded in difficult battles such as Kasserine Pass, but the inevitable outcome was never in doubt, and on May 12–13, 1943 the once-proud Afrika Korps

surrendered, with the total Axis losses during their African adventure being some six hundred and twenty thousand killed, wounded or taken prisoner. Rommel, having flown to Hitler to beg for the rescue of his beloved Afrikaners, was not allowed to return and was thus not among the captured. To quote Churchill again, "The Germans have received back again that measure of fire and steel which they have so often meted out to others."

THE END OF THE BEGINNING

Churchill called the victory at El Alamein "the End of the Beginning" and during the following months Britain and the United States worked toward fulfilling their promise to the Soviet Union to open a second front in the West. The detail of their preparations for D-Day remained shrouded in mystery, thanks mainly to Allied air superiority, which prevented detailed German reconnaissance of Britain, then fast becoming more and more crowded by the build-up of troops and weaponry. It was clearly obvious to the Germans that a major amphibious landing would take place soon, but exactly where and when? They could only strengthen their defences along the entire Atlantic Wall, a complex network of fortifications stretching along the Atlantic and Channel coasts of occupied Europe from Norway to the border between France and Spain. The energetic (and currently unemployed) Rommel was appointed "inspector of western defences" and charged with familiarizing himself with every aspect of the Atlantic Wall and then rectifying any shortcomings by making full use of the Organisation Todt. However, despite his charisma and devotion to duty, he would fail to sort out the muddled chain of command, or end the rivalry that existed between the three armed services. Also, in his opinion, the main battle should be fought on the beaches, which meant armoured counter-attack forces had to be close at hand so that they did not have to move under continual Allied air superiority. However, this was never achieved and would prove to be the Germans' Achilles heel when the invasion finally came.

The Axis forces were soon to get a taste of what an invasion of France would be like, as, having cleared the Axis forces from North Africa, the Allies next began to prepare to assault Italy, choosing to invade Sicily first on July 10, 1943. Success in Sicily in the largest amphibious operation of the war so far was followed by landings in mainland Italy. Luftwaffe Field Marshal Albert Kesselring, Supreme Commander Mediterranean, would soon show himself to be one of the greatest German commanders, conducting a brilliant retreat up Italy. Throughout this campaign and those elsewhere the Allies, having broken the Germans' Enigma code system earlier in the war, were able to read all Hitler's personal orders and other top secret messages almost as soon as they were issued.

The Allied invasion of Italy was swiftly followed on September 8 by an Italian armistice, Mussolini having already been arrested almost two weeks after the invasion of Sicily and taken under heavy guard to a succession of hiding places. (Il Duce would later be dramatically rescued by Otto Skorzeny and Waffen-SS commandos on September 12, 1944.) Italy declared war against Germany on October 13, 1943, and from then on its partisans caused even more difficulties for the hard-pressed German forces, who defended stoutly in such memorable actions as the Cassino monastery, Anzio and the Gustav line, although they could not prevent the Allies reaching Rome on June 4 the following year.

THE WAR AT SEA

Despite its successes against Allied shipping, the Kriegsmarine, both in the Atlantic and Arctic Oceans, was slowly being worn down by the Royal Navy and the US Navy. New technology, decrypting of Enigma messages and countermeasures took their toll of the U-boats, while several large surface ships were sunk in Arctic waters. The latter toll included the Tirpitz, sunk by the RAF with "Tallboy" bombs on November 12, 1943 while she was sheltering in a fjord, and the Scharnhorst, sunk by HMS Duke of York on December 26, 1943. In August of that year the entire Danish minesweeping force had either been scuttled or sought internment in Sweden – a considerable loss to the Kriegsmarine that it was hard pressed to fill. The loss of the Italian fleet when Italy surrendered was an even larger blow, while also in the Mediterranean, thanks to the Royal Navy and Royal Air Force, Malta survived and continued to be a thorn in the Axis side, finally turning the tables on them by hosting many of the preparations for the invasion of Sicily.

The crunch in the Atlantic came between the end of March and May 1943, when at last the Allies were able to field five full escort support groups and make use of all their technological advances such as centimetric radar, improved depth charges, ahead-throwing mortars, radio direction finders and airborne anti-submarine rockets. In the last two weeks of March only 10 Allied ships were lost; in April losses were halved and 15 U-boats were sunk, followed by 30 more in May. Losses were so severe that Dönitz withdrew his U-boat fleet from the Atlantic to rethink their tactics. It didn't work: between June and August, 74 more U-boats were sunk, 24 by RAF Coastal Command aircraft. Only 58 Allied vessels were lost in this period. The U-boats had lost the battle of the Atlantic.

WONDER WEAPONS

Third Reich technologists developed a wide range of secret weapons. Among these "Wunderwaffen", or "wonder weapons", were many innovative and bizarre aircraft, including rocket-powered fighters (such as the Messerschmitt Me 262 and Heinkel He 280), huge gliders (Messerschmitt Me 321 "Gigant") fighter-bombers combinations (Mistel) and a rotary-wing aircraft that was towed by a submarine to get it airborne (Focke Achgelis Fa 330); cruise and ballistic missiles (V1 and V2); huge railway guns ("Schwere Gustav"); enormous tanks ("Maus"); and nuclear, biological and chemical weapons. Some truly were "wonder weapons", while others were just so big they were unworkable. However, Hitler was obsessed with them all, and therefore many German scientists were fully engaged in their development.

RIGHT

Hitler took great interest in German tank production. While this is a relatively small tank destroyer – a "Hetzer", based on the Czech PzKpfw 38(t), it weighed under 18.3 tonnes (18 tons) – the Porsche 205 "Maus" was over ten times as heavy.

BELOW

The Mistel (Mistletoe) combined a fighter (Me 109) and a bomber (Ju 88), the latter with its nose replaced by a warhead packed with 3,500 kg (7,700 lb) of hollow-charge explosive. It was guided to its target by the fighter, which then separated.

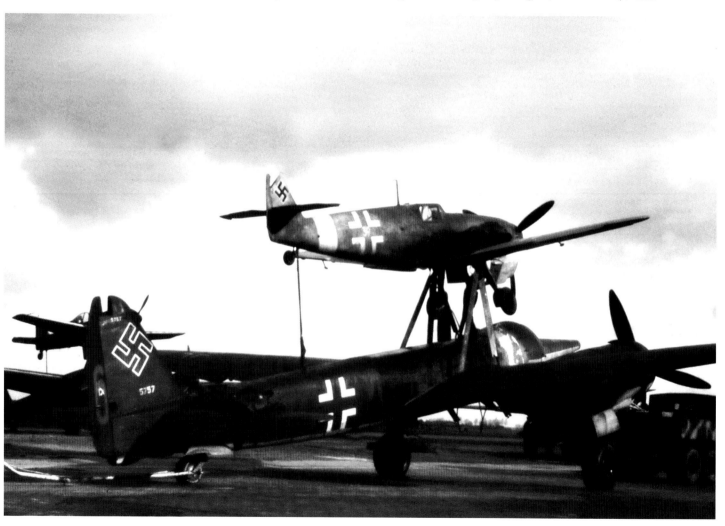

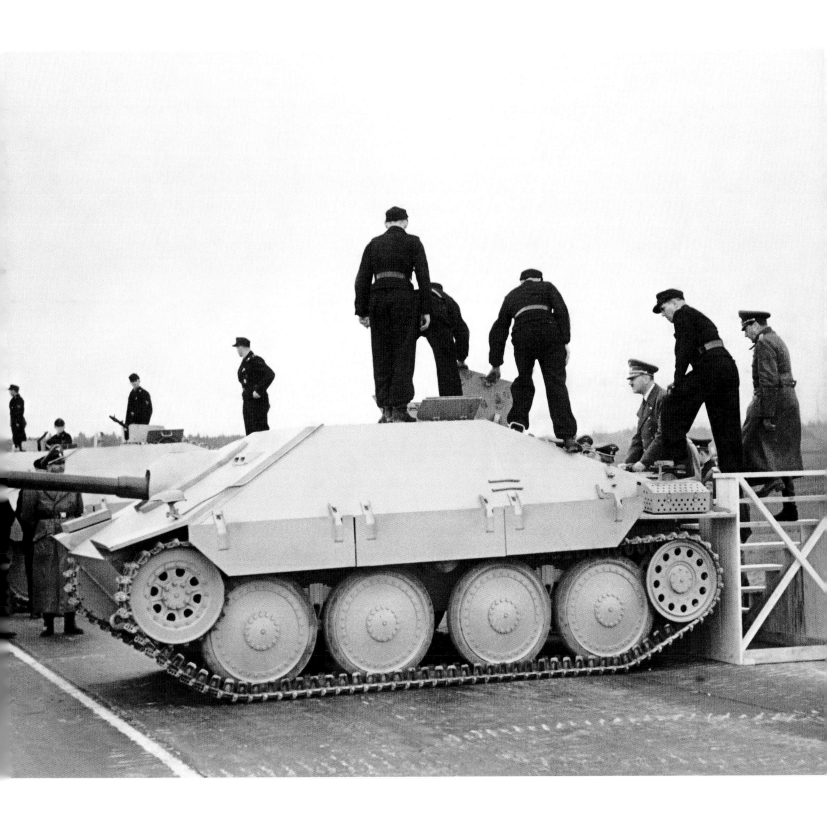

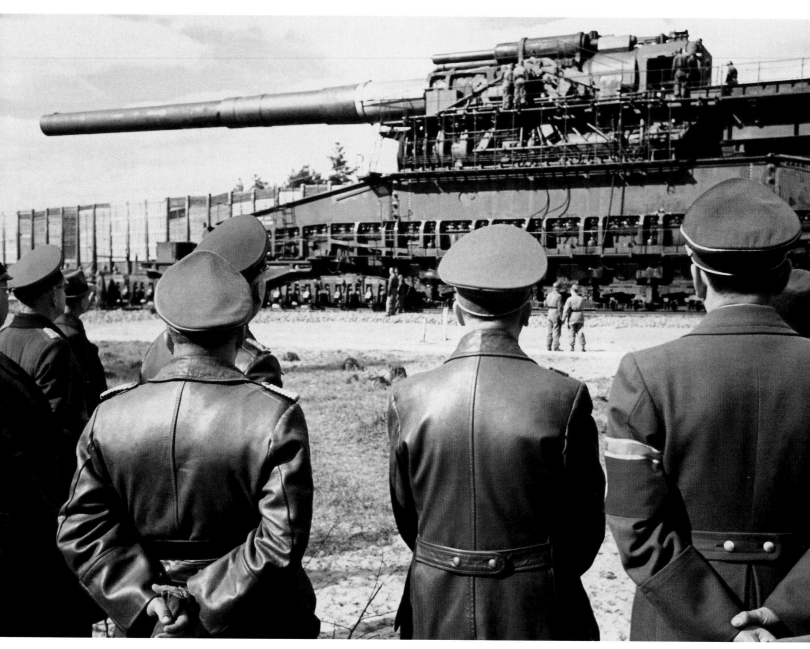

Accompanied by his minister of armaments, Albert Speer,
Hitler looks at the gigantic 1,350-tonne (1330-ton) railway gun
"Schwere Gustav", used to bombard Sevastopol in 1942.
There it fired just 48 of its 80-cm (31.5-inch) rounds – but each
weighed 7 tonnes (6.9 tons). It had a crew of 2,000 men.

Hitler with some of his skilled workers,
including, on his left in a suit, Austrian
motor engineer, tank designer and
personal friend Dr Ferdinand Porsche.

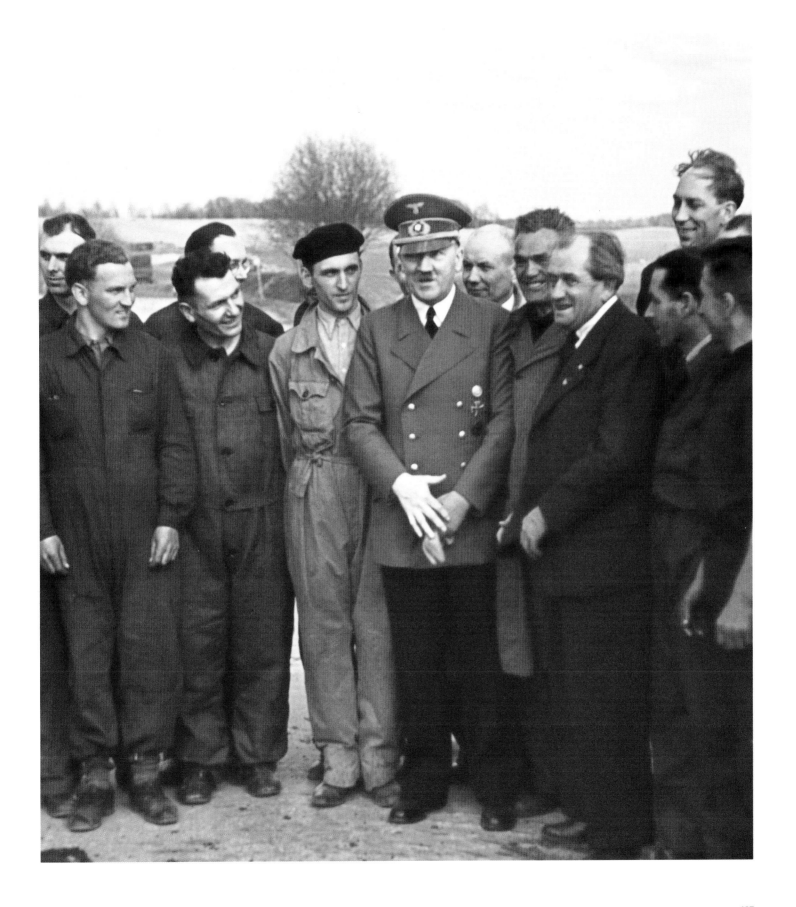

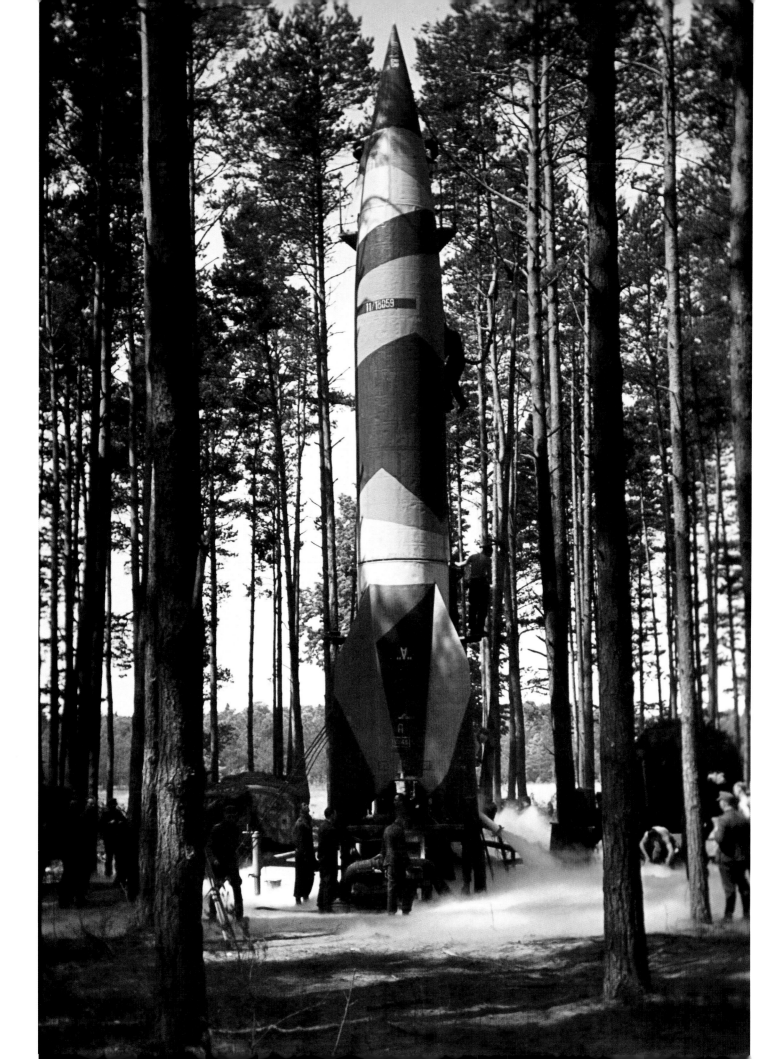

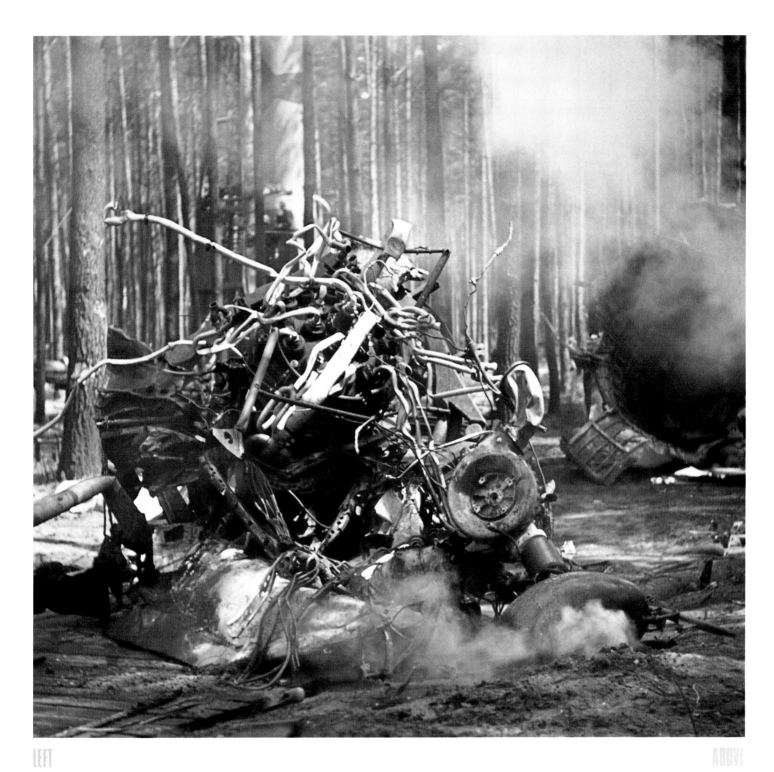

Testing a V2 rocket. The Peenemünde A4 (V2) rocket was a
long-range ballistic missile capable of travelling more than 320
kilometres (200 miles). Like the V1 self-propelled guided bomb,
it was used against Britain.

All that remains of a faulty V2 rocket.
Its power relied upon liquid oxygen
and methanol, while its warhead
consisted of 975 kg (2,150 lb) of
amatol. Of some 3,000 V2s fired,
1,120 were targeted at London
over a period of 200 days.

An alfresco briefing at one of Hitler's headquarters – probably the Felsennest (Rock Eyrie), his western HQ near Bad Münstreifel in the Moselle.

Guarding the Führer. Could this sentry have been on the outskirts of the Führer's Wolfsschanze (Wolf's Lair) HQ, deep in the forest near Rastenburg in East Prussia, or the similarly secluded Wiesental HQ, near Ziegenberg?

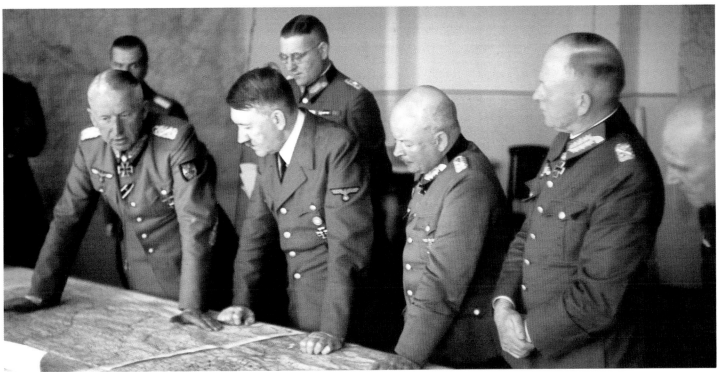

The brilliant Field Marshal Erich von Manstein briefing Hitler on operations in Russia. He was the architect of the daring plan for the invasion of France. One of the few to stand up to Hitler, he was eventually dismissed in March 1944.

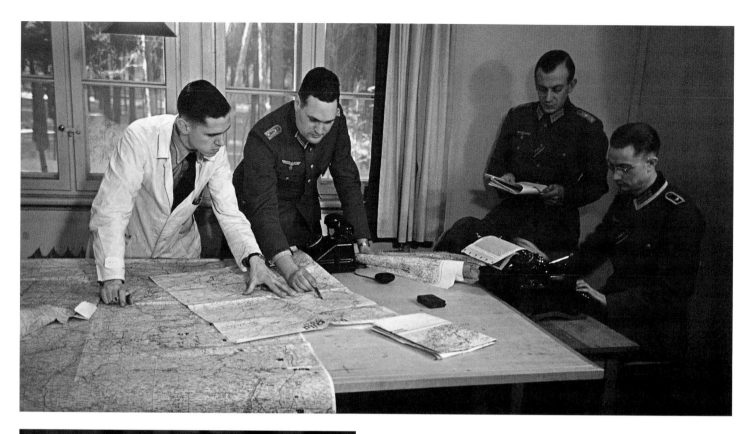

At the Wolfsschanze HQ, Sperrkreis I was reserved for the Führer, Sperrkreis II for his military staff. Above ground there were eight wooden buildings (later enlarged and sheathed in concrete). Here four members of the staff are hard at work.

Swarthy, stocky Martin Bormann was Hitler's secretary. He screened all the papers Hitler signed, and so enjoyed considerable influence. He vanished from the Führerbunker in Berlin on the night of May 1, 1945. His skeleton was found nearby in 1972.

Probably the Third Reich's most colourful figure was Hitler's deputy, Reichsmarschall Hermann Goering, head of the Luftwaffe. A fighter pilot awarded the "Blue Max" in the First World War, he rose with the Nazi Party and pursued an extravagant lifestyle.

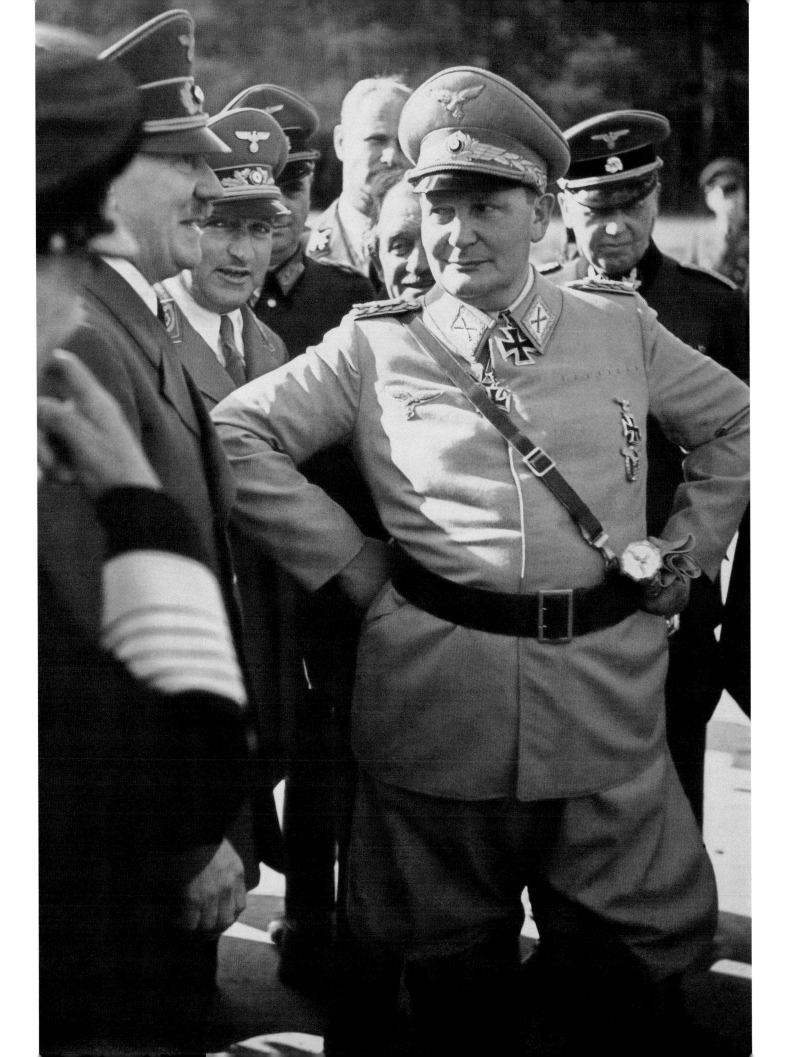

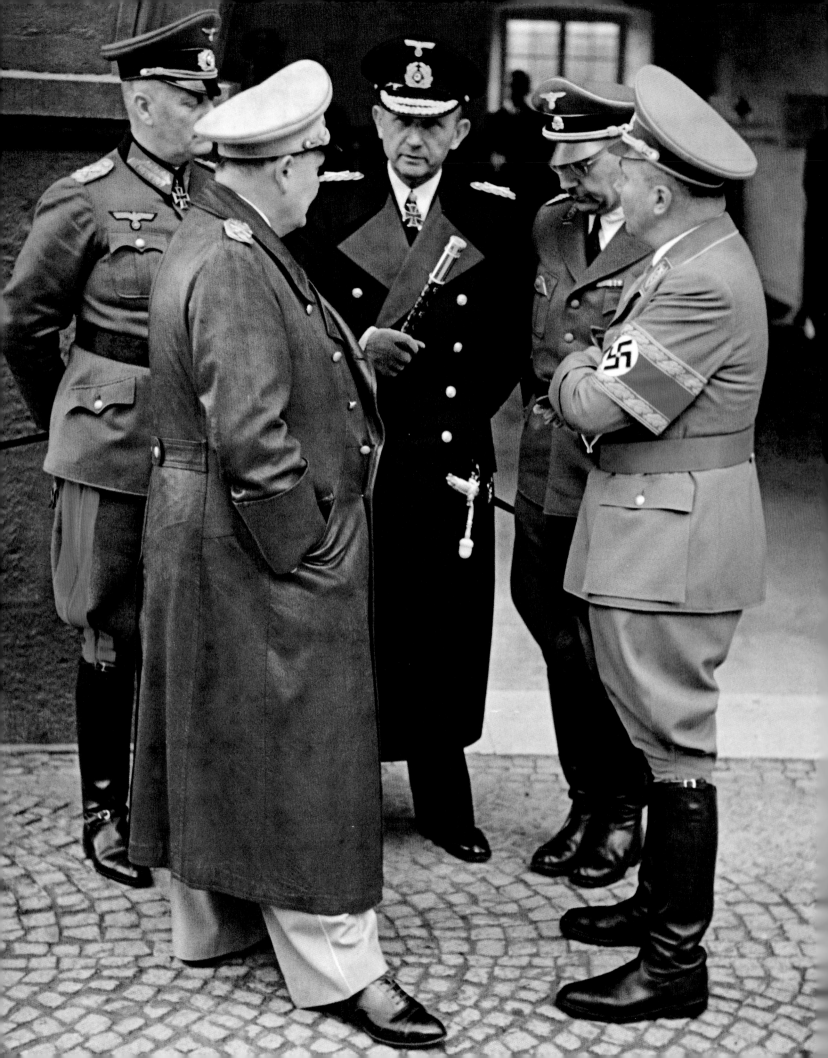

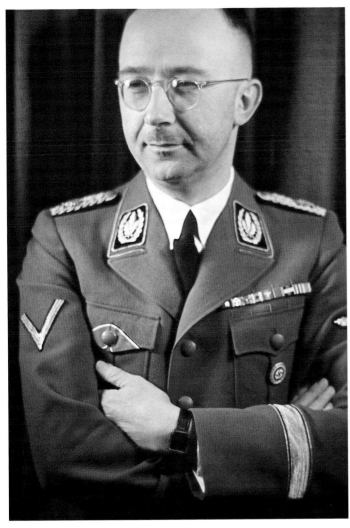

Heinrich Himmler, second only in
power in Germany to Hitler, became
Reichsführer-SS, and, after the bomb
plot of 1944, commander of the
reserve army and, for the Ardennes
offensive, commander of Army Group
Oberrhein – posts for which he was
totally unsuited. He committed suicide
when captured on May 22, 1945.

Admiral Karl Dönitz (centre) with (left
to right) Keitel, Goering, Himmler and
Bormann. He rose from being
Commander-in-Chief of U-boats to
become, in 1943, head of the Navy.

Talking to Hitler is Joachim von
Ribbentrop, the Führer's much-derided
top diplomat. Described by one
biographer as "handsome, arrogant
and empty headed", he joined the
Nazi bandwagon in 1933 and did well,
becoming ambassador to London in
1936 and later Foreign Secretary.

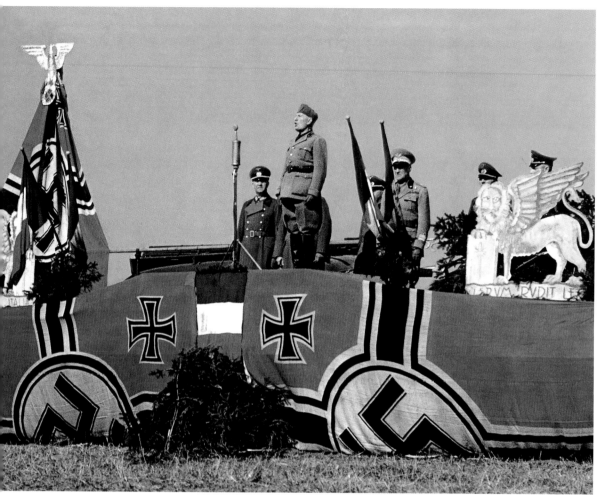

Nazi banners and girls in local costume greet the Nazi leader during a visit to the South Tyrol. This Italian territory had a sizeable German-speaking majority because it had been part of Austria before the First World War.

LEFT

Mussolini speaking during a trip to Bavaria. He and Hitler visited each other's country and in May 1939 cemented the Pact of Steel. However, Italy was always the weaker partner in military terms.

BELOW

These half-naked ground crew sitting on a Junkers Ju 87 dive bomber are probably enjoying the Mediterranean sun. The photograph is dated 1942, so it was probably taken in Italy, where Luftflotte 2 was operating from Italian airfields and had some 250 dive-bombers among their 3,500 aircraft.

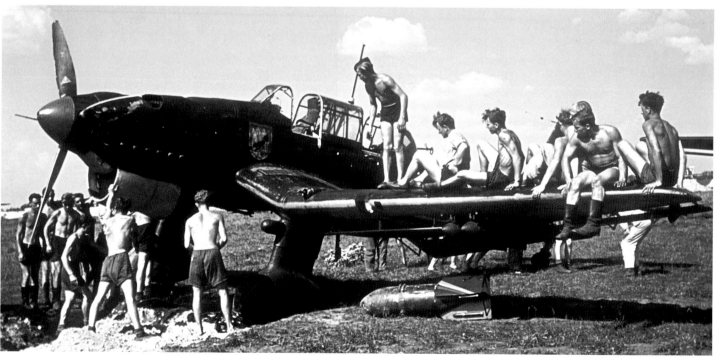

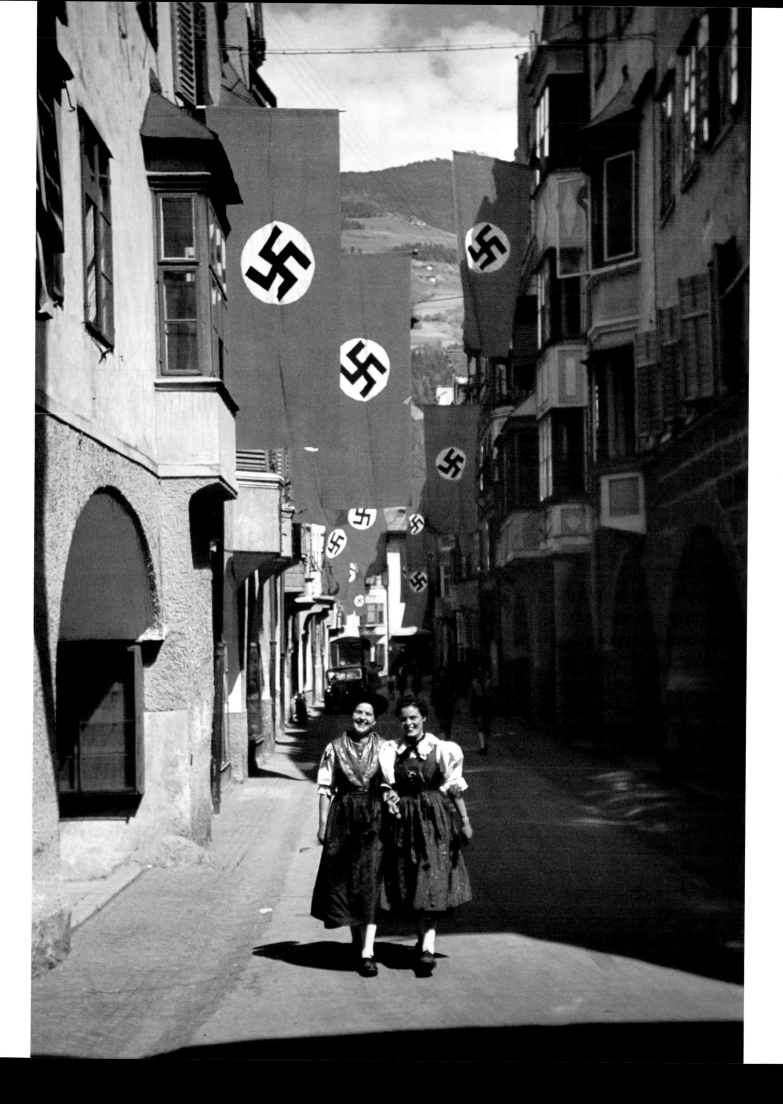

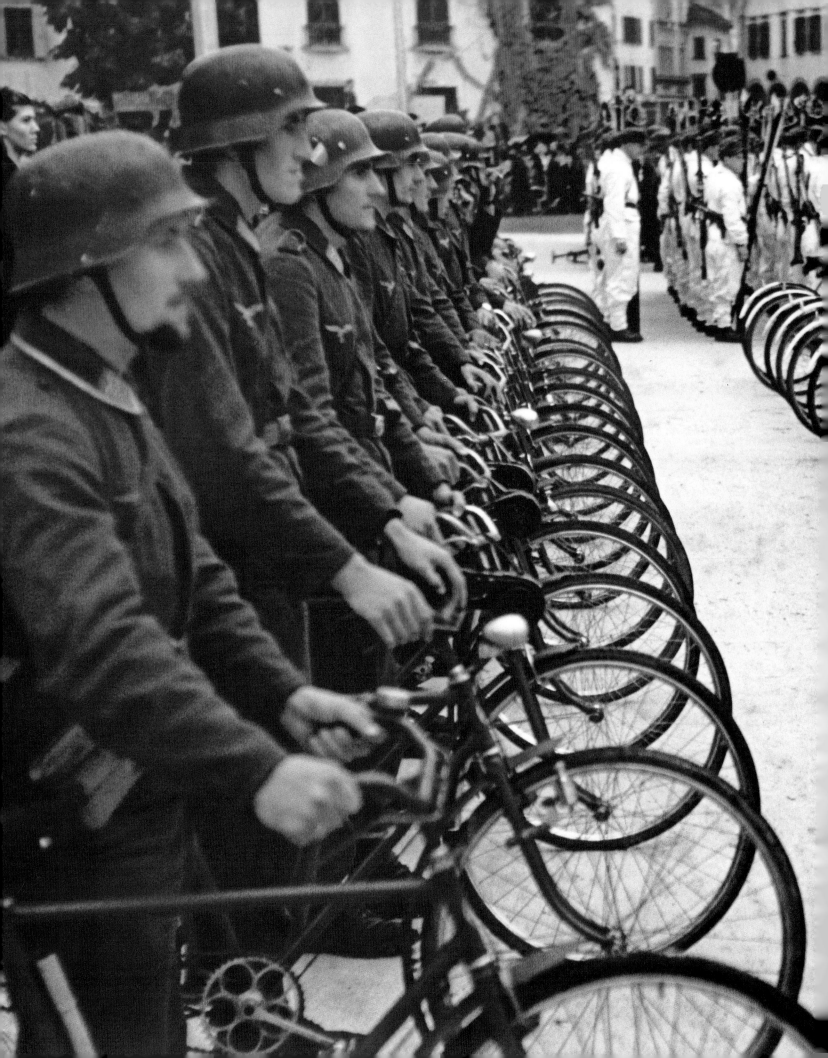

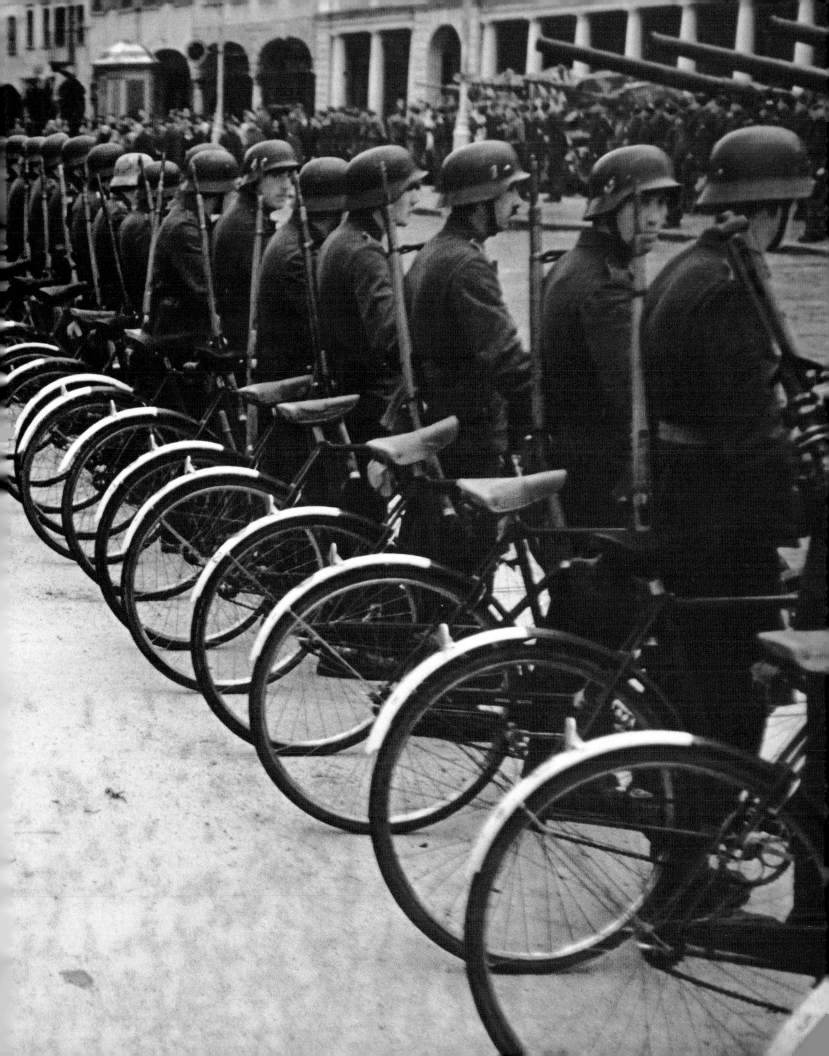

German troops in the South Tyrol. Behind the bicycle troops are white-clad ski troops of a mountain unit, their skis on their backs.

RIGHT

Another ruined village and more helpless refugees. These are in Italy, but the scene was repeated all over Europe as the war continued month after month.

FAR RIGHT

A British Bofors 40 mm AA gun in position well below the ruined monastery at Cassino, which was stubbornly defended by German paratroopers against all comers from January to May 1944.

BELOW

The Santa Trinità bridge over the River Arno in Florence was completely destroyed in August 1944 when US Fifth Army engineers blew up unexploded German mines among the ruins.

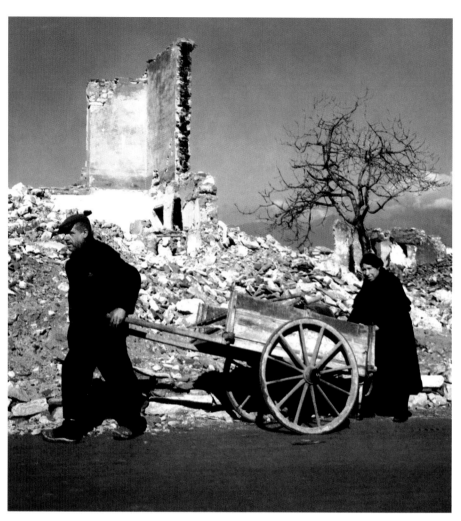

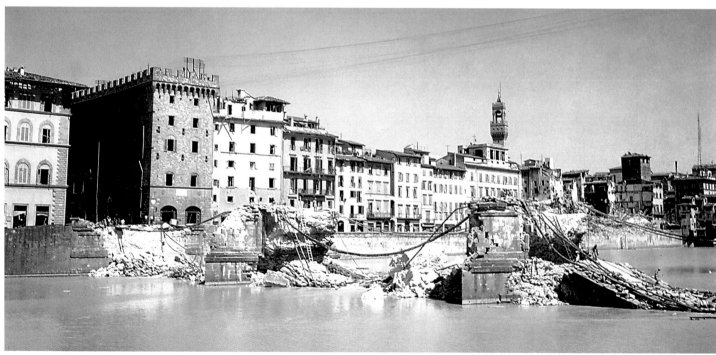

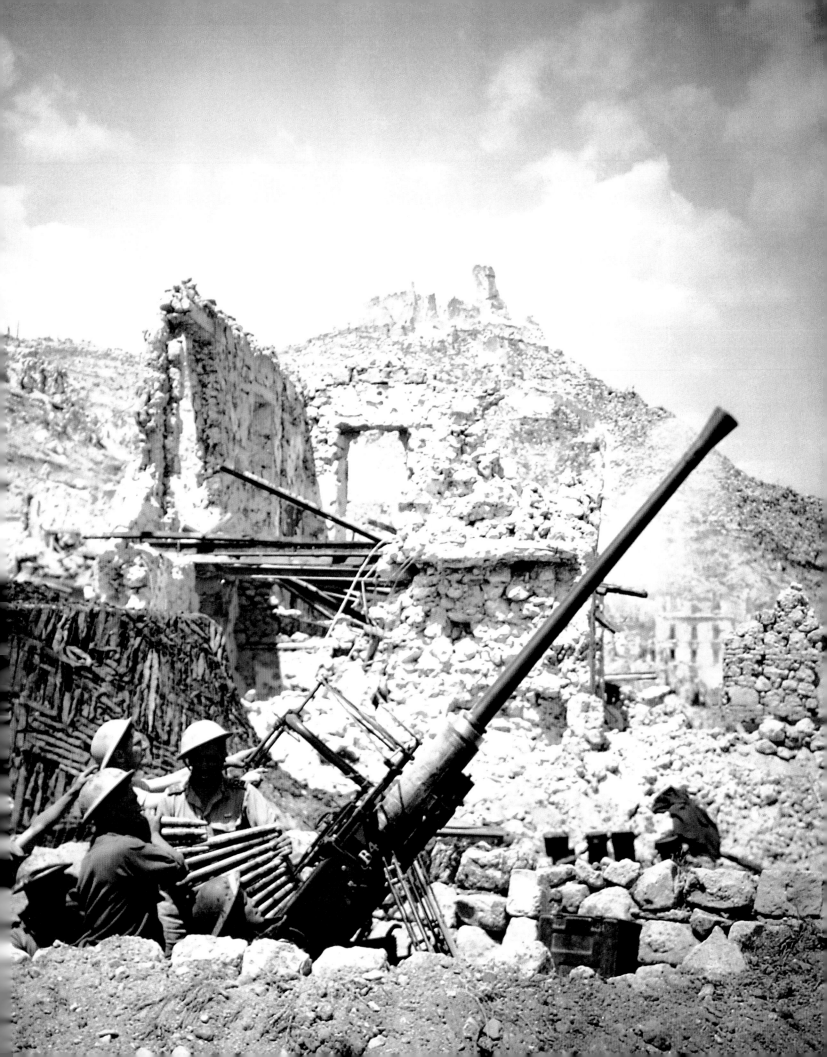

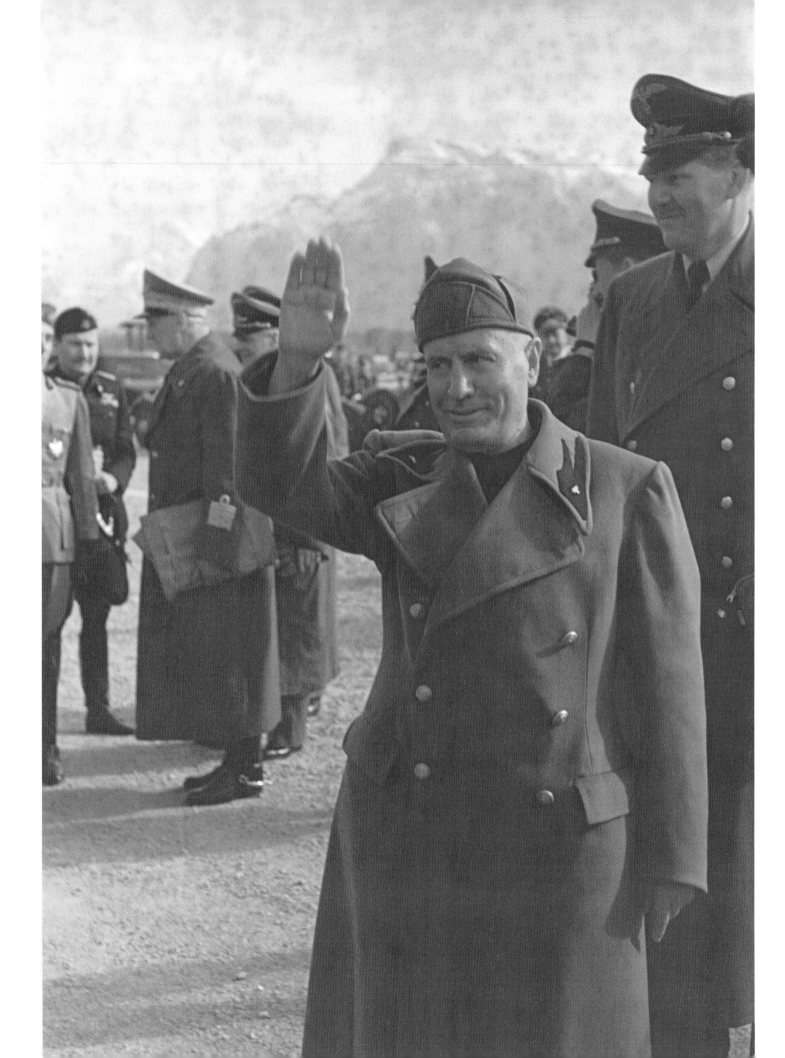

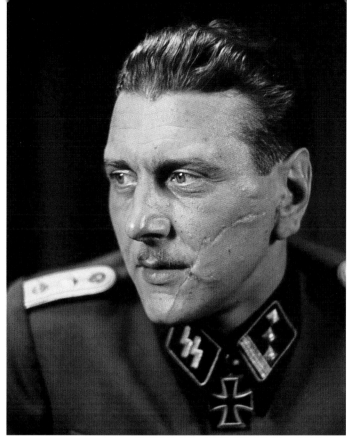

Mussolini after his rescue. Hitler picked Otto Skorzeny to locate and rescue Il Duce after his arrest on July 25, 1943. The Waffen-SS major found him in an hotel on a mountain plateau. Crashlanding in a glider with nine others, he subdued the guards and took Mussolini to Rome in a light aircraft.

Otto Skorzeny was also responsible for the kidnapping of the son of Admiral Horthy, the Hungarian Regent, after which he escorted Horthy to Germany. Such exploits earned him the title "the most dangerous man in Europe".

US mountain troops, probably from 86th Mountain Infantry Regiment, 10th Mountain Division, on a ski patrol in the Apennines. In the foreground a medic deals with a casualty.

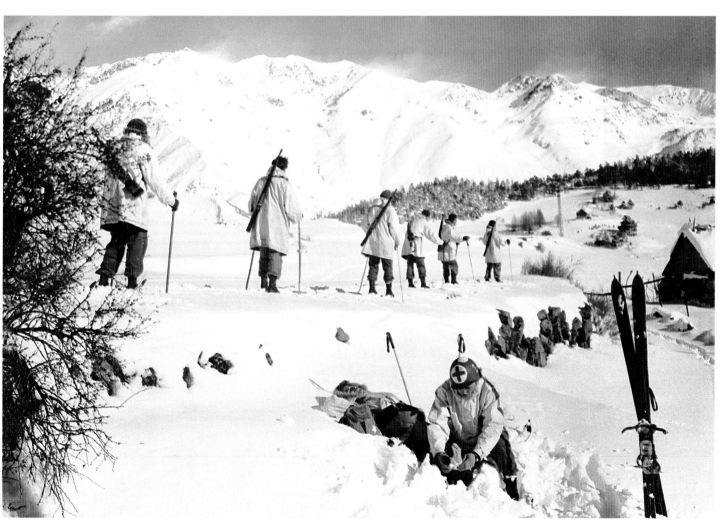

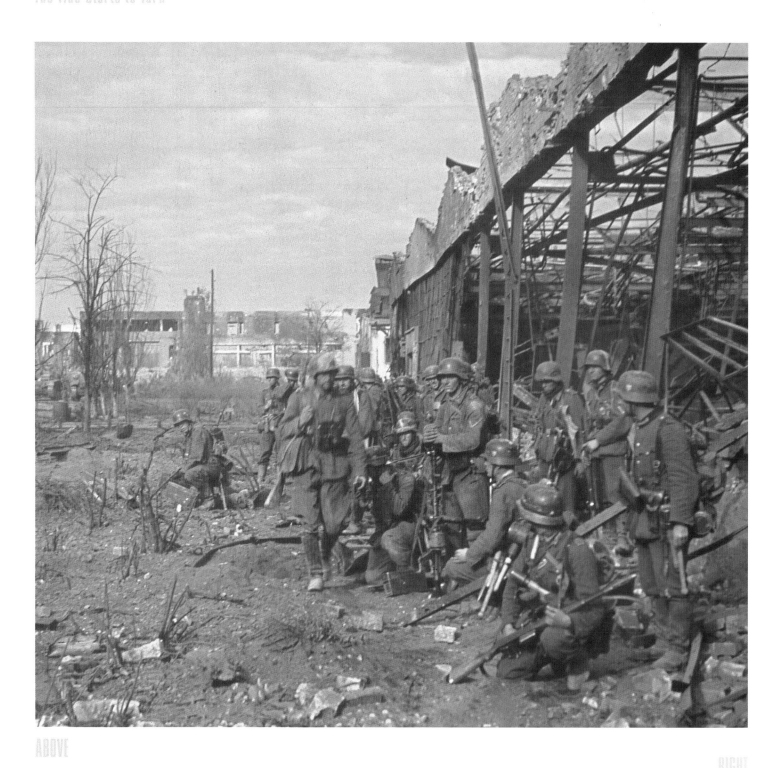

A squad of German soldiers relax after savage fighting to
capture a now ruined tractor factory and other buildings in the
north of Stalingrad. The Germans could not take the entire city
and, after seizing most of it, were themselves surrounded.

Some of the civilian population
trapped in Stalingrad, like this woman,
went on grimly eking out an existence
in the ruins of their city, while the
fighting went on all around them.

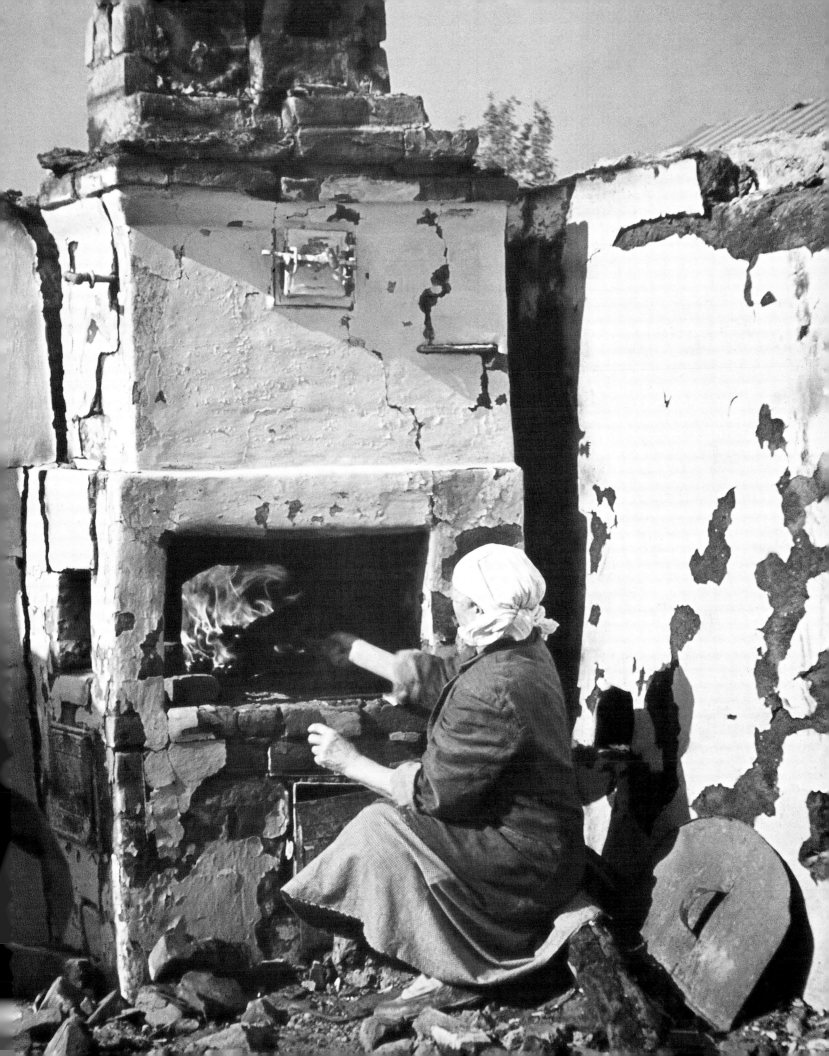

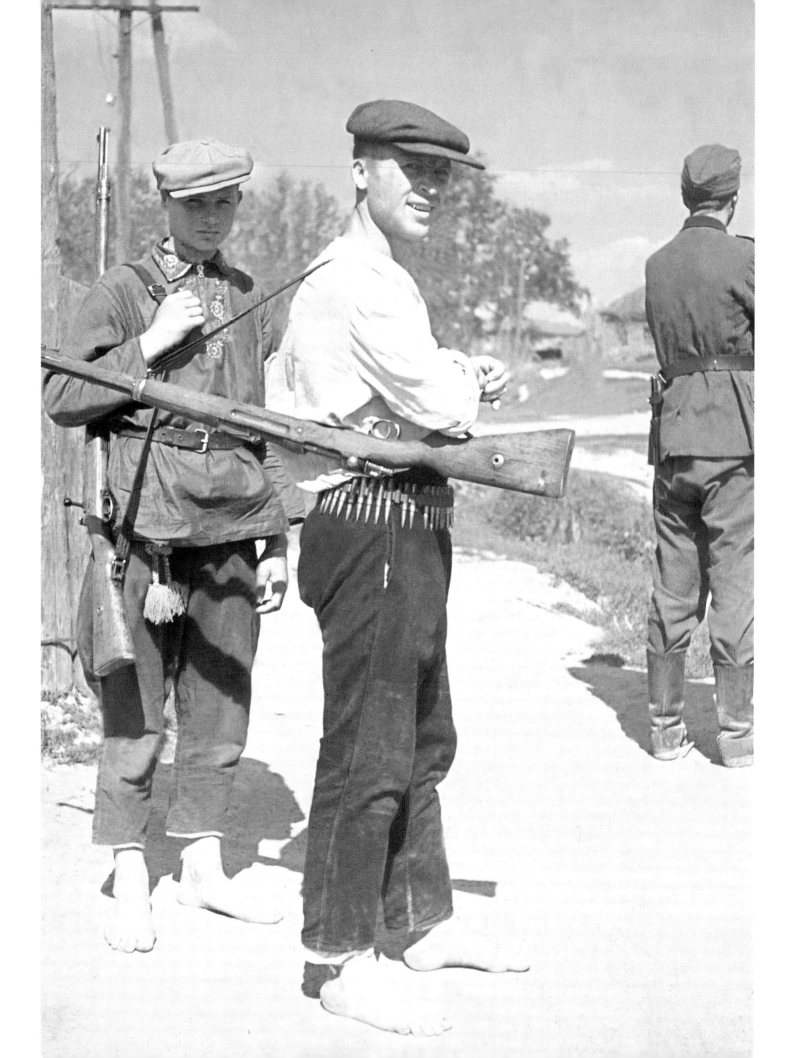

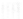

Barefoot fighters, October 1941.
These two men are pro-German
Ukranians deployed by the Nazis to
fight the ever-growing war against
Soviet partisans by operating behind
the front lines.

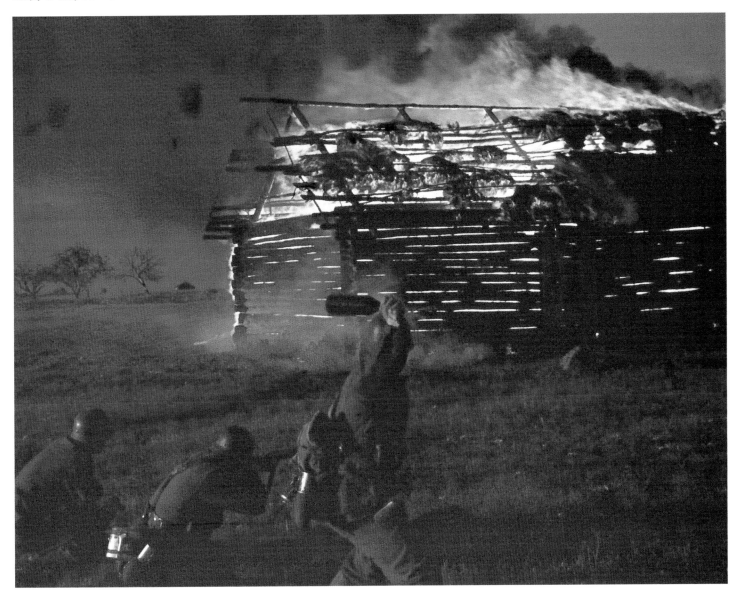

Scorched earth. Buildings could make all the difference to life
and death in the bitter winter weather, and so they were often
fought over just for the shelter they would provide, or destroyed
simply to deny them to the other side.

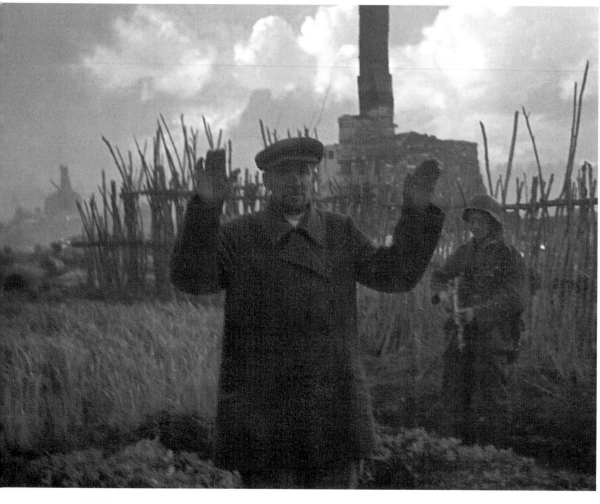

"Bombing up". Two members of a tank crew replenish their main gun ammunition, handing the rounds through the side hatch to a third crew member, who will be stowing them away in the internal ammunition bins.

A captured Russian – is he a soldier, a partisan or an innocent civilian? Whatever the case, as a member of the *Untermensch* – subhuman, as the Nazis saw it – he will probably be sent rearwards for use as slave labour.

A convoy passes a broken-down vehicle on a very muddy track in the limitless wastes of the Russian steppes. The extremes of weather played a major role in warfare on the Eastern Front.

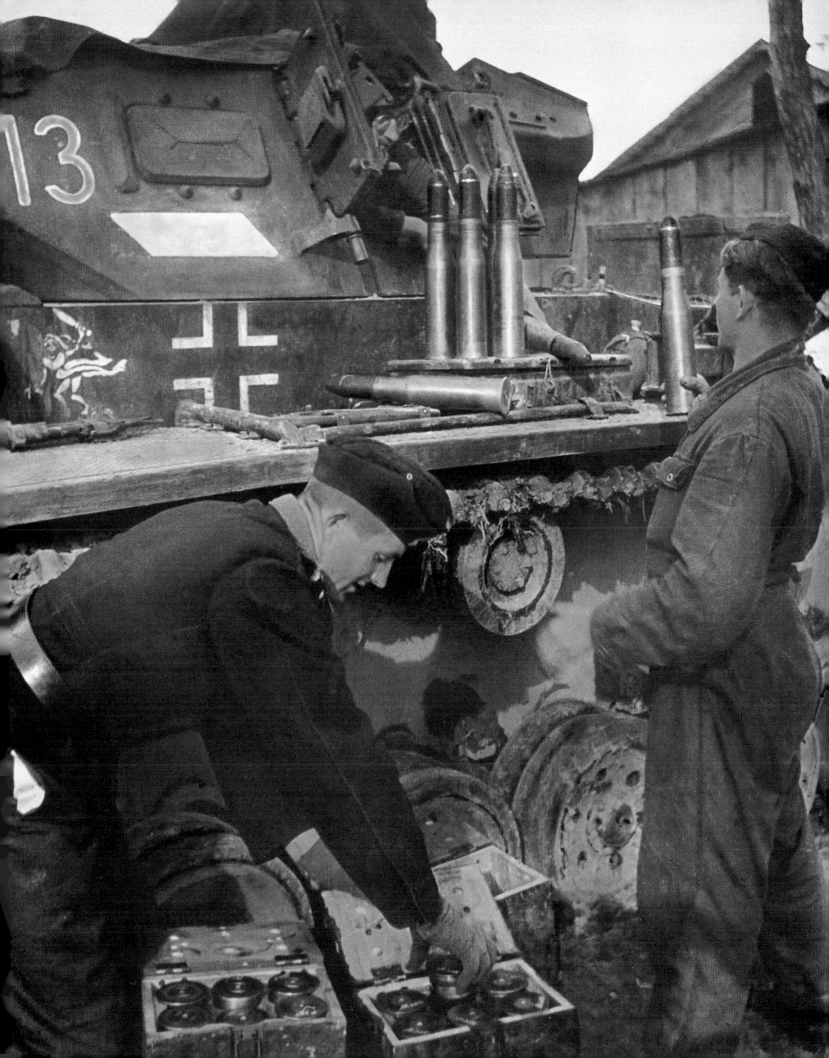

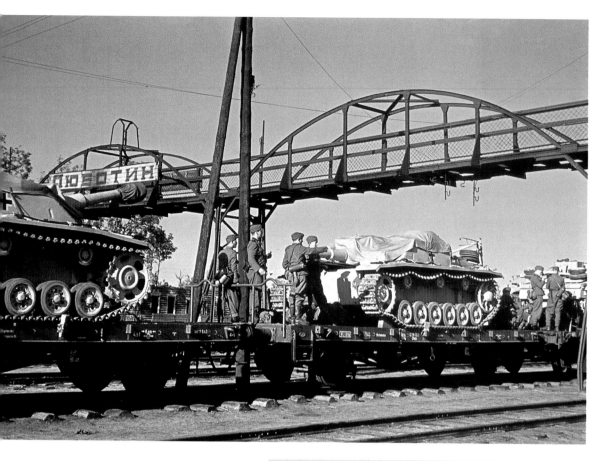

LEFT

PzKpfw IIIs tanks being moved by rail, through Lyubotin in the Ukraine. Rail movement saved track wear and was much quicker than moving by road or across country. Even so, air superiority was essential.

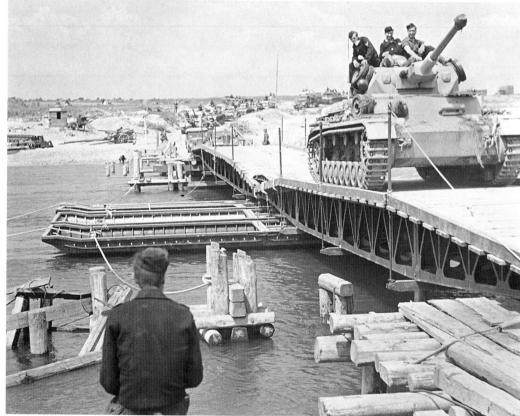

RIGHT

A PzKpfw IV medium tank, crossing a 24-tonne (23.6 tons) pontoon bridge over the River Don. This huge waterway runs southwards some 1,930 kilometres (1,200 miles) through Russia to the Sea of Azov, near Rostov.

Two soldiers in a slit-trench in Russia. The corporal on the right
uses a scarf to keep his ears warm, while his lucky companion
has a fur cap.

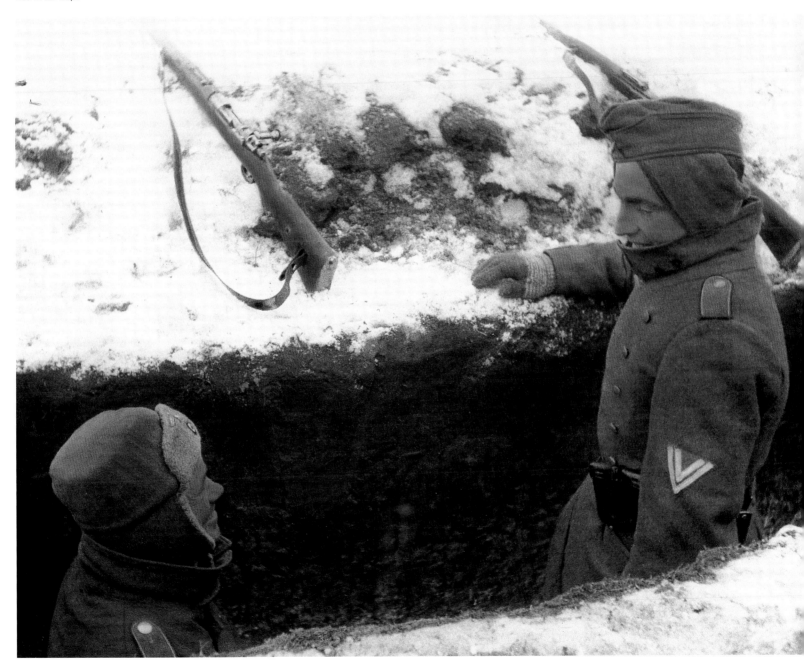

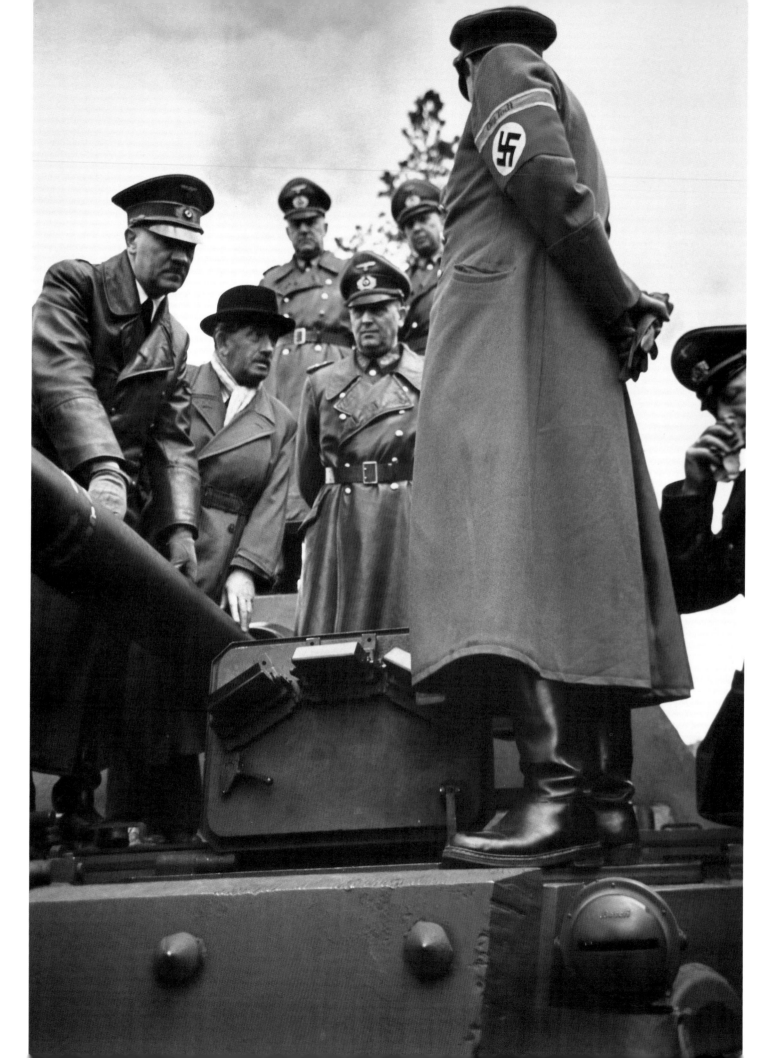

LEFT

Hitler with Dr Porsche, in civilian
clothes, inspecting the new
heavyweight 57-tonne (58 tons)
PzKpfw VI Tiger Ausf E tank. Built by
Henschel of Kassel, it first saw action
in the Leningrad area in August 1942.

BELOW

A Tiger advances. With armour 100 mm (4 inches) thick on the
front and deadly 8.8-cm (3.5 inches) KwK 36 L/56 gun, this
tank swiftly gained a fearsome reputation on all battlefields.

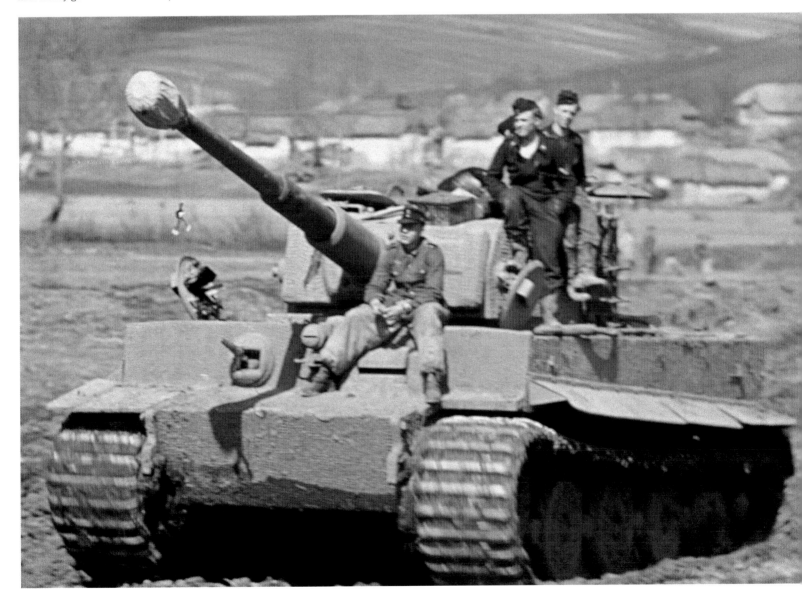

THE ATLANTIC WALL

Needing to defend his rear while he turned his attention to the Eastern Front, Hitler decided to build a complex line of defences stretching from the Arctic Circle to the Spanish border. He did so despite the fact that his blitzkrieg tactics had already proved the ineffectiveness of such fixed defensive lines. The Atlantic Wall, over 5,000 kilometres (3,100 miles) long, was begun in March 1942, after the Führer's Directive No. 40 was issued. But it would not be until late 1943, when Erwin Rommel became Inspector of Western Defences, that it really received the attention it deserved. By then it was too late, not just to complete the building programme but, more importantly, to get the three armed forces to work harmoniously together. "He who defends all defends nothing" is perhaps the Wall's most fitting epitaph.

A long-range coastal artillery gun. The Germans concentrated such massive guns to cover the narrowest part of the English Channel, between Dover and Calais. Later the guns became part of the Atlantic Wall.

On watch in Normandy. This shoreline pillbox, with both open-topped machine-gun post – containing MG 42 and crew – and separate OP position, has most of its 2-cm (¾-inch) thick concrete walls covered with earth and camouflaged.

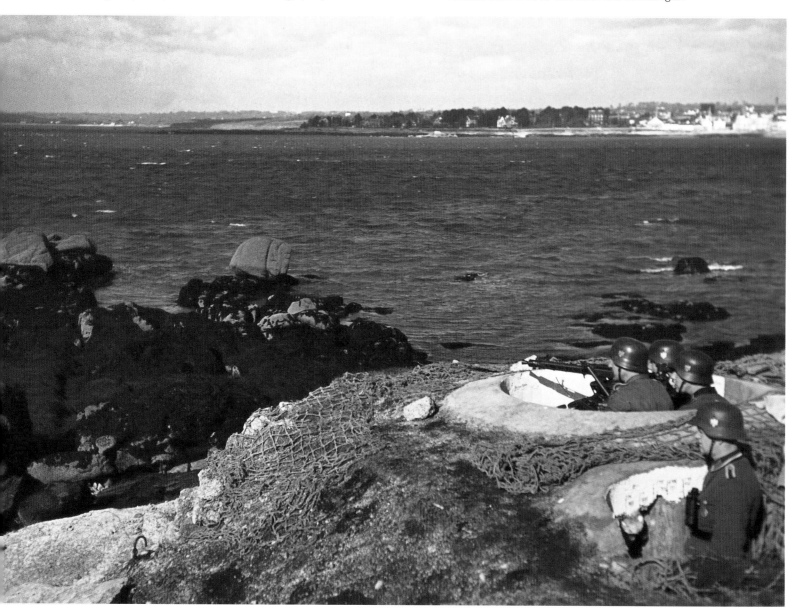

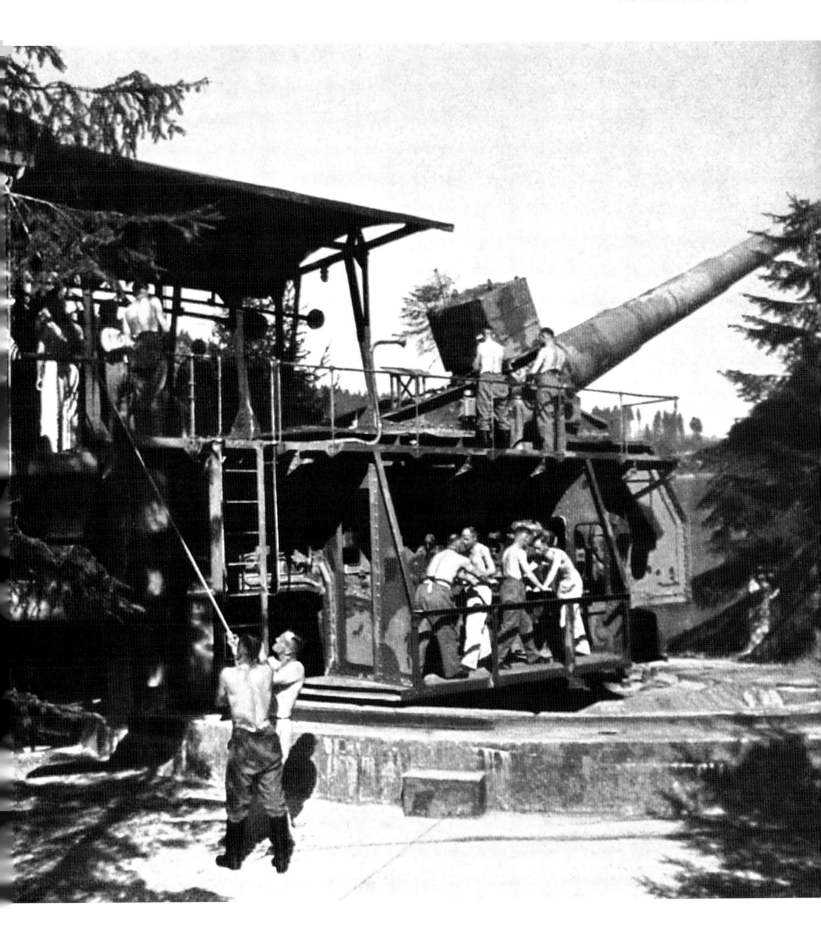

RIGHT

Another enormous gun, with camouflaged casemate, is now in position on the Channel coast, but work on the Atlantic Wall continues.

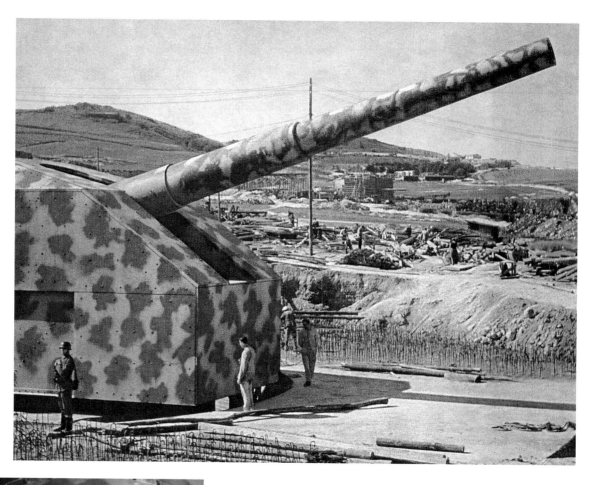

LEFT

A symbol of the Atlantic Wall's apparent impregnability was this awesome 40.6cm (16 inch) SKC/34 naval gun, one of three that made up Batterie Lindemann, just south of Sangatte.

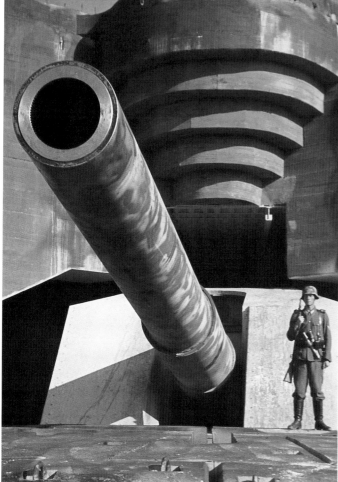

RIGHT

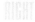

Watch on the Channel. A German sentry looks through his binoculars while his MG 15 machine gun stands ready on its AA mounting. Note the ring sight and 75-round saddle-drum magazine.

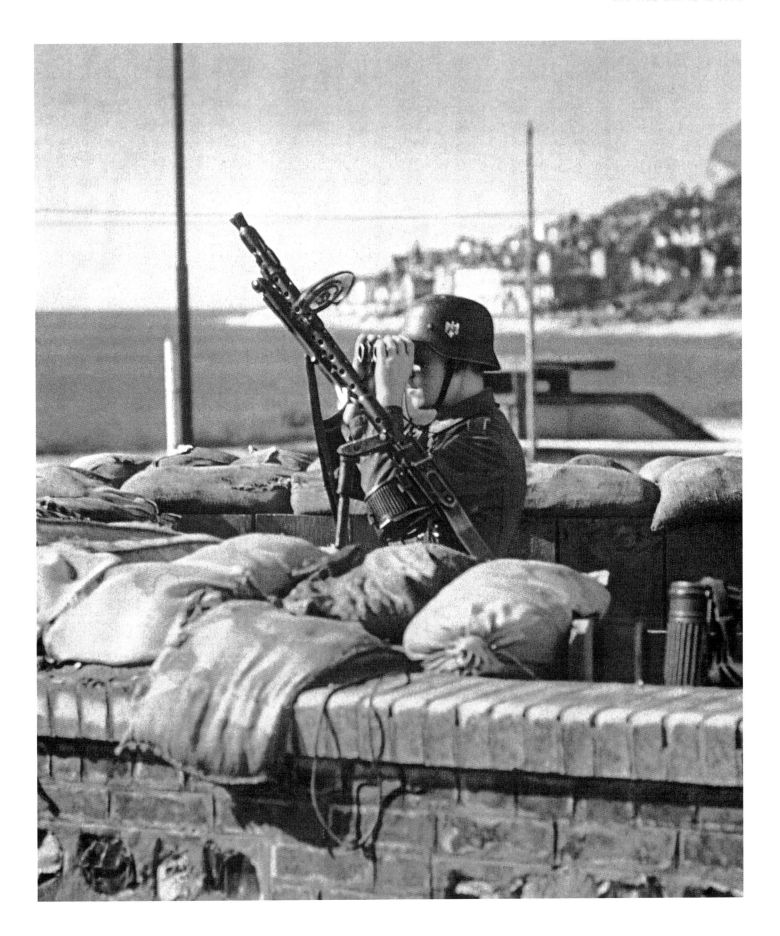

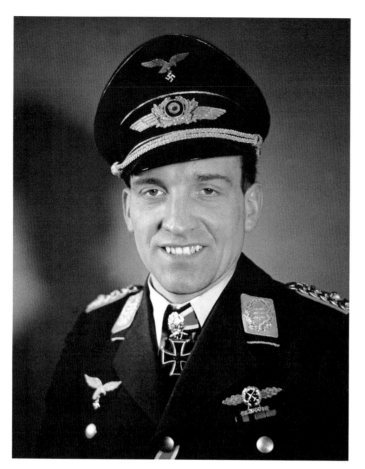

HEROES OF THE THIRD REICH

Despite, or perhaps because of the decline in Germany's military fortunes, the glorification of her heroes continued. The greatest military heroes of any nation are invariably awarded the highest honours for their bravery in battle, and this was the case in Nazi Germany, the Ritterkreuzträger (Knight's Cross winners) being fêted as national heroes. The Knight's Cross of the Iron Cross, with its "additions" of Oakleaves, Swords and Diamonds, was instituted on September 1, 1939, at the same time as the Iron Cross itself was reinstituted. The highest class of the Knight's Cross was the Golden Swords, Oakleaves and Diamonds (worked in 18-carat gold and set with 50 diamonds), instituted on December 29, 1944. The intention was to award it to a maximum of twelve men, but in fact it was only ever presented once: to famed Stuka pilot Oberst Hans-Ulrich Rudel.

Rudel, of the Luftwaffe's Schlachtgeschwader (Ground Attack Wing), was the tenth recipient of the coveted Diamonds, on March 29, 1944, and the sole recipient of the all-gold version.

Many of those who did not survive, unlike Galland (opposite), were given a state funeral, as seen here at Tannenberg in the Black Forest, where Hitler had his HQ in June and July 1940.

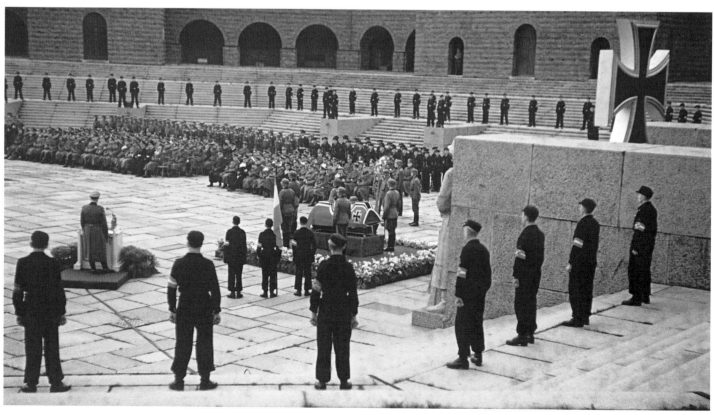

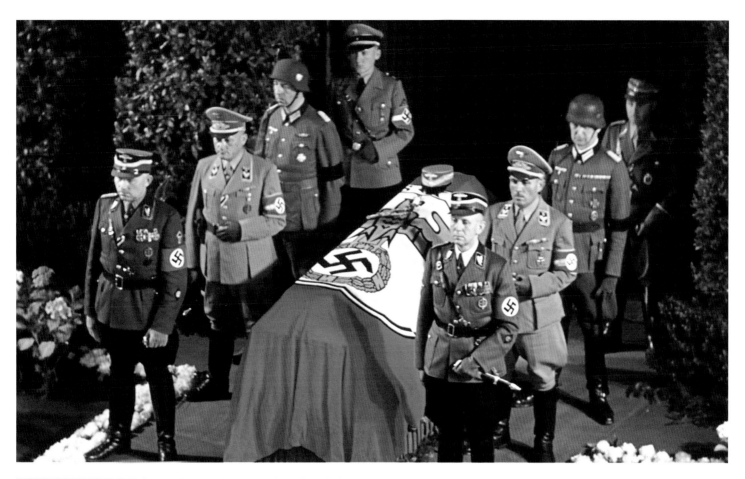

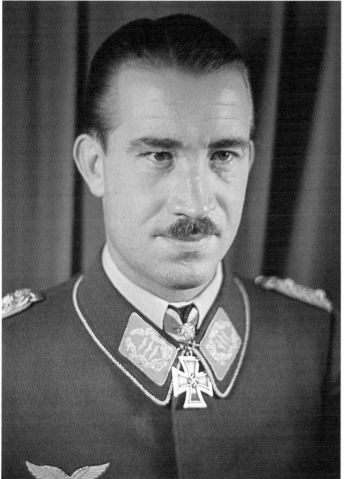

The funeral of Adolf Hünlein, the head of the NSKK (Nazi Motor Corps), shows the pomp and ceremony that the Nazis accorded their departed SS leaders, for the NSKK were part of the Motor SA and thus SS Stormtroopers.

LEFT

Generalleutnant Adolf Galland, a fighter ace, was the second winner of the Diamonds, on January 28, 1942. He won his Knight's Cross on August 1, 1940, his Oakleaves on September 25 of the same year, and became the first recipient of the Swords on June 21, 1941, after his sixty-ninth victory. He survived the war.

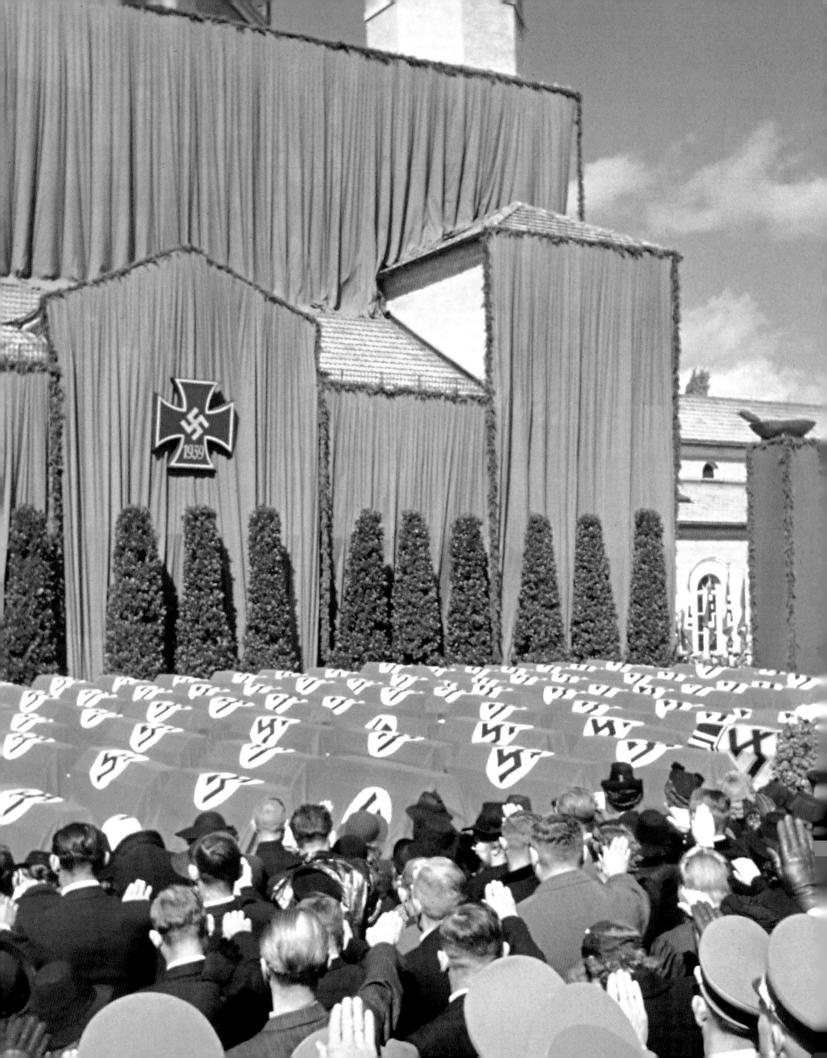

CHAPTER 4

The Home Front

There is disagreement among historians as to how prepared Nazi Germany was for the war that Hitler initiated by his actions in 1939. In power for some six years, the Nazis had had time to ensure that their ideology ran deep and that the mass of the populace agreed with Hitler's actions. The infrastructure of Nazi power – the civil administration, the secret police, the education and youth movements – was in place and producing excellent recruits for the military. There is no doubt that the armed forces were extensively trained, well prepared for battle and well equipped, and that industry was geared to providing the machinery the armed forces required at that stage. Hitler had ensured that there was access to the important raw materials that Germany lacked (almost everything but coal) before the war through trading agreements; during the war he did so by conquest.

Despite these advantages, there were significant problems from which the Nazi regime perennially suffered, particularly those of procurement and political in-fighting. Wastefully, each of the armed forces – navy, army, air force and latterly the Waffen-SS ("armed SS") – had its own procurement offices, as did the Organisation Todt and other agencies. Each had to fight for its share of materials. Furthermore, when it came to weapons development Hitler often made damaging personal interventions – as, for example, he did by insisting that the Messerschmitt Me262 should be a fighter-bomber. The Nazi government was characterized by the in-fighting that took place all the way from senior ministers to minor officials in the myriad internal organizations. Albert Speer, Minister of Armaments after the death of Fritz Todt, gives a graphic description of this friction in his autobiography.

Whether prepared for war or not, the German state and its people saw massive changes and hardships during the period but there was less belt-tightening in Germany – as compared with, say, Britain or the Soviet Union – until quite late in the war. There were numerous reasons for this, the main one being the exploitation of the wealth of the countries occupied by conquest (by taxes and appropriation) and

their labour resources. It has been estimated that taxes on occupied countries accounted for one-eighth of Germany's total costs for the war. On top of this, goods and valuables were appropriated by the Nazis and sent back to Germany.

The main exploitation of the conquered territories took the form of using foreign labour in Germany. This force provided workers for every major town in Germany. As the war progressed and more and more men were needed for the armed forces, so women were drafted in to do men's work. By 1944 the shortage of men was so severe that 100,000 women were called up to operate anti-aircraft batteries, while Hitler Youth boys and girls helped fill gaps in vital services, becoming messengers, telephone operators, hospital orderlies and even firefighters. However, they were but a drop in the ocean. Undoubtedly the armaments factories, mines, steelworks and all the rest of heavy industry would have ground to a halt had it not been for the vast army of foreign workers that were employed, usually in spartan conditions. By 1944 there were over 7 million foreign workers in Germany, including some 2 million POWs. By the end of 1942 some 1.3 million French

LEFT

With so many air-raid casualties to bury, the authorities were forced to hold mass funerals.

civilians laboured in Greater Germany and nearly 3 million Poles were forced to work there. In addition there were slave labourers, who were worked like beasts of burden until they died – of 4.5 million Soviet prisoners taken in the invasion of the Soviet Union, only 1.5 million were alive six months later. By the end of the war Krupp employed forced labour in nearly 100 factories spread across Germany, Poland, Austria, France and Czechoslovakia.

After the war, when confronted with the horrors which this forced labour brought in its wake, many Germans spoke as though they had been "awakened from a fantastic dream in which they had somehow played a part". Finding that they were now in a non-Nazi world where they would be called to account for the working to death of these innocent people, "they stared at the pictures of atrocities in disbelief and horror. They confessed and squirmed and alternately blamed themselves and even more readily the men and creeds they had served." The numbers involved were staggering. For example, in April 1943 Fritz Sauckel, Plenipotentiary General for the Allocation of Labour, proudly reported to Hitler that 3.6 million foreign workers had been pressed into service in German industry, along with 1.6 million POWs. Some 40 per cent of workers in the armaments industry were slave labour, held in concentration camp conditions and worked to death.

THE GESTAPO AND THE SS

For those living in the Nazi state the two most sinister elements of the regime were the secret police – the Gestapo – and the political police, the SS. The Gestapo's role was to track down those who were against the state, from people who told anti-Nazi jokes to resistance cells in occupied territories; with its own legal system, it was judge, jury and executioner, and everyone in Nazi-occupied territory was terrified of its clutches. The SS, under the leadership of Reichsführer Heinrich Himmler, was a police organization that later gained a military arm. Even by 1940 the SS numbered a quarter of a million and was broadly divided into the Allgemeine (general) SS; the Verfügungstruppe – initially a force of three battalions which became the Waffen-SS; the Totenkopfverbände (Death's-head formations), who guarded the concentration camps; the Sicherheitsdienst – the SS's own security service; and the Rasse und Siedlungshauptamt (race and resettlement department), which dealt with colonization of the conquered territories. The SS was responsible for its own recruitment, training and operations, having its own rank system, uniforms and structure.

The SS and the Gestapo wove a web of informers all over Greater Germany, so it was unwise to voice any open criticism of the state. There was always some underground opposition to the Nazis, but people did not dare to ask, for example, about the concentration camps and those who were being sent to them. "We have to put a stop to the idea that it is part of everybody's civil right to say whatever he pleases," maintained Hitler. When anyone was brave enough to do so and was caught, then the punishment meted out was sufficiently severe to act as an awful warning to others. And the organs of the Nazi state received help from inside the conquered countries too. There were always those who collaborated with the Nazis – men like Vidkun Quisling of Norway, whose name has been synonymous with treachery, or Pierre Laval, the Prime Minister of Vichy France.

BOMBING

Apart from the problems of shortages and the secret police, the most obvious sign of warfare to those living under the Reich was the bombing. This was initially confined to military targets, but as soon as it began to take in strategic targets, such as factories and armament works, railways and all the other means of transport that kept the infrastructure running, civilian targets – towns and cities – were increasingly susceptible to enemy bombing, as had been proved during the Spanish Civil War and the Blitz on Britain. And as bombing was the main way that Britain could strike back at Germany in Europe, it was only a matter of time before the raids increased in frequency and severity: 1942 saw the start of thousand-bomber raids on German cities, with horrific results – Hamburg was turned into a blazing inferno that led to the deaths of nearly 45,000 people, most of whom were civilians; in Dresden, 70,000 are said to have died.

This was "total war" of a kind that the British had already faced in the Blitz on London and other large cities. Now it was time to pay back the Germans with a vengeance. Day and night bombing raids by the US Air Force and the RAF caused tremendous destruction and crippled the already stretched German transport system. The results were not dissimilar to what had happened already in Britain: some, in particular younger children, were evacuated to country areas while the rest braved the continual air raids, living in the rubble of their bombed houses. It is remarkable how Germany continued to function even during the worst periods of the war. Factories, such as the great Krupp empire in the Ruhr, still operated; trains ran and weapons of war were produced and somehow reached the front lines, despite being pounded day and night. RAF Bomber Command flew over a third of a million sorties and lost some 9000 aircraft in its strategic bombing campaign. They flew night operations on 71.4 per cent of all the

nights in the war and 52.5 per cent of all the days, dropping 950,000 tonnes (935,000 tons) of bombs on military and civilian targets.

PROPAGANDA

The Nazis believed completely in propaganda. Directed by Dr Joseph Goebbels, Minister for Public Enlightenment and Propaganda, it was used dramatically as the Nazis ascended to power and is epitomized by the Nuremberg rallies of the 1930s, which were huge events designed to show the power of the Reich and the history and racial superiority of the Aryans, and to reinforce the position of the Nazi Party in general and that of the Führer in particular. These massive set-piece events, that involved hundreds of thousands of people, gained a world stage and the use of strong visual symbols – such as the swastika – ensured that anyone who saw photographs of the events would be aware of the strength of Germany. The 1936 Olympics was another propaganda opportunity for the Nazis. They went to town on it, spending the then huge sum of $25 million on arenas. Unfortunately for Hitler, the event would be best remembered for American black athlete Jesse Owens's four gold medals.

During the war the Nazis' propaganda machine went into overdrive. It trumpeted false reasons for the invasion of Poland, maximized the victories of the German troops and minimized the defeats and losses. It poured scorn on the leaders of other nations – particularly Churchill and Roosevelt – and attempted to hit out at the morale of Germany's opponents through every means possible. A good example of Nazi propaganda literature is the magazine *Signal*, which was produced biweekly in 20 different languages. It sold all over Europe – and, until Pearl Harbor, in the United States – and in 1943 its sales reached 3 million. Its content was lively, colourful and very modern – although its articles were, of course, very slanted. Radio propaganda is typified by William Joyce – Lord Haw-Haw – who broadcast from Berlin throughout the war and was hanged by the British as a traitor in 1946. As the tide turned and defeat threatened, the propaganda machine stiffened its sinews and became more overt.

CASUALTIES

In the early days of the war German battle casualties were minimal, the power of blitzkrieg appearing to miraculously achieve success without the horrific casualties that had become the norm during the Great War. Soldiers came home on sick leave and were often fêted as heroes, while the civil population experienced little bombing and saw only minimal destruction. But this would all change. British and American bombing, for example, brought the front line directly into "Main Street Germany", and half a million civilians were killed in what eventually became almost daily and nightly raids. Casualties on the battlefields also grew as success waned. The public mood began to change as large numbers of wounded appeared, particularly from the Eastern Front. When the "butcher's bill" became even heavier, convalescing soldiers were not allowed home, while death notices in newspapers were restricted to just a few in each issue. Over 2 million German servicemen would die and twice as many would be wounded, while millions more were taken prisoner, hundreds of thousands dying as a result, especially in the East. Total deaths among Germans of pre-1938 Greater Germany were some 4.5 million. The implication of the last line of Hitler's Oath of Allegiance had come home to roost.

THE FINAL SOLUTION

The most heinous crime perpetrated by the Third Reich was the deliberate attempt to exterminate European Jewry. From the outset, as evidenced by *Mein Kampf*, Hitler used the Jews as scapegoats for Germany's internal problems. "The Jews are our misfortune," said the propaganda machine and as soon as the Nazis came to power they took steps to dispossess them. From April 1933, when the official boycott of Jewish shops began, to the forbidding of mixed marriages, the confiscation of all Jewish valuables, the forced wearing of a yellow star to denote Jewishness, the destruction of synagogues and the herding together of Jews into "Jewish Houses", state restrictions grew ever more severe. In the pre-war period this pressure reached a climax in Kristallnacht ("Night of the Broken Glass"), November 9, 1938, when 7,500 Jewish shops were looted, nearly 200 synagogues destroyed and the streets covered with broken glass. But these were just the restrictions that were plain for all to see – the horrors of the extermination camps, the gas ovens and the systematic slavery, torture and murder were still hidden from most of the population. Hitler said: "One must act radically. When one pulls out a tooth, one does it with a single tug, and the pain quickly goes away. The Jews must clear out of Europe. Otherwise no understanding will be possible between Europeans.... But if they [the Jews] refuse to go voluntarily, I see no other solution but extermination." At Wannsee on January 20, 1942 this extermination was planned and responsibility for the search for the Jews placed in the hands of the Gestapo. The SS ran the camps to which they were sent. In the last months of the war the SS tried to hide the horrors from the advancing Allied armies – but there was just too much to hide. It is difficult to provide precise figures, but of the 8.5 million Jews estimated to have been living before the war in what became occupied Europe, between 5.5 and 6 million were killed.

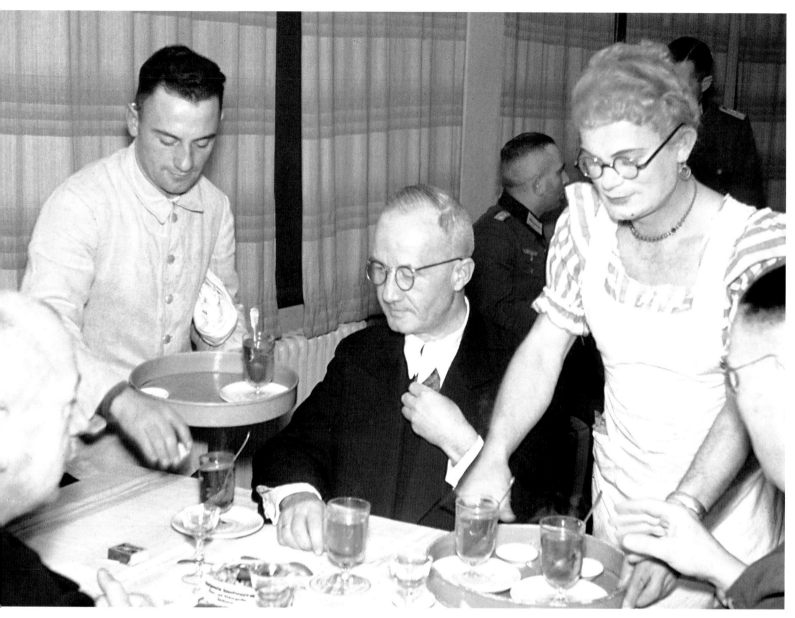

Teepause (tea break). One of the war's lighter
moments, as civilians and military enjoy a glass
of tea with their meal in a German restaurant.

Fresh fruit and vegetables became a rare sight in shop windows, even in such places as the Channel Islands, especially after the rigours of the German occupation began to bite. By the end of 1944 even Guernsey tomatoes were no longer on sale.

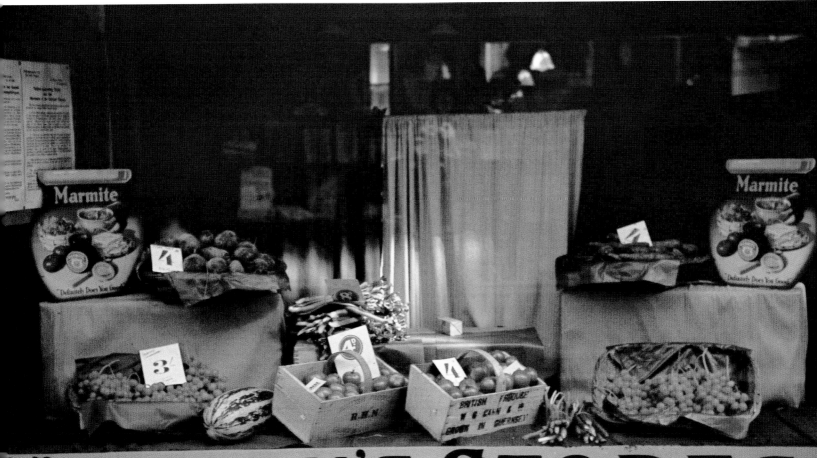

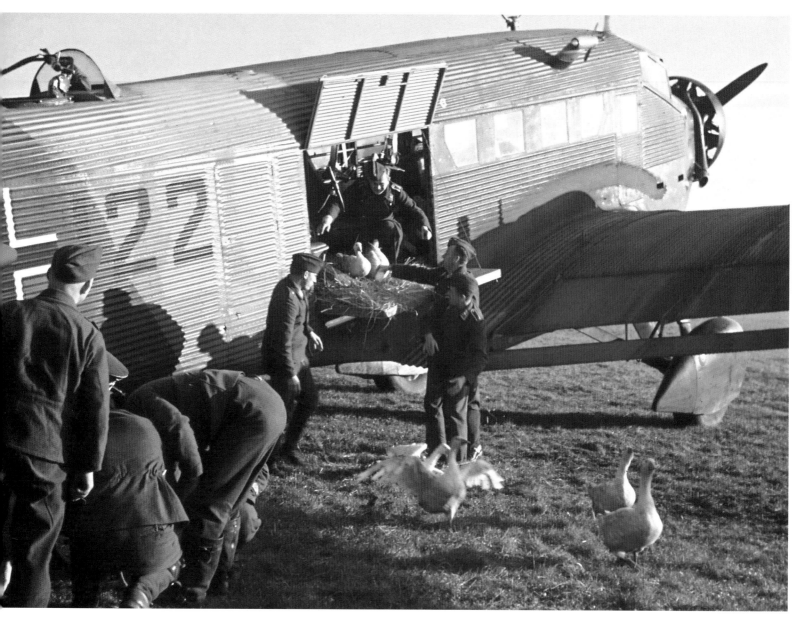

ABOVE AND RIGHT

"Tante Ju", the maid of all work, really did have to carry a
great variety of passengers. Here, live geese and pigs are
the cargo. The Junkers 52/3m came into civilian service
with Lufthansa in 1932, but the aircraft's versatility led to
its extensive use for airborne assault and supply
missions from the beginning of the war.

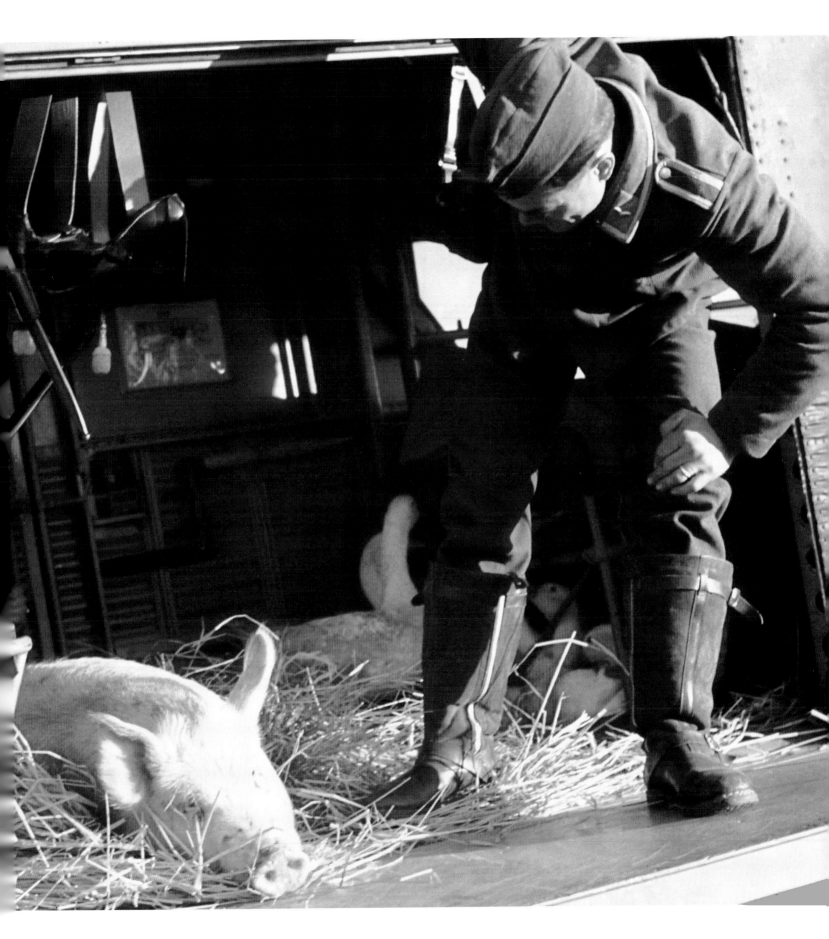

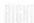

Compare this photograph of the
average wartime German family
with the one on page 18, taken
before the war. The father is now
in uniform, a member of the
Luftwaffe, and is home on leave.

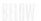

Steins of beer are well in evidence at this 1941 Christmas
party for leaders of the NSDAP. The National Socialist German
Workers' Party had been created by Hitler over twenty years
earlier to replace the German Workers' Party, the DAP.

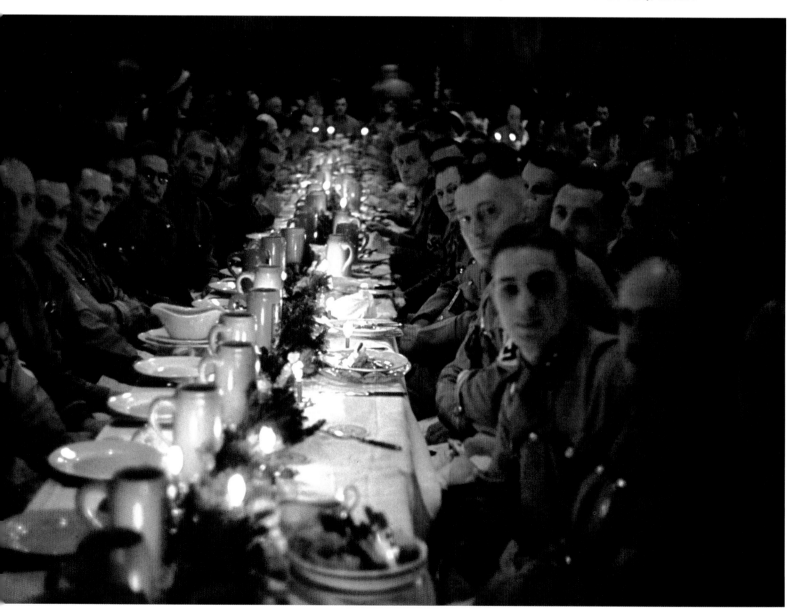

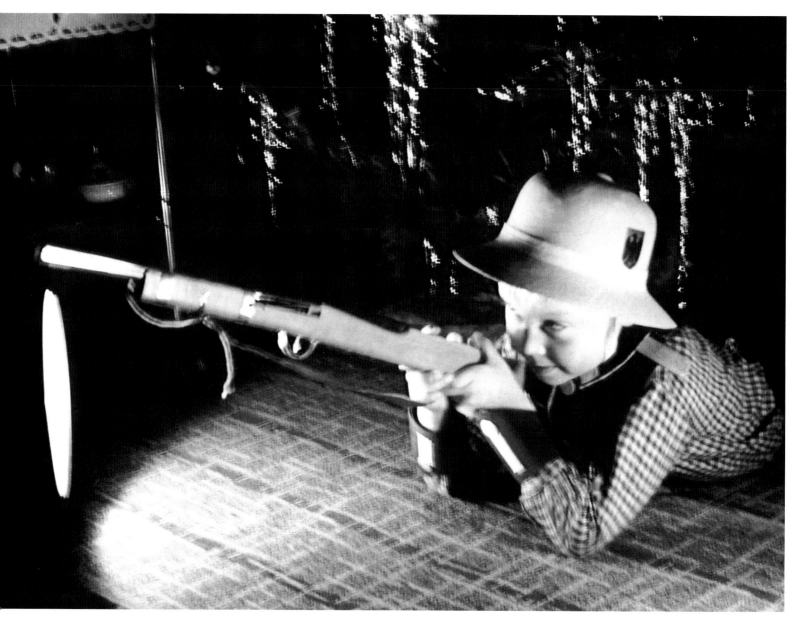

Little boys' Christmas presents often reflected their fascination
with the war. Always popular were wooden guns, uniforms and
helmets – this one is a replica of the tropical pith helmet worn
in the desert by Rommel's Afrika Korps.

Suitably dressed in steel helmet and "uniform" complete with
Nazi breast eagle, the same little lad plays happily with his
Christmas gift of toy soldiers, watched by his smiling mother.

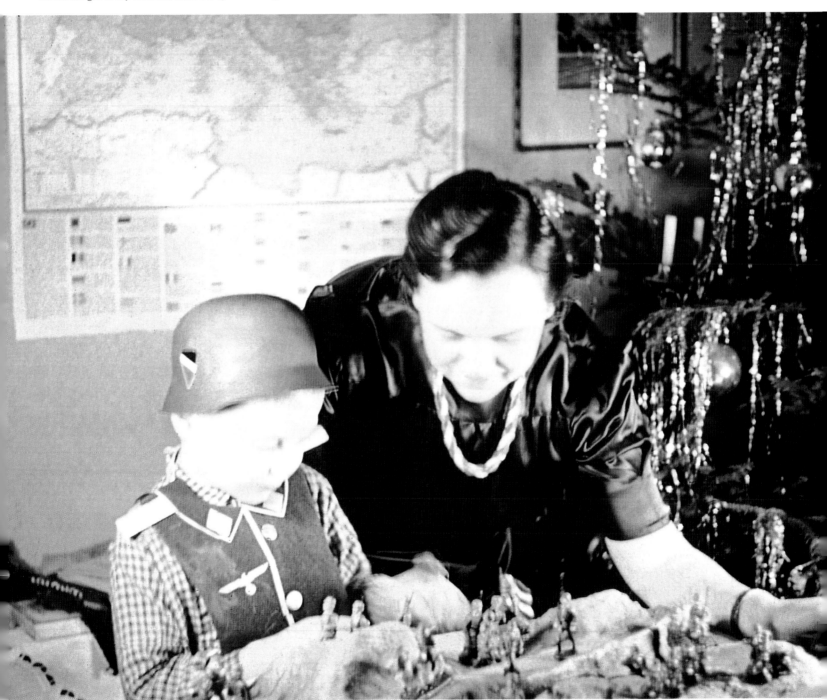

Some war-wounded hospital patients, like this amputee, were allowed "pin-ups" on their bedheads.

PREVIOUS PAGE

Hundreds of swastika flags make an impressive sight at a Nazi gathering held on May 21 1942 in Innsbruck, the capital of the Tyrol district of western Austria.

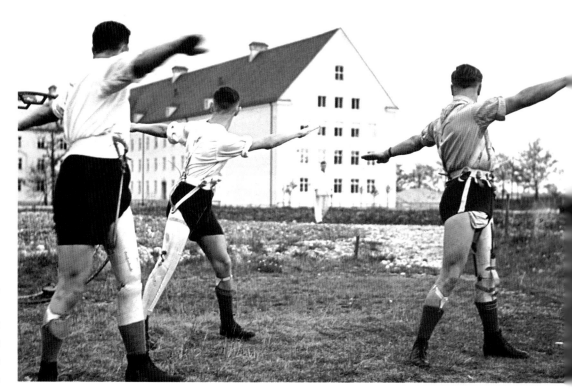

RIGHT

Amputees exercises at a rehabilitation centre in order to get used to their artificial limbs.

BELOW

The sombre funeral of Adolf Wagner, Gauleiter (District Leader) of Upper Bavaria, who died in April 1944. On the outbreak of war he had been appointed Reich Defence Commissioner for Military Districts VII and XIII (Southern and Northern Bavaria). Funerals such as these were designed to impress and inspire those left behind.

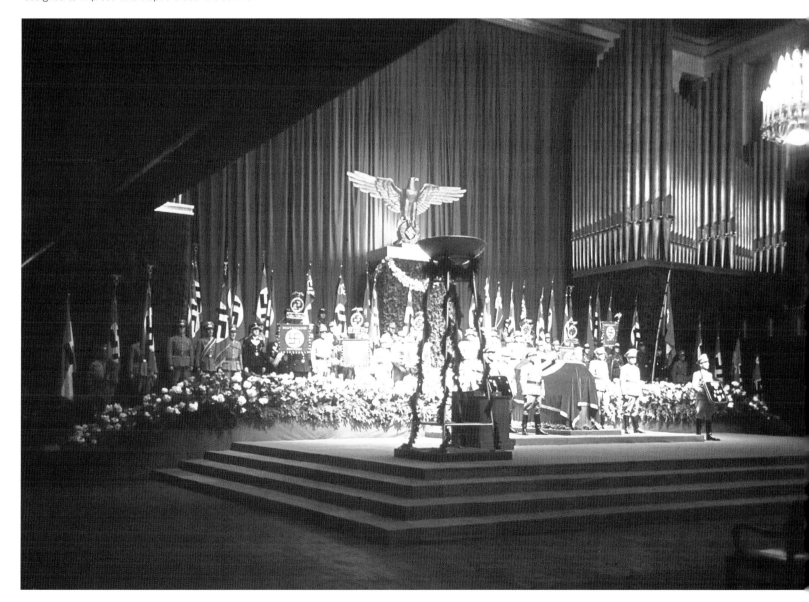

German soldiers waiting for deployment somewhere in France
can't resist the opportunity for a jolly snowball fight. Or was it
staged for propaganda purposes?

Enjoying their gramophone, these two members of the
Luftwaffenhelferinnen (Air Force Female Assistants) are wearing
the force's blue-grey uniform. The arm badge on the nearer
woman appears to be that of the Air Raid Warning Service.
Again, the photograph appears to have been posed and
may have been used as propaganda.

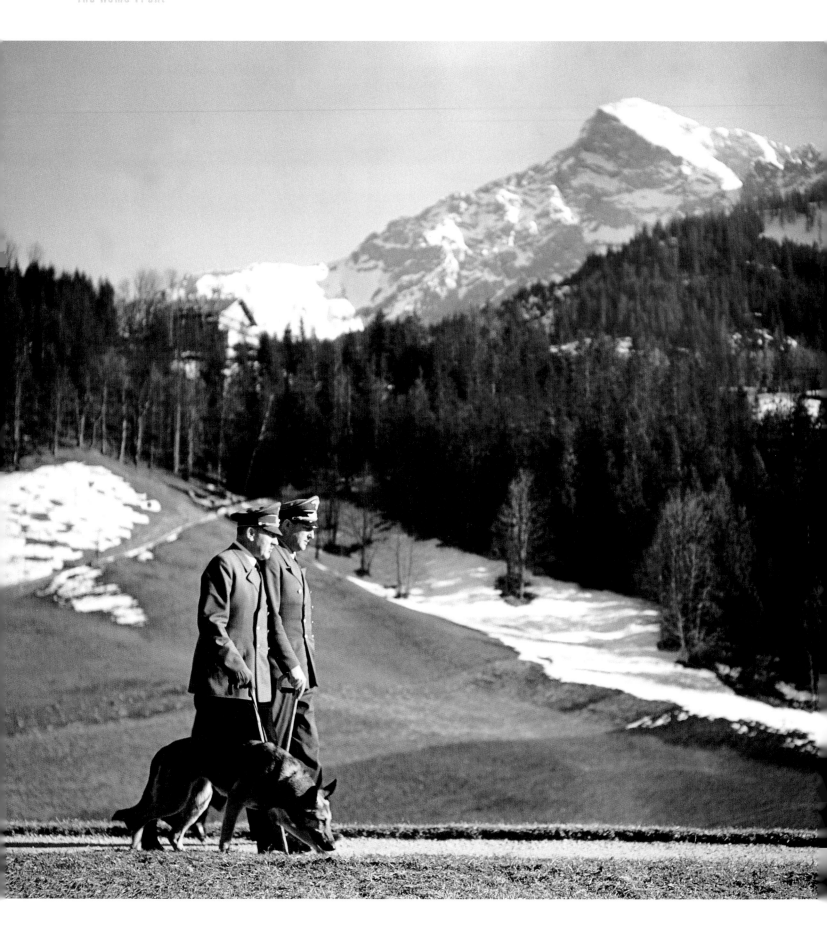

Hitler's private aircraft was an all-metal Focke-Wulf Fw 200 Condor with a range of 3,560 kilometres (2,212 miles) and a cruising speed of 335kph (208mph). It was the third of the three prototypes completed for Lufthansa.

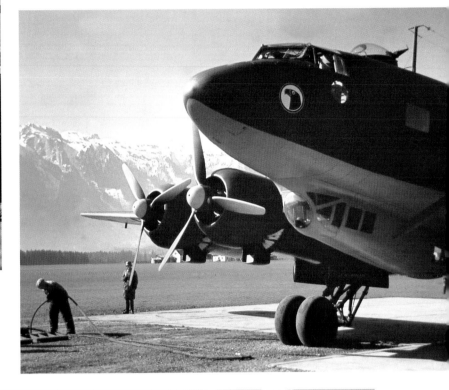

ABOVE

Hitler at home: a rear view of the Berghof, Hitler's mountain chalet on the Obersalzberg, high above Berchtesgaden in south-east Bavaria. Built of stone, it had thirteen floors, but only the top three were above ground. Note the camouflage netting.

RIGHT

Guests arrive at the Berghof, which provided magnificent views of the surrounding mountains. Hitler planned the building himself and had it completed by slave labour.

LEFT

Hitler takes his beloved Alsatian Blondi for a walk near the Berghof. At the end, holed up in the bunker in Berlin, he turned for comfort to the only two creatures on earth that had remained loyal to him – Eva Braun and Blondi.

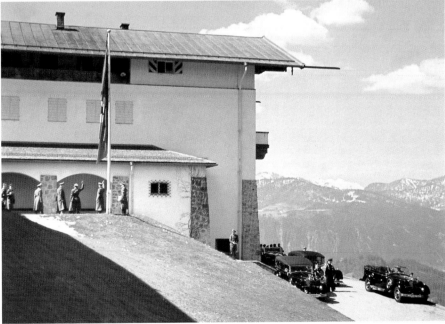

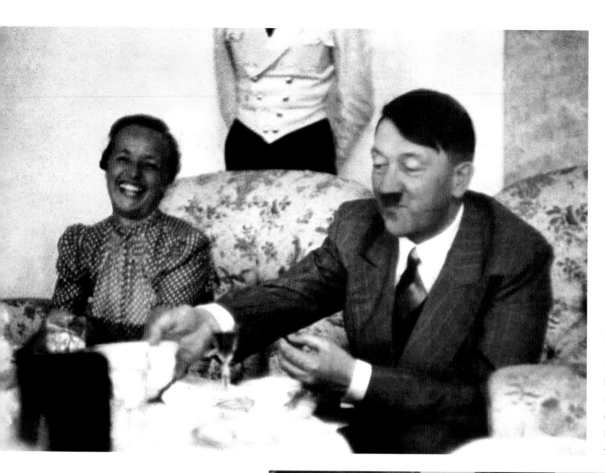

LEFT

Hitler takes tea. According to one biographer, he liked flowers in his room, cream cakes and sweets, dogs and clever women. He also liked films and often entertained friends with the latest releases.

RIGHT

An evening with Adolf and Eva. Hitler's vitality rose towards the end of the day and he hated going to bed because he had difficulty sleeping. As he did not smoke or drink he would chew peppermints or sip herbal infusions while sharing his philosophy of life with guests. This "table talk" has been the subject of a number of books.

BELOW

An adoring crowd greets the Führer during a visit to Munich. He had arrived in a Mercedes-Benz G4 six-wheeled staff car. Fifty-seven of these were built in 1933–4 and used exclusively as open parade cars by Hitler, Goering and other Nazi leaders.

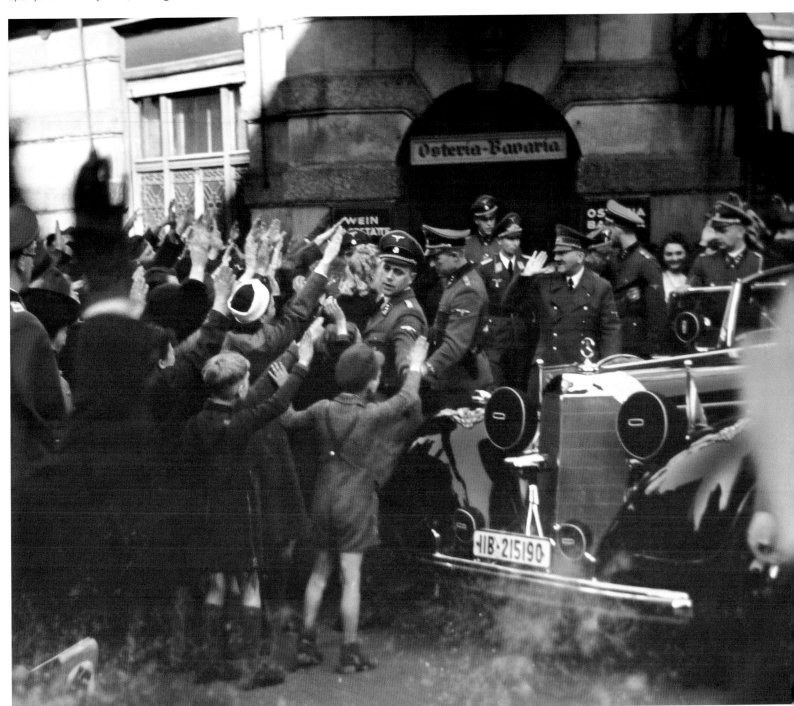

RIGHT

A scene in Stuttgart, photographed in the early part of the war, shows the prosperous-looking and as yet undamaged streets of this major south-west German city.

LEFT

A flak battery near Berlin Zoo. These guns, the 12.8-cm (5 inches) Flakzwilling 40, had twin barrels and were produced by Hanomag. The first eight were installed in various locations in the capital in the spring of 1942.

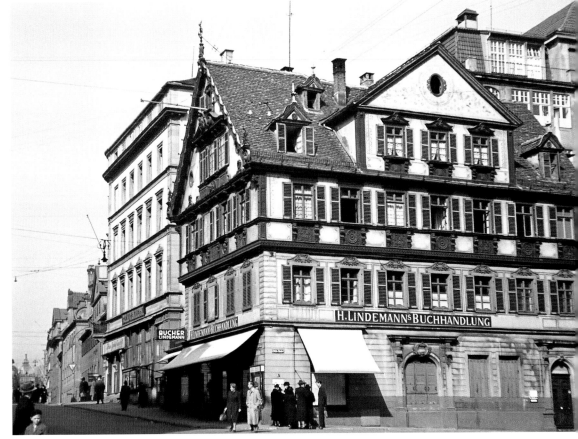

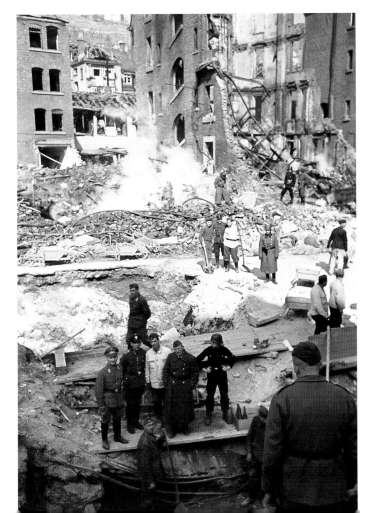

LEFT

Some of the destruction visited on Stuttgart, which between 1940 and 1945 endured 53 major air raids, mostly by the RAF. In total, 67.8 per cent of the city's flats and houses were destroyed and 4,562 people killed.

RIGHT

Pictured early in the war, Stuttgart's central railway station is intact. The banner reads: "Wheels must roll for Victory!"

FAR RIGHT

On March 9–10 1943, 264 RAF aircraft bombed Munich, destroying 291 buildings and damaging more than 2,600. These included many public buildings, such as the cathedral.

BELOW

The trams are still running in Dresden. But on February 13–15 1945 the 8th US Air Force and the RAF almost razed the city to the ground. High explosive and firestorms killed an estimated 35,000.

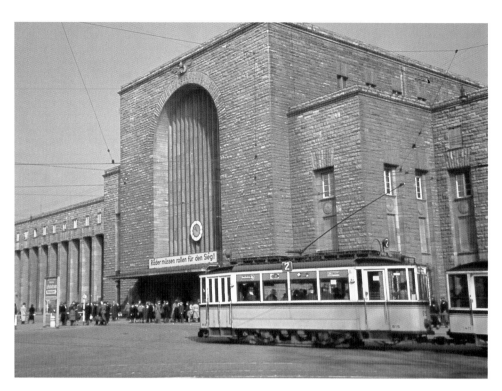

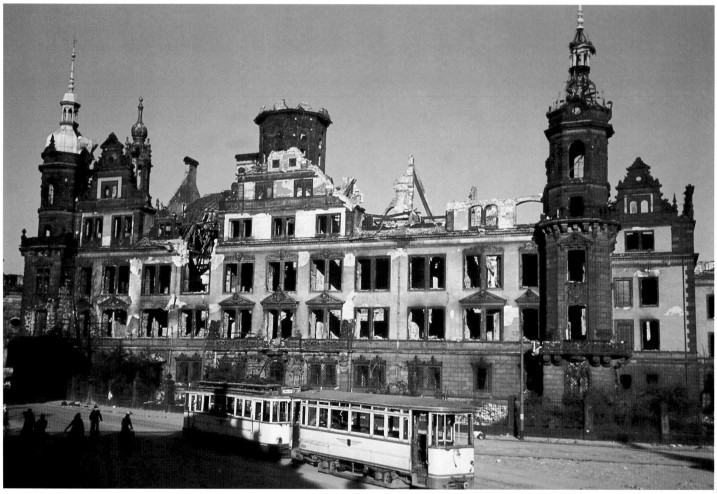

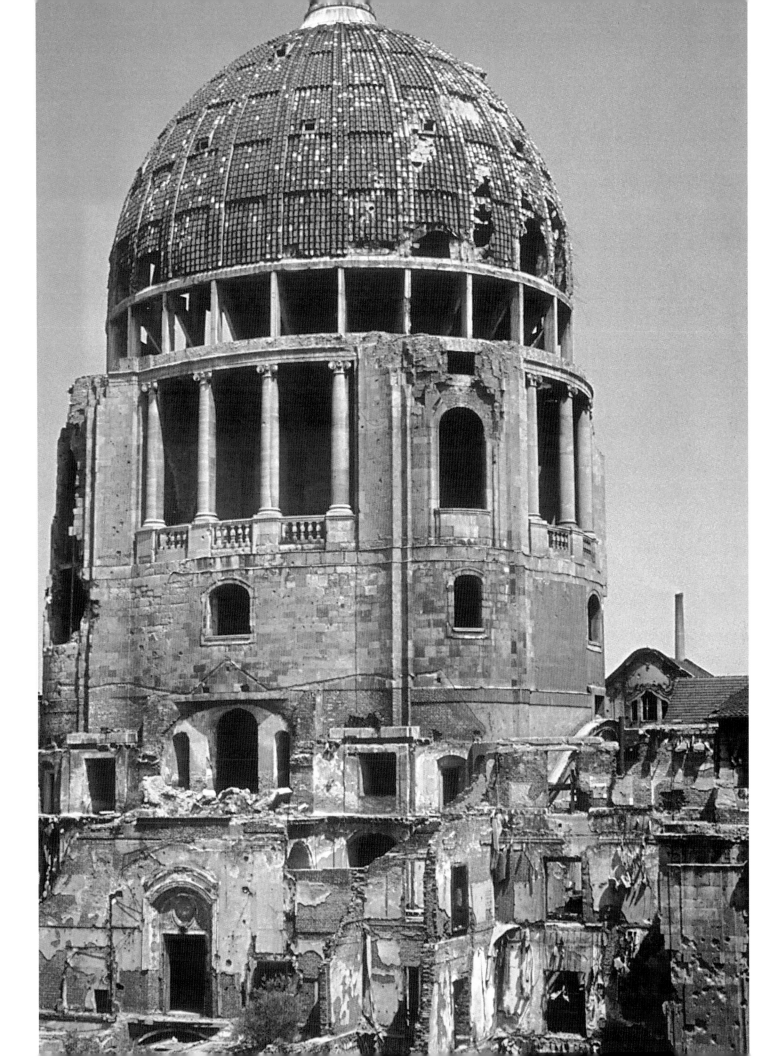

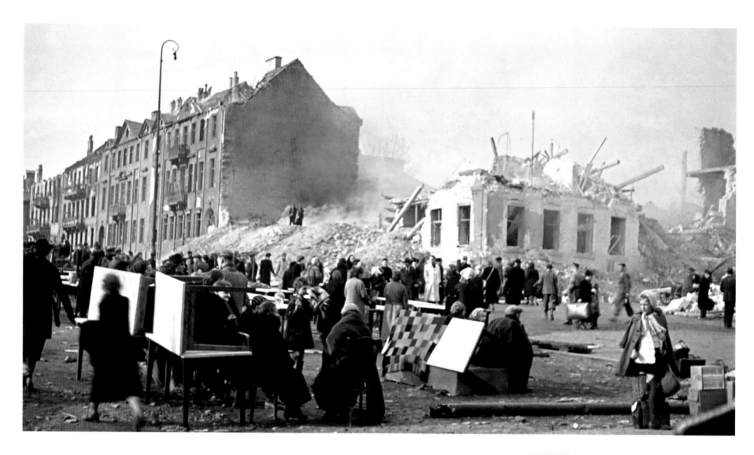

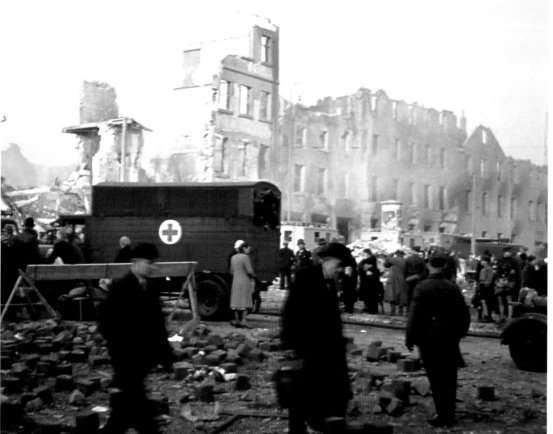

Civilians try to rescue their possessions from the ruins of their houses in Kassel. The RAF Bomber Command records list some major raids in October 1943, during which an estimated 63 per cent of all the city's accommodation became unusable and some 120,000 people had to leave their homes.

An ambulance stands out among the thronging civilians of Kassel's devastated old town. The last large RAF raid took place on March 8–9 1945. This was also the first large raid since those of October 1943, which caused huge losses.

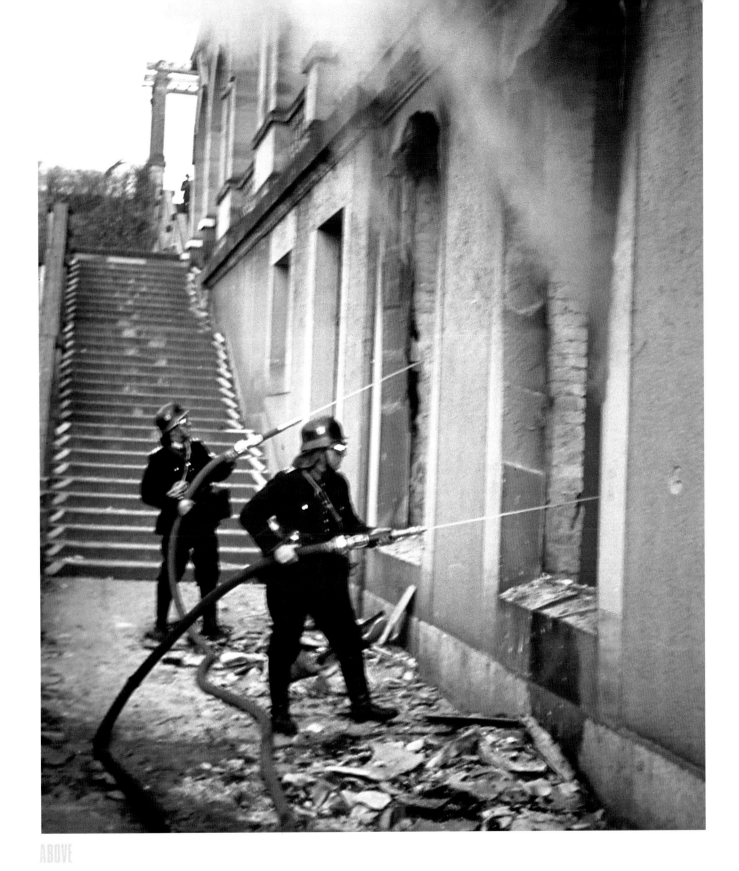

ABOVE

Slowly but surely the war began to have its effect upon the average German civilian, and nothing brought its reality home more forcefully than the Allied bombing raids. In destroying German towns and cities, these crippled not just the nation's industry but also everyday life. After the initial years of victory, Germany was starting to reap the whirlwind. Here volunteer firemen deal with a blaze after an air raid on Kassel.

GENOCIDE

Even before the war the Nazis targeted all those who would tarnish the ideal of the "Pure Aryan Superman", such as the permanently sick and crippled, the "psychologically immoral" or those who were contaminated by gypsy or other unacceptable blood. Thus the genocide came to encompass gypsies, in addition to Jews and the "subhuman" Poles and Russians. As well as carrying out mass extermination (an entire camp of 4,000 gypsies was exterminated by Josef Mengele and his assistants) by gassing or lethal injection, the Nazis used gypsies for all manner of appalling experiments. To quote just one source: "We could hear the terrible crying from the beating and torturing as they put the Gypsies on those cars ... they were crying and shouting, 'We are worried that Mengele and his assistants will come and burn us.'" And they did.

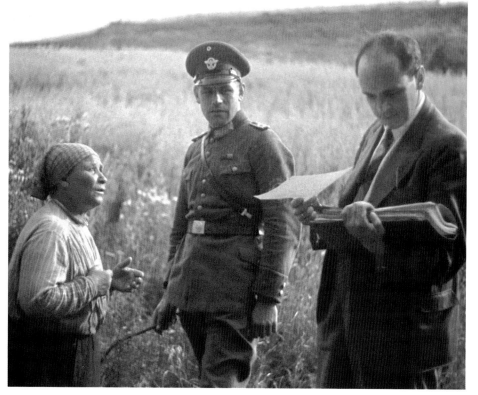

A gypsy woman is forced to submit to a "blood test" by two "doctors". Under the guise of "race research", medical experiments were carried out on these helpless people by murderous SS quacks without any public protest ever being raised.

Accompanied by a policeman, a Nazi "doctor" questions an elderly gypsy woman. At Dachau and Buchenwald experiments were carried out to see how long gypsies could survive on just salt water.

Rounding up the unwanted people of Asperg, near Stuttgart. Whether they were Jews, gypsies or just undesirables, men, women and children alike were subjected to the lust for mass murder of the "Final Solution".

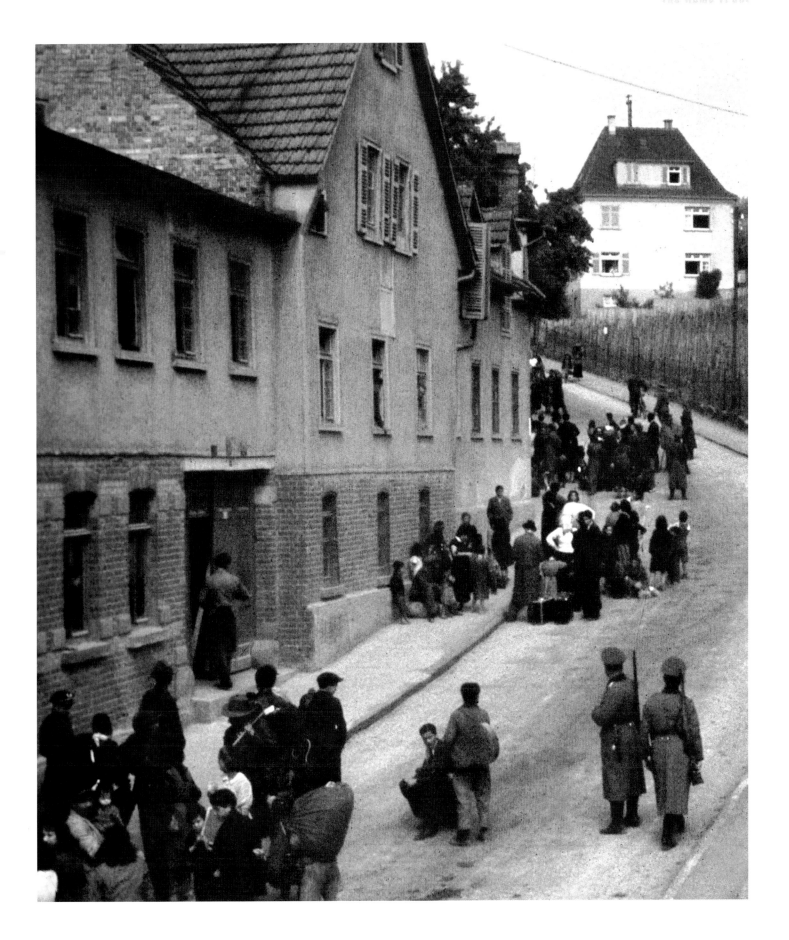

THE NEED FOR LABOUR

As has become clear over the intervening years, the wartime German economy could not have survived without the contribution of the 3.6 million foreign workers and 1.6 million prisoners of war who were forced to work in the country's industry. In particular, the Krupp industrial empire could not have continued production without its slave workers, many of whom were worked to death. But not all Germany's workers were slaves, and on occasion civilians would willingly undertake mundane construction work should the situation require it. This was, however, the exception rather than the rule.

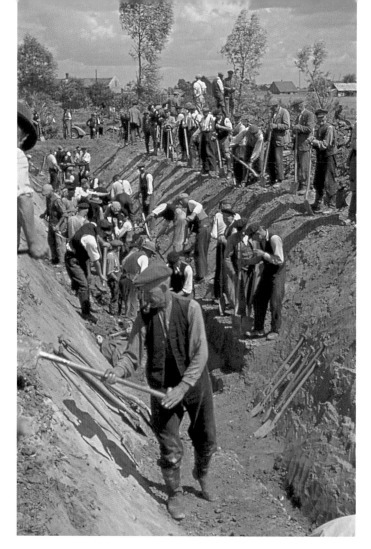

BELOW

Slave labourers from the Mittelbau Dora labour camp, in the Harz Mountains of eastern Germany, working on a V2 rocket. Even skilled labour was considered "expendable" should an explosion occur during dangerous work, because the system of slave labour ensured replenishment.

RIGHT

Civilians help to build the "East Wall" defences in East Prussia. Thoughts about the ever-approaching Red Army, who would be bent upon repaying all the suffering that had been inflicted on Mother Russia by Germany, must have helped these old men to find the energy to dig faster.

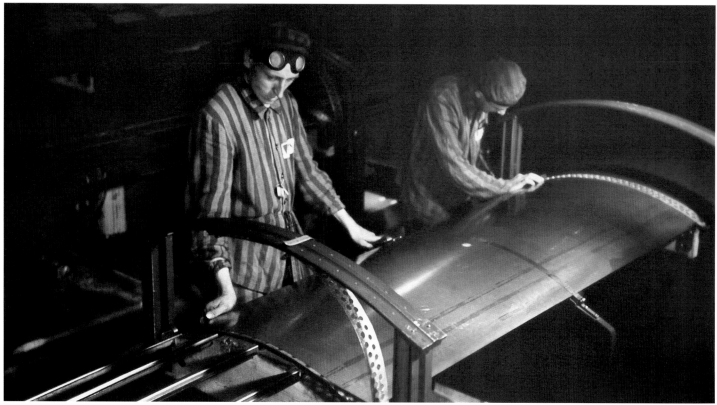

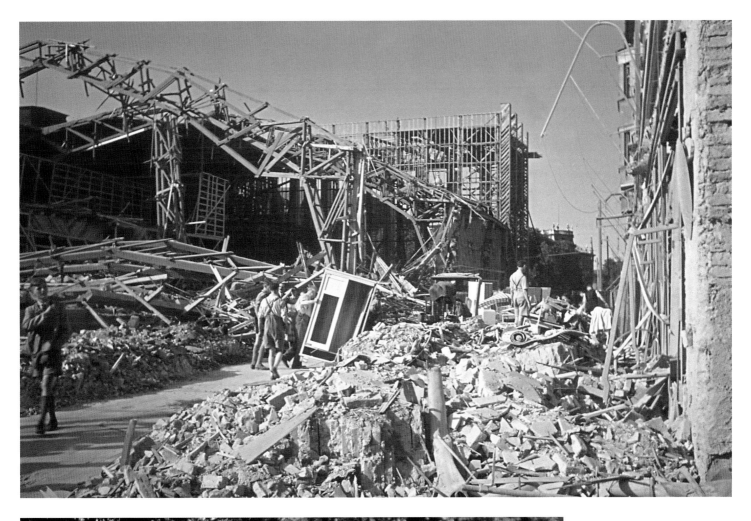

In many towns and cities the local population helped to move rubble produced by air raids. These young men look like members of the Hitler Jugend.

Volunteer firemen in Kassel pose in front of their fire trucks after a night fighting fires. Kassel received its fair share of attention: on the night of October 22 1943, for example, an estimated 10,000 civilians were killed.

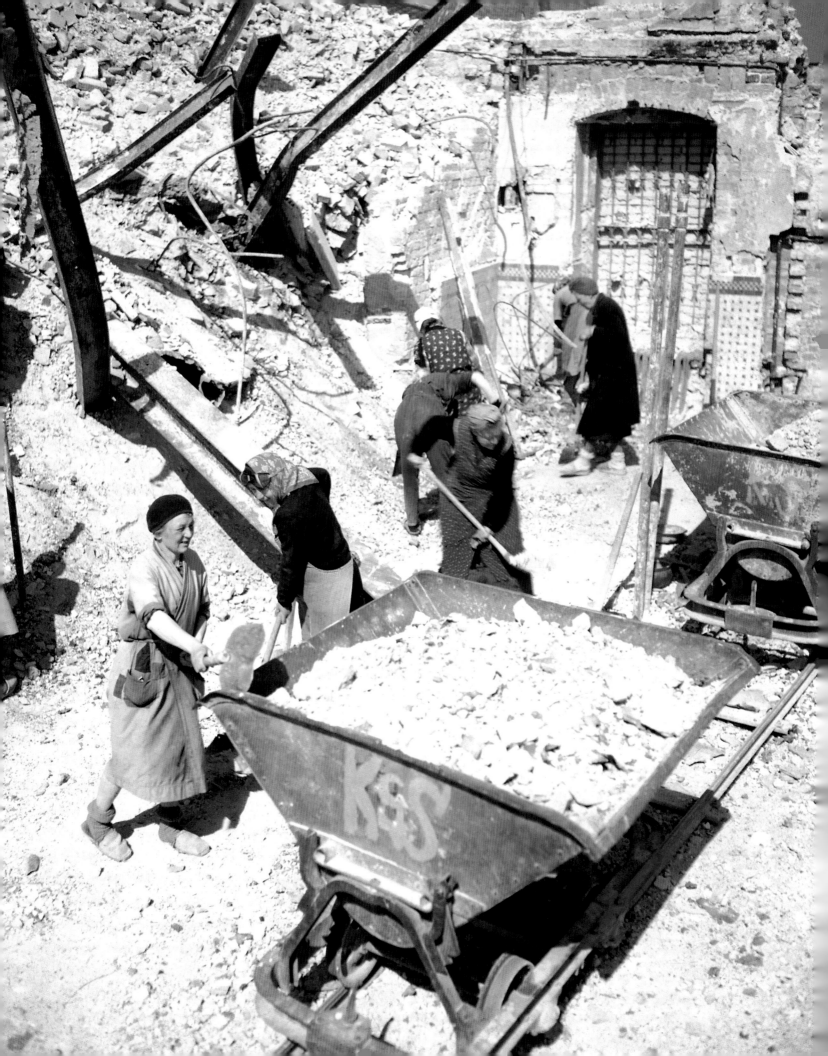

CHAPTER 5

The Fall of the Third Reich

In the spring of 1944 it was not a question of when the second front – the Allied invasion of north-west Europe – would take place, just a question of where. The massive Allied army, over 3 million men training and preparing in Britain, knew this. The waiting defenders dug in behind the Atlantic Wall knew it too. The defences ensured that the Allies would be extremely unlikely to secure a port by direct attack, and Hitler worked on the principle that control of the ports would stop the enemy getting a foothold. The German defenders, an army of occupation that had been in place since 1940, were commanded by Field Marshal Gert von Rundstedt and Field Marshal Erwin Rommel, the second now in command of Army Group B, whose troops had direct responsibility for protecting the beaches. The Germans knew the landings would come soon: they could see the troops training and had even inflicted losses on Allied vessels off England's south coast with the light, fast motor torpedo boats which the Allies called "E-boats". But where was the hammer to fall and when?

This was the crucial question. Hitler thought the Pas de Calais – the closest route – was the obvious choice. Much Allied time was spent in hiding the truth behind deception operations designed to convince the Germans that it was to be the Pas de Calais. Rommel wanted to fight the battle on the beaches – experience had shown that this was the best approach – so he needed his armoured reserves as close as possible to the coast. This was totally at variance with the views of those who actually had direct control of the Panzers, namely General Geyr von Schweppenburg's Panzer Group West.

In fact the Allied sea landings of Operation Overlord, which took place on D-Day, June 6, 1944, would be made on five carefully selected beaches on the Normandy coast and would be preceded by an airborne assault about four and a half hours before the first amphibious landings took place. Massive air strikes by 2,500 bombers and 7,000 fighter-bombers would soften up the beachhead areas, and far enough beyond, to ensure that the Germans were still left guessing as to whether Normandy was just a feint attack and that the real assault would be unleashed, as anticipated, in the Pas de Calais. And, most important of all, the

Allies would bring their own port with them – the Mulberry Harbours, two of them, which would obviate the need to capture one of the heavily defended French ports.

A few days before the Allied landings Rommel had once again been trying to get Hitler to visit the Western Front, so that he could show him how short Army Group B was of both manpower and matériel. He also wished to get Hitler to support his view about control of the all-important Panzer divisions. When it became clear that Hitler would not come, Rommel decided to go and see him instead and arranged a personal interview for June 6. It had been decided that the period June 5–8 was an unlikely time for an invasion as the tides were unfavourable and none of the Luftwaffe reconnaissance reports had shown any obvious signs of pre-invasion activity. So it was that, for a second time (the first was at Alamein in the North African desert), Rommel was away at the critical moment. As soon as he heard about the Allied landings he returned to his headquarters at La Roche-Guyon on the Seine north-west of Paris.

The Allied cover plan worked perfectly, so it was not clear

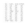

Before the prisoners came home there was a grave shortage of men, so much of the manual labour had to be done by women. Here they transport rubble from bomb sites to earn money to feed their families.

whether the Normandy invasion was the main landing or just a simulated assault ahead of the main one. However, as the battle reports built up it became clear that Normandy was the major assault area and so elements of the precious Panzer divisions were released for counter-attack roles. However, by then it was too late; the Allies had achieved their toehold on Festung Europa, Fortress Europe, and their overwhelming air superiority prevented the daylight movement of the German reserves – for example, the 2nd SS Panzer Division "Das Reich", which moved from southern France to Normandy, was so harried by the Resistance and air strikes that it did not enter action until June 26, by which time the Allied invasion was secure.

The defenders of the Normandy section of the Atlantic Wall fought bravely enough, but crushing Allied naval supporting fire, coupled with almost continuous air attacks, had an inevitable effect. The beachhead was successfully enlarged and an armoured breakout achieved in the west by the Americans, while the British and Canadians pinned down much of the German armour around Caen in the east, then destroyed it in the Falaise pocket. General Patton's US Third Army swept through northern France at a speed reminiscent of that of the Blitzkrieg in 1940, despite the individual superiority of some of the German weaponry, as exemplified by Obersturmführer Michael Wittmann and his Tiger tanks at Villers-Bocage, near Caen. Against the experienced British 7th Armoured Division, on June 13–14, Wittmann almost singlehandedly knocked out 25 tanks and other vehicles, adding to his already massive tally of 119 Soviet vehicles destroyed on the Eastern Front. But individuals could not hold back the inevitable, while only a shortage of fuel could hold up Patton's whirlwind advance. One of the many battle casualties was Rommel, who was seriously wounded when his staff car was strafed on July 17 by the dreaded Jabos (Jagdbomber, fighter-bomber). Rommel would take no further part in operations, but would not be permitted to recover quietly.

At the height of the battle for France, on July 20, the unthinkable happened at Hitler's Rastenburg HQ in East Prussia. There was an assassination attempt on the Führer, when a bomb was exploded during a conference of senior officers. The attempt failed and the plotters, led by Count Claus von Stauffenberg, were apprehended, rounded up and executed. Many others were implicated and would feel the Führer's wrath – innocent or guilty, those against whom there was the slightest whisper of suspicion suffered. One of these was Rommel, whose name had been mentioned by Karl Heinrich von Stülpnagel, who originally supported the von Stauffenberg plot. Rommel was given the choice of committing suicide or facing a

court martial and seeing his family murdered. He took poison on October 13 and was given a state funeral five days later.

Meanwhile the battle went on apace in the West, with Allied landings in southern France on August 15. Paris was liberated on August 20 and Brussels on September 4. The battered German army, which had sustained crippling casualties, was being pushed back behind the Siegfried Line, or Westwall – their equivalent to the Maginot Line, which ran for about 480 kilometres (300 miles) – but it was still strong enough to resist Montgomery's daring plan to seize a series of bridges over the Maas, the Waal (Rhine) and the Lek (Lower Rhine) using three airborne divisions. This operation was initially successful, but the final bridge, at Arnhem, could not be captured from an unexpectedly strong German defence.

As the winter weather began to grip the battlefields, Hitler launched a surprise counter-offensive in the Ardennes. The "Battle of the Bulge", as it came to be called, was the result of a desperate last gamble to split the Allied forces, halt their drive to the Rhine, capture the vital port of Antwerp and perhaps even force the Americans and British to negotiate a separate peace. Helped by the bad weather that severely limited air operations and in complete secrecy, the Germans chose to attack a quiet, sparsely defended area of the US Army front. Led by their armour, they initially achieved spectacular success, until the defenders regained their nerve and contained the German advances, holding on to such key places as Bastogne. The gamble failed, the Germans suffered considerable losses from which they would never recover and the four-week assault ground to a halt. It was to mark the beginning of the end of German resistance on the Western Front. Having forced the battered German army back behind the Siegfried Line by mid-March, the Allied armies stood on the Rhine, from Holland to the Swiss frontier. US and British forces made successful crossings of this great river barrier and struck eastward.

THE EASTERN FRONT

Two and a half weeks after D-Day, over a hundred Red Army divisions began a massive attack along the entire Eastern Front. By the end of June they had pushed the Germans back to a line from Riga to Romania. Hitler issued another of his senseless "no withdrawal" orders to Army Group Centre; they obeyed, as did the garrison of Sevastopol, which was surrounded and then annihilated. German losses were well over 350,000, and by the end of July the Soviets had entered Poland and taken Brest-Litovsk and Lublin. They could have gone on to liberate Warsaw but halted. Anticipating support from the Soviet Union, the Polish underground rose up against the Germans; instead they

were massacred and their capital razed to the ground, while Stalin's forces stood by and watched.

On the other European front – Italy – the Germans had been pushed far to the north, fighting to hold their last real line of defence, the Gothic Line, a series of German-built defences running from coast to coast from north of Lucca to south of Pésaro. Things were just as bad in the Balkans, while in January 1945 the Red Army launched further massive attacks from the line of the River Vistula, sweeping across the rest of Poland and on into Germany. By March the rampaging Red Army was at the River Oder, just 56 kilometres (35 miles) from Berlin, while the battered German people mobilized their meagre resources for a last stand. Berlin was defended by the Volkssturm (People's Guard) which consisted mainly of old men and young boys. Amid the ruins of his capital the Führer took over command of its defences on April 23, just two days before Berlin was encircled and Soviet and US troops linked up south of the city, at Torgau on the River Elbe. Seven days later Hitler and his mistress Eva Braun were married, and then committed suicide in their underground bunker. In the last months he had determined that nothing would be left of Germany after he had gone and had embarked on a scorched-earth policy which, if not halted, would have left the German people in even more desperate straits at the end of the war. Albert Speer, among others, did what he could to negate this tactic and left some of Germany's industrial base salvageable.

On April 30, the same day that Hitler committed suicide, the Soviet forces reached the Reichstag building. On the following day the Red Flag was hoisted over Berlin and the Soviet forces began the "Rape of Berlin", during which they wreaked their personal revenge on Germany for causing the "Great Patriotic War". On May 7, 1945, after nearly six years of war, General Alfred Jodl, representing the Dönitz government, signed an unconditional surrender. VE-Day (Victory in Europe) was rapturously celebrated and the war there was over. Germany was divided into four zones of occupation – US, British, French and Soviet – while Berlin became a divided city controlled by a commission of the four powers.

THE CONSEQUENCES

With peace came a growing conviction among the victors that Germany must be made to pay for the horrors it had visited upon Europe. But should this be the entire German nation or just the most guilty Nazis? Should Germany's war machine be dismantled or its entire industrial potential destroyed? The arguments raged back and forth. For example, should the Germans be forced to pay the same sort of crippling Versailles

reparations that had undoubtedly helped to cause the war in the first place? There was little agreement among the Allies and even the generosity of the Americans' Marshall Aid Plan was scorned by the Soviet Union, condemning almost half of Europe to a long slog of rebuilding. The Soviet Union had already begun to seize raw materials, machinery and vehicles from German satellites such as Romania. A compromise was eventually agreed, the Soviet Union being allowed to take industrial equipment from its zone of occupation, but there is little evidence that it was ever put into actual use.

On the human side, Germany had to be rid of the Nazis, but this was not easy. Denazification was swift and easy in the Soviet zone – the Russians simply shot all government officials down to and including the Bürgermeister (mayor). But the other Allies were understandably more squeamish. At its height the Nazi Party had had over 8 million members, many of whom had held important positions, running the country or industry. Remove them and there would be even worse chaos. So, although some 170,000 known Nazis were captured and tried for their wartime activities, many of them received little or no punishment, while others were spirited away to distant countries thanks to a highly organized escape network. Meanwhile, rough justice was being meted out to collaborators in the various countries in the German "Empire". Many were shot out of hand or received summary punishment.

In November 1945 a tribunal sat at Nuremberg to try the most notorious of the Nazi war criminals. Three of the worst – Hitler, Goebbels and Himmler – were already dead and Bormann had vanished. Others – such as the elderly armaments giant Gustav Krupp – were judged too sick to stand trial. The International Military Tribunal, with judges and prosecutors from the United States, Britain, the Soviet Union and France, tried 21 of the remaining major German war criminals. (There had been 22, but Robert Ley, the leader of the German Labour Front, hanged himself in his cell on the day the trial opened.) In late September the verdicts and sentences were announced: 11 were sentenced to death by hanging, the rest to life imprisonment or lesser sentences. One of those destined to die, Hermann Goering, managed to cheat the hangman by taking poison on the day he was sentenced.

So ended the Thousand Year Reich, but the legacy of its exit left Europe in ruins, and touched the lives of everyone living there. It would take a few more months to force the Japanese to surrender, bringing peace at last after a global war that had caused the deaths of at least 68 million people. As one historian put it, "World War One created democracies and hope. World War Two created police states, despair, disgust with humanity, Cold War mistrust and fear of the 'Bomb'."

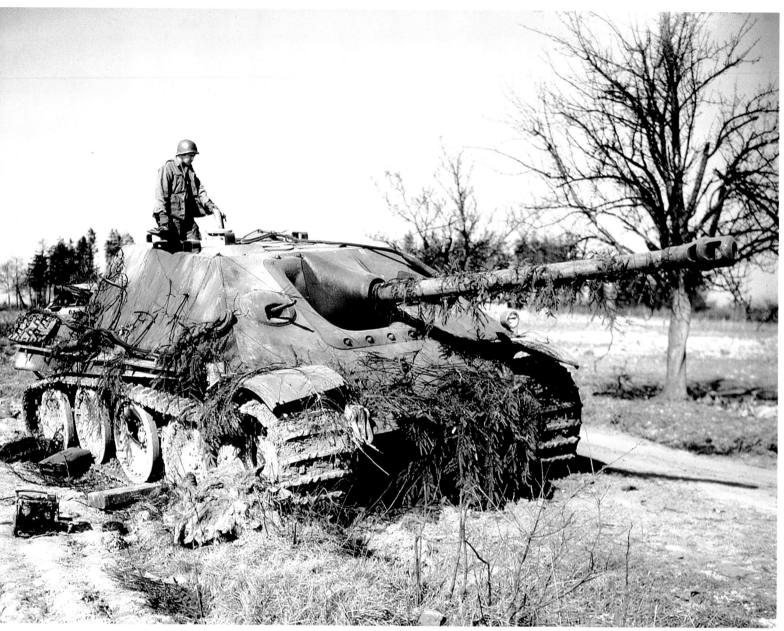

A tank destroyer is destroyed. A Jagdpanther is inspected by a
GI somewhere in France. Of the fewer than 400 of these tanks
built, only about a dozen saw service during the Allied invasion
of Normandy, but their highly efficient 8.8-cm (3.5-inch) gun and
low silhouette made them a fearsome adversary.

A knocked-out Panther, probably from the
Panzer Lehr Division, photographed near
Caen or Bayeux. Its 7.5-cm (3-inch) L/70
gun could penetrate with ease any Allied
tank it confronted.

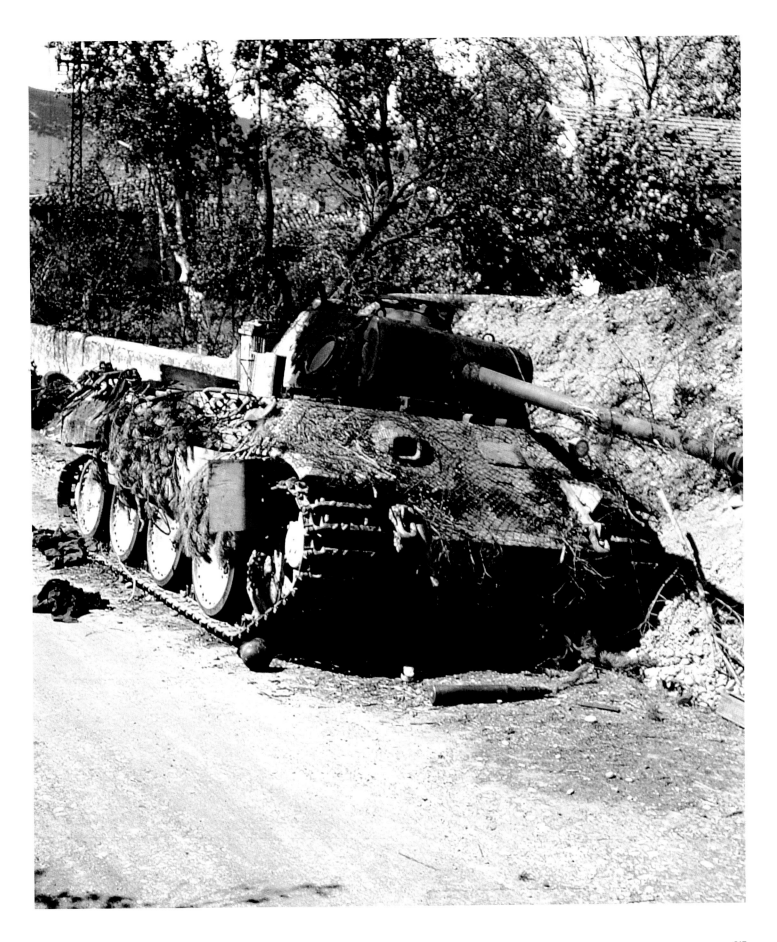

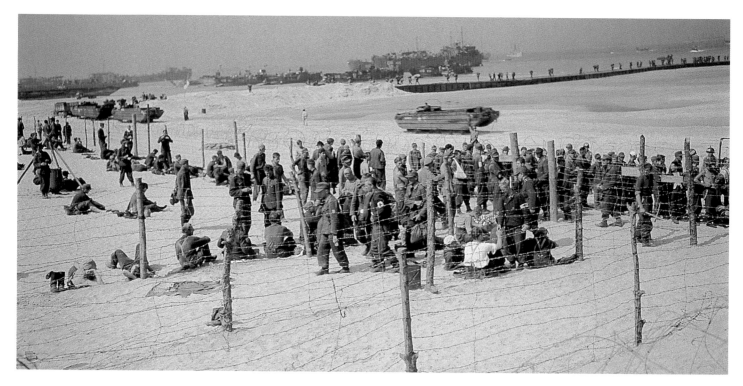

"For you the war is over."
German prisoners are gathered
together on the Normandy
beaches in June or July 1944
to be shipped to POW camps in
Britain. Behind them are a
number of American DUKWs
(amphibious trucks).

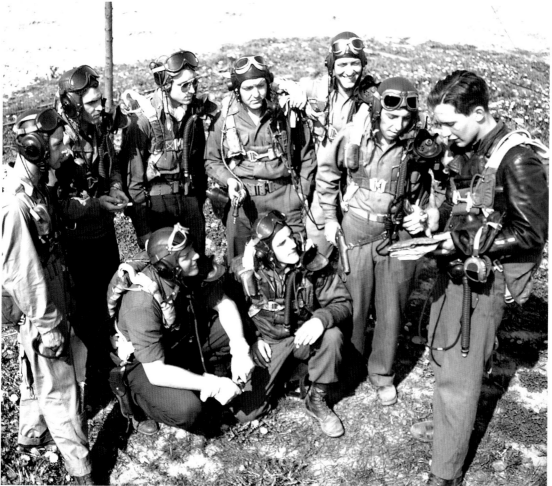

LEFT

American fighter pilots get a
pre-sortie briefing from their
flight commander. The top US
Air Force ace in air-to-air
combat was Major Richard J.
Bong, with forty kills.

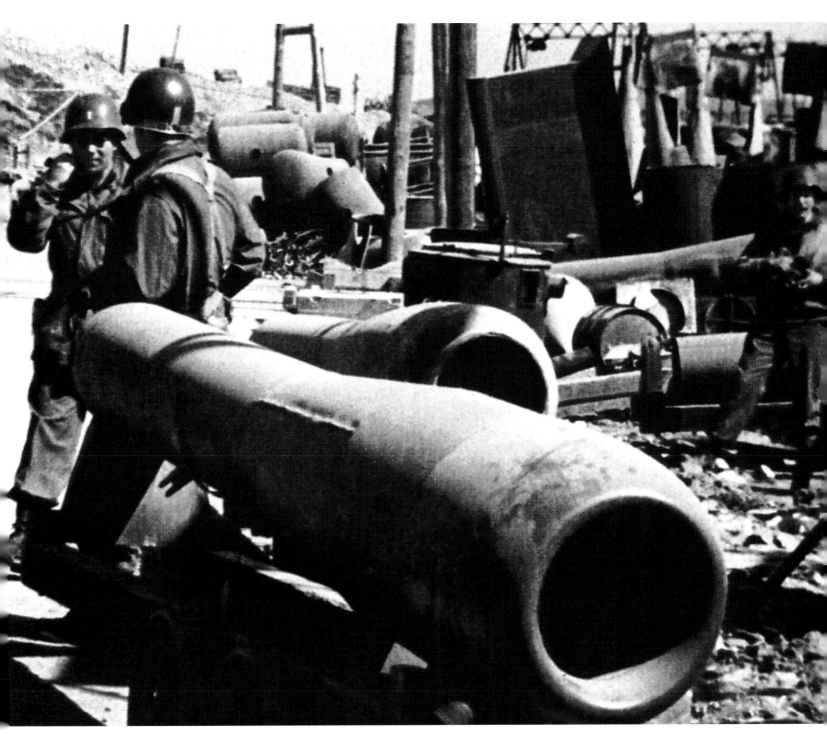

US troops examine V1 flying bomb
parts. The missile's Argus pulse jet
engine gave it a top speed of just
under 800kph (500mph) and a range
of 240 kilometres (150 miles).

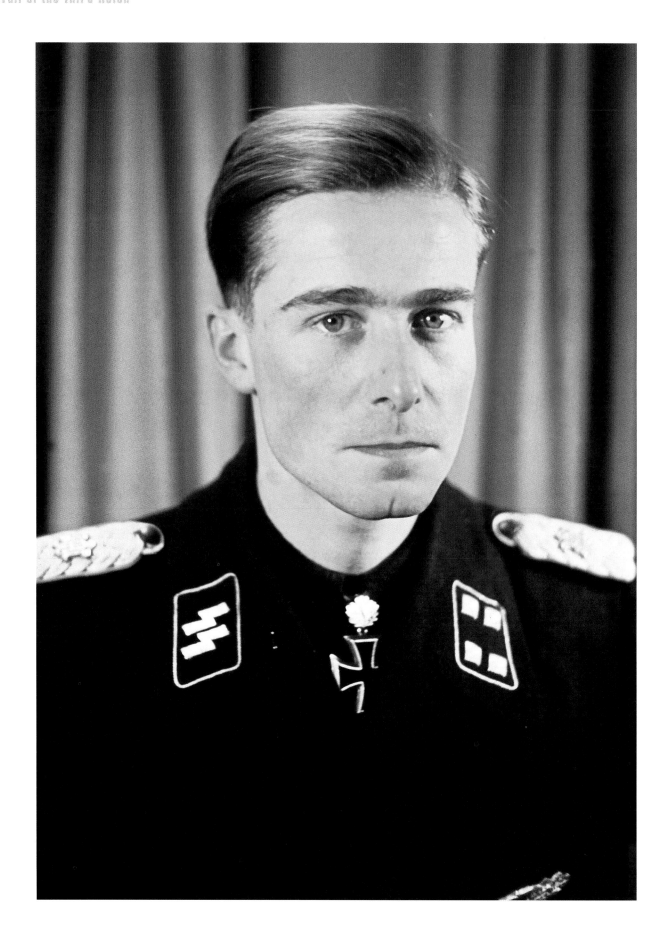

SS Obersturmbannführer Jochen Peiper was a regimental commander in the Waffen-SS. This unit was responsible for the massacre of nearly 100 American soldiers at Malmédy, Belgium, during the Battle of the Bulge.

An American patrol in the Ardennes towards the end of 1944. The bitter winter weather helped the Germans' assault by preventing Allied aircraft from flying, but at the same time slushy snow hindered the advance of their own heavy armour.

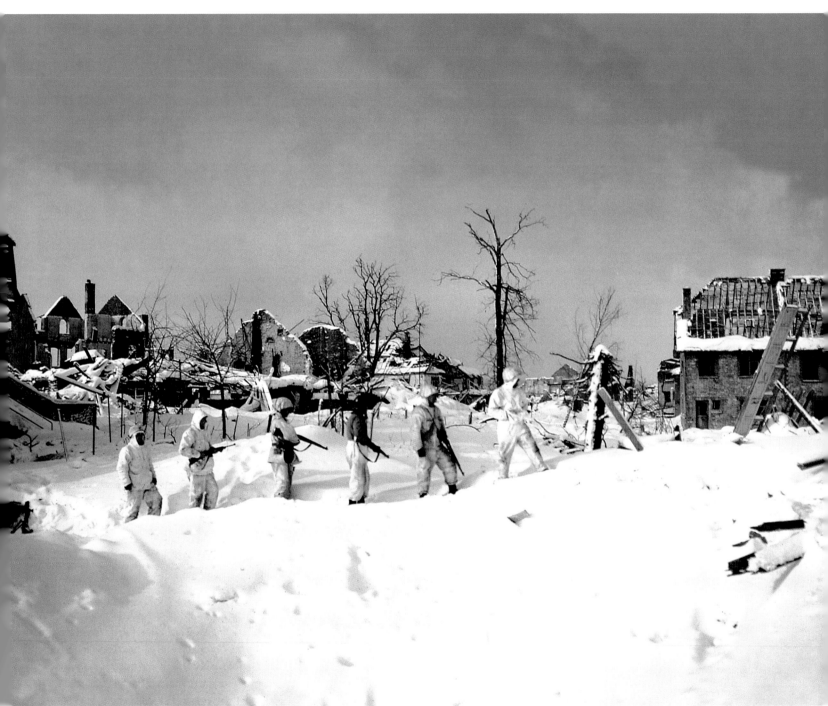

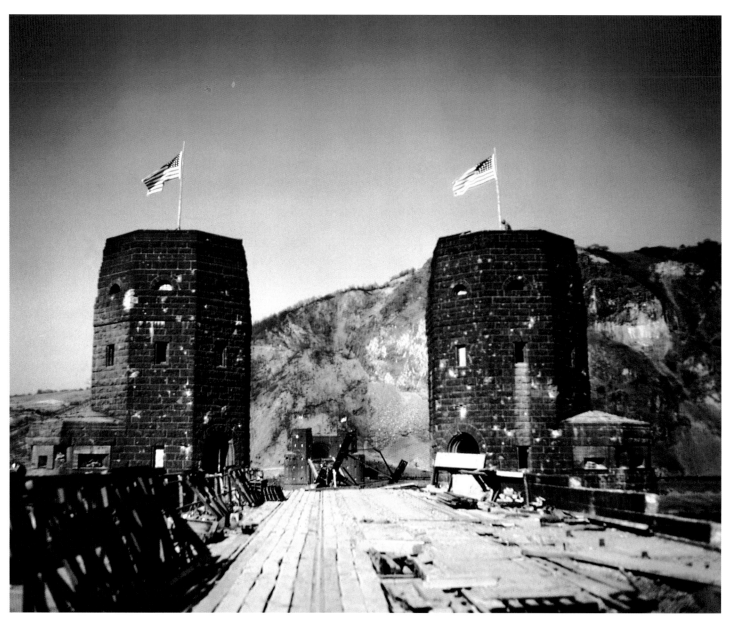

The honour of being the first unit to
capture a crossing over the Rhine that
had not been blown up fell to the US 9th
Armored Division. On March 7 1945
Lieutenant Karl Timmerman and a small
detachment rushed the Ludendorff
railway bridge at Remagen, saw off the
defenders and disconnected the charges
they had just laid.

Waffen-SS General Joseph ("Sepp") Dietrich, holder of the
Knight's Cross with Oakleaves, Swords and Diamonds, had
participated in the "Beer Hall Putsch" in Munich in 1923, in
the early days of the Nazi Party, and at one time had been
Hitler's personal bodyguard. A strong and fearless leader, he
was much admired by his soldiers.

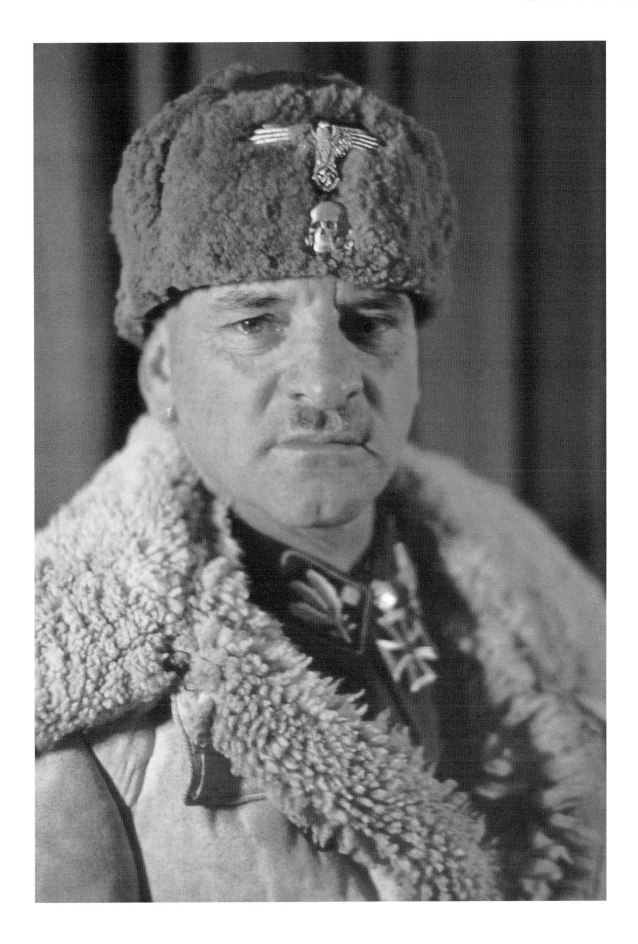

PREVIOUS PAGE

A battered German 2-cm (0.75-inch) Flakvierling 38 self-propelled anti-aircraft gun in position just outside Königsberg, in East Prussia, in the early summer of 1944. The city, which was ceded to Soviet Russia the following year, is now known as Kaliningrad.

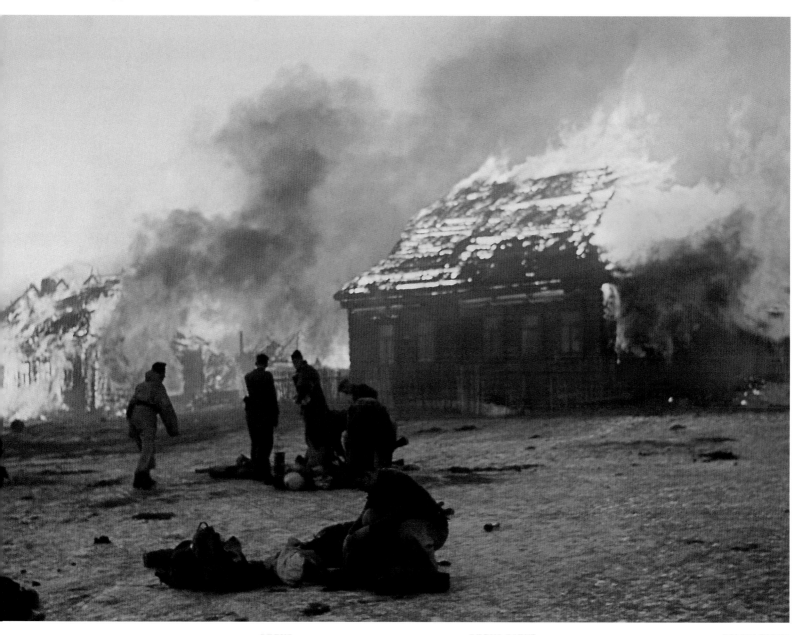

ABOVE

Buildings in East Prussia burn as the Wehrmacht falls back all along the line in response to the inexorable advance of the Red Army.

ABOVE RIGHT

A lone two-man machine-gun team in their snow-covered foxhole prepare their MG 34 for action in defence of Königsberg in early 1945.

BELOW RIGHT

German refugees, their belongings on a two-horse sled, flee from the avenging Red Army, now overrunning East Prussia.

The Fall of the Third Reich

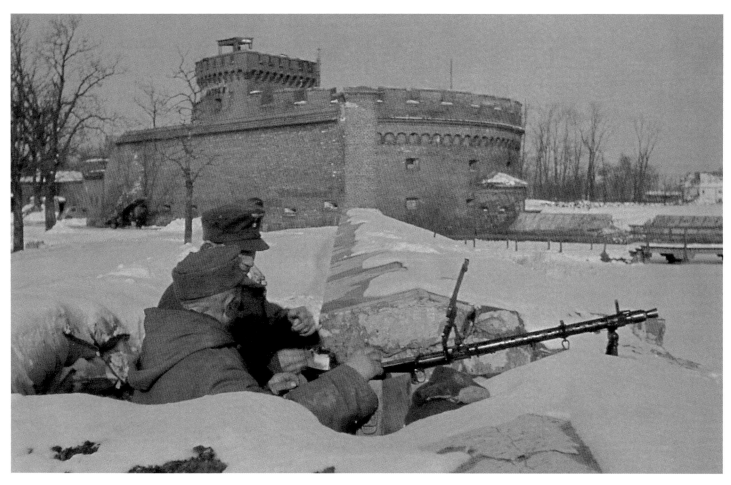

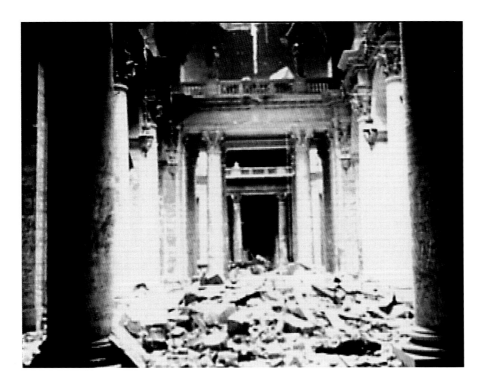

LEFT

This is what was left of the
sumptuous corridor leading to
Hitler's office in the Chancellery
after the Red Army had seized the
building in the heart of Berlin.

RIGHT

A bullet-pocked, graffiti-marked
plaque at the Reichskanzlei
(Reich Chancellery) in Berlin gives
a good indication of the state of
dereliction of the German capital.

LEFT

In January and February 1945, the
Red Army's 1st Baltic Front and 3rd
Belorussian Front Armies swept into East
Prussia, surrounding the German Army
Group Centre in Königsberg. Now it was
the turn of the East Germans to flee or
face the avenging hordes. Here two
women with laden sledges begin their
desparate journey westwards.

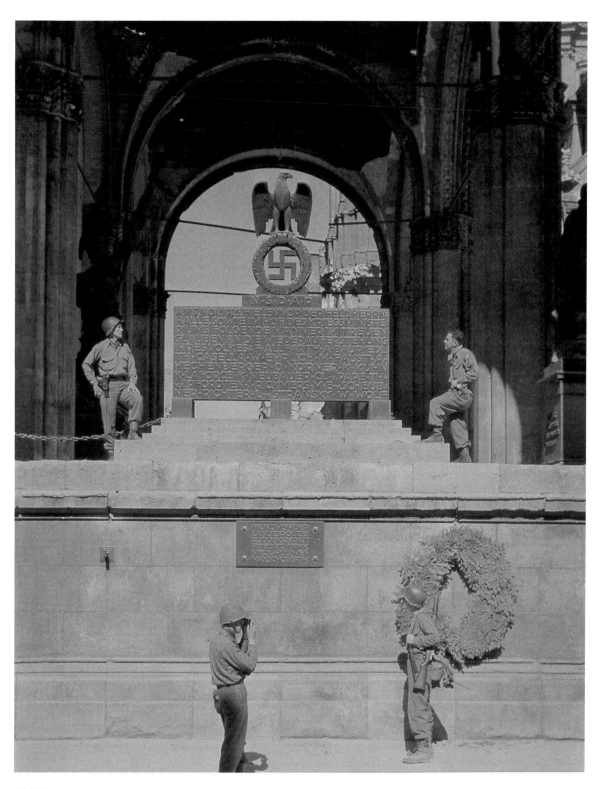

American soldiers photograph a memorial in Munich to Hitler's
Beerhall Putsch. It commemorated Hitler's unsuccessful
attempt to seize power on the evening of 8 November 1923
during a meeting held in the Bürgerbräu Keller.

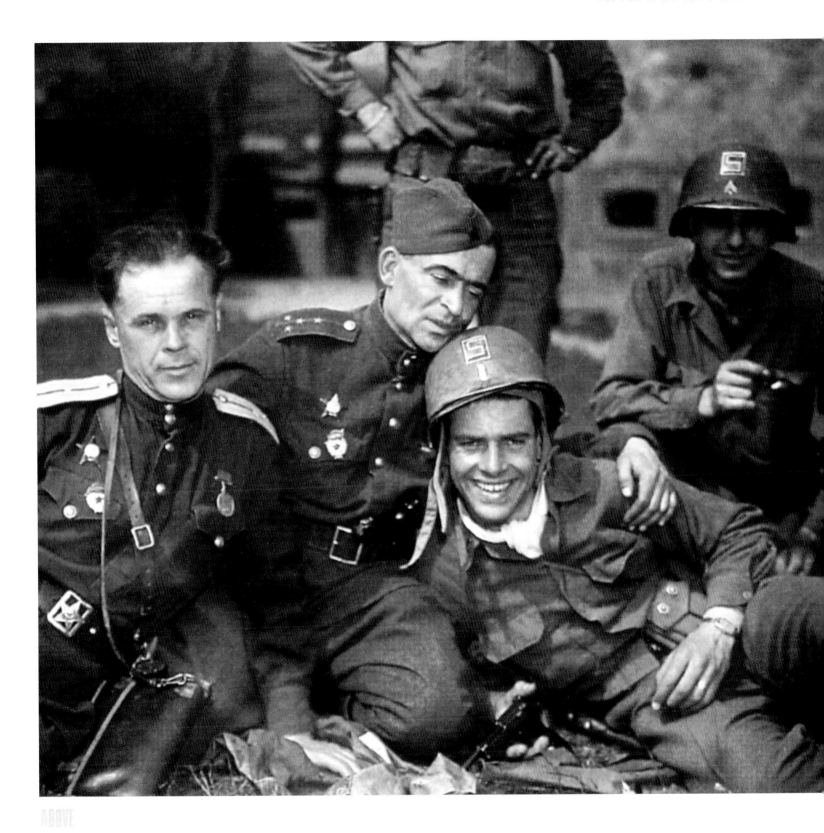

Comrades in arms. Americans of the 69th Infantry Division
and Russians of the 1st Ukranian Army link up at Torgau,
on the River Elbe north-east of Leipzig, on April 25 1945.

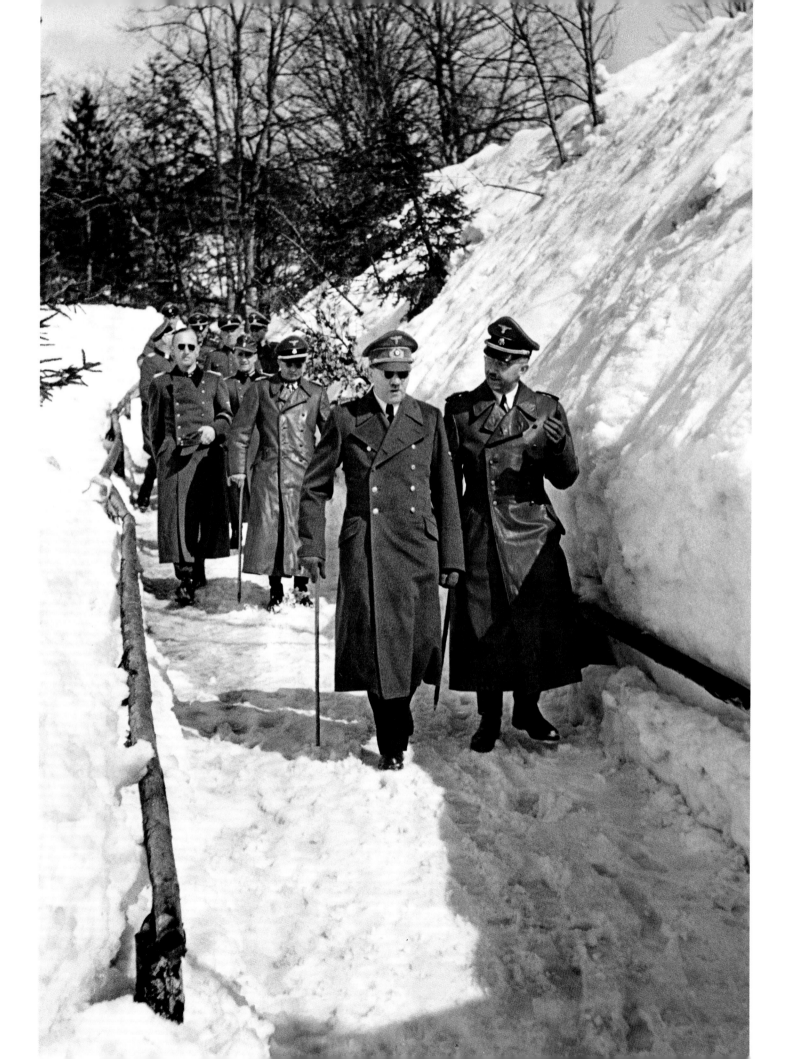

Hitler and Himmler take a snowy walk near the Berghof in early
1945. Himmler, designated head of both the Volkssturm and
the Werwolf – a guerrilla group formed towards the end of the
war – was expected to carry on a last-ditch fight here.

The Bavarian mountains were not to be a final stronghold for
Himmler: in April 1945 he made a clumsy approach to the
Allies, offering to free Jews and capitulate. When Hitler, by now
in the bunker in Berlin, heard of this he ordered his arrest.

BELOW

On March 11 1945 Hitler met with the heads of the 9th Army
at Bad Saarow, near Berlin. Here he talks to General Theodor
Busse, Commander-in-Chief of the 9th Army, while behind him
is General Ritter von Greim, the last C-in-C of the Luftwaffe.

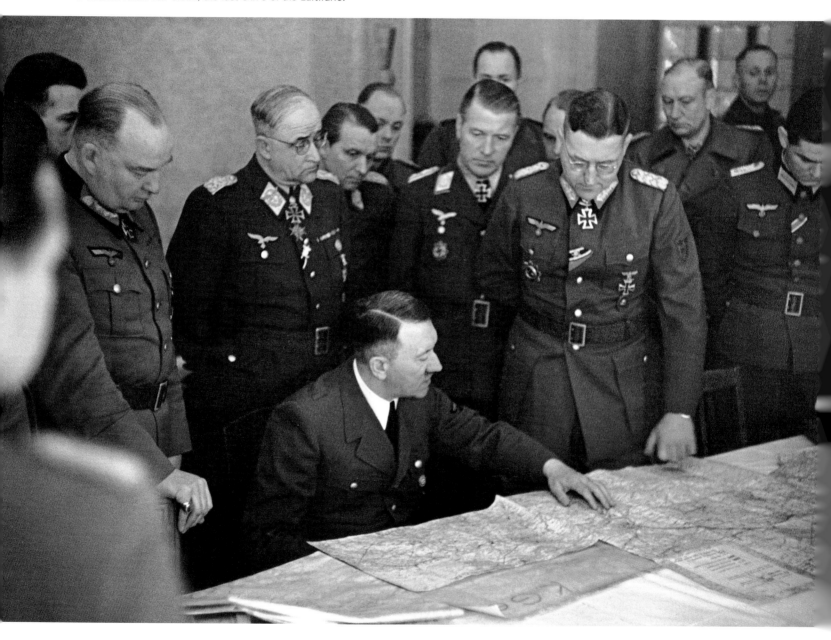

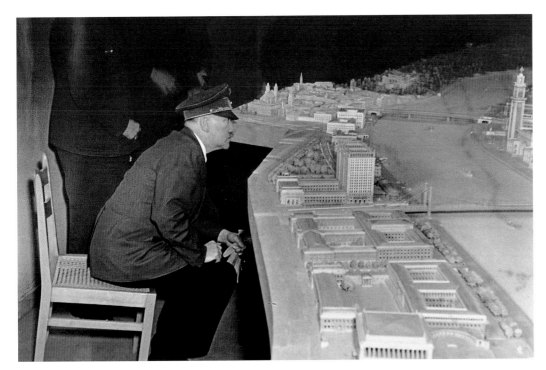

LEFT

Even in the spring of 1945, with defeat imminent, the Führer spent many hours poring over an illuminated model of a grandiose project to rebuild Linz. He was determined the city would outrank Vienna and become the "Jewel of Austria".

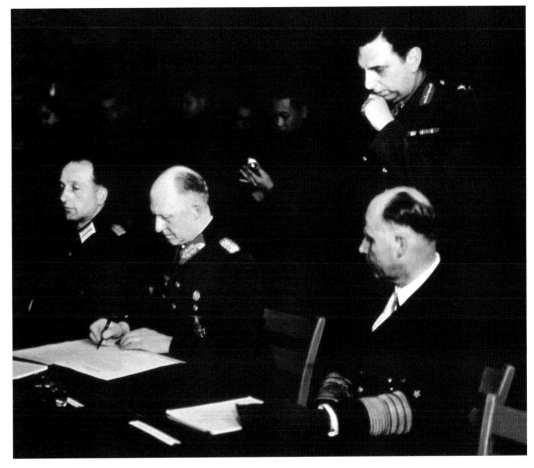

RIGHT

General Alfred Jodl, as representative of the short-lived government led by Hitler's chosen successor, Grand Admiral Karl Dönitz, signs the instrument of surrender at Rheims on May 7 1945. On his left sits Admiral Hans-Georg von Friedeburg, also a member of the German delegation.

THE FINAL SOLUTION

Die Endlösung, the Final Solution, was the code name for Hitler's plan to exterminate all the Jews in Europe and, although estimates vary, it is widely agreed that some 6 million were annihilated by the Nazis. Many of these perished in the concentration and extermination camps which were built in Germany, Austria, Poland and Bohemia between 1933 and 1942. Some of the camps remained in operation until they were seized by the Allies in 1945. The scenes of horror revealed by photographs and newsreel shocked the entire civilized world.

GIs look on stony-faced as they are shown the Torture Room at Buchenwald, near Erfurt. Some days after it was liberated the American broadcaster Ed Murrow delivered a moving and now famous commentary from inside the camp.

Pitiful inmates of Buchenwald look through the wire at their liberators. Deaths averaged some 6,000 a month – from starvation, beating, torture and sickness – and it was not even an extermination camp.

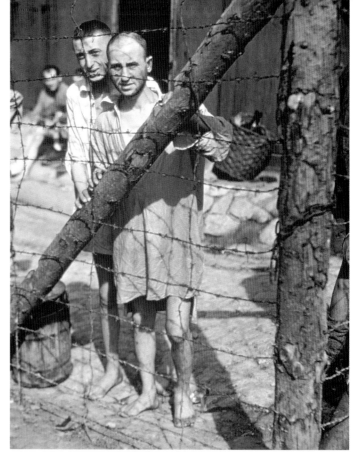

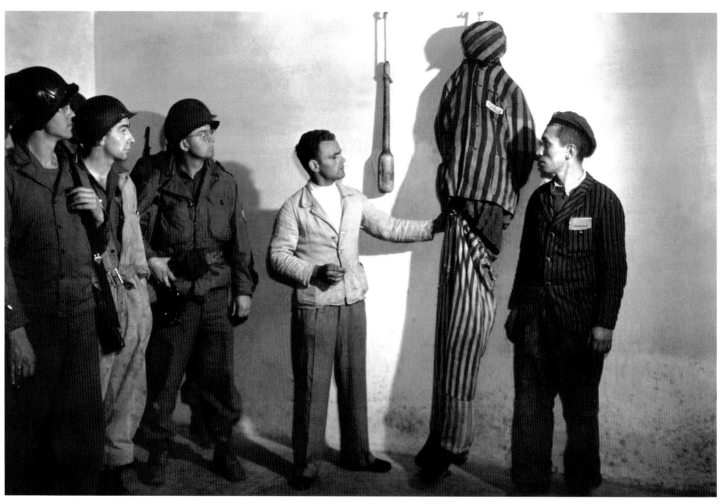

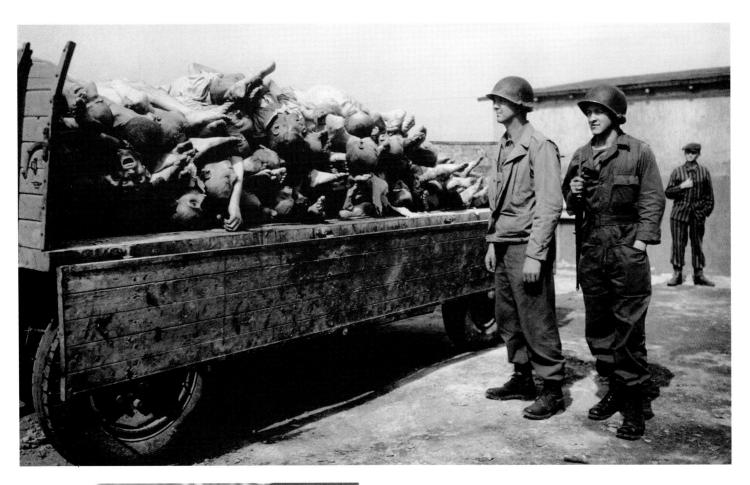

ABOVE

A wagon piled with corpses at
Buchenwald. This was the only way
that anyone ever "escaped" from
the camp.

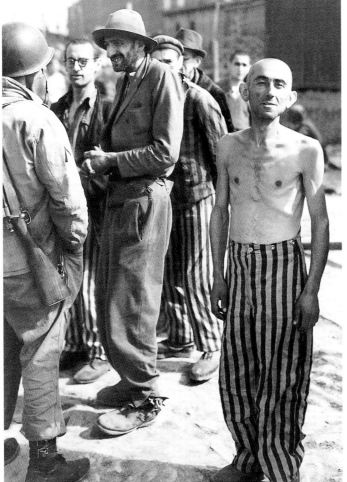

LEFT

GIs of the 80th Infantry Division
talk to emaciated inmates shortly
after liberating Buchenwald on
April 10 1945.

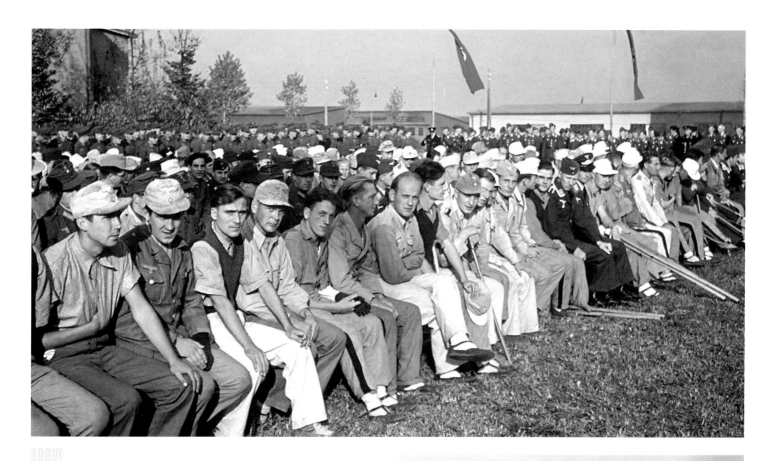

ABOVE

Prisoners just about to be returned to Germany from Britain. Some had to be repatriated from POW camps in North America.

Clearly, the Allies had to provide shelter for captured female members of the Wehrmacht, but this temporary holding centre for women POWs in Germany looks almost like a holiday camp.

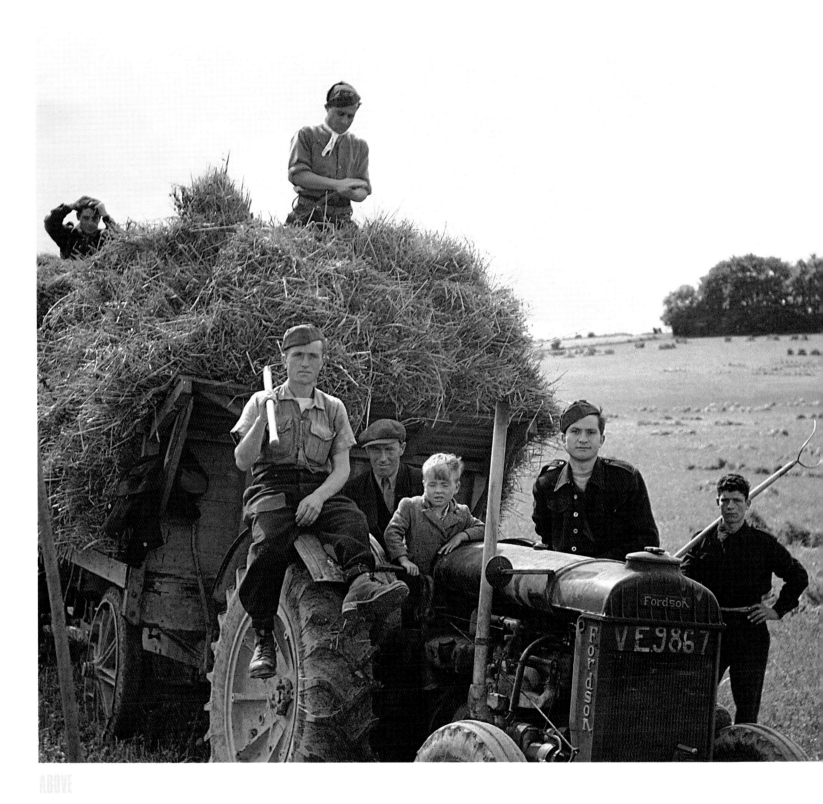

"Over here in England we're helping with the hay." German
POWs were put to work on farms all over Britain. Some liked it
so much that they came back after the war and settled there.

The headquarters of the NSDAP (National Socialist German
Workers' Party) in Munich lies destroyed after receiving a
direct hit in an air raid.

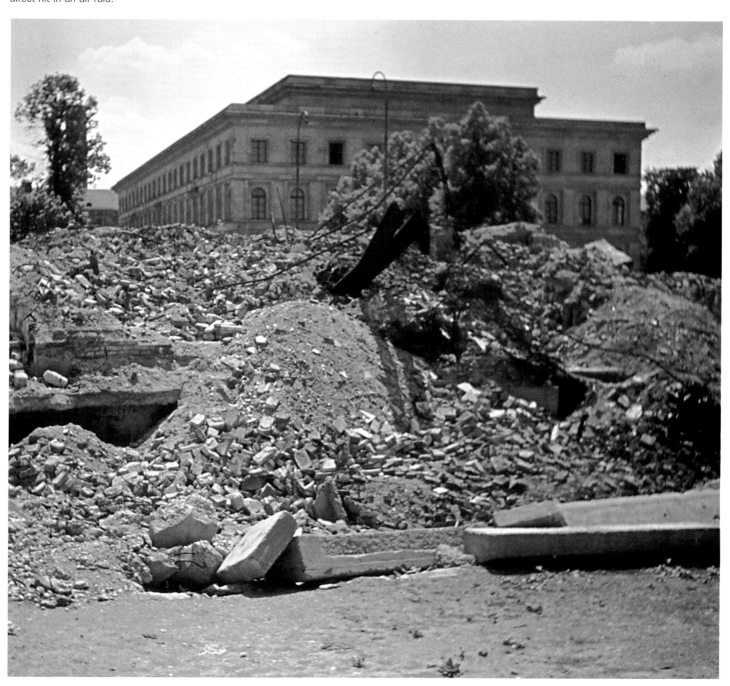

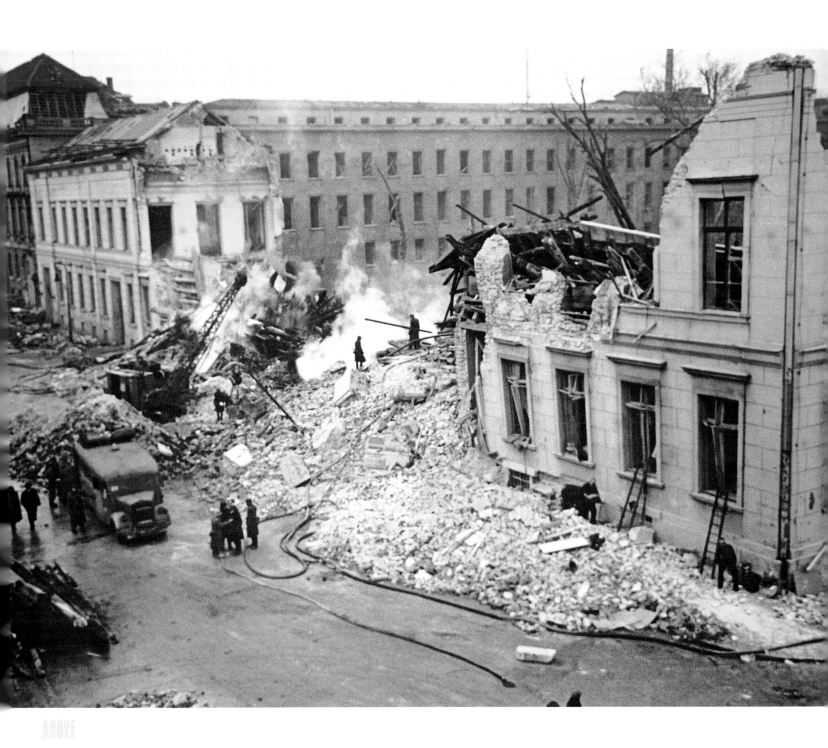

The aerial assault on Berlin, as exemplified by this scene near
the Reichskanzlei (Reich Chancellery), was bad enough, but
nothing like the devastation the city would suffer when the Red
Army arrived in mid-April 1945.

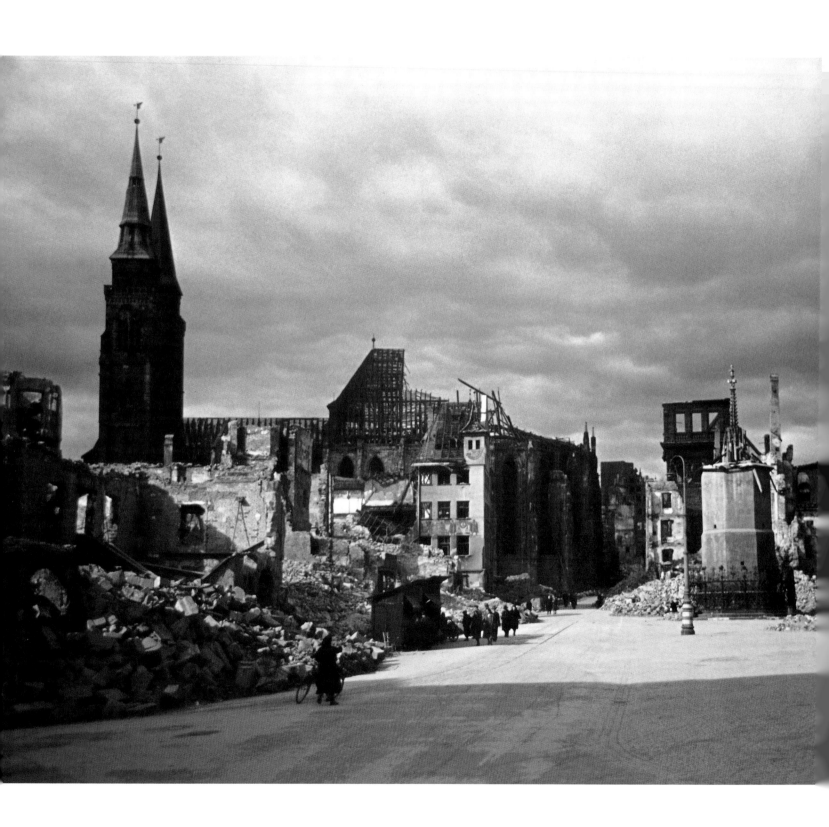

Ruins in Nuremberg graphically illustrate the
destruction wreaked on many German cities and
towns by Allied bombing. Ordinary people across
the country suffered mightily for everything that the
Führer and his lackeys had done in their name.

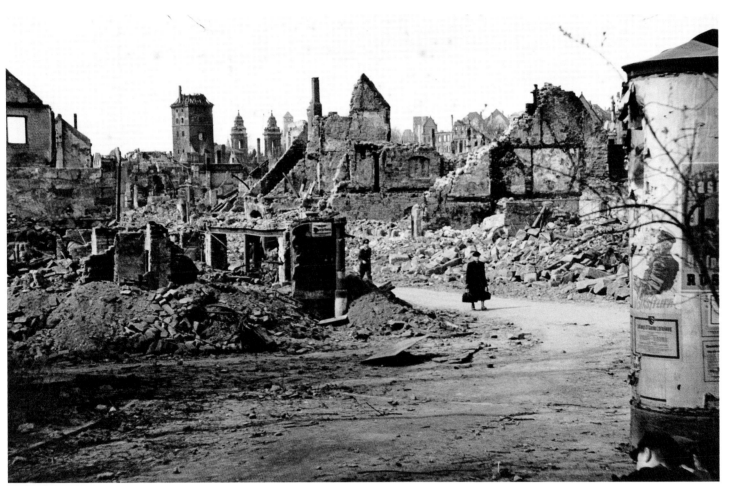

Bags in hand, a woman walks alone through a city
laid to waste. Like her prospects, great swathes of
urban Germany were now in ruins.

NUREMBERG TRIALS

Within months of the end of the war in Europe, those responsible for masterminding Germany's most terrible acts were brought to justice. Hitler and some of his senior henchmen had already committed suicide, but, between November 1945 and October 1946, 22 senior Nazis were tried in public at Nuremberg. The staging of the trial had been agreed by the USA, Britain and the USSR and endorsed by the United Nations. The International Military Tribunal, under Lord Justice Geoffrey Lawrence, sentenced 12 of the accused to death and seven to imprisonment, while three were acquitted. As Germany lay in ruins, the Herrenvolk, the supposed Master Race, witnessed at first hand the disastrous consequences of their desire for conquest and expansion.

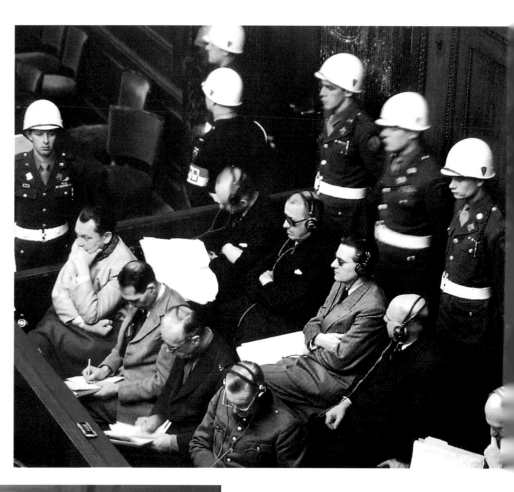

On the front row in the courtroom at Nuremberg, Goering listens intently, while next to him Hess makes notes, as do Ribbentrop and Keitel. Behind them are Dönitz, Raeder, Schirach, Saukel and Jodl (head only). The rest of the accused are out of shot.

A view of part of the courtroom during the Trials, taken in September 1946, just weeks before they ended. The room was always ringed by American military policemen, wearing the helmets that earned them the nickname "Snowdrops".

RIGHT

Karl Brandt was Dr Theodor Morell's successor as Hitler's personal physician. He is seen here just before his execution on June 2 1948 at Landsberg Prison, after he and 22 other SS physicians and scientists had been tried at Nuremberg. Seven of them were hanged.

BELOW

Nazi graves at Landsberg Prison after the guilty had been executed. Colonel Burton C. Andrus and John C. Woods, both of the US Army, were, respectively, their jailer and hangman.

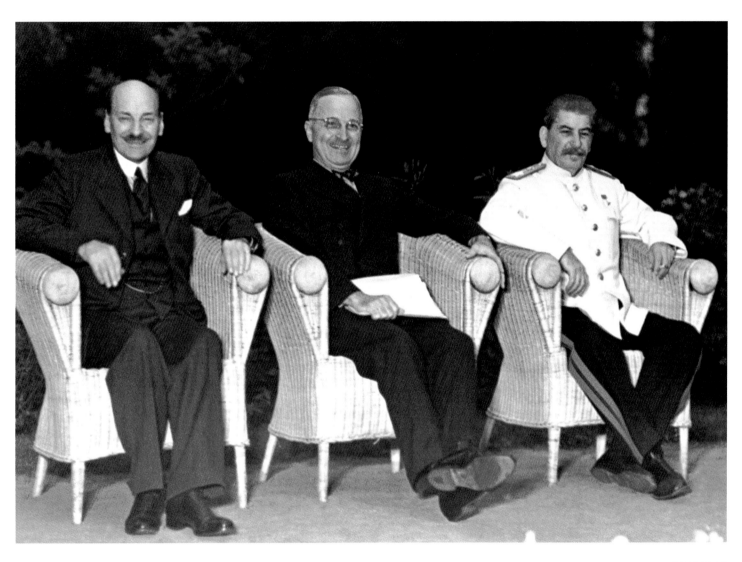

ABOVE

The three Allied leaders at the Potsdam Conference, held between July 17 and August 2 1945: British Prime Minister Clement Attlee (who replaced Churchill), American President Harry S. Truman (Roosevelt had died in April of that year) and Joseph Stalin of the Soviet Union.

RIGHT

A Soviet police checkpoint in Berlin. When the city was divided into four sectors in 1945, checkpoints were set up between the East and West sectors. Here police checked the identities and other details of all who wished to pass from one sector to another.

NEXT PAGE

Allied trucks move through the ruined streets of Berlin. The five-pointed star on the rear of the vehicle is an Allied recognition symbol. Despite the damage, the city still hummed and almost anything was obtainable on the black market.

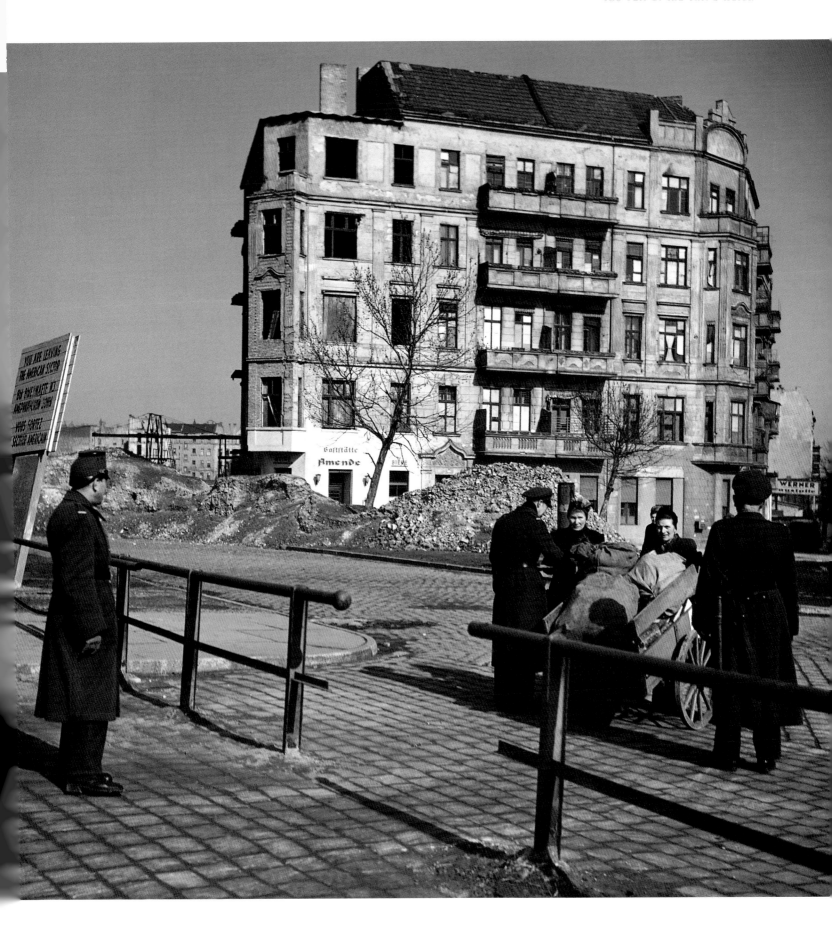

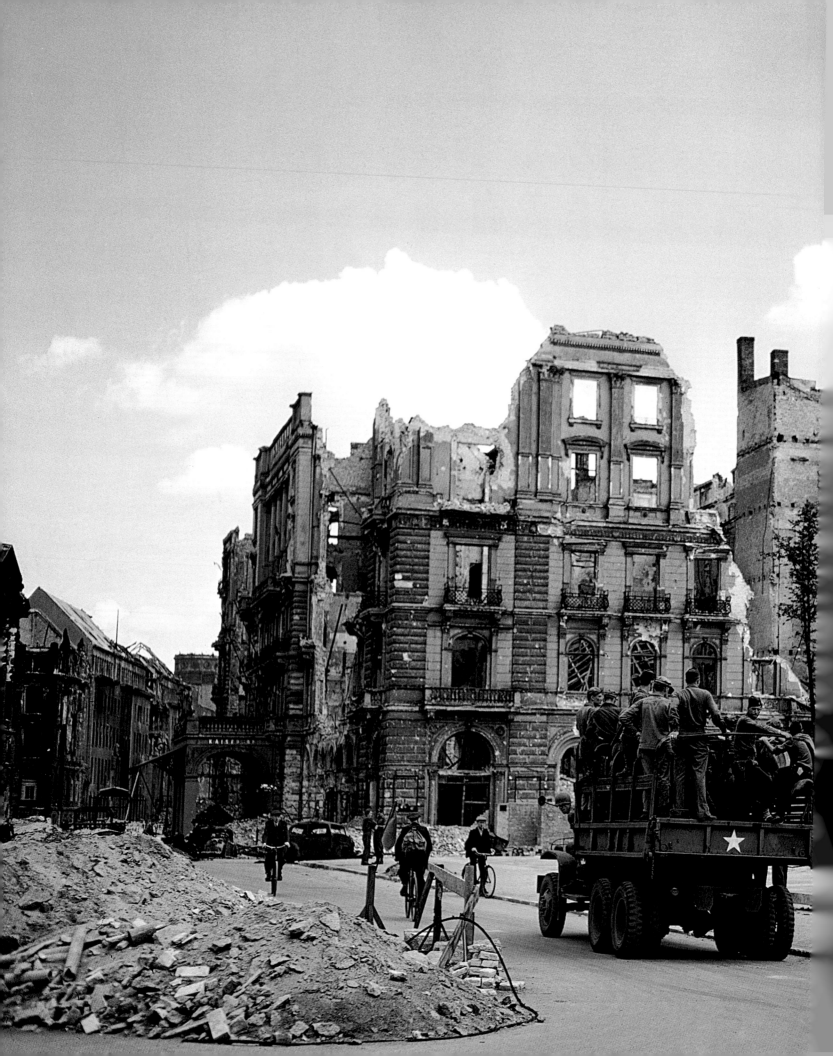

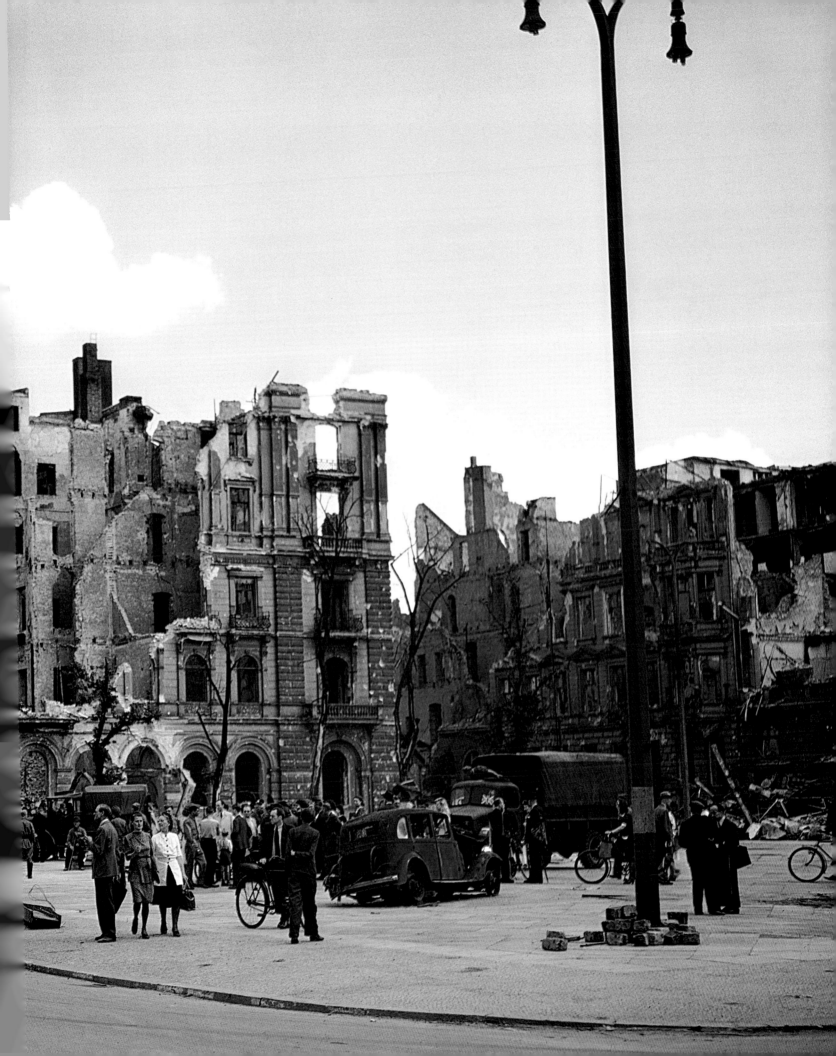

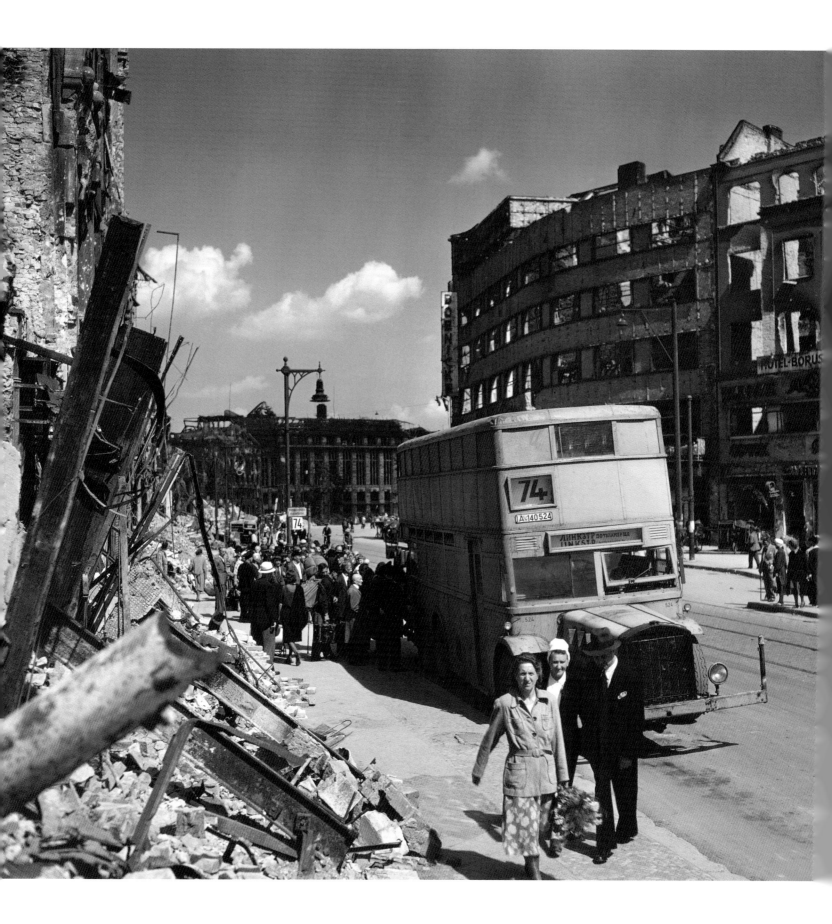

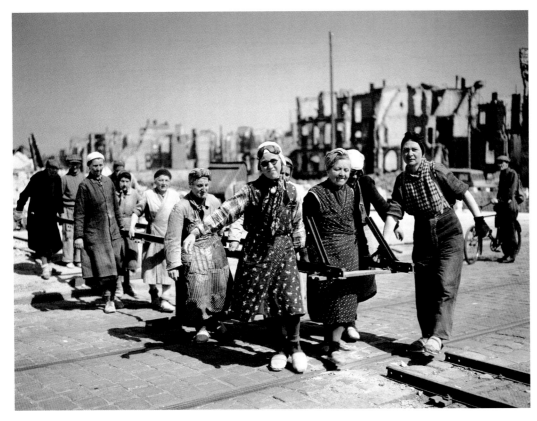

LEFT

Housewives became labourers because work meant food. Crucial supplies were provided through UNRRA (United Nations Relief and Rehabilitation Administration), financed mainly by the USA.

LEFT

The Germans are renowned for liking everything in its place – "Alles in Ordnung" – so, despite the bomb damage, as soon as the streets were clear of rubble, bus services resumed.

RIGHT

When the Soviet military authorities tried to isolate the city from the West, they were thwarted by the Berlin Airlift, a round-the-clock operation carried out by US and British aircraft between June 29 1948 and May 19 1949.

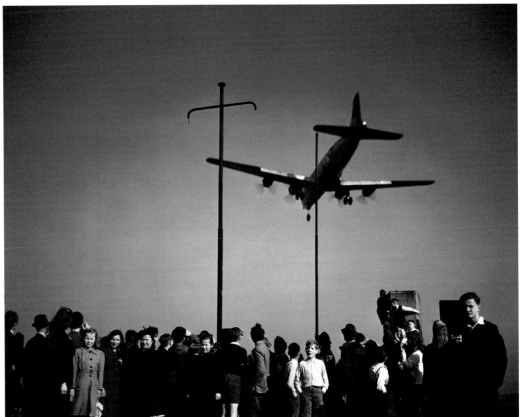

Casualty Figures and Related Statistics

ARMED FORCES

The population of Germany in 1938 was 78 million, of which just under 18 million served in the Armed Forces (Wehrmacht). Of these the total casualty figures for killed and wounded were: 7,856,600 (3,250,000 killed, 4,606,600 wounded). The separate figures for the three armed services (to January 31 1945) are:

	Served	Killed/missing	Wounded	Prisoner/missing
Army	13,000,000	1,622,600	4,188,000	1,643,300
Air Force	3,400,000	294,900*	216,600*	Not known
Navy	1,500,000	149,200*	25,300*	Not known

CIVILIANS

Anglo-American air raids killed just under 600,000 people, of whom 56,000 were foreign workers and 40,000 Austrians. Also some 10,000 were killed in the crossfire when the Western Allies advanced through Germany. On the other side of the country, over 2 million were killed by similar crossfire, revenge atrocities, air raids etc.

Killed 2,350,000*~ **Wounded/disabled** 2,010,000

~ 300,000 of these were killed by the Germans themselves; they were mainly Jews, but also gypsies, mental defectives and those who refused to accept Nazism.

* Source: *World War II Databook* by John Ellis, Aurum Press, 1993.

Further Reference

Museums Worldwide

There are many museums worldwide that deal with the Second World War or with some aspect of the war or its aftermath, because it touched every country in some way or another. The Imperial War Museum in London, the Air and Space Museum in Washington DC and the Memorial Museum in Caen in Normandy are just three major examples.

Specialist Museums in Germany

There are a number of specialist museums in Germany that deal with aspects of the Second World War or the military, and a selective list of these is given below. Further details can be obtained from two websites:

http://www.abcollection.com/eng/museum/germany.php and http://www.museums.simonides.org/germany/germany.html

The Death Camps

While Auschwitz–Birkenau, near Krakow in Poland, was the largest concentration camp and extermination centre – by some estimates, 4 million people were killed here – there are two other examples of these terrible places in Germany that are now museums: Dachau and Buchenwald. The first is some 10.5 miles (17 km) north of Munich and was the first concentration camp to be built, in 1933. A replica of one hut remains to give some idea of the conditions, the rest having been destroyed by the Allies. The only original buildings standing are the gas chambers, where, to quote from *Germany: the Rough Guide*: "open ovens gape at you and bright whitewashed walls almost distract the visitor from the gas outlets set into the ceilings of the shower rooms". There is an exhibition with photographs and a very disturbing documentary film with an English soundtrack.

Konzentrationslager Buchenwald is situated to the north of Weimar. Here an exhibition in a former storehouse gives a history of the camp, which housed about a quarter of a million inmates, of whom an estimated 56,000 died from starvation, torture and disease, although Buchenwald was never classed as an "extermination" camp. The crematorium, disinfection chambers, prisoners' canteen and other facilities may also be visited.

Second World War Museums in Germany

Bad Bergzabern: Westwall Museum
Bad Gandersheim: Museum in Rathaus
Bad Wildungen: Jagd und Militär Museum Schloss Friedrichstein
Berlin: Deutsches Historisches Museum
Berlin-Gatow: Luftwaffenmuseum der Bundeswehr
Berlin-Karlhorst: Deutsch-Russisches Museum
Celle: Celle Garrison-Museum
Dresden: Militärhistorisches Museum
Eckenforde: Lehrsammlung der Marinenwaffenschule
Grafenwöhr: Oberpfälzer Kultur- und Militärmuseum
Gunzenhausen: Museum für Deutsche Kolonialgeschichte
Haigerloch: Atomkeller Museum
Ingolstadt: Bayerisches Armeemuseum
Irrel: Westwall-Museum Panzerwerk Katzenkopf
Kemnath: Heimat und Handfeuerwaffenmuseum
Koblenz: Wehrtechnische Studiensammlung
Königstein: Museum Festung
Lübeck: Lehrsammlung der Grenzschutzschule
Münster: Panzermuseum
Peenemünde: Historisch Technishes Informationszentrum
Pirmasens: Westwall-Museum Festungswerk Gerstfeldhohe
Pocking: Rottauer Museum – Fahrzeuge, Wehrtechnik und Zeitgeschichte
Rastatt: Wehrgeschichtlichtes Museum
Remagen: Friedenmuseum
Rothenbach: Museum für Historische Wehrtechnik
Schlachters: Historisches Heerstechnisches Museum (Private)
Seelower Höhen: Museum
Sinsheim: Auto und Technik-Museum
Soest: Museum der Belgischen Streitkrafte in Deutschland
Solingen: Deutsches Klingenmuseum
Sonthofen: Gebirgsjägermuseum
Speyer: U-Boot Museum
Spiegelau: Museum für Uniformen, Orden und Zeitgeschichte (Private)
Stammheim: Museum Militärgeschichte
Suhl: Waffenmuseum
Wunsdorf: Förderverein Garnisonmuseum Wünsdorfer
Würzburg: Marne Museum der 1 US Infanterie Division

Index

PICTURE CREDITS

The publishers would like to thank the
following sources for their kind permission
to reproduce thepictures in this book:

AKG London: 95, 131, 132, 133, 162, 163,
164.

Bibliothek fuer Zeitgeschichte, Stuttgart: 165,
166t.

© **Bildarchiv Preussischer Kulturbesitz, Berlin:**
22, 32, 33, 49, 52, 60, 79t, 79b, 99, 100b,
101, 117t, 117b, 118, 120t, 120b, 122, 123,
136, 137b, 166b, 167, 168t, 168b, 169, 171,
208t, 222-223, 224, 225t, 225b, 226.

Corbis: /Bettmann: 210, 220, 233b, 234t,
245, 246-247, 248, 249t, 249b; /Christel

Gerstenberg: 89; /Hulton-Deutsch Collection:
237.

**Deutsches Historisches Museum, photo
archive:** 17t, 42, 42-43, 44, 45, 46, 47, 74,
75, 76, 77t.

Lt Col. George Forty: 115t, 115b.

E.W.W. Fowler: 174t, 175.

Walter Frentz Historical Photo Archive: 20, 56,
78, 90, 101t, 102, 103, 111t, 111b, 118-119,
119, 121, 128, 129, 130, 134t, 137t, 143,
144, 145, 146, 147, 148, 149t, 149b, 150t,
150b, 151, 152, 153t, 153b, 154t, 155, 156-
157, 160, 161t, 170, 172, 174b, 176t, 176b,
177b, 183, 196, 197tl, 197cr, 197br, 198b,

199, 200, 201t, 201b, 202t, 202b, 208b, 218,
221, 230, 231, 232, 233t, 239, 240, 241.

Galerie Bilderwelt: 72t, 72b, 73, 77b, 80, 81,
97, 112, 113, 135, 158t, 158b, 159, 187,
198t, 204t, 204b, 205, 206t, 206b, 207,
209b, 214, 215, 217, 219, 227t, 227b, 229,
234b, 235t, 236b, 242t, 244.

National Archives: 216t, 228, 235b.

TimePix/Hugo Jaeger: 2-3, 10, 16, 17b, 18t,
19, 21, 23, 24t, 24b, 25t, 25b, 26, 27, 28-29,
30, 34, 35, 36, 38, 39t, 39b, 40, 41, 48, 50t,
50b, 51, 53t, 53b, 54, 55tl, 55cr, 55br, 57,
58t, 58b, 59, 64, 65t, 65b, 66t, 66b, 67, 68t,
68b, 69, 70, 71, 82t, 82b, 83, 84t, 84b, 85,
86, 87, 88t, 88b, 91t, 91b, 92, 93, 94, 96, 98-

99, 104t, 104b, 105, 106, 109, 110, 116,
126, 127, 177t, 178, 182, 184, 185, 186,
190-191, 192t, 192b, 193, 194, 195, 203,
209t, 236t, 238, 242b, 243t, 243b.

Ullstein Bild: 14, 15t, 15b, 37, 107, 108, 114,
124, 125, 134b, 138, 142, 154b, 161b, 173,
216b.

Voller Ernst: 18b, 31, 188, 189.

Every effort has been made to acknowledge
correctly and contact the source and/or copy-
right holderof each picture, and Carlton Books
Limited apologises for any unintentional errors
or omissions whichwill be corrected in future
editions of this book.